LOVES

OF

THE ARTISTS

Also by Jonathan Jones

The Lost Battles

THE LOVES
OF
THE ARTISTS

Art and Passion in the Renaissance

JONATHAN JONES

**SIMON &
SCHUSTER**

London · New York · Sydney · Toronto · New Delhi

A CBS COMPANY

First published in Great Britain by Simon & Schuster UK Ltd, 2013
This paperback edition published by Simon & Schuster UK Ltd, 2014
A CBS COMPANY

1 3 5 7 9 10 8 6 4 2

Simon & Schuster UK Ltd
1st Floor
222 Gray's Inn Road
London WC1X 8HB

www.simonandschuster.co.uk

Simon & Schuster Australia, Sydney
Simon & Schuster India, New Delhi

A CIP catalogue record for this book is available
from the British Library

ISBN: 978-1-84983-392-9
ISBN: 978-0-85720-321-2 (ebook)

Typeset in the UK by M Rules
Printed and bound by CPI Group (UK) Ltd, Croydon, CR0 4YY

For Sarah, my love

CONTENTS

INTRODUCTION

Great artists have the power to preserve the faces and bodies they love, to make a timeless summation of the immediate sensual moment. That power of art to defy death and decay was the reason why, in former times, princes and kings, merchants and popes paid immense sums to artists to portray them and ennoble their surroundings. Yet the same artists used those same skills to praise (gratis and for the sake of love) the girlfriends, wives, courtesans and studio boys who filled their own lives with delight. These artists were sexual revolutionaries. They lived outside the conventions of their time. They were known for being slaves to passion, prisoners of the sense of sight. All that time looking at the finest faces and bodies, drawing nudes for frescoes, portraying the wives of the great ... how could they fail to be tempted? Where other men love women for a variety of reasons – opines the sixteenth-century writer Baldassare Castiglione in *The Book of the Courtier* – a painter is obsessed with sheer physical beauty. It goes with the job.

Every artist in the Renaissance, the brilliant epoch with which this book is concerned, from its birth in fifteenth-century Florence to the last afterglow of Rembrandt in seventeenth-century Amsterdam, worked with hand and eye. All art then was craft, skilled manual labour. Traditionally the dirt of hard graft had confined painters and sculptors to low social rank. In the Renaissance this snobbery was turned on its head. Artists were, in a revolutionary way, revered as creative geniuses. Yet they were nothing if not physical workers. This combination of the dextrous and the inspired was, for their contemporaries, sexy.

Artists had ocular and tactile charisma. Their hands were lovers' hands just as their eyes were lovers' eyes.

The Loves of the Artists pays homage with its title to the most enjoyable book ever written about art. Giorgio Vasari's *Lives of the Sculptors, Architects and Painters from Cimabue to Our Own Time* is in English generally called simply *The Lives of the Artists*. It was first published in Florence in 1550, and reissued in a vastly expanded second edition in 1568. It is one of the great narrative works of European literature – part history, part criticism, part biography, part fiction. For Renaissance readers there was no need to separate these strands. Like Shakespeare, who was four years old when the second edition of *The Lives* was brought out, Vasari mingled the real and the imaginary in a teeming inclusiveness. And it is love stories that are among the most beautiful and memorable tales he relates about the great artists of the Renaissance. A famous artist runs off with a nun and gets her pregnant. Another seduces the women of Venice by playing his lute. A third delights in young men with curly hair. A fourth dies of sexual excess ... I'll explore such tales in the pages that follow here.

Vasari's stories of artists in love contain truths direct and indirect. Even where he does not deal in literal fact, he reveals the ideas and attitudes of his time – and often he points at a reality that can be substantiated. Where an artist's own writings survive to give a full picture of his world – as is the case with Leonardo da Vinci – it is remarkable how well Vasari's tales are borne out by first-hand sources. What looks like a fact in his gargantuan book may turn out to be made up, but this does not mean that what looks like wild invention is untrue. Yet Vasari gives only the basic impetus to my quest for the love lives of such great artists as Leonardo, Titian, Botticelli, Dürer, Michelangelo, Holbein, Raphael and Caravaggio. In fact only three of the seventeen chapters in this book have their starting point in Vasari. The other fourteen love stories were told in manuscripts that shared

Vasari's love of a good tale or, in the case of later artists, were written by his imitators. Beyond anecdote there are many pieces of evidence that paint the sensual canvas of this history – and the most vibrant, revealing sources are works of art themselves.

To visit an art museum is to travel in time. It is quite incredible that we can now step off a street in London or Paris or New York and within moments be in one of the world's great galleries in the company of men and women portrayed by artists four or five hundred years ago. The art of the Renaissance is the oldest art to which every observer today can respond in a direct, emotional way. The *Mona Lisa*, begun in Florence in 1503, just eleven years after the first European sailed to the Americas, is the world's most famous, most visited – even over-visited – painting. Why is sixteenth-century art so much more accessible than that of, say, the early Middle Ages? It is because the Renaissance laid down new ways of picturing the world that still make sense to us. Organizing pictures according to a lifelike system of perspective, using oil paints to enhance the realism of flesh and eyes and clothes, picturing people on the scale of life, setting them in recognizable rooms and landscapes – the Renaissance made art the mirror of life. This gives its images a special temporal magic. We can enjoy the *Mona Lisa* or Jan van Eyck's *Arnolfini Portrait* or Titian's *Venus of Urbino* as depictions of people like us, who touch our hearts and fill our minds. And yet these people lived many centuries ago, in a Europe just breaking out of ancient patterns of life that had scarcely changed for millennia.

For me this conundrum is endlessly fascinating and tantalizing. To look at a sixteenth-century painting is to look through a window into a lost world. It is to walk among Venetian merchants or meet Henry VIII's wives face to face. Art that still stirs us in galleries belongs to both now and then: it lives in the present and resurrects the past. It is an incredible historical document that discloses not just the faces of people and what they wore but also, when the painter is truly talented, the pores of

their skin, the light in their eyes, the very weight of those clothes – not to mention the taste of their food (look at Caravaggio's grapes, for instance, so sweet, so succulent).

Renaissance art in particular also shows us what their sex lives were like. It is phenomenally sensual, full of love scenes. Those love scenes, nudes and intimate portraits are the central documents with which I propose to liberate the history of passion.

The sensuality of Renaissance art arises from the emotional needs of artists themselves. That is the significance of all the stories that survive of artists overcome by love. When the supremely hedonist painter Titian portrayed a devastatingly beautiful woman he was not working mechanically to some brief, let alone producing hack pornography. He was following his own desires. Vasari is very clear about this. The reason he tells such characterful stories about artists is to show that they are far from servile, ignorant menials, but original, individualistic talents. I believe the reason Renaissance art lives in the present is that it blazes with personality. No two artists from this age are quite alike. Their different love lives are insights into their different artistic characters.

It is not merely that Renaissance artists were enthusiastic lovers and keen portrayers of love. Put the two together and their revolutionary impact on the birth of the modern world starts to hover into view. The art of sixteenth- and seventeenth-century Europe created a new luxuriant imagery of desire. Europeans had not known, at least since the fall of the Roman Empire, the sexual sophistication that Renaissance art popularized. Some sixteenth-century paintings can actually be seen as lovers' guides – and the artist Giulio Romano went further and produced an illustrated erotic manual. Without painting too Gothic a picture of life in a medieval castle, it is obvious that by 1500 – and still more by 1600 – Europeans had access to a more sensual and civilized picture of love and lovemaking. The new art of the Renaissance beautified the human form and celebrated sex as a

pleasure for men and women alike. Many Renaissance paintings depict men seeking to delight women.

When Vasari's *Lives of the Artists* was published in its second edition in 1568 it became an inspiration to artists. If the Renaissance gave him his stories, those stories in turn offered seventeenth-century sculptors and painters models to live by. The very idea of a great artist took its pattern from Vasari – and that pattern incorporated sexual licence and audacity. That is why later Renaissance and Baroque artists, including Caravaggio and Rembrandt, are crucial to the story that I want to unfold. Yet there is another reason for telling a tale of the Renaissance that runs from about 1400 to 1650. The Renaissance – the 'Rebirth' – starts in fifteenth-century Italy as an attempt to redis-cover and emulate the ways of the ancient Greeks and Romans. From Italy it spreads throughout Europe. It becomes, every-where, not just an intellectual or artistic phenomenon but a reinvention of social life and even of what it means to be human. Instead of the communal customs that had ruled Europe for so long, this new set of images, styles and ways of behaving that we call the Renaissance permits, even demands, the discovery of individual potential. Artists – especially Italian artists – stand at the forefront of this new individualism. Their exploration of the senses sanctioned a new intimacy in European life. That is why the social rather than simply artistic shape of the Renaissance provides the timeframe of *The Loves of the Artists*. This is not only the story of the passions that inspired some of the world's great-est art. It is also a history of the discovery of that eternally exotic continent, the human self.

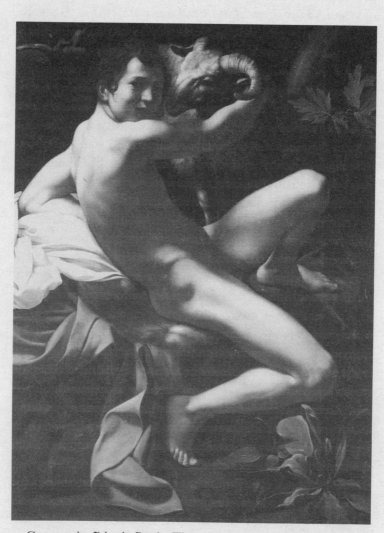

Caravaggio, *John the Baptist*. The model was Caravaggio's lover.

Chapter One

NAKED PASSION

The richest man in Europe sighed. People came to him as if he was their godfather, asking for help, favours, advancement. Outside in the courtyard he could hear his grandchildren laughing, and it would be good to play with them. Instead he was here in his room with a grown man who was crying, pleading with the Capo to help set his life straight.

What's done is done.

Revenge is a dish best served cold.

The usual adages didn't seem much help. That morning, the wretched specimen now sobbing his heart out had had a row with his apprentice. They were (as was all too common in these crafts-men's workshops) sleeping together. The young man had stormed off and left his master heartbroken. Cosimo de' Medici – head of Italy's leading bank and unofficial ruler of the city-state of Florence – wouldn't ordinarily give a Pisan eel for the love trou-bles of a sodomitical sculptor. However, Donatello, who sat here suffering, was a genius, and Cosimo put his hand gently on his shoulder and promised that his worries would soon be over.

So goes the story, as told by a Renaissance chronicle, that Cosimo de' Medici, 'boss' of Florence, personally intervened to reconcile the sculptor Donatello with a male lover. The tale gives a glimpse of how important artists were becoming in fifteenth-century Italy, and of the celebrity of Donatello in his own time.

It also corresponds with the sexual tension that radiates from this artist's most revolutionary work, which happens to be the first great nude statue of the Renaissance.

Donatello was born in Florence with the full name Donato di Niccolò di Betto Bardi in about 1386, and died in 1466. He has many claims to fame: he helped to invent a new kind of 'perspective' picture in which space seems real and deep, created the most graceful equestrian sculpture since the fall of the Roman Empire and gave his statues a fierce inner life that was to be emulated by Michelangelo. His most haunting sculpture is a bronze figure of a boy hero whose naked beauty shattered the art of the Christian Middle Ages and announced the rebirth of the pagan exaltation of the nude. It is a work that tastes of personal confession.

It was (mistakenly) rumoured in the workshops of Renaissance Florence that Donatello moulded the slender limbs of the bronze statue of David, cast in the middle years of the fifteenth century, directly from the body of an adolescent – that his statue owes its precise rendering of shoulder blades and kneecaps to an ambitious exercise in life casting. It is, wrote Giorgio Vasari a century or so after this David was cast, 'almost impossible for craftsmen to believe that it was not moulded on the living form'. This attempt to understand Donatello's most challenging statue as a moulded rather than designed sculpture is a tribute to its intense vitality. That vitality is not simply impressive and admirable. It is shocking. This is a central work in the canon of Western art: the first free-standing nude statue to be made in Europe in the 1,000 years that had passed since the end of ancient Rome. Far from being dulled by respect, it remains troubling. Donatello's masterpiece is not easy to look at without blushing. Had he wanted to disclaim any sexual interest in the young male model whose body he copied in bronze in an age when the crime of 'sodomy' was punishable by death, he might have emulated the cool grace of many an ancient Roman

marble that is beautiful in a distant, sexless way. Instead, he set out to make something that taunts its beholders with an audacious frisson of desire.

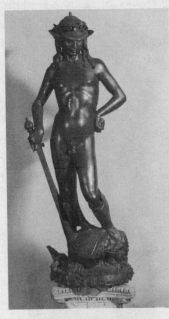

Donatello, *David*. This statue has an erotic boldness
that electrifies the embarrassed onlooker.

It may seem respectable enough in books, a venerable thing in photographs. But to circle the original work is to be slightly befuddled. The statue is slim and slight, and is presented – in the most unmistakable way – for the onlooker's pleasure. The apple-like buttocks are too fleshly, the hand on David's hip too cocksure, for it to remain in any incorporeal realm. This work of art is all about bodies, and how the mind is filled with them. It is about sex.

David has just killed the gigantic warrior Goliath. On the ground beneath him lies the dead man's severed head still in its helmet. In the softness of a shaggy waterfall of moustache and

beard David rests his triumphant foot. That foot is clad in an open-toed boot that rises to just below his knee. David's boots are gratuitous and provocative, like modern erotic underwear, designed to draw attention to his flesh – to toes that peep out, knees that emerge recklessly. He also wears a flamboyant hat, which complements his long falling hair. The large sword in his hand is proudly phallic.

He is a cryptic hybrid of the real and the ideal. His ribcage and stomach muscles are fantastically perfect, yet also in their etched contours tangible and unique. Other parts of him – the skinny arm resting on a hip, his belly button, his dimpled knees – all seem closely, matter-of-factly observed from life even as he adopts the pose of a hero. The twist of his back as he shifts his weight is especially lifelike, especially carnal. If he is godlike from the front, he is human – all too human – from the back. Donatello doted on those buttocks.

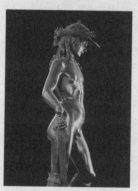

Donatello's revival of the classical nude is perversely energized by a Christian sense of sin.

The courtyard of the Medici Palace, right in the middle of bustling Florence, is withdrawn and shady, almost like a wood-land grove recreated in stone. Leafy Corinthian capitals on top

of round columns could be the tops of trees. Out of them sprout, like enormous branches, wide curved arches that support the building above. Hidden from the street, the court-yard opens on the west side to a walled garden. With its seclusion and stony replication of arboreal shelter, this is a pas-toral retreat at the heart of a busy city – in the home of its busiest family. That sense of rural escape is signalled on the outside of the building. The deliberately rough-hewn, rusti-cated rocks declare the facade to be a border between city and country, prose and poetry. This courtyard was where Donatello's *David* stood, when both the statue and house were new. The architect Michelozzo di Bartolomeo began building Cosimo de' Medici's ambitious residence in 1444; meanwhile Donatello cast his nude sometime between the 1440s and around 1460. It was the birth of a beautiful relationship between luxury and eroticism. Yet the Medici family addressed the bronze *David* to their fellow citizens as a stern and patriotic image, adding a fierce inscription below the sensual and deli-cate youth: 'The defenders of the fatherland will win. God defeats the cruel enemy. See how a boy defeated a powerful tyrant. Citizens, conquer!'

Cosimo de' Medici, known to history as Cosimo the Elder (*il Vecchio*), was too wily to allow his family to seem like decadent hedonists, let alone to get them a reputation for harbouring sodomite art. He built his authority in Florence on a reputation for wisdom and public-mindedness. Whatever Donatello might really be up to with his statue of a nude David, solid citizens vis-iting the Medici Palace were encouraged to see in it a clarion call to virtue – 'See how a boy defeated a powerful tyrant.' The tyrant in question was the Duke of Milan, whose forces, led by the mercenary Captain Niccolò Piccinino, were defeated at the Battle of Anghiari in 1440. This was a triumph after years of struggle between the Florentine republic and its enemies. Plucky Florence, a city of just 50,000 people, had seen off the far larger

Milan. While Milan was a tyranny, Florence was a republic – a city whose people, in theory, governed themselves. Unfortunately, by the time Anghiari gave the republic its moment of glory, this supposedly free city was effectively ruled by the subtle and charismatic Cosimo.

In a posthumous portrait by Jacopo Pontormo, Cosimo *il Vecchio* appears sensitive and contemplative, a soft, enigmatic figure. He was, wrote the early sixteenth-century political analyst and historian Niccolò Machiavelli, 'good to his friends, socially compassionate, wise, prudent, effective, and in everything he said serious and acute'. The story that he reconciled Donatello with a male lover is typical of anecdotes about him that stress his benevolent character. As head of the Medici bank, Cosimo controlled the most sophisticated financial institution in late-medieval Europe. That wealth gave him a vast network of debtors and bought him an army of influential well-wishers. His clients and supporters formed a power bloc that from 1434 onwards controlled the political system of Florence.

Cosimo de' Medici came to power in a city that was enjoying a spectacular cultural revolution. A thousand years of medieval thought, literature, architecture and art were in the process of being overthrown by a generation that wanted to return to what it saw as the far superior civilization of ancient Greece and Rome. Florentine 'humanists', as later historians were to name the intelligentsia who spearheaded this new way of thinking, were not attacking medieval Christianity as a religion. They merely despised almost every expression of it in literature, philosophy and politics over the past millennium. In art and architecture, this meant laughing at the 'barbarism' of the Gothic style – the aesthetic of the cathedrals, all soaring pinnacles, flying buttresses, swaying Virgins and stained glass. Gothic's great champion the Victorian critic John Ruskin argued that it imitated the unevenness and unpredictability of nature. A

cathedral was like a mountain, covered in a tangle of ornament like gorse bushes on a hillside. The remains that Italians could still see, especially in Rome, of classical buildings and statuary were the very opposite of such disorder. Ancient Roman architecture expressed a sense of harmony through rows of identical columns in one of a range of prescribed 'orders', as well as ranks of pilasters – fluted verticals – and regular rectangular windows and doors, lintels and pediments and rounded domes. The same sense of mathematical proportion was expressed in idealized and gracious statues and reliefs.

Florence, like every other European city, had its share of Gothic buildings, from the spire of the church of Santa Croce to its castle-like seat of government, Palazzo della Signoria. Above all it had the immense unfinished cathedral, known to generations of tourists as the Duomo, right at the centre of the largest part of the walled city on the north bank of the River Arno. Green and white inlaid marble panels formed a massive cross-shaped building beside which rose a slender campanile or bell tower, attributed to the fourteenth-century artist Giotto and, in its use of tall pointed windows to stress airy verticality, one of the most pulchritudinous of all medieval creations. Yet at the heart of the cathedral, in the fourteenth century, a vast space waited to be filled. In 1367, a plan was laid down to span this void with something truly unusual: a dome.

In the early 1400s Donatello's friend Filippo Brunelleschi built that dome. When he finished it in 1437 it was hailed as the symbol of a new age, a new way of seeing the world. Rising from a Gothic building, Brunelleschi's dome is a red-and-white beacon of classical harmony, with identical stone ribs supporting identical curving expanses of terracotta. What makes it so completely opposed to the accumulations and accretions of medieval architecture is the superbly controlled and structured development of its design in a beautifully proportioned curve: nothing can be added or taken away without spoiling the composition.

It is a mathematic premise made visible. All of modern architecture, right up to the minimalism of a 1960s New York skyscraper, is implicit in this dome.

Brunelleschi gave Florence a crown of newness when he completed his cupola. It not only revived but also outdid antiquity. The Pantheon, the great domed temple of ancient Rome that survives to this day and in the 1400s stood at the heart of the medieval Roman streets, was created by casting concrete on top of heaped earth then digging out the earth. It is a low hemisphere. Brunelleschi's creation – on a building dedicated to the mother of Christ – is more like a soaring airborne breast. Meanwhile, a short walk away to the east from his dome, Brunelleschi was building a foundling hospital whose architecture expresses the ideal of a nurturing city. Blue terracotta roundels by Luca della Robbia contain white images of babies flying above Brunelleschi's slender columns. They divide a long harmony of semi-circular arches above which a rank of generously spaced rectangular windows, capped with triangular pediments, completes the effect of reasonableness and sanity. The scale of Brunelleschi's Hospital of the Innocents is important: it is not ostentatiously tall but is on a human scale, even a child's scale, designed to welcome rather than intimidate. It is an image of the city as a place of mutual care.

Brunelleschi was also a sculptor. It was announced in the winter of 1401–02 that the city would hold a formal contest to find an artist to cast new ceremonial doors for the early medieval Baptistery in front of the Duomo. In this competition Brunelleschi came second to Lorenzo Ghiberti: the two sets of doors Ghiberti cast over the coming years astonished contemporaries with their sophisticated, lucid storytelling. The second set he made, which long ago earned their nickname the 'Gates of Paradise', were begun in 1425, took a quarter of a century to finish and epitomize a new kind of pictorial art. This new idea of how to see and show the world was explained in Leon Battista

Alberti's theoretical work *On Painting,* written in 1435. Alberti argued that all objects in a painting should be scaled according to a mathematically calculated conical grid leading to a single point in the 'distance' of the picture: in other words a picture was no longer to be thought of as a flat decorative panel but as a replica of the outer world. Everything in it must be imagined, or scientifically mapped, within a precise virtual space.

This is the theory of perspective, which was to transform European art in the coming decades. In early fifteenth-century Florence this new idea was enthusiastically embraced by a gifted generation. The most daring and experimental of them all was Donatello. His sculpted pictures are more ingenious, more exciting than Ghiberti's. His carved and cast reliefs create scintillating illusions of bodies in space. For Donatello the discovery of pictorial depth was an opportunity to portray fully rounded human beings who live and breathe. His bronze depiction of *The Feast of Herod* on the baptismal font in Siena Cathedral, which dates from 1423 to 1427, is set in a stupendously convincing hall where musicians can be seen in a gallery in the distance as people at a table in the foreground reel in shock at the severed head of John the Baptist, presented like food on a plate. As a picture of human reactions to a dramatic event it has a lot in common with Leonardo da Vinci's *Last Supper,* painted decades later. For Donatello the ability to create a scene the mind accepts as real is a means to magnify the emotional impact of art.

At the start of the 1430s Donatello went to Rome to get an accurate picture of the art of antiquity. He stayed there at least a couple of years and – even after Cosimo de' Medici sent a message to come home – came back only when he was good and ready, in 1433. On his return to Florence he carved a response to ancient Greece and Rome that is a work of genius. It was made as a singing gallery (*cantoria*) for the cathedral and its box-like form resembles ancient sarcophagi, the intricately carved

stone coffins that were in his time among the most widely known relics of Rome. Donatello decorated this long box with columns and friezes; but instead of feeling funereal his *cantoria* fizzes with life. Decorations are massed up extravagantly, to create a feast of vital energy: vases, leaves and shells, joyous and natural elements. This is just a frame for the real action. A crowd of enthusiastic children run about madly along the main frieze. Their cavortings are interrupted by pairs of regularly spaced columns, studded with coloured tesserae, but instead of being divided into boxes by these divisions the human profusion simply flows on behind them. The effect is a proliferation of life, a comic abundance that refuses all limits. The *cantoria* is a triumphant Renaissance hymn to life's plenitude.

Dedicating his book *On Painting* to Brunelleschi, Leon Battista Alberti hailed his contemporaries as the makers of a new artistic golden age. He admits in his preface that he thought the arts decayed beyond all redemption until, here in Florence,

> I saw in many, but most of all in you and our friend Donatello [...] An aptitude for every worthwhile project that matches the famous ancients.

This avant-garde of the 1430s was highly conscious of creating something new, of not slavishly imitating antiquity but rivalling it. This creative encounter with another culture – a culture that had to be patiently resurrected from ancient texts and remains – is a unique moment in world history. What other example is there, before modern times, of a civilization questioning its own assumptions by systematically comparing itself with a completely alien set of beliefs, habits and artistic styles? To stand on the piazza in Florence graced by Brunelleschi's Hospital of the Innocents and contemplate those infants floating in an architecture that levitates with them is to realize that fifteenth-century Italians were trying to create a better, wiser, more humane way

of life. They refused to embrace the misery that medieval Christendom accepted, even praised, as the sinful state of life on earth. The Hospital of the Innocents is an affirmation that we should aspire to live well, here on earth, as the ancient Greeks did. It would, of course, be ridiculous to think that as soon as medieval Italians discovered pagan antiquity they ceased to be Christians. But the encounter between fifteenth-century Christians and long-dead pagans was explosive. Over the next two centuries, as it spread across Europe, this ferment would generate new conceptions of every field from cosmology to theatre, and would lead to Galileo, Shakespeare and Cervantes – it was the dawn of the Renaissance. That dawn's brightest light is Donatello's nude bronze *David*. In this work one of the founders of Renaissance art recognizes, in a moment of vertigo, the most challenging and subversive implications of rediscovering the art of pagan antiquity. If the columns and lintels of ancient Roman architecture can be revived, what about the nudity of Roman statues? Why not rejoice, as the ancients rejoiced, in our physical being and the beauty of the human form?

Nakedness is *the* fundamental attribute of ancient Greek and Roman art. Donatello's *David* emulates this ancient transparency. In classical Greece in the fifth century BC athletes competed and trained naked, and were portrayed that way by sculptors. The gods themselves were depicted naked. It was considered a mark of civilization to be honestly naked – for the Greeks recognized that people elsewhere did not bare themselves in this way. In *The Republic* the philosopher Plato mocks the barbarians who actually wear clothes to do sport, poor yokels. Yet it was not merely the naked body that impressed ancient Greeks; it was the ideal male body of the athlete, which resembled the perfect form of the god Apollo. The supreme incarnation of female beauty was expressed in the nude form of Aphrodite, goddess of love, called Venus by the Romans. A fascination with the ideal proportions of a beautiful body goes

back into prehistory in the Greek islands: abstracted yet elegant figures carved from marble on the Cycladic isles in the third millennium BC are tapered and harmonious in contrast to the bulbous 'Venus' figures of Ice Age vintage found in prehistoric central Europe. Cycladic nudes already look like prototypes of the classical Venus. In the fifth century, when Greek culture became fully self-aware, the sculptor Polykleitos composed his *Kanon*, a specification of the ideal proportions of the human body. His ideas were known to the Renaissance through an exposition of them by the Roman writer Vitruvius, who in his book *On Architecture* asserted that

> Nature so made the human figure that the face ought to be one-tenth as long as the body; the same goes for the palm of the hand [...]

Polykleitos and other ancient Greek sculptors portrayed the perfect human form in naked statues of athletes. Most of the bronze originals have vanished but marble copies survive. The Roman Empire embraced the mythology and culture of Greece and had nude statues reproduced by the wagonload. Yet, with the rise of Christianity and the fall of the Roman Empire, the nude was suppressed.

Christianity reviled the body as a rotting vessel of sin. Carnality was the vehicle of lust, the pit of gluttony, the stew of Sodom. St Paul vividly described the horror of the flesh, born in original sin, and warned that

> To be carnally minded is death [...] For if ye live after the flesh, ye shall die.
>
> <div align="right">Romans 8:3–13</div>

Pope Innocent III, late in the twelfth century, had no inclination to soften that condemnation of carnal existence:

Human beings are made of dust, ashes, and, worst of all, disgusting sperm. They are conceived in the lust of the flesh [...] and destined to be a rotten pulp that stinks for all eternity.

Revulsion for the body was in the DNA of medieval Christianity. It went along with a contempt for human potential: Innocent's remarks come from a book that is forbiddingly called *On the Misery of the Human Condition*. The ideal of celibacy arose spontaneously among early Christians, from lone ascetics to women forming communities of virgins, and was systematized by the great medieval Rules for monks and nuns. It was the logical expression of loathing for the sinful flesh.

Donatello's *David* is both a rebellion against this Christian repugnance and a magical transformation of it. The Christian idea of sin is not rejected by this statue. On the contrary, it provides its erotic charge. The unease that stalks its beholder would not have occurred to an ancient Greek. It is a Christian unease. The sensual is still, even today, imbued with sinful associations in Western culture – our inheritance from medieval Christendom. Donatello makes use of this anxiety to give his *David* life, as he draws our eyes to his boy's bronze lingerie.

Near the *David* in the sculpture museum in Florence stands another bronze by Donatello. *Amor-Atys* is a winged boy with many conflicting attributes of classical divinities, including a tail. It is one of the very first depictions of ancient myth in Renaissance art. It is even more bothersome than his *David*. *Amor-Atys* seems from a distance to be wearing trousers; up close these turn out to be loose leggings, slung from a belt, that hang down around his thighs. Look from behind and his buttocks spill over the low-slung leggings. The erotic joke is explicit and bizarre.

It is hard to perceive the sex lives of people who lived more than five centuries ago. Yet with Cosimo as romantic mediator

on behalf of his favourite sculptor we see the metal of Donatello's *David* illuminated. With the casting of this nude, for the first time in history, an artist calls attention to his own sexuality. Ancient Greek sculptors were not saying anything about themselves when they sculpted beautiful male nudes. They were simply conforming to their culture, for ancient Greece considered homosexual desire the highest love. Donatello by contrast lived in a Christian society that demonized and viciously punished 'sodomites'. He does something personal, and courageous, in setting forth his statue of David. This is the flashy creature of his own imagination. This is what he loves.

Chapter Two

BROTHER FILIPPO AND
SISTER LUCREZIA

As Lucrezia cast her eyes modestly on the stone floor she noticed a lizard scamper under a wooden chest. It was midsummer: even the reptiles scuttled for shade. Or perhaps the creature was a symbol of Eve's serpent. For as the friar sat opposite her, drawing at his easel, there was something lascivious in his eyes.

Fra Filippo stared unabashed at the beautiful young nun. His tonsured head affirmed his vow of celibacy, but beneath his cassock something was stirring. He had first seen her when he was on his fresco platform, painting fast then taking breathers as the plaster and paint dried together. Drinking a cup of wine, his legs dangling from the plank on which he sat, he spotted her ivory-pale face, delicate and perfect as an egg. He had to see this face more closely. He plotted.

And here she was, sitting just a few steps away, so he could draw her portrait. It had proved easy persuading the nuns to let Lucrezia pose as the Virgin Mary. Now he sat as close to her as St Luke sits in paintings of the apostle doing the real Virgin's portrait. Like Luke in the pictures, he had all his equipment with him: wooden easel, rag paper treated with yellow ochre dye, a silver-point nib that he pushed down to create soft brown lines.

He plucked up his courage; there was no point in delaying. As his right hand drew the nun's perfect nose, he readied his left to

let his monastic robes fall open and show her what God forbids behind convent walls. But Lucrezia had already spotted it and she looked into his eyes.

'Brother,' she said, 'Is this to be the Lamentation or the Resurrection? For you have risen.'

In the tale of Fra Filippo Lippi and Lucrezia Buti, handed down from sixteenth-century biographies and *novelle*, a Carmelite friar who also happens to be one of the most gifted artists of his age is painting religious scenes in a nunnery in Prato, near Florence, when he is thunderstruck by the beauty of a novice. In order to spend time alone with her he asks if she can pose as the Virgin. Then, after subjecting her to persuasive and honeyed words, he abducts her from the convent during a religious festival and takes her to his house in Florence, where she soon has a baby. The baby is called Filippino. He will grow up to be an artist like his father.

The story happens to be true. Admittedly there is no proof that Fra Filippo seduced Lucrezia by means of portraiture, as the storytellers say he did. But it is a fact, recorded in fifteenth-century documents – including the will of their son the painter Filippino Lippi – that together this friar and nun broke their vows. Lucrezia and her sister left the convent in Prato to live with Lippi. After her son was born she returned to the convent and renewed her vows but Lippi continued to hang around there. Later she left religious life for good. The affair happened in the late 1450s and early 1460s.

It was an act of rebellion and liberation. A man and woman who both found themselves trapped in the chaste life of the Church rejected its discipline and asserted an alternative lifestyle – which happened to be family life. In his portraits of Lucrezia, the adoring Fra Filippo celebrates her not just as a beauty but also as a mother. He praises the domestic satisfactions from which, as a friar, he was supposed to have walked away.

Filippo Lippi was born in about 1406 to a poor family in the Santo Spirito quarter of Florence, south of the River Arno, and lived until 1469. His father, a butcher, died when Filippo was a child and left a family to feed. Filippo was entrusted to the biggest religious institution in the neighbourhood, the friary of the Carmine, whose cloisters still to this day survive as a peaceful retreat from the modern world. For Fra Filippo they were a prison. Certainly the friars trained him as an artist, and to get inspiration he did not have to go far: the revolutionary painter Masaccio had recently decorated the Brancacci Chapel in the Carmine church with frescoes, including a haunting image of Adam and Eve, cast out of paradise, in the shame of their nakedness. But in his career as a religious artist, as he was commissioned again and again to paint the holy works that accord with a friar's vocation, Fra Filippo exhibited an overwhelming fixation that pushed at the constraints of his sacred identity. He was a man who loved women. That appetite for female beauty permeates his art, like a strong perfume wafting through the confessional grille.

Fra Filippo Lippi's *Portrait of a Woman with a Man at Casement* shows a man and woman separated by a stone window frame: the woman who dominates the picture is enclosed inside a room, while the man, in a red cap, sticks his face half-in through the window, making a gesture in which he raises one finger. The sense of obstruction and distance, even as he edges towards her, goes beyond the architecture that divides them. The man is further away from us than the woman: she is in the foreground, in bright light, while he is on a more distant plane, in shadow. They both look towards one another, but do their gazes meet or pass along different lines of vision? This is a painting of desire thwarted. The man – reduced in size, robbed of light – is a would-be lover, beholding his idol at her window. She is all-conquering. She stands in magnificent isolation, hands folded in calm self-contentment. She is regally distant: it is as if we, along with the man at the window, gaze hopelessly on a lady who rules

hearts. Her pearls, painted with astonishing command of three-dimensional form, frame her soft skin in heavenly arrays that trim her headdress and enclose her throat. On her shoulder she wears a brooch studded with expensive gemstones. Her robe is of velvet edged with ermine, and the cloth hanging down from her headpiece is stupefyingly rich in colour and texture.

The adoration of beautiful women also spills into Fra Filippo's religious compositions. From his painting *The Coronation of the Virgin*, in the Uffizi Gallery in Florence, a striking young woman looks outward. She has a gentle face, incredibly appealing and enigmatic, and she is marked out from her companions by the elaborate enfolding of her hair, in a gauzy festive array, and most of all by her frank eyes.

In this same work the friar portrays himself. He rests his head on his right hand in the traditional pose of melancholy and openly broods, apparently discontented or disconnected among the sacred throng. He is kneeling directly opposite the beauty in the foreground of the picture, separated from her by other people, as he meditates, fantasizes, aches. The young woman singled out by his brush lives more vibrantly than other people in the scene; she emerges from the heavenly crowd as a particular person, portrayed with clarity. This was painted in the 1440s. Daydreams of heterosexual love colour its worship, like improper thoughts in church. Fra Filippo is at his most memorable when his art is gripped by his longing for women. It is not his superb *Annunciations* that send hearts aflutter, majestic as they are, but the sweet beauty of the women who animate his religious art. This is because Fra Filippo is truly free as an artist when he touches on earthly love.

Looking at the fervour of this portrayal of an unknown beauty, it is obvious that inviting Fra Filippo Lippi to work at a convent where Florentine fathers sent their daughters to train as nuns was asking for trouble.

*

In Domenico Ghirlandaio's fresco *The Birth of the Virgin* in the church of Santa Maria Novella in Florence, women gather to help at a birth. One of them pours water into a kettle while another nurses the newborn child. Ghirlandaio's setting is a palatial chamber that burgeons with classical decoration, including playful putti who joyously embody childhood. The helpers are witnessed by a patrician-looking gathering of finely dressed women that includes the portrait of Ludovica Tornabuoni – daughter of Giovanni Tornabuoni, who commissioned this cycle of frescoes. What might the picture mean to her? Hope or despair? A daughter born to one of the wealthy families of Florence could look forward to a marriage arranged by her family followed by several scenes of childbirth like this one. That was if she made it to marriage: many young women from elite families faced another destiny.

To marry off a daughter her family had to pay a dowry on her behalf – and the cost of dowries kept going up. For this reason daughters were sorted into those who were to be prepared for marriage and those who were consigned to nunneries to be Brides of Christ, an arrangement recognized by Renaissance Italians as a common abuse of the vocation of the religious life. Both Lucrezia Buti and her sister Spinetta, daughters of Francesco Buti, became nuns at the convent of Santa Margherita in Prato in 1454. It seems reasonable to assume that they were there for the worldly convenience of their family, rather than because of any burning spiritual vocation. For centuries this was a reality of the lives of upper-class Italian women: a frozen history of misery and futility behind convent walls. In the 1640s the Venetian nun Arcangela Tarabotti wrote a savage denunciation of the imposition of convent life on girls with no religious vocation. Her work is called, in no uncertain terms, *Inferno monacale – The Nun's Hell*. She portrays the uninspired novice's acceptance into the religious life as a nightmare out of a Gothic novel:

A girl lies with her face to the hard floor. She is covered with a cloth. Candles are lit near both ends of her body [...] She seems to be dead. She experiences her own funeral rites.

It has been claimed by some that at least half of all noblewomen who took vows at seventeenth-century Venetian convents were forced to do so by their families. Contemporaries blamed the presence of so many unwilling Brides – or prisoners – of Christ for the scandals that regularly hit convents and monasteries. When the nun Laura Querini was interrogated after she and her friend dug a hole in the wall at the convent of San Zaccaria in Venice to let their lovers in, she explained she had no vocation to be there at all. She also said she tried spells and 'marvellous prayers invoking devils' to seduce her lover.

It was the same in fifteenth-century Florence, where it typically cost 1,000 florins to provide a dowry and only 100 to pay for a nun to take her vows. The existence behind religious walls of so many women who did not want to be there led to misconduct like that in the convent of Santa Caterina de Cafaggiolo in 1452, where two nuns were reported to have recently borne children. In this case the convent was urgently reformed. The idea of penetrating a convent's security was an obsession for Florentine men. The vision of beautiful young women locked behind convent walls tantalized them. Cases regularly came before ecclesiastical courts that concerned youths trying to break into nunneries. As a friar, Filippo did not need to break in: he could be invited. An accusation made against him and another man in 1461 says that more than two years after Lucrezia conceived his child – little Filippino had probably been born in 1458 – he was still exploiting religious authority for sexual purposes at Santa Margherita and that both these men who hold offices of sacred responsibility in the convent have had sons born to them there. Fra Filippo's son, the

complainant continues, lives at home with him and is named Filippino.

Fra Filippo and his corrupt colleague were doing what gangs of young men tried to do by climbing over convent walls – get into a celibate community and use it as an adult playground. This cultural fantasy went back to the stories of Giovanni Boccaccio, written in the fourteenth century. In one of the 100 mostly bawdy tales in Boccaccio's book *The Decameron*, the first great masterpiece of Italian prose, a young man called Masetto gets a job as gardener at a nuns' house. To make himself seem harmless he pretends to be deaf and dumb. Soon, thinking he can't hear, the nuns are discussing his attractions, and when he knows they are interested Masetto signals his willingness. He is soon having sex with all the women in the convent – a happy set-up and the outside world is none the wiser. As the narrator of the story comments:

> Most beautiful ladies, a lot of men and women are so stupid they believe all too well that, when a young woman has taken the white veil and the black habit, she is then not a woman and does not feel feminine appetites, as if in becoming a nun she had turned to stone.

Boccaccio is one of the three great Italian medieval writers who made the Tuscan vernacular a literary language. All three are preoccupied with love. Boccaccio finds in love and sex an endless source of stories and jokes. By contrast Dante Alighieri in his poetic autobiography *The New Life* understands his love for a young Florentine woman called Beatrice as a holy quest. But the writer in this triumvirate who spellbound poets, artists and lovers in the Renaissance was Petrarch. Born in 1304 and destined to see his world die around him when he survived the Black Death, Petrarch spent most of his life in southern France. He wrote his most enduring works in the Tuscan tongue,

though he himself preferred Latin. Petrarch's life changed one
day in Avignon when he saw a young woman called Laura and
fell hopelessly in love. He thought and dreamed about her all his
life, even though his passion was unrequited. When she died in
the Great Plague in 1348 he simply went on loving her. The
poems that express his lifelong devotion to Laura are the most
influential of all Western writings on love, emulated in every
European language.

The scandal at the convent in Prato is like a story from
Boccaccio. In his own imagination, however, Fra Filippo Lippi
saw himself as a Petrarch, a courtly lover lauding his lady with
his art. If poets can praise their loves, so can painters. Petrarch
himself tried to preserve the beauty of Laura by commissioning
a portrait of her by the great Sienese painter Simone Martini,
whose *Annunciation*, with its narrow-eyed Mary arching her whole
body in response to the angel's news, gives a hint of how he
might have pictured this famous beauty. The portrait is lost but
Petrarch praises it in his verses:

> But certainly my Simone was in Paradise
> from where this noble lady comes;
> he saw her there and portrayed her on paper
> to bear witness among us to her beautiful face.

Fra Filippo Lippi must have known this poem, for he pays
homage to Lucrezia Buti in two paintings that boldly outdo
Petrarch in the art of love.

The bed in Fra Filippo's circular picture – or *tondo* – *The
Madonna and Child with the Birth of the Virgin and the Meeting of
Joachim and Anna* has red curtains to close it off. There is a tall
wooden headboard. The woman in bed, St Anne, is exhausted;
she has just given birth. Another young woman enters with a
tray balanced on her head: it bears sweetmeats for the new
mother to eat and so strengthen herself. This was a custom that

every wealthy Florentine family observed. We cannot see the picture that would have been on top of the tray, but examples of these finely made objects that survive are so richly painted they often hang in art museums as if they were created as pictures and nothing else. Often they have amorous motifs: Paris carrying off Helen; the Triumph of Love.

Lippi sets the bedroom, with its moment of birth and its sweetmeats tray, inside a fantastical Florentine palace whose soaring coffered ceilings, arched nook, decorative wall, staircase and inlaid marble floors are joined together not by the logic of architecture but the conjuration of painting, which unifies an unlikely succession of spaces through coruscating pictorial bravado. At the heart of the illusion, her beauty binding it all, is a Madonna who is separated from the scene behind her, sitting on a chair, for all the world like someone enduring a portrait session. She has a delicate nose that curves inward, arched eyebrows and a tall, pale forehead. Her hair has been fashionably cut back and is covered by an artfully tied headdress. Gentle shadows play on her face, deepening its unblemished contours, rounding the ivory pillar of her neck. She looks tired, pensive. She has her chubby son on her lap, and as he eats a pomegranate seed – blood-red symbol of his later death on the cross – he looks up at her lovingly. We are invited to share that adoration. This Madonna is lovely, and yet the way she looks at the painter, the curious intimacy of her small weary face, suggests not an artist inventing a beauty or coldly studying his model – but rather a portrait.

The same face appears in another, near-contemporary work of his. *The Madonna and Child with Two Angels*, like the circular scene, was likely done in the 1460s in the years immediately after Fra Filippo Lippi met Lucrezia Buti. Their son was still a young child, so it was a becoming time for him to show her as a mother. The artist marks these pictures as portraits through their unusual composition. They show the Madonna with an unprecedented

familiarity. In the rectangular *Madonna and Child with Two Angels* he creates a monumental frame, only to liberate his lady from it. The wooden panel on which it is painted has been given a trompe-l'oeil stone border, imitating a window casement made out of the grey *pietra serena* quarried near Florence that was popular with the city's architects. Fra Filippo uses carefully studied shadows to give three-dimensional depth and solidity to the stone window, and through it he shows us a captivating landscape. Gardens and tended crops, a productive earth, can be seen behind the Virgin's swirl of silken hair-coverings and halo; above the plump face of Jesus, harsh, high, rocky mountains spike up. In the distance is the turquoise sea. The landscape is luscious and vivid, a masterpiece of perspective painting. Yet where is the Madonna in relation to it?

She is sitting at the window, inside a palace that overlooks the countryside. Her ornate chair with its spiralling bulbous arm, almost ancient Egyptian and appearing to be made of some exotic Eastern wood, culminating in a carved nautilus shell, has been placed to take in the glorious view. The stone frame seems to enclose one 'picture', and the Madonna is definitely outside that picture. She is in front of the casement, coming forward in her chair, and therefore seeming to move towards our space. The effect anticipates and may have influenced the *Mona Lisa* and all subsequent portraits that frame a woman against a landscape. It so resembles a portrait that it surely *is* a portrait. Her hands clasped in prayer are ingeniously visualized as a three-dimensional reality – observe the glimpses of her left palm and thumb behind the right hand, which is closest to us – and sensuously shaded. But this very detail makes them seem human, carnal, even ordinary. There is a theatrical quality to her gesture of prayer, a self-consciousness.

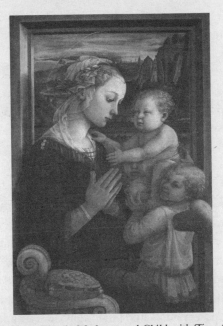

Fra Filippo Lippi, *Madonna and Child with Two Angels*.
This religious painting had a profound influence on
many secular portraits, including the *Mona Lisa*.

As his model lowers her eyes, Fra Filippo worships her beauty.
He pays an almost maniacal attention to the particular love-
liness of this woman. He has done up her hair in a fancy way,
wrapping it in complex webs and shimmers of see-through silk.
From a point on her forehead he slings a thread of pearls like
tiny silvery bubbles of champagne that neatly flow across her
brow into the foamy sea of her headdress. Her cheekbones are
sculpted pearl, her lips pink as coral, her neck a slender taper-
ing alabaster stalk. Fra Filippo Lippi may have been a bad friar,
a rogue and an abductor of nuns, but he made Lucrezia Buti
immortal. This is what it means to be loved by a great artist.

Chapter Three

BOTTICELLI'S DREAM

The narrow streets were pitch black. There was a curfew in place and no house could show a light. He walked hunched to avoid the night-watchmen, his feet following the familiar ways. A dog barked, a fellow curfew-breaker sang a melancholy song. At last the alley opened out and Sandro found himself by the river, whose surface splintered in the moonlight into a thousand crystals. The blue night offered a landscape of shadow. It was better to stand here looking at the city under the sky's velvet canopy than to lie in his narrow bed dreaming of women. Those night women, who tormented him. And then, in the sky, he saw his idol: the pure and remote shining light of Venus.

'For you the surface of the sea is joyous and the tranquil sky glows mistily', declares the ancient Roman poet Lucretius in the prayer to Venus, goddess of love, in the opening lines of 'On the Nature of Things'. This poem, having been lost for more than a millennium, was physically rediscovered by a fifteenth-century Florentine book hunter; its impact on art was immediate. The sea in Sandro Botticelli's painting *The Birth of Venus* (which he would have worked on in about 1484) is as serene and radiant as Lucretius could have wished. It is quite simply a marvel, this sea: Botticelli painted Venus on canvas at a time when most Italian artists were using wooden panels, and up close the

painterly freedom is a surprise. To create the delicate ripples that animate the sea's green surface he has just flicked little wisps of white in quick twists of his brush. The enchantment lies in the relationship between the smooth pale flesh of Venus and the sea's warm colours. This is a painting of space as much as form. Even though Botticelli paints a sea of placidity, the little wavelets are necessary because they recede from the eye and so make us see the water as a plane reaching back towards the depths of the canvas, across which Venus approaches. She comes forward, on the edge of the onlooker's reality. The picture does not depict the birth of Venus from the waves but rather her arrival, shell-borne, at the island of either Cythera or Cyprus. Botticelli glories in the sense of uncanny movement, of Venus gliding out of the distance, as pink flowers float down, their slow descent implying that around Venus the air itself has warmed and stilled.

Zephyrus and Aura, who waft her forward with their breath, also seem to float in a motionless, weightless sky and, as they hang there, embrace. They are lovers. Venus enacts her sway, and her followers make love in the air, free of all fetters, all restrictions – even that of gravity. Aura's white body presses smoothly against the darker male flesh of Zephyrus. Meanwhile Venus poses in a graceful curve, her knee-length hair held in front of her, a hand covering one breast. She tilts her head and there is an indefinable look in her eyes: they are at once focused and looking past us.

Her nakedness is genuinely divine. She preserves a portion of modesty not because this is a prudish painting but out of respect for her cosmic authority. There is a real, tangible sense of supernatural power when you look at this image. It is the goddess Venus herself we are seeing. She approaches; she is near. Her beauty seems to perfume the air around us. Her form sinks into the mind. She is to be worshipped as a pagan deity reborn.

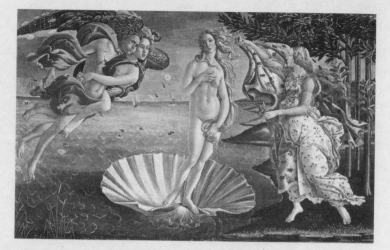

Sandro Botticelli, *The Birth of Venus*. Myth, philosophy and magic shape the mystique of this nude that has come to epitomize Renaissance beauty.

It might seem that the artist who created this painting must have been, like Fra Filippo Lippi, a great lover of women. There is, as it happens, an almost filial relationship between Lippi and Botticelli. Botticelli, who was born Alessandro di Mariano Filipepi in Florence in 1445, and lived until 1510, was Lippi's pupil. In turn he taught and worked with the friar's son, Filippino Lippi – they collaborated closely. Botticelli painted enthroned Madonnas that, in their beauty, prepossessing finery and seated magnificence, pay homage to Fra Filippo's paintings of Lucrezia Buti as the Madonna. Yet in Botticelli's art the adoration of women that saturates his teacher's religious paintings becomes itself a new religion. Like Dante worshipping Beatrice, he elevates his painted beauties to such heavenly status that he cannot imagine touching them.

Botticelli did not marry and in October 1490 he was denounced to the *Ufficiali di Notte* – the Office of the Night – a

magistracy founded in Florence to combat morally lax behaviour (and in particular sodomy) within the city. He was accused of unspecified sins:

> Sandro Botticelli went against the ordinances [*Sander Botticelli fecit contra ordinamenta*].

The accusation went nowhere. Twelve years later, in November 1502, a specific charge of sodomy was laid against him with the same *Ufficiali di Notte*; again it was left hanging.

The most curious story about Botticelli's love life reveals him terrified by the idea of actually living with a woman in his house, in his room. His visions of Venus were for him the very antithesis of normal Florentine family life: they bore no relation to the reality of domesticity, which was to him quite repellent. Meeting him one day, the politician Piero di Tommaso Soderini asked Botticelli why he did not get married. The artist answered with a story:

> I'll tell you what happened to me one night, not long ago. I dreamed that I had got married. This upset me so much I woke up. To stop myself going back to sleep and dreaming again, I got up and walked like a madman all over Florence until dawn.

Soderini never asked the question again.

This image of Botticelli in the blackened streets, panicked by the delirium of his own dream life, is arresting. It matches his art because *The Birth of Venus* does seem to be painted by someone whose dreams are exceptionally lucid. Its modern popularity arose in the nineteenth century in the age of Pre-Raphaelite and Symbolist art, when its hallucination of a goddess struck a chord with aesthete dreamers, and grew in the twentieth century as Surrealism and Sigmund Freud popularized the unconscious. It

has the authority of an accurately recorded apparition. Botticelli dreams that an ancient pagan divinity is coming to see him. This time he does not flee the house. This woman does not scare him. He smiles in his sleep.

In pagan Greek and Roman mythology, the gods are not magisterial patriarchs who judge us from a position of infinite wisdom; they are reflections of human life. They are tremendously powerful, and astonishingly fallible. They are driven by lust and rage, pride and jealousy, just like people on earth. Early fifteenth-century Florentine intellectuals researched the classical world and dug out its lost books but their most heartfelt interest was history, not myth. They wanted to know what it was like to live in the Roman Republic in the age of Julius Caesar and Cicero. They hoped this knowledge might help the Republic of Florence. By the 1480s when republican hopes had been crushed by the autocratic power of the Medici family, Florence became hooked instead on the mythology of the ancients, so arcane, so graceful. Botticelli embodied this cult of the pagan gods. He was not merely illustrating classical texts in his paintings; he was recreating the myths themselves. He strove to see the gods as they really were, pruning away medieval accretions and misunderstandings to recreate the 'true' images of these divinities. He achieved this by looking at works of ancient art, learning the classical language of the human body as capable of perfect proportion and responding emotionally to the pagan tales. All this made him the perfect artist of the age of Lorenzo the Magnificent.

Lorenzo de' Medici, grandson to Cosimo de' Medici, became effective ruler of Florence in 1469 after the early death of his father, Piero. In portraits Lorenzo is saturnine and contemplative. He was a brilliant diplomat who single-handedly managed Florentine foreign policy, a tough enemy to those who crossed him (he tracked down the assassins of his brother Giuliano and had them hanged from windows of the Palazzo della Signoria),

yet also a spendthrift who managed the Medici bank indifferently. On top of all that he was a talented poet who created a culture of rarefied classicism around himself. Botticelli was a star in the circle of Lorenzo de' Medici. It is even possible that his painting *Primavera* includes portraits of the lovers of Lorenzo and Giuliano. This was the moment when Renaissance culture brought the ancient myths of Greece and Rome back to life – and at the heart of this revival floats *The Birth of Venus*.

In the Hall of the Months of the Palazzo Schifanoia in Ferrara, in north-eastern Italy, the gods mingle with monsters and men. These frescoes, painted by Francesco del Cossa and other, lesser hands in the late 1460s and early 1470s, portray the classical gods ruling the world. Yet they rule it as astrological personages, representing the planetary deities that dominate each month. Venus rules the month of April. Below her, grotesque beings symbolize the astrological demons of this month. She herself only partly resembles the goddess Venus from ancient myth: she presides over a court of love, where beautiful young people flirt, play music and embrace, but she is fully clothed, sits on an ornate chariot with little similarity to anything in antique art; and, while she receives the devotion of the god Mars, her lover in ancient myth, he is dressed as a medieval knight. Chivalry and astrology blend with the pagan heritage in this superbly painted arcanum.

Botticelli's Venus looks much more like the goddess of love the ancients actually believed in. She is nude like a true classical statue, modelled in fact on an ancient marble: the *Venus Pudica*, or 'modest Venus'. Yet Botticelli shares the astrological and theurgical ideas about Venus and the other gods that make the frescoes in Ferrara so peculiar and disconcerting. The supernatural invocation of gods as talismanic symbols was waxing, not waning, in Lorenzo the Magnificent's Florence.

The scholar Marsilio Ficino was at the heart of this occult

Renaissance. He was supported financially by the Medici family to spend his life translating and interpreting the Greek philosophical works of Plato, not to mention the ancient magical texts attributed to Hermes Trismegistus. He distilled his discoveries in an exposition of Neo-Platonist philosophy that was to echo through Europe. For Ficino, the pagan gods were not frolicking voluptuaries but spiritual luminaries. In his mixture of ideas, partly Platonic, partly magical, the goddess Venus has special significance. In a letter to Lorenzo di Pierfrancesco de' Medici – Lorenzo the Magnificent's cousin, who is known to have commissioned works by Botticelli – he advised him to pay attention to the astral powers of the gods, above all Venus, for if he properly managed his life by her heavenly signs he would 'live happy and free from cares'. Astrology and spells aside, Ficino believed the philosophy of ancient Greece was really saying the same thing as Christianity, a hugely influential idea that was elaborated in his book *Theologica Platonica*.

According to Ficino's refined spirituality we inhabit the 'sublunary realm', subject to the vicissitudes of change and decay, but we glimpse something better. Beauty on earth, which can never be perfect, is a manifestation of the 'splendour of divine goodness': a trace of the higher, celestial sphere. To love beauty, with a chaste, noble passion, is therefore to worship the divine. Sexual love has a special place in this belief system. If you are in love with a beautiful person, you can elevate this love into a purely spiritual adoration, and so, by transcending the carnal, enter the realm of immortal truth. As Socrates is portrayed as arguing in Plato's dialogue *Phaedrus*, the soul of the lover can rise on wings: 'His wings get bigger and he can't wait to test them [...]'

In another dialogue about love, *The Symposium*, Plato offered a radical view of the goddess Venus that rewrote ancient mythology. There are two Venuses, not just one: the Celestial Venus and the Earthly Venus. The celestial goddess possesses the mind that

contemplates divine beauty. The natural Earthly Venus inspires desire and procreation. Ficino says both Venuses are 'honourable' but the celestial goddess is the way to truth.

Ficino's ideas were taken up and amplified by the thinker Pico della Mirandola, who appears among other Medici courtiers in Botticelli's painting *The Adoration of the Magi*. The ecstatic ideas of these intellectuals suffuse Botticelli's paintings of myth. In his picture *Venus and Mars*, the goddess of love has enchanted her lover the god of war and rendered him harmless: her blessings have harmonized the world and neutered male violence. Philosophy and sexuality sweetly mingle.

Sordid details never bring Botticelli's paintings down to earth. The goddess who brings her gifts of love in *The Birth of Venus* is a transcendent, untouchable presence: she is not earthly at all. She floats on her shell and her feet do not touch sea or land. She moves weightless across the waves. The more you contemplate her beauty, the more it leads you beyond physical care. This is a vision of the Celestial Venus.

No fleshy companion could rival her in Botticelli's bed as he lay there, eyes closed, awaiting his impossible love.

Chapter Four

THE LUSTS OF
LEONARDO DA VINCI

The hall is dim, even in the afternoon. Those high windows do not let in much light. On the far wall, illuminated by flickering candles, a meal is set out. Bread, wine, fish. Painted faces react in horror to some devastating piece of news. Hands are raised in gestures of alarm. Only the centre of the picture is a blank, for the artist is still seeking his perfect model for Christ. Matteo, fresh from prayers, is fascinated to see the latest additions to Leonardo da Vinci's painting of the Last Supper. He is even more enthralled by the artist himself.

Dressed in pink, his long hair immaculate, the court artist of the Duke of Milan is making some gentlemen laugh. While his assistants grind colours by the wooden painting platform, Leonardo is pronouncing a word with comic emphasis.

'*Libidinoso . . .*'

He's talking about a painter – Matteo hasn't heard of him – a Florentine called Fra Filippo Lippi. Matteo has to grin: because this is a monastery and Leonardo is telling a tale about a lusty friar.

Many stories were told of the love life of Fra Filippo Lippi – and one was also told of Leonardo da Vinci recounting that particular tale. Matteo Bandello published his collection of stories the *Novelle* in 1554. In introducing one of its tales he looks back on

his boyhood in Milan in the 1490s, when he, Matteo, was a young trainee monk at the religious complex of Santa Maria delle Grazie with its tranquil cloisters. There he was lucky enough to see Leonardo paint *The Last Supper* in the monks' refectory. His description of the artist at work is a unique document: the only contemporary description of Leonardo's working habits. On some days, remembered Matteo, the painter would just stand and stare at his picture for hours, without touching it. Another day, after thinking for hours, he might touch one detail with a fine brush before going off to work on his clay model of a gigantic horse in his workshop on the other side of the mountainous cathedral. Yet sometimes Leonardo would start to paint and would not stop for hours – no, not even for food or drink.

One day some churchmen visited Leonardo da Vinci there while he was pondering his painting, and wanted to talk to the famous artist. An elderly cardinal asked how much he was paid by Ludovico Sforza, the ruler of Milan. When Leonardo proudly revealed how liberally he was rewarded – 2,000 gold ducats a year plus frequent gifts – the cardinal walked out, shocked that artists now commanded such wealth. So Leonardo then amused some courtiers with a couple of stories about rulers whose generosity showed how much they cherished artists.

In ancient Greece, the all-conquering Alexander the Great had for his court artist the wondrous Apelles. Although not a single painting by Apelles has survived, he was believed in the Renaissance to have been the greatest artist of all time. To compare a painter with Apelles was the highest praise you could give. Once, relates Leonardo in Bandello's story, Alexander asked his court artist to paint his concubine, Campaspe, in the nude. So the beautiful sex-slave of Alexander the Great posed naked, and Apelles got to work. He was stunned. The gorgeous body of Campaspe thrilled him in a way he was totally unable to conceal. Alexander, a man of violent and unpredictable moods, saw all too clearly that Apelles was looking at Campaspe

with an excitement that went beyond the professional. Did he punish his painter? No, Leonardo told his delighted audience. Alexander gave Campaspe to Apelles! That was how much he valued a gifted painter: enough to hand over his concubine.

Leonardo was not finished. In Florence, he said, in the days of Cosimo de' Medici, there lived Fra Filippo Lippi. Although Lippi was a Carmelite friar who had taken vows of chastity, he was also an inveterate love hound. Yet he was such a gifted painter that Cosimo the Elder protected Fra Filippo and forgave his excesses. The wealthy banker became impatient only when he needed the friar to finish a painting urgently. The trouble was that Lippi kept running off to his mistresses. So Cosimo locked him in an upper room of the Medici palace. For a couple of nights the friar put up with it; then, crazed by desire, he made a rope out of bed sheets and escaped to see one of his lovers. Eventually he fell in love with the nun Lucrezia Buti and took her away from her convent. The wealthy and influential Cosimo still protected his artist, and even persuaded the pope to offer him a special dispensation to marry Lucrezia. But Leonardo told how Lippi refused: 'loving liberty too much.'

These two tales that Bandello claims he heard Leonardo tell, back in the monastery all those years ago, are of course about art and sex. They associate artistic fame with amorous gratification and freedom. In ancient Greece, the genius of Apelles conquered Alexander in the bedroom; in fifteenth-century Florence, the excellent art of Fra Filippo allowed him to scorn his monastic vows – according to Leonardo, he gloried in sexual *libertà*.

What is remarkable is that, just a few pages later in his collection, Bandello narrates the tragic deaths of Romeo Montecchio and Giulietta of the Capuleti, doomed lovers of Verona. Thus one of the world's greatest love stories – and one of Shakespeare's sources for *Romeo and Juliet* – stands cheek by jowl with Fra Filippo's libido and Leonardo da Vinci's saucy yarns.

With his use of the word *libertà* Leonardo da Vinci casts artists

as libertines – long before the age of Casanova. Naturally he, like all storytellers, was really speaking of himself.

Leonardo da Vinci was the outcome of illicit desire. He was born in 1452 near Vinci in the hills of Tuscany. His father, Piero, was a notary or property lawyer, and his mother, Caterina, a farmer's daughter. They did not marry. Piero da Vinci went on to have four wives and eleven children in wedlock. Little Leonardo, the bastard child of Piero's country pleasures, lived in Vinci until he was apprenticed as a teenager to the artist Andrea del Verrocchio in Florence. In Leonardo's paintings the childhood memory of a maternal hideaway in the countryside is softly recollected. His altarpiece *The Virgin of the Rocks* portrays a Madonna with young Jesus and John the Baptist in a rural nook sheltered from the world by soaring rocks. Across the water, blue mountains shimmer. In their grotto the holy family – John the Baptist is embraced by Mary as her own child – are visited by an angel of indeterminate gender.

What kind of relationship did Leonardo have with his mother? At Vinci he lived in his father's household. But his art does not suggest a boy starved of maternal affection or women's company. All Italian Renaissance artists praise the tenderness of the Madonna. Leonardo, however, goes much further, into a strange, tight-knit dream-world populated by boys, their mothers, and other boys. Jesus and John the Baptist are warm friends in his pictures. A curly-headed, semi-nude St John plays with baby Jesus: they even share the motherly love of Mary. All this takes place in the countryside, in rocky ravines and pebbly hillsides like the hilly landscape around Vinci.

Leonardo had a stepmother, Albiera di Giovanni Amadori, who married his father in the year he was born. She appears to have accepted him as part of the household. This too can be seen in his paintings. He is engrossed by the idea of showing the Virgin taking care of Christ with help from her own mother, St Anne. In Leonardo's depictions of this theme it is as if Jesus has

two mothers. Mary sits on her mother's lap so the figures of the two women are merged, a double-headed mother offering twice the love.

If these misty invocations of a plenitude of mothers do call to mind Leonardo's own childhood, they also suggest something else about it. The Christ-child's closeness with St John the Baptist associates the gentle world of feminine protection with boyish embraces. In the wild – or in the fields of Vinci – boys become passionate companions.

The city fathers were having none of it. In Florence when Leonardo da Vinci was in his twenties he was accused of sodomy to the Office of the Night. In two depositions he was named along with several other men: the first was dated 9 April 1476, the second 7 June 1476. Spring was the time of love and yearning, when the world wakes, nature blooms, and – as the fifteenth-century Florentine poet Angelo Poliziano put it – 'young guys and girls want to fall in love'.

In Botticelli's painting *Primavera* – 'Spring' – which dates from about 1482, the lusts of spring are embodied by the blue-bodied wind sprite Zephyrus, who sweeps through the trees and seizes a nymph from behind. Botticelli captured the violence, the impulsiveness, in this spring rebirth. Leonardo and his young friends, all of whom were from good Florentine families, were enjoying the spring of 1476 in a way that alarmed the Republic's sex-crime investigators.

On the back of a petition asking for a powerful citizen's support in the crisis, Leonardo sadly asks:

What if there is no love?

The sodomy charges were dropped – though surely because of the elevated social rank of Leonardo's co-accused. Two years later, in 1478, he records that

Fioravante di Domenico in Florence is the friend I love the most, like my brother.

Love had not deserted him.

Yet while the male love between John and Jesus that colours his dreamlike paintings is clearly visible in Leonardo's life by the time he is in his twenties, it accompanies a sensitivity to the beauty of women that mirrors the snug feminine world of his Vinci memories. In the 1470s, perhaps in 1474 when she got married, Leonardo painted a portrait on a wooden panel of Ginevra de' Benci, daughter of a rich Florentine family. It marks a revolution in the portrayal of women.

Ginevra de' Benci looks calmly and even forbiddingly back at us out of low-lidded almond eyes. Her face is a wide pale oval, framed by bronze locks that flare in curls around her cheeks and are parted in a triangle over her high forehead. Her skin is white like ivory, her lips pale. There's an intrigue about her: the pallor is melancholic, and her heavy eyelids coolly sensual. The effect is extraordinary. Through outer beauty, this painting communicates inner character. An inscription in Latin painted on the back of the panel says as much:

Beauty decorates virtue.

The looks that Ginevra shows the world are merely trimmings of her noble personality.

Beauty has authority in this painting. Leonardo lets the face and being of Ginevra de' Benci overwhelm her surroundings and seep from the panel to fill the beholder's mind. One way he achieves this is by crowning her with a radiating pattern of spiky leaves. They are the leaves of a juniper bush. Ginevra sounds like '*ginepro*', which means 'juniper', so the leaves symbolize her. But there is so much more to it than dry heraldic punning. The juniper leaves spread outward like an aura; her soul, or perhaps

her 'virtue', which cannot be contained by her physical body but blossoms outward, a halo of individuality. She fills the painting, her inner self spreading beyond her body, turning the mirror-like lake in a brown and blue landscape behind her into a moody reflection of her sombrely clad beauty.

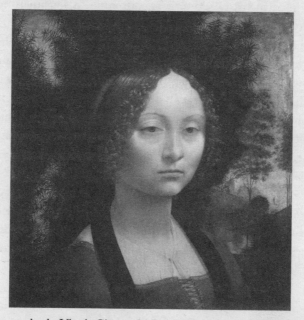

Leonardo da Vinci, *Ginevra de' Benci*. The power of this young woman's personality communicates coolly down the centuries with an authority no portrait had ever before captured in a female face.

No Italian artist had ever allowed a young woman to dominate a painting with her character before. Most Florentine portraits of women that survive from the 1470s are profiles that do not allow the subject's personality to come through at all: these women are posed so as to be reduced to objects of aesthetic scrutiny who have no right to engage in conversation with the

onlooker. Sensitive portrayal was reserved for men. At about the same time that Leonardo portrayed Ginevra de' Benci, Botticelli depicted a young man with long hair holding up a medal of Cosimo de' Medici: the youth looks ardently out of the painting, a perplexing, distinctive character. Women do not get that kind of characterful treatment in Italian portraits of this age – except from Leonardo da Vinci.

One artist who did portray women in the round was Verrocchio, Leonardo's teacher, whose sculpture of a young beauty holding a bunch of flowers shares some of this painting's sympathy. Yet Verrocchio's woman is still far less alive and individual than Ginevra de' Benci – that incredibly charismatic, almost overwhelming presence, once seen, never forgotten. In fact the only real antecedents in Florentine painting for Leonardo da Vinci's Ginevra are none other than Fra Filippo Lippi's tender depictions of women.

Leonardo had a unique skill. No one could portray women like he could. It was to be his standby all his life – the conjuring trick that could get him out of trouble and ingratiate him with patrons and public alike. Eventually it would result in the world's most famous painting, the *Mona Lisa*. And Leonardo needed a party piece: he needed to be able to pull rabbits of portraiture out of his hat because he was continually tantalizing and disappointing people when it came to larger-scale projects. In 1478 he was commissioned to do an altarpiece for a chapel in the government palace of Florence, Palazzo della Signoria. He never finished it. In 1481 a monastery outside Florence commissioned him to paint an Adoration of the Magi. He never finished that, either.

As he turned thirty Leonardo was losing out in Florence to a gifted rival – Botticelli. They had both been taught by Verrocchio, whose workshop Botticelli joined after his time with Fra Filippo, and they were both pioneers of new ways of picturing women. They offered the wealthy and cultivated elite of Florence two radically contrasting images of beauty.

A cult of beautiful womanhood was at the heart of the Florentine Renaissance. That worship began with the Virgin Mary, to whom the cathedral was dedicated and whose nurturing breast was evoked by its flesh-tinted dome. In 1501 in Florence a man called Antonio di Giovanni Rinaldeschi lost a lot of money gambling. In his despair at his lack of luck, he picked up a piece of horse dung and chucked it at a street-image of the Virgin Mary, in a little alley by a church at the Canto de' Ricci. He hit Mary's diadem with the shit. Perhaps he had prayed to her to give him good fortune: his impulse was a reaction to feeling let down, abandoned by Heaven. He was seen by a boy who reported the crime. Rinaldeschi was followed and soon the officers of justice moved to arrest him. He attempted suicide by stabbing himself as they approached – but lived to be dragged to the Bargello Palace, where justice was dispensed. He confessed that he had thrown excrement at the statue of the Virgin out of 'rage'; and that same night he was hanged from one of the palace windows. When the sun came up and the people saw his body swinging, they celebrated heartily.

It was not hate that killed this profaner of the Virgin's image, but love. A deep love for Mary united the community. It was natural for poets and artists to transfigure this Christian cult into a personal adoration of beauties they saw in the streets. Dante's adoration of Beatrice was the love that launched the Renaissance. Botticelli was an avid fan of Dante, whose vision of a journey through the afterlife, *The Divine Comedy*, he would illustrate from beginning to end. His conception of the power of beauty is in a direct line from Dante's worship of Beatrice. As we have seen, he paints in his greatest works not everyday women but goddesses: perfect, heavenly, transcendent beauties. In his rapturous *Primavera* the goddess Venus presides over a woodland court of unreal ladies who include the Three Graces and Flora. All are happy and graceful in their fairyland of myth.

Botticelli must have looked, to the highly educated people around Lorenzo de' Medici at the start of the 1480s, far more modern than Leonardo. While the young artist from Vinci – when he finished anything at all – stuck to portraits and altarpieces, it was Botticelli whose visionary mind could see Venus on her shell, wafting across the waves. Botticelli offered Florence dream women. Leonardo, in his portrait of Ginevra de' Benci, gave them a real one. The Florence of Lorenzo the Magnificent, besotted by pagan myth, philosophy and magic, preferred the dream.

It is said that Leonardo da Vinci was sent by Lorenzo de' Medici to Milan to play for its new ruler Ludovico Sforza on an outlandish-looking lyre he made. This may be a fiction to cloak the fact, embarrassing for sixteenth-century Florentine writers, that their city's most famous ruler let its greatest artist go. Just as Botticelli was painting mythological masterpieces for the Florentine elite in the early 1480s, Leonardo was headed for Milan and there found a place at the court of its ambitious would-be duke – would-be because Ludovico usurped the city state from his nephew and would not formally get a duke's title while the nephew was alive. Which need not be forever. In Milan, Leonardo would fill notebooks with scientific researches while doing enough art to keep his employer happy.

The Sforza castle in Milan was full of electric sexuality, if his portrait of Cecilia Gallerani, the teenaged mistress of Ludovico Sforza, is anything to go by. This painting breathes an atmosphere of meaningful looks in candlelit rooms. It is charged with erotic possibility. Against pale collar bones Cecilia wears a black necklace: the way it is suspended in two loops, one tight on her throat, the other hanging over her breasts, is as outrageous as the phallic elongated snout and claws of the pet ermine she holds with gentle but firm fingers. Her breasts are covered by her embroidered blue, red, gold and black dress, but close to the

painting, by a miraculous anatomical realism, you feel you are peeping down into her cleavage. Even the parting of a sleeve to reveal a triangle of red velvet has something teasingly vaginal about it. Her face, a perfect pale oval, looks out of the painting sideways, surely at her lover, Ludovico. This adds to the sense of assignations, trysts, lovers' secrets. Whatever those secrets are, the painter is in on them: his portrait of Cecilia, which dates from about 1489–90, is distinctly amorous. It is not just Ludovico Sforza who adores this young woman. Leonardo is intensely admiring, as if this were a document of a love triangle. He has in fact taken possession of Cecilia Gallerani. On her sleeves are elaborate black bows and knots that resemble a pattern of knots Leonardo designed as his personal symbol. The same ties and twists appear as tangled foliage in a room he decorated in the Sforza castle. He has persuaded Cecilia to wear specially made clothes that are secretly patterned with symbols of Leonardo himself.

'*Libidinoso.*'

The word that Leonardo applies to Fra Filippo Lippi, while holding forth to an audience of Milanese gentlemen in Bandello's *Novelle*, perfectly captures the charge of his portrait of Cecilia Gallerani. This is a libidinous painting. Far more openly than any Renaissance artist before him, even Lippi, Leonardo paints his own infatuation for this young woman. How can he get away with it? And how does this lusty painting fit the evidence that in real life Leonardo da Vinci sexually preferred men?

A single answer resolves both these questions, and it goes to the heart of the Renaissance. 'Rebirth', that French word means, and it suggests a world of radical transformation. Yet much in the fifteenth century was very old and unchanging. As the historian Johann Huizinga argued in his classic work *The Waning of the Middle Ages*, some of the most potent forces in the culture of Europe 500 years ago were the ripe, and overripe, forms of rituals and rites that were hundreds of years old. When it comes to

understanding images of desire, the most important and endur-
ing of these medieval institutions was courtly love.

In the eleventh and twelfth centuries a ritualized game of love
was invented. In this game, a knight or a troubadour proclaims
his adoration for a lady and vows to serve her. She is often
already married, and he may be married too, but the game is not
supposed to end in actual consummation. Gifts are given, songs
are sung, favours are carried at tournaments. It can all get truly
intense, yet – in theory – it is all theatre. On a twelfth-century
French casket a woman is portrayed leading her lover on a leash
while in another scene a troubadour plays amorous music; in the
tales of King Arthur that were written by French authors,
knights do brave deeds to honour and rescue ladies. But it can
go badly wrong. The tragic love of Lancelot and Guinevere,
Arthur's queen, is courtly love gone haywire. In Renaissance
Italy the conventions of courtly love were just as popular as they
were in medieval France. Jousting was a favourite sport. In
Florence famous tournaments were sponsored by Lorenzo de'
Medici and his brother Giuliano. In a painting of a joust on
Piazza Santa Croce in Florence that survives on a marriage
chest, the portrayal of ladies watching from a window reveals
how sexualized this spectacle was – the men bash each other
with lances to compete for women.

Courtly love was never asexual. It originated in a raw world
of medieval violence. A primitive hot-bloodedness was part of its
appeal – and yet this was poured out in formalized activities.
Petrarch's poems are expressions of courtly love. So is Leonardo
da Vinci's painting of Cecilia Gallerani.

Leonardo threw himself into the lifestyle of Milan's court. He
designed costumes for tournaments. When he invents a wooden
tank in his notebook Manuscript B he even writes that it will be
good for jousting. He specialized in an art form of his own,
grotesque caricature drawings, and surely he did these quickly in
front of courtiers to get a laugh or a grimace. His notebooks also

contain rhetorical arguments about the arts that read like scripts for witty courtly conversation.

In his portrait of Cecilia Gallerani he plays the part of a courtly lover brilliantly, flattering her and trying to seduce her. His portrait is a souvenir of fleeting urges, possibilities, erotic suggestions. He plays the role of the famous Apelles, court artist to Alexander the Great, possessing Cecilia with his art. In the game of courtly love, the artist can use special, enchanting powers.

Courtly love should not lead to sex. It is all words or in the case of this portrait all pigment. Leonardo can play the game, while a young man is waiting for him in bed.

Leonardo loved the life of the court and was never really settled after the fall of Ludovico Sforza drove him out of Milan. At last, seeking that courtly magic, he travelled across the Alps to spend his final years in France.

On 24 June 1518, Francis I, king of France, led his guests to the manor house of Clos Lucé, near his own royal château, where a tent of blue cloth was suspended over the courtyard to create a trompe-l'oeil sky, complete with sun, moon and stars. Under this glittering canopy, the festivities that evening reached their splendid climax of feasting and dancing in a celestial ambience of blue and gold.

This unforgettable night was the work of Leonardo, *peintre du Roy*. The small castle of Clos Lucé was his last home, provided for him by the king along with a salary of 2,000 gold écus, plus 800 écus and 100 écus respectively for his companions Francesco Melzi and Giacomo Salaì. Leonardo became Francis I's royal painter in 1516, when he was sixty-four, but, such entertainments aside, his employer did not expect much work out of him. After a lifetime of trying to combine painting with scientific research, Leonardo was doted on by the young ruler of France as a wise man, a sage. As King Francis later told the sculptor Benvenuto

Cellini, 'He [Francis I] did not think any other man ever knew as much as Leonardo, and not just about art; he believed he was also a supreme philosopher.'

The château where Francis I housed his painter was no servant's cottage on the edge of the royal estates but was a fine mansion owned by the kings of France since 1490, where Francis himself spent part of his childhood. At its heart was an octagonal tower where Leonardo probably lived along with Melzi and Salai and presumably also where he had a workshop for his research. He had stopped painting, it seems, after a stroke, but worked here on ideas that played a part in the golden age of palace architecture in the Loire, designing the vast château of Romorantin. That was never built but apparently influenced the exhilarating Chambord, which was.

In October 1517 in the octagonal tower of his comfortable home the king's painter received a guest, Cardinal Luigi of Aragon, together with the Cardinal's secretary, Antonio de' Beatis. The account of this visit, written up by Antonio de' Beatis, describes not just the elderly Leonardo but some of the works of art he had with him in France:

> He showed the illustrious Cardinal three paintings, one of a certain Florentine woman made after nature at the wish of the late Magnifico, Giuliano de' Medici; another of John the Baptist as a young man; and a third of the Madonna and her little son posed on the knee of St Anne, all absolutely perfect. But indeed because of a paralysis in his right hand no more good things are to be expected from him. He has a Milanese disciple, who was educated by him and paints excellently [...]

This Milanese friend was Giovanni Francesco Melzi, scion of a good family whose villa had been a hospitable retreat for Leonardo when the teenager first joined his workshop. Melzi was

to inherit Leonardo's notebooks, his most treasured works of all, and to guard them in a truly loyal way, helping to preserve a good quantity of these fragile papers into modern times. He was very handsome, witnessed Vasari, who records that many of Leonardo's notes and drawings are

> in the hands of a gentleman of Milan called Francesco Melzi, who in the days when he knew Leonardo was a most beautiful youth, and much loved by him. He is today a nice, good-looking old man and still treasures them like relics, as well as a portrait of Leonardo [...]

This is not the only passage in which Vasari alludes to the good looks of Leonardo's pupils and the pleasure those looks gave him. When Leonardo was first in Milan he

> took as his pupil the Milanese Salaì, who was most graceful and beautiful, having lovely hair, curling in ringlets, in which Leonardo delighted much [...]

Both Melzi and Salaì were with him at the end at Clos Lucé, both on the royal payroll. Antonio de' Beatis simply says Melzi 'lives with' Leonardo. In Milan and later on Leonardo lived openly with his company of pupils, one of whom had the fantastical name Il Fanfoia. Leonardo was loved. After he died in France on 2 May 1519 Francesco Melzi wrote of his loss:

> It is impossible to express the sorrow that weighs me down after his death; and as long as my limbs bear me up I will possess a perpetual sadness, which is merited by the most ardent and lasting love he showed me daily.

Leonardo's portrait of Cecilia Gallerani is an act of hetero-sexual flirtation. By the end of his life Leonardo was ready to

put his feelings for men into pictures, too. Leonardo had with him at Clos Lucé his picture *St John the Baptist*, an insouciantly scandalous masterpiece. Today it hangs in the Louvre, baffling and mocking museumgoers as it has been baffling and mocking onlookers for more than 500 years. From a deep dark night emerges St John the Baptist, a bronze-fleshed male nude, exposing a soft shoulder as he wraps a fur around his disappearing lower body. He smiles an eerie smile as he points a golden finger towards Heaven. Is this Mona Lisa smile beneficent, as he shows us the direction to Heaven, or more personal? For this is not an orthodox image. This St John is explicitly eroticized, his long curly hair – just like the long locks Vasari says Leonardo loved on Salaì – teased and tossed. His naked display is sumptuously created in mirror-like oils that mimic a melting, lamp-lit bedroom view of a lover. Even that finger pointing to Heaven is, of course, ambiguous. It sticks straight up, erect and ready.

A drawing by one of Leonardo's pupils or perhaps even the master himself offers an eye-opener into that erect finger. It confirms that for the artist and his immediate circle this was a deliciously double-edged painting that teetered playfully on the edge of inciting sodomy. The sketch of St John, which also relates to Leonardo's almost identical lost work *The Angel of the Annunciation*, is an insight into how he and his pupils joked about what we might now call the gay subtext of this sacred nude. As the long-haired youth points his finger heavenward in this drawing, he boldly displays an erect cock.

In his great book on Leonardo published in 1939 the art historian Kenneth Clark recognized that 'this extraordinary creature', Leonardo's painting of St John, is 'almost blasphemously unlike the fiery ascetic of the Gospels'. He also suggested that 'part of our distaste for it is due to the large number of pupil's copies which it recalls [. . .]' Without feeling the distaste, the twenty-first century beholder might well recognize that Clark

is onto something here. A lot of paintings by pupils and followers of Leonardo shared the sexual goad of his St John, often in a way that is more explicit and obvious in meaning – being less inspired. An anonymous Leonardesque painter in Milan in about 1500 painted a Narcissus with soft pale skin and curly hair who gazes into a pool, entranced by his own beauty; as the Roman poet Ovid tells the tale in his *Metamorphoses*, Narcissus was so proud in his beauty that he shunned the love of Echo, leaving her so desolate she faded away into a mere reverberation of sound. At last, in a fate that aped hers, he was punished for his self-regard. Out hunting he came upon a rustic pool and gratefully drank:

> While he tries to soothe one thirst, another springs up.
> As he drinks, the sight of his own image creeps up on him,
> a hope without substance, that he thinks is a body,
> when it is just a shadow.

Loving his own male beauty, Narcissus never could tear his eyes from the pool and simply starved to death where he knelt. His last words were a lament for his unattainable love, the boy in the water.

The Leonardesque painter identifies Leonardo's style with this story of a young man hypnotized by his own image, utterly uninterested in the female beauty of Echo. This is not the only painting of Narcissus by a Leonardo follower. Nor is the phallic drawing the only telling reinvention of St John the Baptist. A disciple of Leonardo – often identified as none other than Salaì himself – painted a version of Leonardo's Baptist whose smile is ingratiating, whose nudity seems all the more earthy without Leonardo's bewitching light, and who lacks the slender cross that he holds in Leonardo's original. Without that religious prop, and standing not in mystic darkness but a pastoral landscape, he seems to be making a straightforward proposition. Wicked Salaì.

Leonardo's imitators, none of them geniuses, convey a strong impression of what they saw in his art; they form a homoerotic school. This surely reflects the milieu – perhaps it is valid to say the subculture – of his studio.

Unlike the copy by Salaì, the enigmatic and compelling St John the Baptist painted by Leonardo da Vinci does have a cross, almost invisible as it may be, and his heavenward pointing finger can be, and is, experienced as a spiritual gesture. But to anyone doubting that such a painting can have a licentious side, the words of Leonardo himself offer a sly view – not just of this painting but of all Renaissance art. For in his drafts for a book on painting, collected by Melzi in the *Codex Urbinas* in the Vatican, Leonardo tells what he claims is a true story about art as stimulus:

> If the poet claims to be able to arouse love, which is funda-
> mental to all animal life, the painter can do this even more
> effectively. He can show the lover an accurate picture of his
> beloved, often inspiring the owner to talk to a painting and
> kiss it [. . .] I once made a religious painting, and the pur-
> chaser was so attracted to it he wanted me to free him from
> guilt by removing all holy trappings. In the end his scruples
> got the better of his lust, and he had to throw it out of the
> house.

This passage is startling. Leonardo says frankly that desire, 'love', is at the centre of animal existence, including the lives of humans. He goes on to say that a fundamental effect of art is to arouse that love: in other words, eroticism is one of the primary and most marvellous uses of art. Painting is more arousing than the spoken and written word; therefore the painter is superior to the writer. Most unexpected of all is the example he gives of the erotic power of art: a religious work. He painted a holy image whose owner was so stirred by its beauty, so driven to kiss it, that

he tried to pretend it was not a sacred image by having its holy insignia removed before finally returning it to Leonardo in self-disgust.

In Salaì's version of *St John the Baptist* he has removed the cross, to allow it to be seen as a purely secular portrayal of male beauty, if the purchaser so wishes. But Leonardo gives his Baptist a cross and a quality as divine as it is carnal, deliberately making this picture both holy and unholy. The best 'explanation' for the *St John the Baptist* is that it illustrates, or experimentally proves, his theoretical claim that a holy subject may be dangerously transformed, by the power of painting, into a piece of erotica.

It was not the only erotic picture in the octagonal tower of Clos Lucé. Antonio de' Beatis also saw 'a certain Florentine woman made after nature at the wish of the late Magnifico, Giuliano de' Medici'. This does not mean the *Mona Lisa* – contemporaries, and Vasari later in the century, knew very well that Monna Lisa Gherardini was the wife of a Florentine merchant. Instead, the portrait of a woman that Leonardo painted for Giuliano de' Medici in Rome in the 1510s was a half-length nude, the so-called *Mona Vanna*, that has long since vanished.

From 1513 to 1516 when he left for France, Leonardo lived in the capacious Belvedere Palace in the Vatican as a client of Giuliano de' Medici, Duke of Nemours, the pope's brother. In 1516 Giuliano died, which explains why Leonardo ended up taking a painting commissioned by him to France. It is gone, but a copy by a pupil survives. It has a half-masculine Leonardesque face and may at first sight seem as muscular as a Michelangelo attempt at the female nude, but in fact, the fleshiness of Mona Vanna's shoulder and arm show the copyist's attempt to render Leonardo's portrayal of nakedness in an immediate way, 'after nature' as de' Beatis stressed. The *Mona Vanna* was distinguished by its quality of direct observation as the young woman lent towards the artist, showing her shoulder and breasts, posing in a way that stressed candidness and self-revelation.

With this lost erotic portrait Leonardo outdid his own earlier portrait of Cecilia Gallerani, the young lover of Ludovico Sforza. If in that mesmerizing work he compares himself with Apelles painting Campaspe, here the allusion to Alexander the Great's court artist is even more explicit and pointed – for he depicts Giuliano's lover naked. He proves the incredible, thaumaturgical power of painting to 'show the lover an accurate picture of his beloved', as he says in the *Codex Urbinas*. Leonardo's own definition of success for such a picture would be for the owner to want to 'talk to a painting and kiss it'. The way Mona Vanna leans forward and turns her head towards the beholder invites just that response: this nude engages her lover in conversation, invites a reciprocal motion, a kiss.

Chapter Five

DEATH IN VENICE

They lay together in the darkened room, rotten grapes flattened like black flies on the floor around the bed. Propped up on bolsters, she stared at him as she died; and he was too weak to respond, to take up his lute one last time, to sing his love.

The young woman is not idealized. Her face is beautiful, but in a down-to-earth way. Plumpness fills out her cheeks and chin. Her neck is quite thick and short, overhung by a fleshy throat. A red robe lined with fur wraps her shoulders; with her right hand, she pulls back this refined garment. Holding the fur in her fingers, she looks with steady brown eyes at someone we cannot see. The gesture of opening her gown is for this person. And what does the onlooker see? A soft round breast with a big nipple, caressed by a translucent scarf. Her body revealed within the robe's nuzzling fur is milky. Along the silhouette of her exposed breast, pinkness hovers. She allows us – along with whoever she gazes at so steadily – to see her breast's white cloud. It is a moment with a tang of real life as a few strands of dark-brown hair hang in a loose spiral by her left ear, messing her hairstyle with casual allure. Behind her, bursting around her like a radiating crown, is a laurel bush. Its pointed leaves suggest that the scene takes place in a garden, but the oddity of the composition is obviously more formal than that. The laurel is emblematic. For a Renaissance

onlooker it might suggest the love poetry of Petrarch, who made the laurel the emblem of his longing for Laura. This young woman is a new Laura, portrayed in Venice in 1506, the laurels signifying her name and telling a tale of love. On the back of the wooden panel to which the canvas is fixed, the man for whom the painting was made is named as a Messer Giacomo. Like Petrarch, he has had the beauty of his Laura preserved by art, but this Laura is the hero of her own picture, as she opens her robe, looking calmly at Giacomo.

Giorgione, *Laura*. This painting launched a
Venetian art craze for sensual women.

The inscription also names the artist who collaborated with the woman to create this masterpiece. He is called 'Zorzi di Chastel fr[...]' – better known today as Giorgione.

He was born in the late 1470s – the exact date is long lost – in Castelfranco in the territory of Venice. He was drawn seaward, into the salty lagoon, to train as a painter in Venice itself. By the time he was in his twenties Giorgione would revolutionize the art of this city-state. When he arrived there, Venice was known for religious art. Giorgione gave it a new artistic obsession: sex.

Carnal beauty was more than an artistic theme for Giorgione, the stories say. It is said that he lived for love, that he was the perfect Renaissance romantic, a skilled player of the lute, strumming sweet sounds under ladies' windows, luring them to linger over his songs and his gentle compliments. Those Venetian nights were hot for young Giorgione. But they were deadly, too. One night he visited his lover to find her sick with plague. Instead of running away, he stayed with her. What must their last hours together have been like? The artist, so gifted, chose to lie down with his dying lady. Perhaps he played to her. Perhaps the last thing she heard was music. One thing is certain: his own death would be lonelier than hers, when the authorities took him from his lover's death bed to the Lazzaretto Nuovo – the island out in the lagoon where people exposed to the plague were separated from the world of the healthy and the living.

So say the storytellers who wrote down the life of Giorgione in sixteenth- and seventeenth-century Italy. Giorgione's paintings – the handful that can safely be credited to him – amount to a manifesto for a new kind of art and perhaps a new kind of life. Sexuality is the stuff of beauty, says Giorgione, and the impulses of our flesh can lead our minds to places the grey cells would never find for themselves. His art has something philosophical and unusually considered about it. His picture of Laura exerts metaphysical authority. It sounds with echoes of Leonardo da Vinci. In giving this young woman an aura of laurel leaves Giorgione quoted the juniper leaves in Leonardo's portrait of Ginevra de' Benci, and in celebrating her beauty with a raw

sexual energy he drew inspiration from Leonardo's picture of Cecilia Gallerani. Behind the romance of Giorgione is a very serious artist who takes up the challenge of Leonardo's ideas. For Leonardo, in his notes on painting, there is no art more laudable than erotic art. To awaken the animal spirits is a noble enterprise. Giorgione takes that project very seriously indeed.

The folktale of Giorgione is interwoven with his art. It is part-true, part-fantasy, and very suggestive. Artists became defiant individuals in Renaissance Italy. Giorgione was fiercely individ-ualistic, rejecting the workshop system to paint at home, by himself, selling small pictures to private clients. He advertises his pride in a powerful self-portrait. The story of his frenetic love life, which ended in tragedy, dramatizes him as an individual – but its terrible conclusion sinks him back into the crowd of the sick and the dead who haunt history. For every beautiful paint-ing, how many deaths destroyed talent in the age of plague? For every Giorgione whose memory survives, how many nameless lovers have sunk forgotten into time's lagoon?

The immediacy of Giorgione's *Laura* is what makes this painting so transfixing: she is here. The spontaneous naturalness with which Giorgione invests her includes accurate details of con-temporary fashion. The disarray of the young woman's hair is not chance but the style of 1506 in Venice. Just a year previously, the German painter and printmaker Albrecht Dürer, on a visit to Venice from his native Nuremberg, portrayed a woman of this prosperous maritime republic. Her hair too hangs loose around her face. Again, though, what is conspicuous is her assured expression: she looks almost quizzically off to the right, while the beholder wonders who such an acute character might be.

Dürer's trip to Venice was probably his second. After the first, which took place in the 1490s, he made drawings to compare how women dressed in Venice and Nuremberg. In his own German city he shows women in muffling medieval garments of

all-covering respectability. In Venice dresses have low necklines, hair is shown off. Dürer seems to have explored Venice in depth on his second visit in 1505, for he wrote to a friend disparaging his wife back home and even apparently wishing her dead while portraying not just this Venetian but another young woman, too, with warmth. The thrills to which Albrecht Dürer responded were still amazing the British traveller Thomas Coryat a century later. In the early 1600s Coryat found Venice to be the sex capital of Europe. The courtesans of Venice – prostitutes who operated from their own homes rather than on the street, who expected men to give them gifts and treat them as mistresses rather than simply paying for sex, in short who acted out a theatrical role as companions and lovers – were very visible and famous Venetian characters. Poor prostitutes also existed in large numbers. Reformers feared for their fate. The courtesan Veronica Franco, a poet, wrote of the misery behind the glossy mythology of the Renaissance sex trade. She tried to persuade the Venetian senate to provide halfway houses for former prostitutes, and advised young women not to follow her into this life.

Nanna, a courtesan who discusses the sex lives of sixteenth-century Italians in copious – and scabrous – detail in Pietro Aretino's *Dialogues*, published in two parts in 1534 and 1536, defends her profession. Admittedly, she is a fictional character invented by a man. It is not hard to see how much she fulfils the author's fantasy of the happy prostitute. But on the other hand this is a sprawling gargantuan book whose abundant social detail is hard to reduce to mere pornographic ventriloquizing. Nanna's arguments in favour of her work were sly and subversive. She exposed the hypocrisy of convents and marriage, the institutions that controlled women's lives. Nanna was once a nun – but the nunnery she describes is more like a brothel. Exploited by male clergy, vulnerable to all manner of corruption, she found nothing sacred or liberating behind the veil. Neither did she discover

anything but exploitation and lies when she left the convent and got married. At least as a courtesan she is her own boss, and can dupe men instead of being used by them.

Venetian prostitution was a reality and, like any social reality, it was complex. People lived in this way. Their lives are elusive and yet at the same time very immediate. For the fact is that art galleries are full of paintings of the faces and bodies of Venetian prostitutes. Occasionally the bleakest realities are glimpsed in these pictures: a painting by Lorenzo Lotto shows a crowd of the Venetian poor in which there is a high proportion of women in dresses that might be those of street prostitutes. An observer in the 1590s says brutally of these women 'flirting about Venice' that 'everyone shouts and gesticulates obscenities at them'.

One thing is indisputable about the Venetian sex trade: it intrigued artists. Dürer's paintings of 1505 and Giorgione's *Laura* in 1506 are portraits of courtesans, the founding classics of a genre that was to flourish for decades to come. On his 1610 visit, Coryat reports that courtesans often keep portraits of themselves along with tasteful furniture and magnificent tapestries in their elegant houses. In their bedrooms, he adds, they have pictures of the Madonna. Perhaps some of the Venetian paintings of beautiful women that we admire today as pinnacles of Western culture once decorated the apartments of courtesans themselves. Certainly, they star these women. A painting by Palma Vecchio of an unknown blonde woman that dates from about 1520 is absolutely typical. As in Giorgione's *Laura*, this woman pulls her clothes open to present her attractions. She has loosened the blue rope that fastens her white shift. As she lowers her green dress, she displays the gorgeously nippled tender dome of her breast. In her hand she proffers flowers: given her confident undressing it makes sense to see this as an allusion to the ancient Roman festival of the Floralia, sacred to Flora the goddess of flowers, in which prostitutes played a prominent part. The ancient Roman poet Ovid described the bawdy,

springtime Floralia in his festal poem 'Fasti', an extremely well-thumbed classical work in the Renaissance. Paintings such as this, in which women display breasts and flowers, associate prostitution with the springtime goddess Flora.

There was a very good reason for Venetian artists to paint prostitutes: they were prepared to pose naked. The way Laura opens her gown is far too audacious to be – as is sometimes sentimentally said of frank Venetian pictures – a portrait of a young bride. Such explanations strain credulity and many examples of the genre defy pious interpretation. A stunning picture painted in about 1509 is claimed by the museum which owns it as a Giorgione. The woman in this painting wears a shawl, which she is about to pull back, as she tilts her head in a challenging way: it is manifestly an erotic moment. She too has some of her hair dangling loose, and here we can see another meaning to this regular feature of the early courtesan paintings of the first decade of the 1500s: her unkempt hair and loose clothing make it seem like she is in a bedroom.

It may be possible to go further than simply to say Giorgione's *Laura* is a portrait of a courtesan. Perhaps she is an especially renowned courtesan of her day. The second of the two portraits of Venetian women that Albrecht Dürer made in 1505 looks remarkably like Laura. She has exactly the same centre-parted brown hair, a similarly rounded face, a similar look in her eyes. Allowing for the stylistic differences between the two painters – Dürer's bony precision versus Giorgione's melting tenderness – these two portraits, done just a year apart, could conceivably be the same person. If she is indeed a particularly well-known Venetian beauty of her day, who commanded the attention of both Dürer and Giorgione, this might be another meaning to her laurel corona. She bears the laurel; she is the best. The woman in Dürer's painting is clothed. But for Giorgione, the same or a very similar woman poses in a magnificent fur-lined coat, a gauze scarf, and nothing else: before she shows her breast

to the man named on the back of the painting she shows it to Giorgione. His appreciation is intense. He lushly honours her flesh. There is an intimacy in this painting between subject and artist, a collaborative wit: even as she exposes herself, Giorgione gives her a statuesque and classical authority that makes it a controlled and volitional gesture by her.

We get a closer glimpse of Giorgione the man of passion in a self-portrait that brings him blazing into life. He looks at us with a questioning cock of the head. It is we who need to explain ourselves, not him. To add to the belligerence he is wearing armour. Light from outside the picture makes the shoulder extensions of his back-plate and breastplates, joined by a strap, shine brilliantly. Armour fascinated Giorgione for its reflective qualities. In the *Madonna* that he painted for the cathedral of his home town of Castelfranco, a saint stands in full armour that catches dazzles of light in its burnished surfaces. The light that illuminates Giorgione's armour in his self-portrait also brightens a green sleeve, and picks out his face as a gold isle surrounded by blackness. Stubble flecks his upper lip and chin, while his eyebrows furrow together in annoyance or perturbation. Half his face is cast in deep shadow. His eyes are shadows, too – windows on melancholy and fury. His hair is long, curly and unkempt, a black mane. This is a self-portrait as a troublemaker. Giorgione strikes a tough pose that yields, as we look, to brooding and introspection. Giorgio Vasari illustrated the Life of Giorgione that he published in 1550 with an engraving of this portrait, in which, according to him, the artist poses as David armoured to fight Goliath. Giorgione was not the only artist to identify with the Biblical giant-slayer. His contemporary Michelangelo wrote that while David fought with his sling, he, Michelangelo, will use a stonemason's bow drill. It is an image of the artist as hero. Giorgione, like Michelangelo, sees himself in that way. But it is the pensiveness of his painting that hangs

around, and this longhaired severity is captured in the engraving in Vasari's Life of 'GIORGIONE DA CASTELFRANCO, PITTORE VINIZIANO'.

The saturnine portrait fits well with Vasari's account of Giorgione. This was no middle-of-the-road professional, says Vasari, but a man of noteworthy personality. Giorgione was born into a humble family, and yet all his life seemed gracious and well bred. He was trained in Venice and lived up to this city's amorous reputation, for he 'delighted continually in the things of love [...]'

Vasari connects the delight Giorgione found in love with his being a Venetian. He also connects it with music. Giorgione wooed his lovers with musical skill. He was an accomplished lutenist and singer, to professional standard:

> and the sound of the lute pleased him marvellously; and indeed, he played and sang so divinely in his time, that he was often in demand to perform at musical sessions and noble gatherings.

This characterization of Giorgione as a consummate lover and keen musician is shared by the Venetian artist and writer Carlo Ridolfi in his 1648 work *The Marvels of Art*. He says that Giorgione lived on Campo San Silvestro in Venice where he gathered a merry company around him and played 'the gallant man', wooing women with his lute.

The music in Giorgione's life can be confirmed from contemporary sources. In 1510 Isabella d'Este, the marchioness of Mantua and a keen art collector, was trying to track down a painting of a night scene by Giorgione. She suggested her agent ask two friends of his, named Marchetto Cara and Lorenzo da Pavia, for their help. They were respectively a leading musician and a maker of musical instruments. The fact that Giorgione's

closest friends included two renowned music professionals is very noticeable. Surely it makes it more likely that he was the musician his first biographers say he was. To find further evidence of Giorgione the lover, we need to follow him through the narrow streets and over the bridges of Renaissance Venice.

Light is filtered by the high buildings that hang over Campo San Silvestro, where a plaque makes the false claim that Giorgione died in a palace overlooking the church. On a bright afternoon cool shade gathers in the square, making the sky seem all the more luminous overhead. As we walk from here through the alleys and passageways of the San Polo neighbourhood towards the Rialto Bridge, time stalls and reverses. The crowds of modern tourists fade and older sights and sounds assert themselves. By the time we reach the Rialto it is 1504, and men in multi-coloured hose punt women across the still green water of the Grand Canal in gondolas with canopies that give the wives of wealthy Venetians both shade and privacy.

The bridge that crosses the Grand Canal at the Rialto, the oldest part of the city of Venice, where early settlers established their community, is – in 1504 – made of wood. It stands on tall posts driven beneath the water and has a drawbridge in the middle that can be raised to allow masted vessels to pass through. The water is crowded with little boats and gondolas while the bridge and banks bustle with pedestrians. A boat passes with a young woman standing in a fine dress and jewels – a betrothed noblewoman celebrating her marriage. At the markets near the Rialto grand arrays of fish and fruit and piles of vegetables are laid out in the morning sun. On a square close by, bankers have their desks.

The mercantile energy of the Rialto is a meeting of east and west, north and south. Since its early times before AD 1000 the port of Venice on the Adriatic, naturally protected by a shallow lagoon that is difficult for outsiders – and enemies – to navigate, has traded with the fabled Orient, sailing to Byzantium and

beyond, every season. Spices and silks from Asia have for cen-
turies reached Venice and been sold on across Europe, whose
lords crave the luxuries only Italian middlemen can provide.
While turbaned ambassadors and Jewish traders boost the city's
cosmopolitan sparkle, merchants from 'barbarian' northern
Europe also mingle with the crowds. The most spectacular build-
ing at the Rialto expresses their importance. The Fondaco dei
Tedeschi looms beside the wooden bridge, a colossal warehouse
and trading centre for German merchants in Venice.

One night in 1504 reflected fires turn the Grand Canal red
and gold. Charred threads of silk waft on the breeze. Buckets of
water are passed uselessly towards the Gothic inferno. Next
morning the Fondaco dei Tedeschi is a blackened ruin.

The wooden cranes are soon in place to rebuild this important
commercial centre, and it rises over the water bigger and brasher
than ever. New decorations are planned to dignify it, and that's
what brings Giorgione to stand surveying the new facade from
the Rialto Bridge, planning his unlikely scheme of public art.

Venice has enough lions. The animal that symbolizes St Mark,
the patron saint of the Republic of Venice, has been carved in
stone and painted in the Doge's Palace ad nauseam. Portraits of
doges, altarpieces of the Virgin, and – among the Slovenians or
Schiavoni who trade here – totems of St George are plentiful. It
is time for something new. Giorgione is going to paint nudes in
the sky.

In the twenty-first century only one of his nudes from the
facade of the Fondaco is recognizable, and it has been removed
from the exterior wall to hang in the safety of the city's
Accademia Gallery. A woman with shadows for eyes looks out of
a cracked web of fresco shards: as Vasari pointed out long ago,
nothing is worse for frescoes than the Venetian *sirocco*. There was
never much chance of paintings on an exterior wall so close to
the moisture of the Grand Canal enduring the centuries. Yet
Giorgione's faded nude is mesmerizing. She looks as if she might

be 2,000 or more years old, a Venus painted in ancient Rome, such is her ruin. Out of the pale mist of the fractured fresco, breasts bulge, a belly button recedes. A pink softness among the fissures reminds us of the sensuous power of Giorgione's *Laura*. We are looking at the ghost of a masterpiece. Faded as she is, the nude in the Accademia is patently carnal and lifelike. The artist who was remembered as a great lover gave the bodies of women a new place in art and in the life of the city, a lofty public place. But there was more to the revolution than that. He did not paint ideal figures from antique models, but from life. He gratified his own fantasies and passions. In the heart of Venice he elevated the imagination, and the desires, of the artist.

Vasari confesses in his Life of Giorgione that he cannot make sense of these frescoes – still there on the building, albeit fading rapidly, in his day – and nor can anyone else: he has asked Venetians but they are as puzzled as he is. He recognizes the radicalism of Giorgione in painting what is evidently personal and self-expressive rather than morally uplifting for the community. For in his nudes on the Fondaco, says Vasari, this painter followed no allegorical programme but only his own conception. He suggests the artist had a free hand to adorn the new building because:

> [...] the fame of Giorgione had grown so great in that city that the people in charge decided he should paint it in fresco, according to his own imagination, so long as he showed his genius and created something excellent in this very visible place. And so Giorgione did it, but painted what he wanted [...] and I for one have never understood it.

If it seems far-fetched to see a Renaissance work of art as wilful fancy, as opposed to communally sanctioned symbolism, we need only look to Florence, which provided a model for Giorgione's free painting. The most famous public artworks of

the first decade of the sixteenth century were designs for wall paintings in the Great Council Hall in Florence that Leonardo da Vinci and Michelangelo devised in competition with one another. Michelangelo's *Battle of Cascina* gave Giorgione, working in their immediate wake, particular licence. Michelangelo, who was about Giorgione's own age, proposed to decorate the Great Council Hall with an imposing scene of male nudes: his cartoon for *The Battle of Cascina* dwelled on a moment when soldiers bathing in the River Arno have to leap out of the water, naked, to face the enemy. This surprising scheme of a city's public space invaded by nudes clearly helped Giorgione to conceive, and get permission to execute, his line-up of naked women in the heart of Venice, right at the Rialto. The daring of Giorgione was to assert his own sexual taste in what would usually in such a place be a religious work or a political allegory.

The most impressive recent public sculpture in Venice as Giorgione took on his grand project was an equestrian statue of the mercenary captain Bartolomeo Colleoni, by the Florentine artist Andrea del Verrocchio, on Campo Santi Giovanni e Paolo. Male, armoured, brimming with political virtue – this was an appropriate image to loom over passers-by. Meanwhile, Dürer worked inside the Fondaco dei Tedeschi on an altarpiece to solicit divine protection for the new building. Yet, on the outside of the same building, Giorgione was shortly to subvert such traditional civic images. We can see the spirit of his Fondaco frescoes in his painting *Laura*, which was done when he was getting busy with the public project in 1506. Another painting, from 1504, also superbly demonstrates the sheer freedom of mind that informs his nudes.

Judith stands, sword in hand, her foot on the bloodless severed head of Holofernes. That foot is naked: bare toes nestle in the tangled mane of the assassinated warrior. As she feels his soft black hair against her skin, we contemplate her leg, a curvy

golden bow of flesh exposed by a slit pink skirt, her thigh glowing against a hem arched like a Gothic window, embroidered with a jewelled flourish. Her other leg is more modestly concealed by flowing skirts, so her magnificently bared limb is paired with the glittering steel blade that she holds lightly in elegant fingers, its point pressing the earth. Giorgione's Biblical heroine wears a jewel on a gold chain against the parting of her chestnut hair, which hides her ears and lies smooth to shape a perfect half circle of ivory brow. Her skin is painted with pearly perfection, a light shadow sculpting her classical nose. Her eyes are downcast, lost in a calm, dreamy mood. Wisps of hair dangle over her creamy throat. On her breast, she wears a huge, elaborately set sapphire. Judith's modest eyes and the high collar of her dress, above all the cross-shape of the sapphire ornament, fit well enough with religious convention. But her eye-catchingly nude leg nuzzling a man's hair thrusts the painting away from piety towards eroticism. There is no religious or symbolic reason for Judith's leg to be nude. This marvellous limb is pure painting: an illusion made real by colour.

To walk today past the Fondaco dei Tedeschi, stripped of its frescoes, through clogged streets, to the Ca' d'Oro – the House of Gold – is to get another perspective on the nudes that once floated over Venice. Nowhere conveys the wealth of the Republic of Venice in its heyday better than this jewel-case of a Gothic palace. The ground floor is a refined kaleidoscope of different-coloured marble tiles illuminated by a gate onto the Grand Canal. Upstairs, expansive, spired windows frame the view of Venice as dramatically as her slit skirt frames Judith's thigh. The tall, narrow palace contains a museum, and along one wall are faded fragments of fresco from the Fondaco dei Tedeschi. They are part of the grand project to put nudes on high, but they are not by Giorgione. They are the work of his collaborator, the young Tiziano Vecellio – later to become renowned in the English-speaking world by the name of Titian.

Even in their dilapidated state it is possible to discern contrasts between the frescoes of Giorgione and Titian in their shared enterprise. The nudes painted by Titian are heroic. Giorgione's woman in the Accademia Gallery looks like she's just got out of the bath.

Titian's precise birth date is as elusive as that of Giorgione. It may have been about 1490; in any case he was younger than his working partner on the fresco of the nudes. He came from the mountain town of Pieve da Cadore, in the Dolomites, and like Giorgione was drawn to Venice to train as a painter. Precocious as he was, his broken images from the Fondaco are under the sway of his elder. For instance, they include a woman who looks like a naked Judith with a sword, an interpretation of Giorgione's erotic *Judith* – but as Vasari (who thought this figure was actually by Giorgione) asked, how can a Judith be naked?

'I have not been able to find out what he intended her to mean [...]'

Titian's *Judith* (or *Justice*) was born out of Giorgione's painting of Judith, and her flash of leg. In both paintings the constraints of meaning are exceeded by the power of physical beauty as paint savours flesh.

One of the most intoxicating examples of this Venetian delirium of flesh and paint is, unexpectedly, not a painting at all but an engraving that dates from about 1508. Giorgione's imitator Giulio Campagnola was a printmaker as well as a painter. Campagnola's most captivating and Giorgione-like print shows Venus – or rather a naked model – resting on her side in front of a clump of foliage on the edge of a wooded grove. In the distance are farm buildings and a castle. She looks away, her face – what we can see of it – dreamy and self-absorbed. The artist portrays her body with awe. Her thighs and buttocks are majestic. Her dimpled back is shaded and her spine a black valley. But the genius of the print lies in its 'stippled' technique. Giulio Campagnola has found a way to reproduce the magic of

Venetian paintings of the nude with the black-and-white inked art of engraving. The body of Venus and the lush vegetation that surrounds her are created with fields of tiny dots: anticipating the Pointillists of late nineteenth-century France, this extraordinarily sensual print uses a radical method to break up fixed lines and capture the fluidity and warmth of a human body. Giulio Campagnola's superb achievement makes plain to us what it was that mattered, in Venetian sixteenth-century painting, to sixteenth-century Venetians. He is so struck by the sensuality of the new, soft way of painting the nude that he has sought a way to imitate it in a much more restricted medium. The function of Campagnola's dots is that they dissolve hard forms into a soft play of light: an emulation in ink alone of the effect we see in Giorgione's painting of the misty flesh of Laura. Painting in Venice in the sixteenth century makes the body its empire, and relishes the ability of oil paints to portray the human form as a curvaceous and yielding play of light. Instead of being modelled like a hard sculpture, Venetian beauty is mirrored in ethereal tints. The flesh becomes a pink, red, yellow, brown, white ocean of colour.

In the nineteenth century, when Giorgione's frescoes were still in place near the Rialto, on the canal-facing facade of the Fondaco, the critic John Ruskin observed them with a singular intensity. The architecture of Venice is steeped in colour, he remarks in his book *The Stones of Venice*, published in 1851–53, and if you lack an eye for colour you cannot appreciate it. The astonishing variety of coloured marbles in the courtyard of the Ca' d'Oro bears him out. It is an influence of the East, he suggests, this Venetian love of colour. There is solid evidence for that claim too, in the chromatically scintillating glass and crystal treasures brought back to Venice from Byzantium after the Fourth Crusade and today still kept in the treasury of St Mark's Basilica. If a passion for colour, absorbed in trade with Eastern cities of silks and carpets, was a fundamental Venetian cultural

trait, this enthusiasm gave birth in the age of Giorgione at the start of the sixteenth century to a realization that painting could depict the human body as colour, so that, as Ruskin was to record,

> [...] the strong tide, as it runs beneath the Rialto, is reddened to this day by the reflections of the frescoes of Giorgione.

Today they are gone, the shards husbanded indoors, and only in the pages of *The Stones of Venice* are those waters red.

Giorgione's most ambitious gift to Renaissance art was to translate the conventions of pastoral poetry, established a millennium and a half earlier by the ancient Alexandrian poet Theocritus and his great Roman emulator Virgil, into a genre of painting. In pastoral poetry the writer poses as a rustic, identifying with the shepherds of Arcadia, who in Greek legend played pipes and sang verses in wistful cadences of love and loss. In Virgil's Eclogues, composed in the first century BC, we meet the archetypal shepherd-poet:

> Tityrus, reclining under the spreading cover of the beech trees,
> You ponder the woodland Muse as you play your slender flute.

Virgil's shepherds sing of love requited and unrequited, tell sad and comic tales, compete with one another and insult each other. Giorgione in his art resembled the swain Tityrus, lazing beneath the trees, playing his gentle melodies. He transformed this literary tradition into a new kind of painting, at one and the same time landscape and storytelling. In his picture *The Tempest*, which was done in around 1507 and hangs today in the Accademia Gallery in Venice, a blue veil of cloud is riven by a

lemon-yellow streak of lightning. The towers and domes of a city are lit up by the storm's eerie light. A green waterway with a wooden bridge over it separates the outskirts of the town from a woody shore in the foreground where, near classical ruins, a young man who may be a soldier or a shepherd stands gazing at a woman who sits, naked except for a white shawl, breast-feeding her baby. Her face and dishevelled hair are reminiscent of the portraits of courtesans in which Giorgione and his contemporaries honour the beauties of Venice. But if she is a courtesan or prostitute she has been brought low, abandoned by the men who courted her, forced to look after her baby in the countryside across the water from the unfeeling city. Her naked-ness is both beautiful and subversive. Instead of displaying her breasts and artfully concealing her pubic hair, as is more common in nude paintings, he shows a brown bush of hair between her legs, while her conspicuous breast is being fiercely sucked on by her child.

The young man who looks at her is aroused. He holds a staff upright. Nearby are two massive – though broken – columns. His codpiece bulges. This phallic imagery suggests both lust and frustration. Erotic union, in this painting, is complicated. It leads to babies. Women who – like so many painted by Venetian artists – survive outside marriage and the family by selling sex are vulnerable to changes of fortune. This young woman seems des-titute. The only person interested in her plight is another would-be lover. Giorgione puts pastoral poetry into a painting, yet twists it brutally. His rustic scene suggests the shepherds and shepherdesses of classical verse. The young man might be a poet-shepherd, composing a poem of longing for a rustic lass. But the myth is exploded as soon as it is created: this nymph is a homeless woman, a beauty abandoned. The shepherd's lech-ery is just another problem for her. Harsh reality is illuminated, suddenly, as if by lightning.

Next to this painting in the Accademia Gallery hangs

Giorgione's picture of an old woman, *La Vecchia*. She points to herself as she holds a banner inscribed '*COL TIEMPO*': 'with time'. She is painted with tender realism. Light falls on her face, softening her flesh. The joke is not on her but on any male beholder who, like the youth in the storm staring at a pauper trying to feed her child, simply cannot resist Venetian beauty.

In a painting by Titian from about 1509, the rustic realism of Giorgione's *Tempest* is mimicked in a way that helps us to understand the original work. The composition with a young mother and a man in the country is obviously derived from Giorgione. Here the woman seated under a tree with her child is begging. The man near her, in armour, is definitely a soldier rather than a shepherd. He does not ogle but instead turns away from her in disdain, rejecting the appeal for alms.

Giorgione opened up a new landscape for Venetian art. Working in a city cut off from land by its lagoon, he and Titian provided Venetian houses with scenes of airy, scented, romantic rusticity. The pastoral world of woods and fields and streams, peopled by rural characters, is a landscape of love. Yet Giorgione's pastoral characters are real Venetian people, and he hints at darkness on the edge of town. It is a daring view of pastoral verse. The pastoral tradition allowed urban, educated poets to masquerade as shepherds. But Giorgione uses it instead in *The Tempest* to depict real – not fake – poverty in a realm not far away from the city. His depiction of marginal and neglected lives in *The Tempest* is redolent of his own milieu and fate. Living close to the courtesans who were his models, and apparently not earning very great sums of money, he bequeathed an art that is erotic and hallucinatory, and yet pungent with the dangers of life. If she survives, the woman in *The Tempest* may end up an elderly beggar like *La Vecchia*. The uneasy pastoral of *The Tempest* foreshadows his own death, outside yet close to the city of Venice, on an isle of sickness and sorrow.

*

In autumn 1510, on the quarantine island of the Lazzaretto Nuovo, Giorgione died of the plague. He was about thirty-four.

These stark details revealed by a document in the State Archive of Venice match the story told of Giorgione's death by Vasari and the Serene Republic's home-grown art chronicler Carlo Ridolfi. Giorgione died for love, says Vasari:

> While Giorgione was busy bringing honour to himself and his country, and making lots of visits to entertain his many friends with his music, he fell in love with a lady, and they rejoiced in one another and in their love. It happened that in the year 1511 [sic] she was infected with plague without her knowing anything about it; and Giorgione, seeing her as usual, caught it from her.

Vasari is quite specific: Giorgione was exposed to the plague when his lover contracted it. It is plain from the contemporary evidence that he was in close contact with a plague victim, whoever that person may have been. That was why he had to cross the water to the sad shores of the Lazzaretto. But can the story that he was infected by his lover be believed?

This experimental, audacious artist did not leave much property. The inventory of his posthumous goods that confirms the circumstances of his death lists quite humble possessions. They included a woman's dress. More subtle evidence that Vasari's tale – repeated in the seventeenth century by the Venetian Ridolfi – is rooted in truth lies in his unusual perspicacity for the time about the nature of disease. For Vasari's account in stressing the transmission of infection from one person to another goes against what medical authorities believed about plague in Renaissance Europe – and conforms to the way science understands it today. Such a glaring contradiction of received wisdom suggests a direct empirical observation, that is, a true story.

From the first massacres of the Black Death in the fourteenth century until the early 1700s, bubonic plague recurred regularly in Europe, especially in congested cities. No city at this time reproduced its population naturally. Deaths exceeded births in their clogged, filthy streets and densely packed houses. Only the allure of the city, where wealth and trade freed people from the repetitive routines of rural existence, drew endless ranks of migrants to join the crowds and, often, the dead. Venice was one of the most plague-ridden cities of all. Its island isolation, which protected it from attack, also made it harder to flee in a hurry when pestilence struck. No wonder San Rocco, who was believed to have powers of protection against plague because he himself had recovered from it with the help of an angel, became one of the city's favourite saints. In the Scuola Grande di San Rocco in the San Polo district of Venice, terrifying seventeenth-century frescoes on the grand staircase depict the horrors of a plague outbreak in the city in 1630 that killed half the population. Bodies lie piled up in front of the Doge's Palace while a woman cradles her dying or dead child.

There was no concept of bacterial infection in early modern Europe. Physicians did not blame outbreaks of this devastating illness on the bacillus *Yersinia pestis* and its ability to leap from rat fleas to humans; epidemics were instead attributed to a 'miasma', a pollution of the very air. Such ideas went back to Aristotle and Hippocrates and bore only a vague relation to the actual experience people went through. Witnesses of plague could see perfectly well that it seemed to pass from one person to another. Giovanni Boccaccio began his collection of tales *The Decameron* with a disturbing eyewitness account of the Black Death in Florence in 1348. He explicitly says it was contagious:

> [...] those who were ill could communicate it to the healthy if they happened to come in contact, much as a fire leaps to dry or oily things that are near it.

While doctors repeated worthless ancient theories that bubonic plague was caused by foul air, people who survived epidemics could see that what we call infection existed. So did Vasari when he claimed that Giorgione caught the plague from his lover. His remark stands out as starkly as Boccaccio's eyewitness observation did from conventional fables of illness. Far from resembling an anecdote invented out of thin air, Vasari's account of a plague death in Venice, going against sixteenth-century medical myth, has at least a taste of truth.

Pastoral poetry was shadowed by death. Virgil's swains lamented a singer called Daphnis, dead before his time. They sang of how nymphs wept for him and even the wild hills and forests themselves grieved and lions roared the loss. Nature shook in sympathy. This association of the pastoral landscape with death and lamentation has resonated through Western culture. It encompasses such masterpieces as John Milton's poem 'Lycidas', in which he remembers a friend drowned in the Irish Sea against a backdrop of mountains and rivers, and Poussin's painting in which shepherds marvel at a Latin inscription on a tomb: '*ET IN ARCADIA EGO*', meaning 'I too was in Arcadia', which refers to the dead, or 'I too am in Arcadia', referring to Death itself. It also, on a less lofty note, inspired eighteenth-century aristocrats to raise knowing monuments to favourite pets in their manicured parks.

In about 1512 the artist Sebastiano del Piombo painted a disturbing picture of a death in Venice. Sebastiano, like Titian, like Giulio Campagnola, was part of a new generation of artists who were enflamed by Giorgione's sensual vision. His early portraits of courtesans and beautiful women are consciously erotic. But in his work *The Death of Adonis* Sebastiano associates love and death. A young man, the beautiful Adonis, lies on his back on the earth of a leafy isle. His flesh is grey and bloodless and dead. Under the trees, Venus mourns. She stays near the body, naked, clutching her ankle distractedly, while Cupid tries to

comfort her. All the fun has gone. The nymphs of Venus's court sit about lethargically while a bearded satyr brings seashells in a vain attempt to comfort her. Across the water Venice endures, the campanile and Doge's Palace brightened under a cloud-robed sky of gold and blue. Painted soon after Giorgione's death, this enigmatic work mourns a youth who was lost before his time. He had a special relationship with love. Adored by Venus herself, his beauty has now become an emblem of mortality. Venus cannot abandon the decaying corpse of her idol. The empty shells, brought by the satyr for her to handle and study, are not just pretty things but the beautiful relics of dead animals: she should forget the rotting flesh of Adonis and cherish what lives forever, the pearly beauty of his soul. The view across the lagoon puts this scene of mourning on an Arcadian island close to Venice. It is on the wrong side of the city to be the Lazzaretto Nuovo, but the association of love, death and youth and the lagoon of Venice is uncannily reminiscent of the actual death of Giorgione. Is this painting an act of remembrance?

That would be in accord with the pastoral tradition to which Sebastiano's scene belongs. With its setting under the trees in a leafy landscape, its depiction of a natural rustic world where the old gods and nymphs and satyrs come out of the shadows to play – and suffer – on earth, this painting associates itself with conventions of pastoral that Giorgione had transposed from poetry to painting. If Virgil's shepherds can mourn to the melodies of nature, why should Sebastiano not play on his sad reed for Giorgione?

Adonis is dead. Venus weeps. In Sebastiano's painting of a death on an island in the lagoon, the conventions of pastoral poetry make it entirely imaginable that this is a lamentation for the beautiful Giorgione. A greater painting, which also dates from soon after the young revolutionary's death, looks even more like a pastoral lament for Giorgione.

This painting is known as the *Concert Champêtre*. It was for a long time said to be a work of Giorgione himself. The ruffled luxury of its brushwork makes it far more likely to be one of the first masterpieces by Titian, but no one would deny that it holds up a mirror to Giorgione's painted world. Whoever painted it emulated the enigmatic rustic storytelling of his masterpiece *The Tempest*. In fact this painting is so steeped in the Giorgionesque that it could almost be an illustration to Vasari's Life of Giorgione. According to Vasari, as we have seen, the short-lived artist delighted in two things: love and music. Here we see those delights brought together in a landscape setting just like the pastorals he pioneered. A debonair musician in red cap and sleeves, with long hair, nurses a lute on his lap – the very instrument Giorgione is said to have played. Next to him is a rustically dressed youth, with curly untamed hair, whose eyes meet his in an intent look. A woman with her back turned to us has a flute. Making music and making love are related in this scene, as they are in Vasari's Life of Giorgione.

Music vibrates through the painting. Nature is a concert. As a shepherd approaches we seem to hear the baas of his sheep. We hear the prickly trees as if a breeze were fluttering and rattling their leaves. We hear water trickling onto stone. We hear the air move. And everyone is in motion to the music of nature, in a circular harmonic wave, responding to one another with stately, grave precision, like dancers. They have been singing, and their shared note hangs in the painted air. It is the world of Giorgione made immemorial. Graceful and sensitive lovers take pleasure in one another, living the Giorgione life. The lute-player, his face dark and turned to the side as he holds his hand above the strings ready to pluck them, is a perfect Renaissance lover – and suggestive of the dead artist. This was probably painted in about 1511, soon after the plague took away one of Venice's greatest painters. Through it, a pure note of love eternally vibrates.

These paintings are fraught with the flavour of Giorgione's life and art. They are also reminiscent, decades before it was written, of Vasari's Life of Giorgione. Supposing they really do refer to Giorgione and his premature death, this raises a tantalizing possibility. Art historians like to refer slightly contemptuously to the 'legend' of Giorgione, exiling his powerful artistic personality to the realm of fiction and reattributing even his renowned *Sleeping Venus* to the young Titian. But it looks from these paintings as if the image of Giorgione as a lute-toting lover and a romantic loser was cherished by his contemporaries in Venice who knew him well. Sometimes the legends are true.

Chapter Six

THE BAKER'S DAUGHTER

Life in the villa was out of control. The fool upstairs kept bringing in new pets and the pornographer could never shut up about Pan groping that boy. The wine was kept in gold flagons. The fruits all seemed to be shaped like body parts. Grinning, someone took a fig and split it open, then pushed a cucumber into it. The prince of painters took his lover's hand, led her out into the garden and whispered, 'Take off your clothes ...'

There is no mistaking Raphael of Urbino's closeness to the woman who poses semi-nude in his painting known as *La Fornarina*. She sits in a garden, among dusky leaves that set off her brightly lit beauty. She smiles and looks off to one side, self-conscious as she poses for her lover. Over her black hair she wears a gold-and-blue scarf tied behind her head; she is dressed in pink shining skirts and holds a flimsy wisp of sheer transparent stuff over her stomach. Through it her belly button is an obscure, blurred well: the veiling does not conceal her flesh but divulges it through a distorting shimmer. The same optical luxury bends and estranges the view of her right upper arm where the material rests on it. Her hand, holding up the silk, rests between her breasts, which are naked, firm against her fingers and observed from life: the way they bulge from her chest and crease against the skin under her shoulders is quite unlike the

smooth blandness of some idealized statue. Her nipples are seen in detail. Her fine blackened eyebrows and pink cheeks quicken a face that is beautiful but not fictionally so. Her nose is strong and classical yet with flared nostrils. The blush of her cheeks too is probably intended to be an 'imperfection'. That blushing is a sign that she is sitting nude for her portrait and is not used to it: she is posing like this for her boyfriend. Her big round eyes are at once humorous and ever so slightly embarrassed. Still – how is it possible so boldly to describe her as Raphael's lover?

Her left arm, inclined towards the beholder and resting on her luxuriant skirt, is fleshy and full: it makes an uneven, imperfect silhouette, like the arm of an actual human being as opposed to a classical goddess or artistic daydream. Raphael relishes the soft generosity of its surface that flows out of the tender pillows of

Raphael, *La Fornarina*. The richest painter in Rome displays his proudest possession in this painting of real-life beauty.

her chest. He is displaying here a command of nude painting – a savouring of the human body – that easily matches the sensualists of Venice. But he is more confessional and more verbal – for this painting speaks. It uses words. The picture is a declaration of love: by him and his sweetheart. For high on her arm, close to her shoulder and parallel with her breasts, this young woman wears an ornate and expensive, specially made armband in blue and gold with the words 'RAPHAEL URBINAS' embroidered in precious thread in Roman lettering. She is his: so much so that she wears his armband like a signature, not just on her portrait but on her body too.

Raphael of Urbino in about 1518 lays claim with this painting to a woman who was not his wife, and broadcasts their passion in a work that is truly sensual and unequivocally a portrait. Raphael's love is not a trivial thing. He has commemorated it forever, and put his lover before us for all time to be admired and puzzled over. Who is she, really?

And who is he?

When Raphael painted this very personal portrait he was in his mid-thirties, a handsome, elegant man, adept in the politeness of courtly life, the very pattern of a gentleman. He got his pleasing manner from an early childhood spent around the cultured court of Urbino, where he was born in 1483. His father was a painter and poet who was a minor ornament of the palace there. Raphael trumpets his association with Urbino on his lover's armband. As for his looks, at about the same time that he painted this autobiographical work he also depicted himself together with a male friend on whose shoulder he is resting an affectionate arm. The friend is gesturing towards us with his hand on his sword hilt while he turns his eyes back to look at Raphael. The companion's sword, sophisticated clothes and refined face proclaim him a gentleman. But Raphael is steadier and more confident: while the other man is all energy and impulse the artist is authoritative and cool, looking directly out

of the painting. He has a moustache and short beard and shoulder-length hair. His eyes are smouldering coals under neat black brows. He is not steady from lack of energy, but by the exercise of self-control: for his eyes contain passion aplenty.

Raphael puts that passion into his erotic portrait of his mistress. The painting's sexual boast – this beauty is his – associates fame, glory and genius with physical gratification. To be a great artist in the Rome of the popes is, it seems, all about getting laid.

Personal as this painting is, it is also a public vaunt – and an act of artistic rivalry. Raphael was already well established in Rome in 1513 when Leonardo da Vinci came to live in the Belvedere Palace, in the Vatican, enjoying the patronage of the pope's brother, Giuliano de' Medici. It was here in Rome that Giuliano's mistress posed nude for Leonardo to paint her. The *Mona Vanna* must have fascinated young Raphael with its unabashed declaration that oil painting is a technology that can heighten the pleasures of love. Leonardo's nude portrait of his boss's lover confirmed one of the most libertarian claims that he makes for painting in his notebooks. Once upon a time, on the birthday of King Matthias of Hungary, says Leonardo, a poet presented him with a new work in his honour. Then a painter gave him 'a portrait of the lady he loved'. The poet was outraged that King Matthias was too busy enjoying the picture of his mistress to read the poem. The king told him to be silent: this painting was better than any words. Who wants waffle?

'I want something I can see and touch . . .'

Leonardo's nude portrait gave its beholder something to see – and touch? Raphael's portrait of his own mistress is directly modelled on Leonardo's lost work. His lady also sits naked; she too is seen in a half-length format. The daring concept of a nude portrait has been taken from the disreputable work that Leonardo painted and given a sheen of wealth and status.

Both pictures tell of nights of love in the city that was the capital of the Western Church. The difference is that Raphael

portrays his own mistress, not another man's. His painted document of his own sex life takes us into the secret life of the papal city, where cardinals mixed with courtesans and artists lived the pagan life of the senses among feasting sybarites.

In Raphael's fresco *The Fire in the Borgo*, which he painted in about 1516–17 in a room of the Vatican Palace named in its honour, a city is seized by terror. A fire is sweeping through the crowded quarter of Rome next to the papal residence. While the pope himself looks safe on his balcony in the distance, for the flames do not approach the gold mosaics on the facade of the ancient basilica of St Peter or the palace adjoining it, the ordinary people of Rome are fighting heroically for their lives and the lives of others. A woman carefully hands down her baby from the roof of a blazing building while smoke and flame approach behind her: the house below is a glowing inferno. A naked, muscular youth is trying to climb up the wall to help, while another man reaches to receive the baby. A son carries his elderly father on his back, while the old man's grandson walks beside them and a nurse behind: they seem to have emerged from the same furnace that was once a house. Mothers who have escaped the flames nurse their children in the open street, the safest place, while men and women alike rush water to a colonnaded building, a fine work of ancient Roman architecture. This painting is set in the ninth century when, as Raphael imagines it, Rome still had many pristine classical structures. With amphorae and bowls filled with water, the human chain tries desperately to hold back the fire. Other people, meanwhile, have turned to a higher authority. Seeing the futility of human effort alone they kneel in supplication on the raised piazza in front of the pope's palace, calling on the pope to intervene. He is doing just that. Pope Leo IV is not helplessly watching the fire. He raises his hand in benediction. According to legend, Leo's blessing miraculously put out the flames, proving the sacred power of the papal office, and saving the lives and homes of the people of Rome.

Anyone who thinks of Raphael as an aloof classicist, so perfect in skill that he lacks the human touch, ought to visit the Vatican, brave the crowds that flow down a corridor lined with maps of Italy that express the temporal power of the Renaissance popes in green-and-blue topographical detail, be carried with the frantic tide into the *stanze* frescoed by Raphael and feel the pathos of *The Fire in the Borgo*. Here, the classical knowledge and natural poise of this princely painter are the very characteristics that allow him to express a collective tragedy. The fear that stalks his disaster scene is at once tempered and brought to a noble, moving authority through the balance and grace of his disposition of bodies and buildings, his expression of pain and horror without sensationalism or exploitation.

It did not do him any harm with his patron, either. Pope Leo X was more than content with the painting's lightly veiled flattery. All the frescoes in the Room of the Fire in the Borgo – others in this chamber are *The Battle of Ostia* and *The Coronation of Charlemagne* – star popes who had previously taken the name Leo. In portraying Leo IV saving the Borgo from fire by his miraculous benediction, Raphael pays homage to his own employer, the tenth Leo, who in his portrait by Raphael, done in 1518, sits at a table studying an illuminated manuscript. He holds a magnifying glass, its convex lens framed by a circle of gold, to help him appreciate fine detail. The book is turned to an illustrated page of bright scenes and ornate borders that Raphael depicts hypnotically. The pope is scanning this book for its visual luxury rather than pondering theology. Beside the book is a costly bell for him to summon attendants. Power pulses in this painting. Half-shaven and tough, Leo X grimaces, aware he is being portrayed, looking away from the artist in pride and conscious dignity. But his hands are soft and chubby, his neck fat, the body under the papal robes well fed.

Giovanni de' Medici was the son of Lorenzo the Magnificent. Even as he appreciated classical art and pursued extramarital

affairs, the ruler of Florence was conspiring to ensure his son an outstanding career in the Church. Giovanni was entered in holy orders when he was eight, and soon had a fistful of benefices before inevitably becoming a Cardinal. When he was elected pope in 1513 and took the name Leo X, he was still only thirty-seven years old, 'a startling thing', observed the sixteenth-century historian Francesco Guicciardini. In 1516 Leo appointed Guicciardini to diplomatic service in the Church, so the historian was familiar with his benefactor's character. He liked him, so we may perhaps believe his claim that the man on a red velvet seat in Raphael's portrait suffered from 'an unhealed fistula on his rump'.

In the great *History of Italy* that he wrote in the 1530s, Guicciardini depicts Leo X as ineffectual – his calls for Christian action against the Turks were merely attempts to avoid censure for doing nothing, the pessimistic historian suggests, viewing such behaviour as typical of human weakness – but he was a model of comparative sanity after his two predecessors as popes. Of Rodrigo Borgia, elected as Pope Alexander VI in 1492, when he was already the father of several growing children, Guicciardini repeats the infernal rumours: the Borgia pope planned to give 'temporal grandeur' to his eldest son, the Duke of Gandia, but his younger son, Cesare Borgia, had his brother murdered and thrown in the Tiber. This was partly out of rivalry, says Guicciardini, and partly out of jealousy over the two young men's incestuous relations with their sister, Lucrezia. He adds that Pope Alexander, too, lusted after Lucrezia Borgia, his own daughter.

Incest and murder aside, Pope Alexander did advance the Borgia children ruthlessly, treating the Vatican as a dynastic palace, where he, Lucrezia and Cesare presided over such events as the Feast of the Courtesans, at Halloween in 1501, where comparatively reliable sources have it that fifty Roman courtesans enjoyed supper with the top brass of the Church, danced

naked and had a competition in which the prizes were men. Was this the Rome of the popes or of the Caesars? Even if many of the tales are discounted as calumnies, the worldly nature of Alexander VI and his family's exploitation of the papacy remains stupendous.

Then there was Julius II, elected pope in 1503 and filled with loathing for the Borgias. Julius – born Guliano della Rovere – was angry with everyone, a raging old man by the time he became pope. 'Certainly', observes Guicciardini,

> everyone was amazed that the papacy was given with such enthusiasm to a cardinal who was known to be naturally difficult and contentious; a restless man [. . .]

That restlessness continued in office as Julius waged war to assert the temporal power of the Church in Italy, leading his own armies into battle. In Raphael's mesmerizing portrait of Julius he wears a beard to mourn the rebellion of Bologna against a rule he had personally imposed with the sword.

Both Alexander VI and Julius II ruled more like secular princes than holy men. Leo X was no different in principle but he was neither as tangled in intrigue as Alexander nor as warlike and unbalanced as Julius. His big political aim was to use the papacy to reaffirm the rule of the Medici dynasty in Florence. Meanwhile in Rome he presided over a cultured, hedonist court where money, taste and gourmandizing accompanied sermons that urged a Christian enjoyment of life.

This was the best of times and the worst of times in the history of the Church. These popes returned to Rome an architectural splendour not seen since ancient times. The Borgia apartments in the Vatican with their decorations by Pinturicchio, the interiors of Castel Sant' Angelo, Bramante's Belvedere Palace, Michelangelo's Sistine ceiling, even the Via Giulia that gave the medieval streets of Rome near the Tiber a new

augustness, all date from the years when the Christian world was a football passed between the Borgia, della Rovere and Medici clans. Paradoxically, the art paid for by these worldly popes is among the great spiritual assets of Catholicism.

Leo X inherited Raphael – and was delighted with the inheritance. The young painter began decorating the apartments or *stanze* of Julius II in the Vatican in 1508, when he was in his mid-twenties. A decade later, continuing this vast work for Leo, he was by far the most sought-after and well-paid painter in Rome. Raphael worked with a team of handpicked assistants, including some notable artists in their own right, to fresco chapels, loggias and even bathrooms in the epicurean Rome of Pope Leo. But rumours about Raphael's love life were growing, and the cracks in his courtly persona were starting to show.

In 1511 the Sienese banker Agostino Chigi set up house in Rome with his Venetian lover Francesca Ordeasca. They were not to bother marrying until 1519 – yet when they did the pope attended the ceremony. Chigi could do pretty much what he wanted because his wealth was Midas-like. The gift that turned all he touched to gold was a concession to run the pope's alum mines at Tolfa, near Rome. He won this contract from Alexander VI in 1500. Alum was critical in the textile industry as a colour fixative, and the Tolfa mines were its main source – so Chigi's wealth multiplied. He was not simply a financier but an entrepreneur. A Sienese chronicler in 1510 recognized Chigi's precocious capitalism. After the Spanocchi family went bankrupt, he explained, Chigi took over their rights to manage the mines, sold alum in the Low Countries and other far-flung places that needed it, and became Italy's grandest merchant.

Agostino Chigi's magnificence made him a leader in Roman society to rival the pope himself – as Leo X sardonically observed during one of his banquets. Before the situation could get nasty, Chigi pulled back a curtain to reveal that the excess was skin deep. They were dining in a stable.

The true arena of Chigi's bountiful lifestyle was his villa next to the Tiber in what is now Trastevere, on the opposite bank to the knotted streets of the centre of the medieval town, and on the same side of the river as the Vatican itself. The Villa Farnesina – as it is now named after its later owners, the Farnese family – is today cut off from the river by the Lungotevere embankment. Its gardens, which in Chigi's day included fish ponds and a riverside loggia and grotto, originally went right down to the water. At another of his banquets attended by Leo X the waiters simply tossed away dirty dishes into the river. Servants with nets were concealed downriver to retrieve them without spoiling the coup de théâtre. The food was as diverting as the spectacle: guests at Chigi's feasts dined on parrots' tongues and Byzantine eels.

In 1517 to 1518, the same period of his life when he painted his lover with her blue-and-gold armband, Raphael was working on an exciting series of frescoes at Chigi's villa. He was decorating one of its open loggias with scenes of the immortals at the wedding of Cupid and Psyche, set in a profusion of grotesqueries and painted vegetation. The effect of this ceiling is zestful and life-affirming, though not as moving as it might be had Raphael painted it all himself. His drawings were the basis for figures, many of which were coloured by his assistants. His original drawings are more spontaneous than the paintings – and strikingly sensual. In one red-chalk study in the Royal Collection, Windsor, the Three Graces bend forwards as if on the edge of the River Tiber, peering in the water, about to bathe. Raphael uses the drawing to look at a nude from three points of view. It is conceptually daring but sensitive, as if observed from life. The nude nearest the onlooker turns to show her prominent buttocks, while another half-hides her breasts while flashing her belly button. In the painted version of this group in the loggia, stiff brushwork mutes the subtle and lifelike beauty of Raphael's drawing. But however many artists worked for him – Sebastiano

del Piombo joked that fifty would be waiting to attend him when he left his house each morning – it was Raphael's vision that Chigi was purchasing. Raphael was giving the plutocrat a banquet of ideas. His drawing of the Three Graces for this project is an original reinterpretation of a popular classical theme. Raphael himself had painted a small picture of these mythic figures in about 1504, when he was around twenty-one, that imagines them as perfect beauties. They stand with linked arms, holding golden orbs, with two nudes facing the onlooker and another turning her back. The group has a mathematical and abstract feeling to it: the symmetrical beauties of those early Graces embody harmony and perfection.

In the same period that he painted his early picture of the Three Graces standing in cosmic balance, Raphael designed an ethereally perfect temple in his picture *The Marriage of the Virgin*. Under a pure blue sky, the polygonal temple stands on a pink-and-white piazza, circled by an arched colonnade and capped by a dome. The sky is visible through it. This is a dream of perfection, like the little picture of the Three Graces. This longing for utopian grace is a golden braid in Raphael's art and sometimes he does seem to have glimpsed the underlying order of the universe.

In 1511–12 Raphael painted *The Triumph of Galatea* in the garden loggia of Chigi's villa. Today the room is a closed salon but when the painting was new in a roofed space open on one side, its watery representation of a sea-nymph surrounded by amorous tritons, blowing trumpets and pursuing their lusts on the smooth blue waters, would have offered a magic mirror to the River Tiber at the bottom of the garden. This painting anticipates all the Baroque fountains that were to fill Rome with dripping monsters and gods. It is an image of aquatic pleasure that links the Tiber with the Mediterranean Sea, and the city with the amniotic joys of uninhibited sea creatures. But it is curiously unearthly for a depiction of nudes. Galatea and her

companions are fantasies, not observations: this is an orgy of ideal types. Raphael paints a pure vision of a mythic world populated by nudes whose delight in one another is the lust of spirits for geometrical forms. It is cool and remote, like watching astral events through a powerful telescope. These entities are awe-inspiring but scarcely reflections of everyday life.

In his drawings for his later frescoes at Chigi's villa in 1517 to 1518, the epoch of his portrait of his mistress, Raphael is observing real women. The mood is very different. His lofty conceptions of ideal beauty have given way to the contours of individual bodies. In his drawing of the Three Graces he pays attention to the quirks of real-life physicality. In other words he is looking at women as a Venetian might, up close and without preconceptions. This impression of him drawing spontaneously from the nude at Chigi's villa is reflected in a story Vasari tells in his Life of Raphael:

Raphael was a very amorous person and very affectionate to women, whom he was always ready to serve.

That was the reason why his friends helped him in his carnal delights [. . .] Thus when he was painting the first loggia in the palace of his dear friend Agostino Chigi, a rich Sienese merchant, he was not able to concentrate or work due to his love for his lady. Chigi, in despair, and with great difficulty, fixed it so the lady could stay continually with Raphael at the house where he was working, and so the job got done.

Raphael was so enamoured of his lover, says Vasari, that she had to move into Chigi's villa while he designed the Cupid and Psyche frescoes there – it was the only way to keep his mind on his work.

There, as they gazed into one another's eyes, Raphael and his mistress were surrounded by sleaze. The gilded life of the Roman

Renaissance had an edge to it here, as the wealthy banker showered funding on some truly outrageous characters. There was the painter il Sodoma, who frescoed Chigi's bedroom in 1518 with a painting of Alexander the Great and his bride Roxanne. This painting may be connected with Chigi's plans to marry, in 1519 – after years of living together – his lover Francesca Ordeasca. Sodoma came from Chigi's native city, Siena. His real name was Giovanni Antonio Bazzi. Vasari explains the origins of his alias:

> [...] he was a jolly and free-living man, giving people a laugh with his way of life, which was far from honourable. Because he was always surrounded by boys and beardless youths, loving them beyond decency, he was nick-named Sodoma; and far from being offended by this name, he was proud of it, writing songs and verses about it that he sang while playing his lute.

In Siena he was also known for keeping a bizarre menagerie of pets. Vasari, revealing how the idea of the artist as an extraordinary character was being popularized in sixteenth-century Italy, suggests that this eccentric persona made Sodoma a celebrity: far from getting him burned, his reckless life made him famous. It certainly convinced Chigi to bring a local star from Siena to Rome. It was quite a front that Sodoma put up: in an age that reviled 'sodomy' he rejoiced in being a sodomite. Like the narcissistic followers of Leonardo da Vinci, he apparently associated art with his right to a sexual identity wildly at variance with Christian convention. Instead of hounding him out of town, the Sienese were impressed. It was his greatest moment when the city's richest son, Agostino Chigi, had him fresco the Villa Farnesina along with Raphael.

Sodoma's *Nuptials of Alexander with Roxanne* in Chigi's bedroom is a showily sexual work. It is hard to agree with art historians

who see in it a call on Chigi to marry and Christianize his relationship with his mistress. Why would Chigi commission a reminder to himself to do that in the form of a fresco? Instead, this bedroom painting celebrates the life of the bedroom. Roxanne sits on the edge of a staggeringly ornate four-poster bed, perhaps not that different from the bed Agostino and Francesca themselves shared, in a villa that is a double of Chigi's. Cupids flutter around wishing amorous joy to the newlyweds as Alexander and Roxanne prepare to consummate their marriage. This is intimate history painting and Sodoma's design may have been created with the advice of Raphael himself as he took his own satisfactions in the villa by the Tiber.

Another debauchee hanging around Chigi's villa was the writer Pietro Aretino, who has a good claim to be the inventor of modern pornography. We've already briefly met him and his creation Nanna. Aretino was a spectacular instance of Renaissance individualism. His father was a cobbler, and his mother became the mistress of the local lord. Born to this at once humble and aspirational heritage in Arezzo in Tuscany in 1492, he was to write himself to fame and fortune and live in ease in Venice in a house on the Grand Canal. He achieved this at a time when writers did not usually expect an income from literature as such but relied on patronage and Church benefices. Aretino made real money from writing, not only by publishing his works but by reaping indirect profits. Charles V, ruler of the Habsburg lands – including Spain, Holland and Mexico – and, in his role as Holy Roman Emperor, the greatest power in central Europe, was so stung by the writer's scathing pen that he gave him a pension to moderate his opinions. In a world that had no newspapers, Aretino's letters were direct comments on contemporary events and personalities, with the added bite that he addressed his journalistic 'columns' personally to the mighty before putting them into print.

Like any writer with an eye to the market, he recognized sex as a subject. Both his play *The Courtesan* and his *Dialogues*, starring the articulate courtesan Nanna, open the door on Renaissance bedrooms in a way that goes much further than Sodoma's fresco. At the start of his career he was part of the sophisticated set at the Villa Farnesina. When Aretino first came to Rome, in the reign of Julius II, he was a live-in guest of Chigi. He often discussed art with Raphael. Out of the fun and games at Chigi's place his career as a pornographer would be born.

Aretino, in fact, claimed that he got his inspiration directly from the villa itself and specifically its collection of antiquities. In creating villas with ornamental gardens, Renaissance rulers and tycoons were emulating the lifestyles of ancient Romans. By the early sixteenth century, fanatical admirers of ancient Rome and Greece had been studying classical literature and excavating classical art for 100 years. The research into pagan antiquity started as a high-minded effort to recreate the political nobility of the old Romans. By the 1500s, however, humanists and art collectors were well aware that ancient Romans did not spend all their time making speeches at the senate. They knew that ancient art and literature were full of sex. Agostino Chigi collected ancient erotica among his treasures. Aretino found it inspiring. He said he got the courage to be a pornographer from a statue owned by Chigi, proof in marble that there is nothing wrong with art seeking to stimulate the senses:

> And so the poets and sculptors, ancient and modern, have sometimes amused their genius writing and sculpting lascivious things – as in the Chigi palace where the marble satyr sits, trying to violate a young boy.

This statue survives. It is an image of the goat-legged god Pan, with devilish horns, making an aggressive overture to Daphnis,

a naked youth playing the pipes. The ancient artist has given Pan tremendous vitality: his hairy legs, rich beard and curly locks are emphatically real, as is his penis. Most of all the action is dynamic and dangerous: this classical statue explodes with sexual violence.

Raphael's portrait of his lover was born out of the libertine atmosphere of Chigi's villa. Surely the green garden foliage behind the seated nude in Raphael's painting is part of Chigi's garden? The painting dates from the time he was working here. Where better to pose his mistress undressed?

To paint his lover was to show her off to his male friends. The most intelligent man he knew was, as it happened, always asking him to explain his idea of beauty. Baldassare Castiglione's bright-blue eyes suggest the clarity of his mind, as his grey fur cloak, ruffled white shirt front and dark collar convey the refinement of his manners. He is a man of both style and wisdom in his portrait by Raphael, which dates from about 1515. His soft beard is well trimmed without being overly neat, just as his expression is keen without being harsh. Castiglione valued spontaneity and warmth – characteristics that are just as important as wit, learning and political understanding in his definition of the perfect gentleman, which emerges in a dialogue between famous personages at the ducal palace in Urbino in his Renaissance bestseller *The Book of the Courtier*. His portrait is a tribute from a courtly painter to a courtly writer and diplomat as Raphael's balanced, humane style, communicating both authority and affection, holds a mirror to Castiglione's tempered naturalness.

Raphael is in turn praised in Castiglione's book, which was read by every aspiring courtier in Renaissance Europe from Mantua to Greenwich. *The Book of the Courtier* even records one of the painter's jokes. It's a bit blunt. Two cardinals tried to get Raphael to chat with them by saying the figures of St Peter and St Paul in one of his frescoes were too red in the face, reports Castiglione.

Raphael came back immediately: 'Lords, it is no marvel; I
did it with great deliberation, for we can believe Peter and
Paul look red with shame in heaven – just as they are here –
to see the Church being run by such as you.'

Given their known analysis of the nature of beauty – does it
adhere in particular faces or is it an abstract ideal? – the dis-
cussions of painting that Castiglione puts into the mouths of his
cast of speakers may well reflect, or have stimulated, conversa-
tions with Raphael himself. If so, Castiglione's version of the
story of Alexander and Apelles is particularly resonant.

This is the story that Matteo Bandello has Leonardo tell along
with that of Fra Filippo Lippi in his *Novelle*, a tale told as one of
the favourite instances known in the Renaissance of the status
due to great artists. Castiglione makes it a fable of princely
generosity:

So we read that Alexander loved Apelles of Ephesus so
much that once, after he got him to portray one of his best-
loved women naked (*nuda*), and then realized that his
excellent painter, seeing her marvellous beauty, was ardently
in love with her, without hesitation Alexander gave her to
Apelles as a gift [...] It was a sign of his great love for
Apelles, to please whom, he did not hesitate to displease her
[...]

The speaker here is Count Ludovico of Canossa, a friend like
Castiglione himself of Raphael. Another speaker claims that
Count Ludovico prefers painting to sculpture 'out of kindness to
your Raphael'. *The Book of the Courtier* describes the largesse of
Alexander with a more gracious colour than Bandello does in his
Novelle. Instead of simply being aroused by his model, Apelles,
'seeing her marvellous beauty, was ardently in love with her'. He
even gives some passing thought to her feelings.

Artists, the Count of Canossa goes on to argue, are more alive to physical beauty than other people may be – for it is their field of expertise. Cesare Gonzaga, soldier and diplomat, hearing the Count's anecdote of Apelles, laughs that he too likes looking at women:

> I am not a painter, but I certainly enjoy looking at one particular lady a lot more than your good Apelles would if he came back to life.

Ludovico disagrees, arguing that Cesare's contentment is not merely a response to his lady's appearance. It is the fruit of a deeper affection. The heart is moved not only by looks but by 'charm, intelligence, the way she talks, her gestures, and much more [. . .]' But when it comes to simple beauty, setting aside all these considerations, an artist is bound to respond with special intensity, he claims, for surely,

> that love which is solely born of superficial physical beauty will mean far more to someone who knows more about it than to one who knows less. That is why – to get back to our proposition – I think Apelles rejoiced much more when he contemplated the beauty of Campaspe than Alexander did: for it is easy to believe that surface beauty was the sum total of what they both loved in Campaspe.

Raphael was Castiglione's closest friend among artists and may well be the painter the Count of Canossa has in mind when he claims that artists have a keener eye for sexual attractiveness. Beautiful women were a theme Castiglione and Raphael corresponded about: as Raphael writes to Castiglione in a 1514 letter,

> I say to you, to paint a beauty I must see more beautiful women, on one condition: you are to help me select the best.

In his portrait of the woman with the blue-and-gold 'RAPHAEL URBINAS' armband, the artist is not only recording his personal life. He is also making a statement akin to the suggestion in *The Book of the Courtier* that artists have a superior sexuality. What king or millionaire, Alexander or Chigi, can enjoy his lover's body as Raphael does?

This is why Renaissance artists were held to be great lovers. They made love with their eyes. Like Giorgione, the handsome Raphael was said to be addicted to love – and good at it. He himself says as much in his portrait *La Fornarina*.

Her name is la Fornarina. Anyway that is the legend. In the eighteenth century this name, meaning 'the baker's daughter', was given to the lover of Raphael. That name has no basis in history but it is forever hers, partly through the labours of nineteenth-century artists who relished the love life of an artist they worshipped. In the Romantic age the story of la Fornarina was famous. The French painter of pearl-skinned beauties Ingres portrayed Raphael at work on his portrait of la Fornarina with his lover beside him. The British romantic J. M. W. Turner moved the location of their love from Chigi's villa to the Vatican loggia so he could include a sweeping vista of Rome. The last great artist to illustrate Raphael's love life was Picasso – and his etchings replace romanticism with hilariously obscene sexual fantasy. His suite of prints *Raphael et la Fornarina* was done in 1968. In one image la Fornarina lies back on ruffled draperies with her breasts flopping about and her legs parted for Raphael, who displays a huge eye and a phallically long throat, to stare between them. Pope Leo X watches from behind a curtain.

Picasso brought the legend to life and also gave it back to history. As told and pictured by nineteenth-century admirers of the Renaissance, the story of Raphael and la Fornarina became sentimental. Picasso's pornographic version matches better with the hedonist culture of courtesans, self-styled sodomites and erotic writers in which Raphael painted his sexual boast.

Is this a document of feeling as well as desire? Raphael's nude portrait is not the only image of 'la Fornarina' that he painted. A portrait in the Pitti Palace in Florence apparently portrays the same face, this time seen more softly, her dress magnificent and enfolding, a veil spread over her hair. With precious stones about her neck she is swirled around with gold and silver. Here Raphael is a lover both physical and soulful, weaving a mystique about his lady as someone rare and precious. It was painted in about 1515, *La Fornarina* probably three years later, so if they are truly the same person that suggests a long-term love, not a casual fling. Long term or not, soulful or strictly sexual, Raphael took a risk when he proclaimed his love for this unknown woman in his art. His status was such – his fame and courtliness had trans-ported him to such heights – that he was involved in the kind of marriage negotiation usually confined to the nobility. In 1514, his thirtieth year, Raphael wrote to his uncle in Urbino explain-ing why he had rejected his family's suggestion of a suitable bride from back home:

> First, about taking a wife: with respect to the one you origi-nally wanted to give me, I tell you that I am very happy, and thank God every day that I said no [. . .]

He then goes on to tell of his success – the pope has put him in charge of the building of the new St Peter's and he is awash with gold ducats. So why would a wife from Urbino obstruct this suc-cess? Because, he explains, a very senior man of the Church wants to marry Raphael into his own family:

> I wandered from the subject of the marriage proposal, but to return to it I reply, that you should know Santa Maria in Portico wants to give me one of his relations in marriage, and with the permission of my priestly uncle and yourself, I promised to do as His Reverence wished.

'Santa Maria in Portico' was Bernardo Dovizi, Cardinal
Bibbiena, cultured friend of Leo X and a man whose family was
well worth marrying into. In his portrait by Raphael he looks
worldly wise and so secular that his intelligent, humorous face
seems at odds with his clerical robes. If there was any doubt
about his attachment to material things, the bathroom – the
Stufetta – that Raphael created for him in the Vatican lays those
doubts to rest. Frescoed in a recreation of the magnificence of
ancient Rome, this room is a glimpse of a Renaissance Vatican
where comforts were many. Raphael was betrothed to Bibbiena's
niece until her early death. And yet, having insisted to his own
relatives in Urbino that he would marry Cardinal Bibbiena's rel-
ative, he makes declarations of another love in his paintings. Was
la Fornarina lower class? A courtesan? Raphael's passion for
beauty, the passion that painters feel more acutely than anyone,
was driving him to ignore his own rules for success in the Rome
of the popes.

In April 1520 the Venetian art lover Marcantonio Michiel made
a note in his diary of the tragic news. *Item, morse Raffaelo da
Urbino* ...

On the night of 6 April 1520 Raphael died in Rome. He
was still only thirty-seven – in fact it was apparently his thirty-
seventh birthday – and a helpful miscalculation convinced the
Roman elite that he was thirty-three or thirty-four, the age of
Christ when he endured the cross. The loss of Raphael, not
only painter to the pope but also architect of St Peter's, was
mourned as a second Passion, a blow to the Church itself.
Looking at his self-portrait, or remembering him in the flesh,
people said he was the spitting image of *Nostro Signore*. The day
of his death, eerily enough, was Good Friday. Like the cruci-
fixion of Christ the death of Raphael shook the very
foundations of the earth, people said: it was marked by terri-
ble signs. Part of the pope's palace crumbled to dust, as if God

wanted to express the momentousness of this passing (in fact there had been a partial collapse in Leo's palace a few days before, apparently as a result of building works). For contemporaries in Rome it resembled 'one of the signs that showed the death of Christ'.

Raphael was buried in the Pantheon, the great Roman temple with its coffered concrete dome that was used (and still is today) as a Christian church. He had set funds aside in his will for his chapel there. Along with fine words for Raphael it bears an epitaph to Marietta, the niece of his well-connected friend Cardinal Bibbiena. In death, he is conjoined with the young woman he seems to have assiduously avoided marrying in life. Meanwhile the name of his real lover is nowhere, effaced by the official version, only for later generations to reinvent her as la Fornarina.

In about 1520 Janus Lascaris, an eminent Greek scholar and good friend of Leo X, wrote a Greek verse lamenting Raphael's death. His poem implies the fatal fever was caused by his sex life. Lascaris says that when the god Hephaestus (the Roman Vulcan) saw how lifelike his images of the gods were, he concluded that his own wife Aphrodite (Venus), together with Grace, must have helped him. So the jealous Hephaestus plotted revenge on Raphael.

Lascaris says that Hephaestus gave Raphael a raging fever for dallying with Aphrodite. It looks very like a reference to all the gossip about Raphael's sexual achievements at the Villa Chigi. In 1550 Vasari too said that Raphael died of a surfeit:

Meanwhile he continued to pursue his passions in secret. And keeping on like this in his amorous pleasures, having one time debauched himself more than usual, he returned home in an extreme fever and the doctors thought he was too hot. Which was why, with him not confessing to the sexual excesses he had performed, blood was let with little

prudence; in such a way that he weakened, and felt himself passing away – for if anything he needed a restorative.

And so he made his will and first like a Christian sent his lover from the house and left her the means to live honourably.

The poem by Lascaris is a fragment of contemporary evidence that backs up Vasari's dramatic claim that sexual excess did for poor Raphael. They both agree on the nature of his illness, 'a violent fever', as well as in blaming it on Venus. It was common in the sixteenth century to blame the deaths of apparently fit and energetic young men on sexual exhaustion. The notion that sex can exhaust and waste the male body goes back to the *Hippocratic Writings*, a repository of ancient Greek medical lore. Yet this old association of sex and illness acquired new urgency when an epidemic of syphilis hit Europe in the 1490s. In about 1507 or 1508 the Mantuan court artist Lorenzo Costa painted a portrait of his doctor, Battista Fiera; it may have been a gift to thank Fiera for treating the syphilis that Costa is known to have endured. Another work of art that may deal with syphilis is Matthias Grünewald's great *Isenheim Altarpiece* in Colmar, near Strasbourg: this was painted between 1510 and about 1516 for a monastic hospital that treated syphilis along with other necrotizing illnesses, and its gruesome depiction of Christ on the cross appears to refer to the sufferings of patients. Christ is nailed up against the bleakest of lightless skies. His grey-green-brown flesh is covered with black pustules or buboes which match those in descriptions of the form of syphilis that raged in the 1490s and early 1500s. As a Sicilian doctor observed in 1495:

The first symptoms are itching sensations and horrid pain in the joints. Fever takes hold and increases. Disgusting scabs cover the skin until it is overwhelmed by lumps and swellings that start out red and turn black.

The afflictions of syphilis may well be portrayed in the *Isenheim Altarpiece*. But no one described any sores on Raphael; and besides, the disease was often survivable and not an instant killer. Grünewald's altarpiece gives hope to the sick: after what feels like a crucifixion they will, at last, be resurrected like his shining vision of the risen Christ. On the other hand a Ferrarese doctor recognized in the 1490s that a non-pustular version of the disease existed, which showed no marks on the skin but tormented the victim with internal abscesses, and this became the more common version (perhaps because people covered with pustules found it harder to find sexual partners to infect).

The sickness and death of Raphael occurred in April: in a Renaissance world so much more cyclical and seasonal than our own, so self-consciously in tune with nature, this was the spring-time, the only pretty ring time, when people are inspired to make love. It was in the spring of 1476, remember, that Leonardo da Vinci was accused of sodomy. Perhaps the party life at Roman villas intensified in the spring of 1520 and plunged Raphael into a round of heroic lovemaking. Maybe he caught a fever from lying out in the gardens with a lover on a spring night.

One thing is for certain. The belief in sixteenth-century Rome that he died of sexual over-exertion was a reflection of the city's reputation. Raphael was at the centre of a wealthy, sophisticated set who emulated the decadence of ancient Rome. The city that ruled the Christian world was infamous for orgiastic parties. In a jokey detail of Raphael's frescoes at Chigi's villa, in the loggia where cardinals came to dine, a cucumber penetrates a purple fig to this day.

Sex killed Raphael, they said. If so, it outlived him and received a first-rate legacy from the rich young artist.

Giulio Romano, born in about 1499, was the most glittering young painter working for Raphael in Rome, his second-in-command and most trusted worker on all his projects. When

Raphael knew he was dying in April 1520 he named Giulio his co-heir.

It was an incredible inheritance, and Giulio Romano knew just what to do with the resources of Raphael's workshop. He would publish erotica. Among Raphael's team was the gifted engraver Marcantonio Raimondi. Raphael had respected the printmaker's art, and made use of printing to disseminate his own works in a series of engravings by Raimondi. He even designed images, including a powerful *Massacre of the Innocents*, solely for Raimondi to engrave. Giulio Romano also had a project for Raimondi – but he made sure he was on his way out of Rome before it hit the bookshops. In 1524 Giulio, basking in his reputation as Raphael's heir, became court artist at the little city of Mantua beside a northern-Italian lake. Before he went, he gave Raimondi a series of sixteen drawings of sexual acts that were published as *I Modi* – or *The Positions*. These are unpretentious erotic pictures. Just as Raphael painted an unreserved nude portrait of his lover, Giulio Romano shows a variety of sexual positions in raw and uninhibited images – or so it would appear from the few remaining fragments. *I Modi* barely survives because it caused uproar in 1520s Rome. Marcantonio Raimondi was thrown in prison. The man who stepped forward to champion a free press, save a persecuted artist, and make money for himself by climbing on the *I Modi* bandwagon, was Pietro Aretino. It was to be his making as a pornographic writer.

'I scorn the thieving judgement and swinish custom which prohibits the eyes from seeing what delights them most,' said Aretino. 'What is wrong with seeing a man on top of a woman?' As a notable figure in Rome he complained angrily to a papal official, Giovanni Giberti, then appealed directly to the pope. As a result of Aretino and others' efforts Raimondi was released. Now Aretino played his startling masterstroke. He wrote a series of sixteen robustly explicit sonnets to accompany the engravings, and in this form, with Aretino's verses beneath the original

pictures, *I Modi* was republished. As its fame grew all over Europe it would become known as Aretino's work, with illustrations by Raimondi. In Vasari's words,

> I don't know which was worse: the ocular offence from the drawings of Giulio, or the aural outrage from the words of Pietro Aretino.

It was one thing to display erotic antiques in exclusive villas but printing was democratic and global. Who knew how far these images could reach? Leo X's successor, Pope Clement VII, had to act. Aretino left Rome in disgrace for his part in the scandal, but his fame as a writer was secured. That probably did not reassure him when, for this and other offences, he was stabbed and nearly killed by an assailant who was likely sent by the Vatican. But Vasari points out that Giulio Romano himself was lucky to escape:

> [...] if Giulio had not already left for Mantua when it was published, he would have suffered the Pope's angry punishment.

It might be tempting for a modern beholder to see *I Modi* as somehow a 'subversion' of Renaissance art – a down-to-earth and honest piece of pornography that exposes the titillating yet evasive mythological paintings that decorated palaces. In fact the opposite is true. The publication of *I Modi* came at the start of (and helped to create) the most brimming phase of Renaissance mythological painting. Giulio Romano was a leader of this spectacular art of myth, and his drawings of sexual positions fit in neatly between the ceiling of Cupid and Psyche that he helped Raphael to paint in Rome and frescoes of Cupid and Psyche that he painted in the Palazzo Te in Mantua in 1527–30. Eroticism inflames Giulio Romano's art. In his picture known

simply as *The Lovers*, which dates from the mid-1520s, a couple embrace naked on a *lettuccio* or day bed while an old woman, perhaps a servant, peeps around the door. The painting is a peek at sex in a Renaissance palace, with the bed and its gold-and-green curtains rivalling the opulence of Roxanne's four-poster in the Villa Farnesina. In another work from about 1525, *Lady at her Toilet*, he takes his cue from Raphael to portray a woman naked except for her jewellery and fashionable turban, with a transparent veil over her thigh, as she pauses to bare her body to the artist in a palatial interior.

Giulio Romano's masterpiece is the Palazzo Te in Mantua, which he both built and decorated. From the outside it is a low, expansive building given life and force by rusticated stone, massive pilasters, and a profusion of unexpectedly situated windows, lintels, arched niches and blank windows. But the excitement really begins inside, where Romano's simultaneous mastery of architecture and painting provides unexpected illusory distortions of physical space. In the Room of the Giants, great chunks of rock actually seem to fall towards the disorientated visitor as the gods hurl down stones upon the rebellious giants: perspective painting makes the scene that fills walls and ceiling disconcertingly dynamic, the room becomes an illusory cosmos.

In the Room of Cupid and Psyche the same dramatic spatial games are applied to the erotic depiction of myth. Up there in the heavens, Psyche sees Cupid in his palace: the view from the floor is radically foreshortened so that under a coffered ceiling we see Psyche from below, getting a glance of the underside of her raised thigh. Giulio Romano is offering, literally, a new perspective on the nude. He plays the same trick in a view of a nymph: as we look up from below she seems to be standing on the edge of a precipice in radical perspective as if she actually were above us – we get an arresting view of the underside of her breasts. Set in nocturnal chambers or among silvery clouds these tantalizing paintings, like *I Modi*, cast new light on the erotic

power of the artist. Flashes of hips, breasts, raked at wild angles – these paintings have the same active sense of the body that makes Raimondi's prints so alive. A collection of fragments of the original prints for *I Modi* resembles an erotic montage, all movement and athleticism. A woman raises her body as she rests her head on a bolster; the unseen man is holding her up by her legs in a position as airborne as the nudes in the Palazzo Te.

The court of Mantua was having a good time in the 1520s. As Giulio Romano captivated viewers from above, the painter Antonio Allegri, known as Correggio, born in about 1489, transported them with a more intimate, voluptuous art. Correggio worked in Parma, whose churches he graced with frescoes as vertiginous and stunning as those of the Palazzo Te, but in a more virtuous cause, while for wealthy clients across Italy he created mythological scenes of exquisite sumptuousness. In about 1525 he painted for the ruling Gonzaga family of Mantua a scene that may represent either Venus and Cupid spied on by a satyr, or the god Jupiter, transformed, creeping up on Antiope. The exact identification probably does not matter. What matters is the radiant body of the woman sleeping in an abandoned and ecstatic sprawl. In his vision of a sleeping beauty Correggio looks at her face on, from above. The ground in the painting tilts upward, so we see the nude frontally, with an equally clear view of her face thrown back on a blue silk sheet – brown eyelashes, golden hair, a strong cheek – and of her throat in gentle shadow, breasts depicted with honeyed realism, expansive luminous stomach, imperial hips and well-fleshed legs. Her beauty is unveiled from head to toe and the onlooker is like the satyr, awestruck and delighted. The male hair that hangs from his goatish thighs is painted with the same misty richness as the pearly body he contemplates: the setting of lush foliage, too, is created with subtle grace.

Correggio, like Giulio Romano in his erotic drawings and paintings, loves the unexpected point of view. Nothing could be

more direct than this painting: it is arguably the most daringly sexual of all Renaissance nudes. What is he saying to the courtiers of Mantua if not 'Go to bed'? He was a religious man, who lived a respectable family life in Parma (it was said he worked ceaselessly to support his large family), yet Correggio saw the ancient myths, without any spiritual or philosophical veiling, as sexual stories. His classical paintings use painterly refinement to give jaw-dropping reality to the licentious tales of the ancients in what he plainly intends as fun.

The excuse for Giulio Romano's *Positions* was the most fundamental premise of the Renaissance: it is good to emulate those paragons, the ancient Greeks and Romans. His designs are directly indebted to Roman erotica. For Correggio and other visualizers of myth that same classical legacy allowed any stimulation it amused their wealthy clients to see. The discovery of classical erotic art is usually credited to the eighteenth century, when excavators at Pompeii started to uncover brothels, lewd frescoes and explicit artefacts that found their way into the famous Secret Cabinet at the National Archaeological Museum in Naples. But the enthusiasm for digging up ancient sculpture in Renaissance Italy produced spectacular works long before this, like the lecherous Pan that Agostino Chigi owned.

Not only did Renaissance collectors know of such pornographic classical works but they also restored them in resourceful ways. A marble depiction of *Leda and the Swan* from the Grimani Palace in Venice was restored in the sixteenth century to make Leda embrace her creature with hot abandon. The sculptor Andrea Riccio, who worked in Padua near Venice, went further still and created his own classical erotic art. Riccio made small bronzes that are at once technically refined and rugged in their sexuality. His portrayal in bronze of a satyr couple embracing, today in London's Victoria and Albert Museum, shows the goat-legged creatures engaged in a reckless kiss, their lips joined

forever in time-darkened metal. It is loyal to classical examples like the Farnese Pan, yet original in its animal lust.

In about 1523 Parmigianino, a younger and equally gifted contemporary of Correggio in Parma, painted a portrait of a man and his art collection. In his hand the unknown collector has a Book of Hours, at once a precious artefact and an instrument of prayer; yet the intense, troubled eyes in his blood-filled face veer away from it. On the other side of him, directly behind his head, as if it embodied his thoughts, is a classical marble fragment of the lovers Venus and Mars together with Cupid. While the collector holds a holy book, his thoughts seem drawn to the lusts of antiquity. This portrait dates from the very years when Giulio Romano and Correggio were diverting the nearby court of Mantua with hedonistic renderings of classical myth. Was Parmigianino commenting sardonically on the saleability of indecent antique-style art? Or was he dramatizing a genuine psychological dilemma for Renaissance souls torn between piety and the seductions of classical myth?

Correggio's vision of myth as pure sexual fantasy reached a peak when he painted a set of four canvases of the loves of Jupiter for Federico Gonzaga to give as a gift to the emperor Charles V when he visited Mantua in 1532. Charles was the most powerful man in Europe, and a devout champion of the Catholic Church. Perhaps the meaning of these paintings for him was a political compliment: like Jupiter, the emperor of gods, he can achieve his will in any place, in any way, against any resistance. Correggio engrosses us by making impossible copulations bewitchingly real. Io sits naked on a white sheet draped over an earthy seat in a woodland, beside a clay amphora; its brown colour matches the earth and contrasts with her pale back. She swoons as a huge blue paw embraces her. Jupiter has come to Io in the shape of a mist. His face materializes out of the smoky pall that swathes trees and enfolds bright leafy branches to kiss her neck. As he surrounds

her, at once mighty and gentle, she throws her head back in pleasure.

Raphael lit a spark of sexuality when he portrayed his mistress undressed. He promoted the idea of painting for sheer sensual pleasure. As his pupil Giulio Romano spread this message through erotic prints and frescoes, and Correggio made the loves of the gods deliriously real, Raphael, dead in his tomb, missed out on the orgy he helped to start.

Chapter Seven

TITIAN AND HIS MODELS

A sunset sky blazes pink over the Grand Canal. Behind a row of pointed windows in a long candlelit room poses a woman, naked except for the fur draped over her shoulder. The painter looks up from his easel and approaches her. As night swallows the sky he gestures towards a conveniently placed bed.

The art of Titian is one long love story. It is romantic and sensual, and filled with characterful women. These women – all of them – are adored by the artist. Although he married Cecilia, a girl from his home town, after they already had two children, the overwhelming evidence of Titian's art is that he was never a one-woman man. He was a Venetian libertine who loved all the women he could get. Painting meant making love, both meta-phorically and, when the modelling session was over, literally.

In Titian's portrait of his great friend Pietro Aretino, the scan-dalous erotic writer appears a man of stateliness and dignity. Aretino stands wrapped in an immense robe of velvet with a silk collar, its deep-rose luxuriance parted just enough to reveal the gold chain mantling his chest. Aretino's long flowing beard lends him the aspect of a Biblical prophet. As the light that illuminates his garment's complex textures and red hues casts a silver glow on his face he turns as if to look askance on some new subject for a stinging satire or vehement attack. The chain was a gift from Francis I, but even in his thank-you letter to the French king

(published by him, like all his correspondence) Aretino does not curb his curt tongue:

> But your presents are so late that they are about as much good as food to a man who has gone without eating for three days [. . .] and now I do not believe there is any more doubt about the coming of the Messiah of the Jews; for the gift has got here.

Titian portrays his closest literary friend not as a comic, or scurrilous author, but as a moral commentator whose words resound across Europe. It is a painting of authority: the authority of Aretino's voice and Titian's brush. Aretino showered praise on this painting of himself:

> No one has ever seen such a fantastic thing [. . .] A marvel painted by a man of qualities [. . .] It seems to breathe and live as surely as I do.

After all this praise he adds a playful remark: 'If he had been paid more the clothes would be really dazzling.'

It's a joke among friends. By the time this portrait was painted, in 1545, Venice's most famous artist and writer had known each other a long time. Titian left very few letters or even quotable remarks to help later generations understand his paintings, but Aretino never stopped putting thoughts into words. His writing is a window on Titian's art.

It is a window in which a courtesan is sitting.

Aretino settled in Venice in 1527. In that year Rome was put to the sack by a mercenary army. It was, wrote the contemporary historian Guicciardini with a shudder, a year

> replete with horrors and things with no recent precedent, including governments being toppled, rulers proving tyrants,

terrifying destructions of cities, severe food crises, the whole
of Italy hit by plague, in short a plenitude of death and sav-
agery and refugees.

Yet it was a good year for Aretino. Of all Italian city-states,
Venice was the perfect place for a writer and a roué. It did not
have the venerated literary tradition of Florence with its Dante
and Boccaccio. Yet it had the most dynamic publishing trade
in Italy – made famous by the renowned Aldine Press, which
set a new standard for quality books in the early sixteenth
century. It was also a free Republic that, despite having fallen
from its medieval peak of prosperity and mastery, was pro-
tected by its imperial possessions, internal stability and famous
offshore seclusion from the violent upsets that turned other
Italian states upside down in these years. The Republic of
Venice became the home of Italy's free press, publishing vol-
umes that would be too threatening elsewhere. Aretino helped
it get that reputation. His writings are nothing if not free in their
speech. In the first of his *Dialogues*, published in 1534, the cour-
tesan Nanna tells of how as a young woman she entered a
convent only to find within minutes of taking her vows that the
nuns liked to follow up an extravagant meal by passing around
dildos made of Murano glass. Then she saw the frescoes in the
convent:

> In the last picture were shown all the modes and all the paths
> by which it is possible to fuck and be fucked; and the nuns
> are obliged, before taking the field with their lovers, to
> attempt the poses shown in the picture: and this is so as not
> to be awkward in bed [...]

The convent was a school for sex. A mistress taught the young
nuns how to please a partner, as if they had entered not a holy
house but a brothel:

She shows novices how to position themselves when lust so stimulates a man that he wants to ride them on a chest, through a ladder, in a seat, on a table, or on the ground.

On her first night behind monastic walls, Nanna was left behind when all the nuns and monks went off to enjoy themselves in their cells. She went with the one man who was left, and just as they were getting started the General of the order knocked at the door of the convent. It was not the end of the fun. Peeping through a hole in the wall she watched the General sporting with senior nuns. This culminated in eight people in a congress that Nanna compares with the ancient sculpture the *Laocoön*, discovered in Rome in 1506, which portrays a Trojan priest and his sons being strangled by snakes. The look on the General's face was just like Laocoön, says Nanna.

As she goes on with her tale Nanna's language becomes evermore comically Baroque until her listener Antonia complains:

> I meant to say, and then it slipped my mind: speak clearly, say cunt, cock, arse and fuck [...] You with your 'cord in the ring', 'pinnacle in the Colosseum', 'leek in the garden', 'latch in the door', 'key in the lock', 'pestle in the mortar' [...]

In reply, Nanna goes on talking in absurdly complex images. It is an orgy of language: like Shakespeare half a century later, Aretino rejoices in the number of ways in which he can allude to the same acts. This profligacy of language showcases the rhetorical excellence prized in Renaissance writing. Aretino displays the *copia* (plenitude) of his literary voice. His *Dialogues* are sustained performances of verbal creativity.

Nanna's lover sent her a prayer book:

> Left to myself I turned open the little book to read the Magnificat: and opening it, I saw that it was stuffed with

paintings of people fooling around [...] and I fell into such loud laughter [...] that a sister who was a pal of mine came hurrying from a distance, and when she asked, 'What are you laughing at?' Without delay I told her all; and when I showed her the book, we enjoyed it so much we longed to try the positions (*modi*) in the paintings. We needed the glass dildo: my companion fitted it so well between her thighs that it appeared to be the tool of a man stiffened towards his temptation. So I went down on my back [...]

Aretino, who collaborated to create the visually detailed erotic masterpiece *I Modi*, envisages Nanna and her fellow nun being aroused by the dirty pictures infiltrated into an apparently innocuous prayer book. Erotic paintings incite the acts they depict. Titian already knew this. He had been inciting people for years.

Titian, born in the Dolomites around 1490, collaborated and competed with Giorgione when he was still a teenager. The art they created was hugely popular with Venetian art collectors who squandered cash on nudes and portraits of semi-dressed beauties to hang in their splendid palaces on the Grand Canal. Soon even the established artists were trying to enter this lucrative flesh market.

A young woman sits on a bench that is covered with an exotically embroidered red Turkish carpet. Behind her is a window opening onto a hilly landscape that recedes to blue peaks under a golden horizon, which is itself closed off by a silky layer of cloud and mist the same duck-egg hue as the mountains. She looks into a little mirror held in her hand as she adjusts the blue-patterned, pearl-fringed headdress on her reddish hair, while a larger circular mirror fixed on the wall behind allows her – by combining the two reflections – to get a rear view of her coiffure. Apart from the ornate blue headgear, and a pink sheet that

hangs over her arm and drapes her thigh, she has no clothes on. The artist watches her frankly as she goes about her business, showing a nipple as she looks, calmly, in the glass. Beside her a letter lies open on the bench: surely it proposes an assignation. She is preparing for a tryst with her lover.

The wooden panel is signed and dated on the back. It was painted by Giovanni Bellini in 1515. It might be taken for a masterpiece by a member of Giorgione's generation – except that Bellini was about eighty-two years old when he did it, and had only one more year to live. He was not a contemporary of Giorgione and Titian, but their teacher. In this painting the established Venetian master of the day, famed for his portraits and altarpieces and well paid for them both by private patrons and the state of Venice, turns his hand to the new erotic art invented by his pupils. He triumphs. There's a uniquely cool poise to this picture and personality too: it is truly a naked portrait. It displays nudity in a different way, Bellini's way. This woman's flesh is set off by the gold and blue of the sky and her headgear, the red and pink of the bench and wrap: amid all this play of colour she seems a silver vision, her nudity neither taken for granted nor paraded but striking the painter as some kind of quiet miracle.

This painting, and its creator, connect the passion for flesh that seized Venetian artists soon after 1500 with the long history of the city's culture. Venice is a city of reflections that wobble in the water, green algae clinging to the stones of palaces at the waterline, red sunsets over the Grand Canal. The city's craftsmen responded to this limpid beauty. By 1291 there were so many glassmakers in the city they had to be exiled to the nearby island of Murano to prevent fires caused by super-hot furnaces ravaging the rising palaces: Venetian glass in the thirteenth century was already laced with filigree ropes of decoration. Bellini, whose career began in the 1460s, was the first great Venetian painter, and illustrates how a sensual painterly technique arises

out of the city's very identity and fabric. In his altarpiece of the *Madonna and Child Enthroned with Saints* from the church of San Giobbe, painted in about 1480, he sets the throne of Mary beneath a grey classical vault that culminates in a mosaic-covered dome-shaped niche. The mosaics are painted with eye-fooling perfection: we can see, simultaneously, both the separate gold tesserae and the overall effect of reflected light in whose glowing surface letters hover in an early medieval script along with an inter-folding rank of angels. The mosaic is set back in the deep vault, so that it is not overly bright but instead a mirror of subtlety: its burnished light seems to shape the delicate atmosphere of the entire painting. Filigree shadows play on it. The building to whose mosaic-filled heights Bellini's painted architecture alludes is the basilica of San Marco, the city's proudest church, a nest of onions next to the Doge's Palace on the piazza that shares its name. This building, the symbol of Venice, has been embellished over the long centuries since it was founded in AD 832 with many-coloured marble columns, ancient statues of emperors and horses, and, inside, gleaming mosaics that brighten and darken, fill and empty with light like echoes of the sky itself as the illumination from high, restricted windows waxes and wanes. The mosaics of San Marco are a permanent Byzantine heritage at the heart of Venice, witness to the city's early history as, first, a subject city of the eastern Roman Empire that survived as medieval Byzantium, then a trading partner, maritime rival and finally victor over this eastern Christian capital. Bellini's 1515 nude, a masterpiece from close to the very end of his life, shows how the civilization of Venice, so steeped in optical luxury, turned to the sensory stimuli of the bedroom and sexuality as themes for painting: how the mysterious mosaics of San Marco led by shady paths to the portrayal of love and beauty that obsessed this city's greatest artists.

At about the same time as Bellini was painting his mirror-gazing nude, the young Titian, in around 1514 or 1515 and now

aged about twenty-five, also painted a woman who is taking advantage of two artfully arranged mirrors to see her hair from behind. She has long, golden-brown tresses that shines as she arranges it with a fleshy arm, while her dress hangs loose over her breasts and a white underdress falls down to reveal the tender expanse of her shoulder. The mirrors are being held up for her by an adoring man: as he stretches a red-sleeved arm to position the large circular convex mirror behind her, he shows her a small rectangular mirror with his other hand. With his shadowed and attentive face he studies her noble features, brightened by a window reflected in the convex mirror and obstructed by the curve of her head.

Like Bellini's nude, this is a masterpiece of colour rooted in the unstinting visual world of Venice. The mirror behind the fleshy beauty shimmers like a canal in moonlight. Titian takes the colours of Venice to new peaks of sensuality – unmatchable ones. He understands how the rough weft of canvas can intensify the texture of an oil painting, and his paintings exploit that fact to make clothes seem real. In this painting, as in others by him, the soft crispness of a white sleeve, the silky darkness of a dress, are mesmerizingly substantial. These woven textures contrast magically with what seems the heavenly ambrosia of skin, the luminous fullness of flesh. In his painting of the woman and man with two mirrors, the beautiful woman seems to burst out of her partly laced dress front, her body a heroic and splendid fact that leaves Titian speechless with awe. Struck dumb by desire, all he can do is paint what he sees and share his passion for the beauty of women.

Is the man in this painting, serving his lady by showing her reflections of her beauty, the artist himself? The black-haired man gazing, smitten, at his love does not have to be a self-portrait for this to be an allegory of Titian's art. Like the man with the mirrors, Titian shows the beauty of women its true image. His paintings attempt to hold that beauty as a mirror holds it, and

like a mirror their natural place is the bedroom. Titian pictures himself as a lover: to show a true reflection is an act of love. He tells us in this painting that he is a lover among artists, an artist among lovers.

It is a bedroom scene. The woman is getting dressed. Who is she? She is someone Titian painted more than once. Her broad face appears too in Titian's painting *Flora*, which shows her holding a posy of flowers as she stands ready for bed, wearing a white shift that ruffles against her honeyed skin as it falls to expose the red areola of a nipple.

Both these paintings are passionate acts of admiration. Titian paints this woman with the closeness of a lover. Yet she is just one of the faces, and bodies, who populate his art and inspire his ardour. Titian is a lover among artists – but not a constant one.

Decades later, when Titian was working on a nude painting for Cardinal Alessandro Farnese, someone who had seen it in Venice wrote to the young churchman to reassure him that, compared with this, a previous nude by Titian that had excited him resembled a nun. It's a telling perspective on how clients saw Titian's secular paintings. They enjoyed them as erotica. The women in these paintings are available to the eye. They display themselves. In Titian's painting of a woman with mirrors, she lets her lover see her as she dresses: he is invited into her cosy world. It is because Titian has access to that world that he can share it with his viewers. But what world is it? Whose bedroom?

The agent of the Duke of Ferrara in Venice painted an explicit pen picture of Titian at work:

I went to see Titian, who is not in the least feverish: he looks alright, if a bit tired. I suppose the girls he paints so often in various poses incite his desires, which he indulges beyond what his body can take.

This observer of Titian at work mentions quite casually that – of course – he sleeps with all his models. Titian's models were at the heart of his life. Though he worked for dukes, princes and monarchs, he never liked to be away from Venice. He once explained that this was because he needed his regular models – he needed his beauties around him, to people his paintings. In his Life of Titian in 1568 Giorgio Vasari – who visited the painter in 1566 in his Venice studio and saw the old man still painting, 'brushes in hand' – makes an incisive observation about how Titian worked. In the first decade of the 1500s, he says, Giorgione and those who learned from him, including Titian, started to set themselves 'before living and natural objects and counterfeit them [...] In colours'.

In other words, these painters of Venice did not follow the principles of careful preparatory drawing that were held to by Florentine artists such as Vasari himself. They simply set an easel in front of a landscape or a model and painted from life. He doubts this is a good way to paint the nude, which should be done from many drawings out of which the artist synthesizes an idealized invention:

> You need to study the nude for a long time, if you want to understand it, which you cannot do without drawing on paper; to always keep naked or draped models before you while you are painting is a huge restriction.

Through Vasari's critical eyes we see exactly what Titian actually did: he kept before him, while he painted, models naked or draped ... Titian's art does not only *seem* sensual; it *is* sensual, created in direct response to people he kept before his eyes as much as possible. His working drawings were not assiduous preparatory studies (only about thirty drawings on paper even survive by him) but bold sketches on canvas, which he reworked

in colours alone. The agent of the Duke of Ferrara was very clear what went on at the end of Titian's sessions with beautiful women 'in different poses'.

It may be hard to visualize a Renaissance artist posing a model as Venus or Diana and literally expecting her to stay in that position as he worked on his canvas. It seems like a cliché of art, not the reality of artistic work. Yet one sixteenth-century artist who wrote about his own life in detail describes exactly that set-up. He even says that it led naturally to sex.

In a studio in Paris an artist is taking revenge on his mistress. He recently caught her with another man and although his first impulse was to kill them both, decided on reflection to exact a more inventive penalty. First he made them get married on the spot, then he started hiring her as a nude model. Now he makes her pose naked for him every day. He gives her money, she strips. They eat. They have sex. He orders her to adopt uncomfortable naked poses for deliberately punitive periods of time, while he makes a model of her in clay. As well as revenge, he gets an artistic boon from her modelling for she is 'beautifully made'. But it is a violent relationship: she keeps insulting him, he beats her savagely, they reconcile, have sex again, and he beats her again. His portrayal of her naked body progresses well, through all this squalor and chaos and cruelty.

It might be a tale of Romantic Paris circa 1830, or avantgarde Paris circa 1900. Yet it comes from the autobiography of Benvenuto Cellini, who was born in 1500 and died in 1571. In his late years, Cellini dictated the story of his life to 'a sickly boy' who wrote it all down in a manuscript that was finally printed in the eighteenth century and became – as it sounds – a cult of the Romantic era, dramatized in an opera by Hector Berlioz that exults in love and lost-wax casting. Cellini was a Florentine; his father was a musician in the city band and was disappointed when his son rejected music to train as a

goldsmith. The boy had a rare ability to produce precious objects in metal, which took him to Rome in the age of Leo X and Clement VII – yet everywhere he went his delicate crafts-manship contrasted with a destructive, unstable personality and readiness with weapons. Cellini killed to avenge his brother's death, to get even with a rival, to settle a dispute in Siena over a horse. He was uncontrollably aggressive, yet escaped the death penalty because his artistic talent was so highly valued by popes, dukes and kings.

The nude high-relief that Cellini cast in bronze as a result of his modelling sessions with his lover Catherine survives. It is a woodland fantasy in bronze, greened by time. Four metres wide, semi-circular, it was created for the Golden Gate of Francis I's favourite château of Fontainebleau, although it later ended up decorating the Château d'Anet, home of Henri II's mistress Diane de Poitiers. A naked nymph, her body elongated and colossal, hugs the gigantic head of a stag that symbolizes the hunting forests of Fontainebleau; wild boars stuff their snouts into the scene. This rustic nymph of the forest, a nude person-ification of the joy of hunting, is a testament to the reality of naked modelling in the Renaissance. Cellini's story of how he forced Catherine to pose for him in the dying, ruinous aftermath of their relationship could scarcely be a more explicit account of a sixteenth-century artist observing a model as he created a work of art. As he puts it:

> And I said to myself: 'I pursue in this way a twofold vendetta: firstly she's married [. . .] So indeed this revenge is effective against him, and spectacular against her in making her pose in such uncomfortable positions, as a result of which I win reputation and profit. What more could I desire?'

By the time Cellini cast the immense, delicate slab of his *Nymph of Fontainebleau*, he had finally driven Catherine away. To pose for

his final touches on the bosky nude he found a new model, fifteen-year old Jeanne:

> This one had a beautiful figure, and was quite dark-skinned; and because she tended to wildness, had few words, was fast in her actions and frowning in her looks, these things made me give her the name *Scorzone* (little snake) [...] Working with this girl I finished the *Nymph of Fontainebleau* in bronze as I wanted it, and also the two Victories for the door.

Once more Cellini took sex with his model for granted:

> This young girl was pure and a virgin, and I got her pregnant; she gave birth to a daughter [...] This was the first child I ever had, so far as I remember. I assigned to this girl as much money as an aunt of hers with whom I left her was happy with; and that was the last I saw of her.

Behind the august bronze form of the *Nymph of Fontainebleau* are two women, Catherine and Jeanne, and a daughter whom Cellini never saw again after giving her away as a baby. Cellini may have been an amoral egotist but in his autobiography he does lay bare the secret life of high art. For these two models how many women who posed for Titian go unnamed?

After he got a government commission in 1513 to paint a battle scene for the Greater Council Hall at the Doge's Palace, Titian was given a working space in the Ca' del Duca, a palace in the San Marco district that faces right onto the Grand Canal. Models could come there by gondola, like the women who are ferried in boats, under canopies, in Vittore Carpaccio's painting *The Healing of the Possessed Man*. Their gondolas would pass some of the finest palaces in Venice to get to Titian's studio, close as its site is to the fifteenth-century Palazzo Contarini-Corfu, Ca' Foscari and Ca' Giustinian. These last

two form an unbroken facade of splendid Gothic windows and balconies, white stone against brown bricks, reflected in the green water.

Is it possible to be more precise about the identity of the models on their way to Titian's studio? Like other Renaissance cities, Venice had sumptuary laws that stipulated how different ranks and categories of people should dress. Cesare Vecellio, a writer on dress in the 1590s, says that courtesans 'are not allowed to wear pearls like decent women', although they sometimes wear them anyway by getting men to pose as their husbands. Out of doors they expose their bare necks under their cloaks, and wear Roman-style shoes under their *pianelle*, or platformed backless slippers. A pair of *pianelle* that survive in the Victoria and Albert Museum in London have wooden boat-shaped platforms covered in green-blue velvet, silver braid and bobbin lace. The versions worn by courtesans could be far higher than these, which are a couple of inches: it was complained that courtesans strode about like giants. This went with their theatrical bearing:

> They can easily be singled out by their behaviour, for indoors and out they boldly show their made-up faces and whitened breasts, and reveal their legs in fine stockings.

Thomas Coryat, in his 1611 account of a tour of Europe, sets out to describe courtesans properly, as they are such a prominent class in Venetian society yet are usually ignored in accounts of the city, so he complains, even though 'the name of a Cortezan of Venice is famoused over all Christendome.' He claims that the Italian word *cortezana*

> is derived from the Italian word *cortesia* that signifieth courtesy. Because these kind of women are said to receive courtesies of their favourites.

He has been told there are about 20,000 such women in Venice and its outlying islands. When you visit a Venetian courtesan, he says from personal experience,

> shee comes to you decked like the Queen and Goddesse of love, in so much that thou wilt thinke she made a late transmigration from Paphos, Cnidus, or Cythera, the ancient habitations of Dame Venus. For her face is adorned with the quintessence of beauty. In her cheekes thou shall see the Lilly and the Rose strive for supremacy, and the silver trammels of her haire [...] Also the ornaments of her body are so rich, that except thou dost even geld thy affections, (a thing hardly to be done) or carry [...] some antidote against those Venereous titillations, shee will very neare benumme and captivate thy senses [...]

Coryat clearly cannot 'geld' his feelings for these women. But he stresses, as did the Venetian sumptuary laws, the absolute distinction between them and the honourable women of the elite:

> For the Gentlemen do even coope up their wives alwaies within the walls of their houses [...]

It is because Venetian gentlemen are so possessive of their wives that they permit the sex trade: it is an outlet for attentions that might otherwise threaten 'the chastity of their wives'. This was also a virtue of boat travel, according to Vecellio, for closed gondolas kept wives safe and secure. Only at home were noblewomen encouraged to show off dresses, jewellery and hairstyles for the pleasure of their husbands. Meanwhile noble girls

> are so strictly supervised in the paternal home that even close relatives often have no idea what they look like before their wedding [...]

On their way to mass, their faces were to be veiled. So much for any idea of Venice as a generally latitudinarian city: the wives and daughters of the elite were under strict supervision, confined to those great palaces along the Grand Canal, sitting on terraces to bleach their hair blonde. Carpaccio's painting *Two Ladies on a Terrace*, which dates from about 1500 and was originally part of a larger picture that also shows men duck-hunting in the lagoon, shows two wives doing just that. It demonstrates that by that date pearl necklaces already symbolized marital purity and honour. The two women are surrounded by emblems of marriage, fidelity and chastity, including dogs and birds, and lilies and myrtle in a vase. A pair of discarded *pianelle* shows that the recent bride who rests her arm on a parapet is a stay-at-home. To prove the point further, she wears pearls. Laws are made to be broken and visitors to Venice reported wives as well as courtesans dressing more floridly than elsewhere. But the distinction between honourable and dishonourable femininity in this Republic dominated by a male oligarchy makes it extremely clear what kind of women posed for Titian.

They wear no pearls, and expose bare expanses of throats and chests, just as the courtesans of Venice were described. It is not just that Giorgione's Laura and the still more sensual *belle* pictured by Titian are courtesans. They are supposed to be recognizable as such: that is part of their fascination for the artist and his original audience. When Carpaccio wanted to portray married women he used the codes to do so, including pearl necklaces; when Giorgione, Bellini and Titian wished to depict the city's most notorious group of women they too used sartorial symbols. Neither Laura, nor Bellini's nudes, nor Titian's beauties of the 1500s and 1510s wear pearls. They all flaunt their throats, breasts, and sometimes far more, gladly and confidently. The contrast with gentlemen's wives and daughters, borne behind veils from palace to church and back, is glaring – and intentional.

Titian's paintings celebrate erotic abandon, free from the rules of everyday Christian decorum. Venice was famous for its festivals, including one of the most renowned carnivals in Europe, when men and women wore masks, the social order was suspended and liberties could be taken. Throughout Europe in this age, carnival was the world turned upside down. The sexuality of courtesans had a carnival freedom, as they paraded about in intimidating slippers. Coryat reports seeing courtesans at the theatre in carnival-style masks:

> Also their noble & famous Cortezans came to this Comedy, but so disguised, that a man cannot perceive them. For they wore double maskes upon their faces [...] If any man should be so resolute to unmaske one of them but in merriment onely to see their faces, it is said were he never so noble or worthy a personage, he should be cut in pieces before he should come forth of the room, especially if he were a stranger.

Maybe someone was winding him up slightly. But the image of courtesans in masks connects them with the inversion of social norms that prevailed at carnival time. The Venetians told Coryat that the sex industry was a moral safety-valve – just as carnival was a release of pent-up social tensions. In Titian's paintings, the carnival of sex is sophisticated and luxurious. Just as wealthy men became the paramours of courtesans, the inventory of Venetian art by Marcantonio Michiel shows how these same men collected art to hang in their stupendous homes. Titian titillated their eyes. Yet he was no cold pornographer. His paintings are acts of love by the friend, confidant and lover of a succession of women who probably lived as courtesans, and who play that role in the bedroom of his art.

Titian's *Violante* was painted in about 1514–16. With blonde hair (all Venetian women had blonde hair, it was said, due to

their open-air bleaching method) glittering in the light, she turns to face the artist. Her dress sleeve subtly falls off her shoulder, just a bit, to add to the dazzling colour-field of her unadorned throat and sloping breasts. Her face is clear and strong, framed by those golden shimmers of her ethereal locks. It is a sexual painting: Titian is arousing desire. The sleeve demands to be gently pulled back further. She looks, she participates, as if she is sharing something with the painter. Her name, Violante, is an echo of a romantic legend. It was believed in the past to be a portrait of Violante, the daughter of Palma Vecchio, who was said by Carlo Ridolfi in the seventeenth century to have been Titian's lover. That is a sentimental fiction. But she does give the appearance of being familiar with him – one of those models he was said to sleep with. Another painting, *Young Woman in Black* apparently of the same woman, has still greater confidence: she faces us directly and instead of a dress wears a nightshift, which exposes her shoulders, and a black coat (a man's coat?) she seems to have just thrown on. As she looks back at us with her hair hanging casually, it seems for all the world as if she and Titian have just made love. Surely these two paintings really do portray his lover – not the legendary 'Violante', simply someone who shared his bed. The paintings are almost 'Before' and 'After' images. They are tender expressions of lust: decorous on the edge of abandon in the first picture, warm and relaxed after lovemaking in the second. To look at them for long is to feel privy to a passionate relationship, maybe quite short-lived, between Titian and this young woman.

The masterpiece of Titian's early images of beautiful women is *Flora*, which dates from about 1516–18. As we've seen, it portrays the same woman to whom Titian held up his mirrors. Flora is painted with love and tenderness: the look in her eyes is noble. But it is a very sexual depiction. Her exposed breast has an amazing form and weight. You can almost feel it in your hand.

Every millimetre of exposed skin has a radiant reality. Flora is beautiful, body and soul.

Pietro Aretino's friendship with Titian makes his account of the life of a Venetian debauchee highly relevant to how we see Titian's paintings. For Aretino in his letters from Venice describes a life of sophisticated hedonism. Arguing that winter is more fun than summer, he paints a lovely word picture of December delights in a Venetian palace, praising

> that oil-soaked bread you eat around the fire in December and in January, downing a few cups of young wine while the roast turns on the spit, and tearing off a piece of blackened pork without caring if you burn your lips and fingers. At night you go to a bed the warming pan has preheated and embrace your mistress [. . .]

Aretino embraced many mistresses. But he does not talk about his sex life as a cold pursuit of carnal knowledge. On the contrary, like that later Venetian libertine Casanova, he speaks of love affairs. He warns against falling in love, pokes fun at friends who have fallen in love, and confesses that he himself has fallen in love. He is not talking about betrothal and marriage. Rather, he means an intense affair, sincere and emotional as well as sexual, in which the lover gives his mistress gifts and sends her poems and love letters. Aretino had a mania for falling in love that casts an intriguing light on Titian's paintings. In all the Venetian pictures of *belle* that survive there is a romanticism along with the carnality. In the masterpiece of the genre, Titian's *Flora*, this sweetness is so entrancing it makes lust itself seem innocent. That sweetness is very much the way Aretino speaks of his love affairs:

> I pass from one madness to the next, never doubting that my affairs will last forever. But behold, the second succeeds the first and the fourth the third, all linked together like the debts

of my prodigality. Certainly, in my eyes lives a passion so
tender that it must have every good-looking woman; nor can
it ever be satiated by beauty.

In his eyes lives a tender passion: this makes a perfect description
of Titian's paintings of women. In the mid-1530s, when he and
Aretino were firmly established as friends, Titian painted a series
of sensual portraits of one very recognizable woman. Just as
Aretino speaks of his string of loves, each of which he expects
to last forever, in this group of paintings Titian idolizes the
beauty of a woman who poses for him candidly and whom he
adorns with his art as a lover might shower a mistress with gifts.
In one painting she poses fully clothed, richly dressed in green,
with fine hairstyle and jewels, looking directly and sensitively out
of the picture. In another picture she bares one shoulder and
breast while holding a fur over the opposite shoulder. She stands
in very much the same pose in both paintings, looking gravely
outward. The impression it gives is that she has never done this –
posing naked – before, either for a painting or a lover.

Titian's most dramatic way of honouring courtesans was to
portray them as Mary Magdalene, the prostitute close to Christ
who in medieval Europe became one of the most popular
saints. She was in effect patron saint of prostitutes – and in
Titian's paintings real women play her part like donning a car-
nival mask. One of his greatest religious works, *Noli me Tangere*,
was painted in about 1513 or 1514. Its emotional impact
depends on the reaction and expression of a woman who gazes
intensely at a male figure: he is the risen Christ and she is Mary
Magdalene. In Titian's painting she has the long luscious hair
and classical profile of one of his paintings of courtesans. She
kneels before Christ and looks with reverence and feeling at his
reincarnated form, as he arcs away from her like a bow. Her
intense action and the look in her eyes give the scene deep
pathos. The uncanny nature of this encounter, a meeting that

is also a loss – 'Touch me not' or 'Do not desire to touch me,' says Christ – is heightened by the light-filled sky, the blue mist of the horizon, the little rustic hamlet on a hill. Titian's *Noli me Tangere* takes the Venetian art of light and colour to new heights of rapture. He had the ability to make the sky truly glow. He could at the same time – even on a small scale, as here – give Mary Magdalene's white shift and red dress a dappled, rough texture like real cloth.

Titian's other depictions of Mary Magdalene were to depart from this painting's humble astonishment to honour her as a very earthly beauty. The small figure of the Magdalene in *Noli me Tangere* may already look like a courtesan, who has been overcome by religious fervour. In the portrait-scale *Penitent Magdalene* that Titian later painted for the Duke of Urbino, she takes on the sensuality of his bedroom paintings. It is an extraordinary image. Mary Magdalene is in the wilderness, repenting: yet even as she looks towards Heaven, the gold light that falls on her face lights up the bright tresses of hair with which she attempts to cover her nakedness, casting them in a bronze fire of luxuriant glory. The unbridled hair that is an iconographic feature of Mary Magdalene in the wilderness – Donatello, for instance, had portrayed her as a hirsute, emaciated hermit – becomes here rapturously beautiful. Under her hair, her flesh is voluptuous. Even the arm that holds her hair against her chest is an alluring expanse of honeyed softness. Most subversive of all, however, are the large breasts that peep out from her hairy adornment so that, far from hiding them, her wavy locks caress them.

Leonardo da Vinci boasted in his notebooks of painting a religious work that was incongruously erotic. In this painting Titian risked the same daring ambiguity. He carries it off with such confidence that his painting is both sensual and genuinely Christian: the heavenly gaze of Mary Magdalene is sincere. Of all Titian's paintings this is the most explicit in its attitude to Venetian courtesans. The woman is observed from life and it

Roman copy of Greek original, *Pan and Daphnis*. The presence of
this ancient masterpiece in the Chigi palace in Rome during the
Renaissance gave license to a new wave of erotic art.

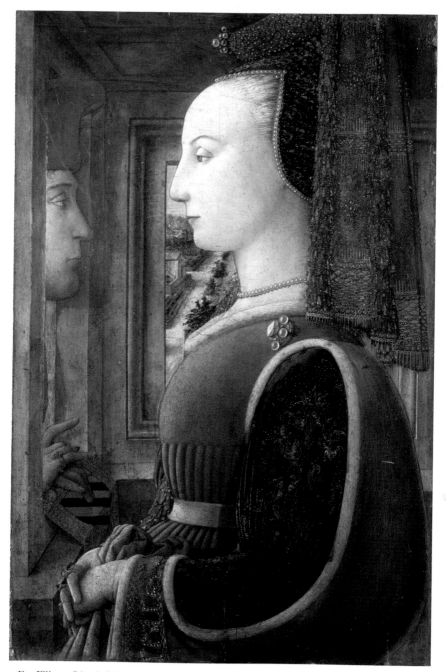

Fra Filippo Lippi, *Woman with a Man at a Casement*, about 1440–46. All the intensity of medieval courtly love lingers in this enigmatic scene.

Leonardo da Vinci, *Lady with an Ermine*, about 1489–90. This painting sexualizes portraiture in its flirtatious energy.

Giorgione, *The Tempest*, about 1505–08. A woman breastfeeds her child as a man looks on lustily in this mysterious pastoral.

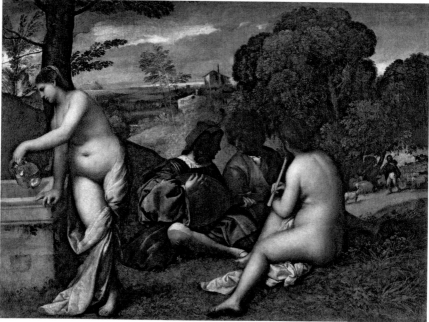

Titian, *Concert Champêtre*, about 1511. The young Titian pays homage to Giorgione in this vision of love and music in the country.

Titian, *Flora*, about 1516–18. This is the most ravishing of all the half-length portraits of beautiful women that set Venetian art alight in the early 1500s.

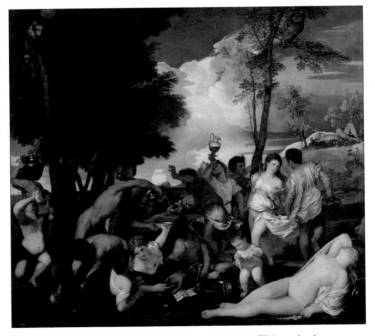

Titian, *Bacchanal of the Andrians*, about 1519–21. This orgiastic scene opens a window on the sexual freedom of Titian's studio.

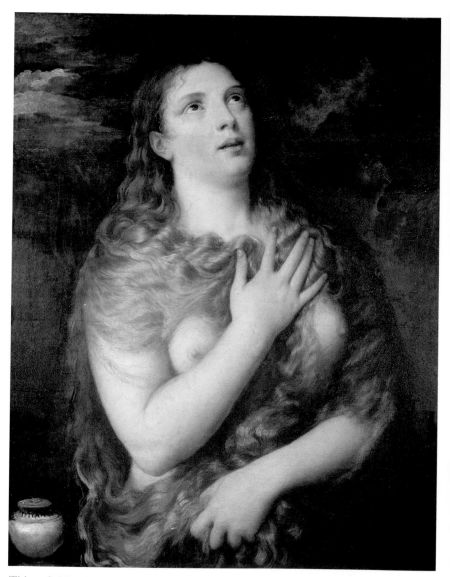

Titian, *St Mary Magdalene*, about 1535. Sex invades the sacred in this provocative painting, which dates from a period when Venice petitioned its prostitutes to repent.

Correggio, *Jupiter and Io*, about 1530. The god Jupiter in the form of a cloud engulfs a nymph in this scandalously exact rendering of ancient myth.

Lucas Cranach the Elder, *Venus standing in a Landscape*, 1529. Where Italian nudes are often voluptuous, Cranach's are skinny and sinful.

surely makes sense to assume that she is a courtesan posing as the saint of her profession. In Venice, when this was painted, the figure of the Magdalene was being invoked more and more as a model for prostitutes who chose to repent. In the 1520s a wing for former prostitutes who vowed to emulate the Magdalene was founded in the new Hospital of the Incurables. In the early 1530s, when Titian painted his sexy Magdalene, the nunnery of the Convertite, specifically for 'converted' prostitutes, started using buildings on the island of the Giudecca across the water from St Mark's Square. Venetian paintings dwelled on portrait-like visions of Mary Magdalene at a time when reforming groups such as the Company of Divine Love were fretting about the religious as well as social challenge of the city republic's sex trade: in a painting by Titian's contemporary Giovanni Girolamo Savoldo, a Magdalene covered in a silver hood stands by a tomb on a Venetian island. The view of Piazza San Marco across the lagoon is compatible with it being the Giudecca. Is this an allusion to the nunnery being created for modern Magdalenes there?

In these portrait-scale paintings the Magdalene is seen as a living person. Yet if Savoldo's painting is uneasy, Titian's is triumphant. It is even possible to see in it a defiance of the new moral anxieties. This model appears to believe she can bask in her beauty and worship God at the same time – and Titian agrees.

Emotion and character are at the heart of Titian's portrayals of women. His models are courtesans, and they are loved with courtesy. Not only lust but also esteem for women drives his art. In all his half-length pictures of *belle*, culminating in the rhapsodic *Flora*, psychological as well as physical realism adds to the intoxicating immediacy and promise. His portrait known as *La Schiavona* (*The Dalmatian Woman*) insists on the charm of reality: the woman in this painting, an upper-class portrait subject rather

than one of his models, is depicted with a slight double chin that does not stop her being beautiful as she regards us bluntly. She has her hand on a marble relief of a similar-looking face in profile: it resembles the portrait busts of ancient Rome, which used a warts-and-all aesthetic to insist on their accuracy. This woman is a very vigorous presence. Her wide body is dressed in violet fabric suggested so acutely by Titian's brush that it seems to be real cloth, collaged into the painting. Behind her is empty space. Titian presents this person not in abject flattery but honest portraiture. She lives forever as an individual.

That pressure of character animates his more standardized 'beauties', too. A young blonde woman appears in his moving pastoral scene *The Three Ages of Man*. She and her lover – a shepherd and his sweetheart – nestle close together in a countryside overlooked by a sky of melting blues and silvers. In the meadow beyond, an old man sits contemplating two skulls: by a broken tree, a putto looks at two sleeping babies in one another's arms. These images seem to tell the story of the lovers from cradle to grave: two souls born together and destined to die together. Maybe. But the emotional heart of this painting is the young woman. Painted with a thrilling sensuality that relishes her bare arm and the fall of her breasts and her fleshy throat, she also possesses inner drama. As she holds two flutes she looks deep into the man's eyes, and the hope, love and innocence in her face is heartbreaking.

The women in his painting *Sacred and Profane Love* are enigmatic. Created in about 1515–16, this picture got its name in the seventeenth century. It sets a mythological encounter in a captivatingly real landscape. In the meadows in the distance, hunters hunt and a shepherd cares for a flock of sheep. A castle on a hill catches the sun that irradiates a gold band of the layered sky, beneath a plane of blue and a billowing sail of cumulus cloud. Close to the onlooker, right at the front of the scene, two women and a child gather at a grey stone sarcophagus. The boy has

wings: he is Cupid and at least one of the women is presumably his mother Venus. Or are they – as the seventeenth-century title suggests – two versions of Venus, the goddesses of 'profane' and 'sacred' love? The sarcophagus apparently bears the arms of the prominent Venetian gentleman Niccolò Aurelio, who got married in 1514. Is the painting an allegory of marriage? The woman in a blue dress and gloves is in that case a bride, accepting the blessing of the nude Venus. Alternatively, in an older, Neo-Platonist interpretation of this painting advanced by the twentieth-century art historian Erwin Panofsky, the clothed woman is the Earthly Venus, and the naked one the Celestial Venus. The castle behind the Earthly Venus could stand for secular and material life; the church spire beyond the incense held by the Celestial Venus suggests the spiritual life, as it points heavenward.

And yet there's a baser aspect to it all. Giorgione liked to paint different views of the same nude, from the front and behind. Titian, too, in a letter to a client later in his career, explains that because in a recent work he has shown 'everything from the front' his next will offer a rear view. *Sacred and Profane Love* reveals another contrast: between nakedness and fashion. The woman in a silver-blue dress is immaculately chic, right down to her leather gloves. To compare her with nude Venus is mentally to undress her. The painting, on a coarse physical level, contrasts the smart clothes in which Titian's models might arrive at his studio with the nakedness – *pianelle* and gloves and dresses discarded – that was his as he worked at his easel, and afterwards.

In Dosso Dossi's painting *Witchcraft, or The Allegory of Hercules*, a disreputable company are gathered around a table at night. A wizened old man – the legendary Hercules, gone to seed – sits next to a younger, grinning figure who has a weaver's distaff. Other men, sardonic characters, stand close to the table while two women are seated among the jokers. One of the women has a

sharp classical profile. She shows her breasts while holding a bowl of fruit so that a round red apple mirrors her exposed nipple. It's a scene of courtly decadence, complete with courtesans. In another painting by Dossi a male courtier is portrayed next to a woman who bares her teeth like a follower of Bacchus, intoxicated and frenzied; he is entertained by her alarming company. Elsewhere, Dossi depicts a crazed satyr snarling at a nymph.

These paintings come from Ferrara in north-eastern Italy, whose territory in the 1500s neighboured that of Venice and is where palaces and arcades still preserve the heart of a Renaissance city in the shadow of the mighty Estense Castle. Entered by a drawbridge, equipped with cramped dungeons and soaring towers, this castle seems harsh and forbidding – until you find the roof garden and the erotic paintings of myth. Many other works have long since been sold abroad: the painting of a courtier and a maenad or nymph is a cut-out piece of a ceiling decoration from one of this castle's rooms, now exhibited as a framed painting in the National Gallery in London. The louche character of Dosso Dossi's art is a window on life in this fortress and other palaces of the Este family in Ferrara five centuries ago. Jokey and a bit savage, Dossi paints a picture of a facetious, dissolute court where sex and violence lurk behind every door.

In the early sixteenth century that court included Lucrezia Borgia, daughter of Pope Alexander VI and bride of Alfonso d'Este. Alfonso was her third husband: her first marriage ended in divorce, her second with her husband's murder in the Vatican at the behest of her brother Cesare. Ambassadors from Ferrara negotiating her marriage to Alfonso, son of Duke Ercole I d'Este and a keen soldier, said they were exhausted by the nightly parties in the pope's palace. Yet at Ferrara she was never accused of poisoning anyone. She had a (probably) platonic affair with the Venetian humanist Pietro Bembo. She courted and maybe more than courted the husband of her cultured sister-in-law Isabella d'Este. She was also suspected of having a former lover

murdered on the streets of Ferrara. Her relationship with her husband, Duke Alfonso, was not close but it survived her love affairs and in 1508 she gave birth to an heir, Ercole II. 'She daily gave the most wonderful festivals and banquets,' remembered a French knight who spent time at the Este court. A later Este banquet, in 1529, included on the menu fried chicken marinated in white wine with sugar, roast capons, quails, eels.

In 1519 Lucrezia Borgia died after a birth went wrong, and Alfonso d'Este was left a widower. He had his distractions. He was an expert on the new warfare of artillery and fortifications; the defences of Ferrara were famous and he personally supervised the casting of cannon. He also had his *camerino*, a secluded room in the elevated wing called the Via Coperta that joined the Estense Castle to the Ducal Palace. From about 1511–12 onwards Alfonso d'Este sought ambitious paintings to decorate this apartment, following a mythological scheme devised for him by the humanist Mario Equicola. Michelangelo and Raphael agreed to paint large classical scenes, Dosso Dossi as resident artist contributed smaller pictures and old Giovanni Bellini got the ball rolling with his painting *The Feast of the Gods*. It was truly to be a room of sensations. Yet it was not going well. Michelangelo's work seemed a dead letter. Raphael designed his picture, but nothing more than a drawing of *The Triumph of Bacchus in India* ever seemed to materialize. Alfonso sent increasingly furious letters to the renowned artist in Rome, warning Raphael to remember who he was crossing. In the end the field was open to an increasingly famous young painter who worked within easy reach of Ferrara. Titian as he neared thirty had a chance to create a grand sequence of mythological paintings. From 1518 to 1523, visiting Ferrara only for brief periods and painting back home in Venice where, as he reminded the Ferrarese, all his models were available, he created a banquet to feed the eye and mind.

In the first of his reimaginings of classical myth, which

illustrate descriptions by the ancient author Philostratus of paint-
ings in a villa, a crowd of cupids harvest apples in front of a
shrine to Venus. Vast apple trees, broken by the light into planes
of shade and deep green, overhang the golden crowd of children
who clutch at the fruit while other cupids fly up to the high
branches to pick more. A statue of Venus shines in the sun, as
some of the cupids remember to pay homage to the goddess. In
another of his works for the *camerino* Titian depicts Bacchus and
Ariadne, with the mortal princess stranded on the isle of Naxos
discovered by the god of the vintage and his followers. As she
turns in amazement, Bacchus leaps from his chariot; beside him
walks a young satyr, innocent and childish until you see that he
is pulling behind him, on a rope, the severed head of an ass.
Maenads crash tambourines, a bearded man advances swathed
in snakes, an adult satyr waves a torn-off animal leg in the air
and in the rear the fat old chief of the satyrs, Silenus, slumbers
on his donkey. In the blue sky tinged with gold and white, a con-
stellation glimmers – it is Ariadne's destiny to have her crown
raised among the stars by Bacchus.

The originality of these paintings, canvases large enough to
serve in place of frescoes, is to give myth the stature of the most
serious narrative art. They are pensive as well as joyous. In their
scale, proportions and heroic scope, they possess true authority.
Titian is equipped with the new confidence of sixteenth-century
Venetian art in portraying the human body. He can display
crowds of cupids and Bacchanalian celebrants with a reality and
conviction that is enhanced still further by his command of
landscape and skies. Titian's art began in landscape. He and
Giorgione set pastoral romances in woodlands and breezy hill
country under magnificent unfurling clouds. In the Ferrara
paintings these pastoral settings are reconceived as Greek islands
where lush trees and dazzling azure heavens make the antics of
gods and their followers seem natural and real. There is an
infectious life in these pictures: they bubble with the ecstasies of

Venus and Bacchus. Titian's *Bacchanal of the Andrians*, the most orgiastic of his Ferrara paintings, shows what happened on the island of Andros after Bacchus turned the water in a stream into wine. The red, translucent, enchanted drink is held aloft by a reveller. It is in a jug of purest Venetian glass: you can see silver sunlit clouds through its neck and handle. The wine within remains horizontal as the dancing drunkard precariously tilts the vessel on the palm of his hand. Lying down and talking to her friend, a woman raises her flat Greek-style wine cup behind her to be filled; her drink is poured by one of a group of naked, leaping men. This is quite a party: the booze has relaxed everyone's inhibitions and set off a dance of wellbeing. A young woman, her clothes loosened, dances with a half-dressed young man. All the hedonism implicit in Titian's early paintings of courtesans and pastorals is released in this grand outburst of pleasure. The wine is an aphrodisiac. Bacchus is the god of ecstasies. As they spin in a mutual dance, the couple gazing into one another's eyes seem to be unwinding their remaining clothes. While the two women reclining in their dresses chat, they are surrounded by male flesh. A woman lies nude in the foreground, her golden body exposed. She is elated in her abandon.

The artful orgy that is Titian's *Bacchanal of the Andrians* is an aesthetic version of the grubby goings-on that Aretino described in Nanna's nunnery. By the time Aretino settled in Venice both he and Titian were conquering Europe from this comfortable base. Titian was selling paintings to an ever-expanding range of princely purchasers. In portraits of such people as Francesco Maria della Rovere, Duke of Urbino, of Ranuccio Farnese and the emperor Charles V, he creates unprecedented images of character, authority, fame and family. In Venice he portrays the senators and Doge. As Titian paints the great, so Aretino addresses them in words: his letter thanking Charles V for releasing Francis I after capturing him at the Battle of Pavia in 1525 could not be further in tone from the voice he gives Nanna:

In what mind, in what heart, in what thought (except in your mind, heart and thought) could the desire have taken hold to liberate an enemy?

This tribute to the emperor is fulsome. Titian's portrait of *Charles V on Horseback* shares its enthusiasm. It is a vision of the Habsburg ruler as a timeless imperial statue come to life, impervious to attack, riding in shining armour across a landscape that rolls away beneath his horse's hooves under a sky of dominion and promise.

Titian and Aretino mapped and chronicled the world from the island city that Titian never liked to leave for long. It was surely Aretino's political and social connectedness that helped Titian establish an artistic empire across the continent and picture that continent as a gallery of famous faces. In his letters, Aretino never missed an opportunity to praise Titian – he actively promoted his friend to the great and the good. At home, they were wealthy enough to enjoy Venice in all its swagger. Aretino in one of his letters addresses Titian himself, 'my revered friend', to tell how, at home and laid low by illness, unable to even savour his food, he rested on his window sill and appreciated the everyday regatta of the Grand Canal: barges and gondolas, the Rialto Bridge, the Riva dei Camerlinghi, fish market, ferry and Ca' da Mosto. Raising his eyes to the sky he saw a display of light and shadow, a phenomenon that Titian's rivals might paint in a hopeless attempt to equal him. In the end he was so overcome by the beauty of the sky that he cried out, 'O Titian, where are you?'

Aretino's Nanna is a brash courtesan, a woman who confidently enters the palaces of the rich and holds men (like him) to ransom. The self-mockery is that he, too, is one of Nanna's fools. She jokes about the preferences of men from various cities and countries. While the Florentines are all talk, Venetian men are her favourites. They know what they like: 'tits and arse and soft, pert flesh'.

It's a good description of Titian's nudes. He painted the most shameless of them in 1538. The *Venus of Urbino* is so real it seems possible to kiss her. Everything in the scene, including its beguiling view of a room in a palace where servants rummage in a clothes chest, plants grow in pots on the window ledge and oriental hangings trim the walls, is calculated to confirm her absolute presence to the beholder. The room is intentionally distracting because that is a good way to confirm its reality: interpretations that brood on the supposed marital symbolism of the chest miss the point that in drawing the eye to this background business, in a space whose perspective depth is created with total conviction, Titian is manipulating us, lulling the mind to see this as an actual place, offstage fussing and all. 'About suffering they were never wrong, the Old Masters,' wrote W. H. Auden, referring to Bruegel's painting *The Fall of Icarus* in which a ploughman works on while a boy in the distance falls to his death. About pleasure they were never wrong either: the beauty of the *Venus of Urbino* is all the more immediate and alive because of its setting in the everyday life of a Renaissance palace.

Once those details are internalized, along with the little dog who loyally snoozes, the eye is drawn to the body this woman displays so liberally. Nudity is a cosmic phenomenon in this painting. It is as magnetic as a planet, as bright as a star. Titian contemplates this woman's beauty with a sense of mystery. After so many years of depicting the human body it can still astound him. Every millimetre of this body has been created, recreated, by his brush as he responded to a real woman who posed for him. In every tiny part of her is an optical congress of pigments whose layers and complementarities at once give form and fluidity to her flesh. She is defined without being trapped, in her living, breathing presence. To look close-up at the delicate firmness of her nipple is to feel self-aware and startled: it is like looking at a fellow visitor to the gallery who happens to be naked.

Chapter Eight

MICHELANGELO IN LOVE

Voices sang in harmony to the sad strains of a viola da gamba while servants poured Tuscan wine. The Roman sunset reddened the Capitoline Hill, perfectly framed in an arched window. Men in black sipped the red cup of sorrow as a singer reminded them of their exile from Florence, that beautiful woman now pitilessly embraced by her Medici master. While they listened to the doleful words of the Republican song its author stood in a doorway, beard ragged, clothes dingy, face hewn as if by a chisel. His coal-black eyes were inflamed by love as he gazed on a handsome youth silhouetted against the window's violet vista. His heart, a piece of old dry wood, suddenly caught fire.

The miracle of the human form, divinely alive, shines forth from a statue in the heart of Rome. Close by is the Pantheon, ancient temple to all the gods, home to the tomb of Raphael, faced now by cafés across a piazza blessed by a spurting fountain. At the Tazza d'Oro customers sip espresso as the bright sun quickly dries away last night's rain. But all that is forgotten in front of the nude. His beard is graceful and curly, created by dimpling and furrowing the pale soft-seeming marble. His long hair cascades down his neck, as fine and precious as tendrils of foliage carved by nameless masons in a Gothic cathedral. He is a naked aristocrat. In the eighteenth century the British painter

Sir Joshua Reynolds was to lament that modern gentlemen were unlikely ever to pose nude for their portraits as the ancient Greeks did. This nude, carved in 1519–20, displays the hairstyle of a Roman gentleman of that date, as if he had stepped straight from courtly business in the Vatican or a nearby palace and stripped to pose.

And yet the look in his eyes as their pierced pupils fix on an invisible object is otherworldly and unfathomable.

His chest is broad; his stomach, too, expands so that his torso is blocky on his powerful legs. He is thirty-three years old, and his body is not that of some twenty-year-old Greek athlete. Folds of skin and traces of fat give it maturity. Still this man is strong. His arms and shoulder blades are massy yet taut. Muscle and sinew are shaped from the marble so keenly that his flesh seems to slide and slip; his roughened knees to strain with the effort of keeping still. His buttocks are prominent, but less striking to the eye than his penis resting on twin cushions of flesh. Unfortunately it is usually concealed by a gilded metal ribbon that swirls over the statue's groin and has nothing to do with the *Risen Christ*'s creator, Michelangelo.

Christ stands in this ancient place of worship holding a marble cross and staff, whose weight his body easily balances. He is the way and the light, and he is a beautiful classical nude, his handsome features dominating Santa Maria Sopra Minerva and making its important frescoes by Renaissance painters seem pallid. The power of the nude is to oblige all eyes to contemplate what it is to be human. No artist ever understood that better than Michelangelo. His statue of a Christ who first took the form of a living mortal, then died and was resurrected, invites contemplation of the mystery of embodiment itself. In that mystery, Michelangelo included the incarnation and reincarnation of Christ's penis. He imagined Christ as a man of superb good looks, yet riven by thoughts and emotions beyond all human understanding.

Michelangelo, who was born into the old Florentine family of the Buonarroti in 1475, was in his mid-forties when he carved this statue, and he had been making nudes since he was a teenager. He carved *The Battle of the Centaurs*, a nest of writhing bodies, their limbs rising from a marble block like eels from a pool, for Lorenzo de' Medici when he was perhaps seventeen. For the Florentine Republic when he was nearly thirty he completed his statue of David, eyes blazing, chest seeming to breathe, veined hand hanging next to rangy legs. On the ceiling of the Sistine Chapel when he was still in his thirties he painted the naked Adam reaching a fingertip to God, and in the ceiling's layers of illusory architecture sprouting from real architecture, image within image, story within story, depicted the *Ignudi*, a rank of male nudes who simply sit up there tantalizing the mind. And yet, for all these masterpieces, in 1520 his most poetic works were yet to come. The *Risen Christ* is one of Michelangelo's mature surprises. In comparison with *David* or his still earlier *Bacchus* it is almost flabby – and yet this departure from the ideal releases a compassionate and tragic sense of the mystery of our corporeality. Christ took on this form, the human form, so he could suffer. His flesh is in itself an act of compassion, its ordinariness a generous identification with the ordinariness of our lives and deaths. Only in his Raphaelesque face is there an equation of mental and spiritual perfection, for his thoughts are with his Father.

Michelangelo is a uniquely serious and self-contained artist. Ideas that in others might seem risqué or perplexing – such as putting a nude Christ in a church at the heart of Rome, with a handsome beard and dangling testicles – in him carry total conviction. There is no doubt that Michelangelo looked at the male body with intense desire. There is equally no doubt that for him, the contemplation of beauty truly is – must be – an encounter with the divine. The nudity of Christ is a revelation of the marvel of a god become fully human. That revelation is

too philosophical for the Church, which to this day cannot accept the statue's penis.

It was not only Michelangelo's art that evolved in potent new directions when he hit middle age. So did his life. When Michelangelo was young his life was all work. He spent long hours, expended unimaginable energy, carving statues and painting ceilings. To look at the colossal legs and mighty hanging hand of his *David*, installed outside the Palazzo della Signoria in Florence in 1504, is to wonder at the sheer human strength of mind and body it must have taken to release such a lifelike, fluid form out of a block of marble. Gazing up at the ceiling of the Sistine Chapel is even more intimidating. How did an artist create such a complex painting while standing on a terrifyingly high platform, his face running with colours as he turned it ever-upward? No one can stand in this chapel without imagining the labour of Michelangelo. His vertigo is infectious. His achievement seems superhuman.

After Michelangelo finished the ceiling he found he had more time to think and live. This came about for good and bad reasons. The instant glory the ceiling got him was such that his fame as the greatest artist in Italy should have been unassailable. He had lived his youth in his art: his heroic exploit in the Sistine Chapel was like some athletic triumph. Having trained himself to perfection, Michelangelo had his world record. Yet he found himself perversely, stupidly, out of favour. The pope who commissioned the ceiling in 1508 was the fiery and impulsive Julius II. Soon after he finished it the accession of Leo X changed Rome's culture: of the two geniuses working in the Vatican for Julius it was the courtly young Raphael who appealed to cultivated Leo. He found the intense, brooding, introspective Michelangelo alarming and difficult – '*terribile*', as he put it to Michelangelo's friend Sebastiano del Piombo.

A slower working pace enriched Michelangelo's imagination. As he was not yet forty when he finished the Sistine ceiling in

1512, and he was to live until 1564, dying in the same year Shakespeare and Galileo were born, he had plenty of time to write poetry, become an architect and get involved in politics – all of which he was to do, with incandescent individuality.

He also had time to fall in love. He did that in his own way, too.

There are no records of Michelangelo having love affairs with either men or women before the 1530s. Love seemed to have passed him by. Young Raphael teased him about it. In his fresco *The School of Athens* in the Vatican palace, Raphael portrays Michelangelo as a solitary thinker, meditating alone, apart from the crowd. While wine flowed and courtesans larked about in the depraved high-life haunts of Renaissance Rome, grim Michelangelo – as Raphael sees him in this portrait – sat by himself and scribbled his tragic verses.

When Michelangelo did fall in love it was to be a truly heroic emotional outpouring. Just as his artistic creations yearn for transcendent glory, the passionate, and public, love that seized Michelangelo in middle age was awe-inspiring. It consumed his entire being. And because he expressed it in poetry and art, this ardour endures as a monument to the transfiguring power of love.

The great love affair of Michelangelo's life came at a time when he was exploring esoteric feelings through sculpture, architecture and poetry. In the austere works he undertook at the Florentine church of San Lorenzo in the 1520s Michelangelo created an art of eerie introspection. There are no images of people, naked or otherwise, in the vestibule of the Laurentian Library that he designed in that decade. Instead dark-grey niches of *pietra serena*, columns inserted into the white walls and colossal scrolls combine like elements of a musical composition. The niches are shaped like windows, but their interiors of grey stone give no light. This room creates, intentionally, a sense of foreboding and tragedy.

What kind of figures might fit such a premonitory room? The answer can be found in a short walk around the building, past the market stalls that surround San Lorenzo. In the Laurentian Library's entrance hall Michelangelo manages to create visual poetry through a completely abstract repertoire of effects, an achievement not lost on the abstract artist Mark Rothko when he visited Florence in the 1950s and took inspiration from this uncomfortable place. In the New Sacristy that he began in 1520 on the other side of the same holy site, Michelangelo combines that same aesthetic of architectural dissonance with statues that only reinforce the mystery. Here, in a domed chamber where marble ghosts of doorways sit on top of real doorways, pressing downward with their immense weight, stand the magnificent tombs, completed by 1534, of two lesser members of the Medici family: Lorenzo, Duke of Urbino, and Giuliano, Duke of Nemours.

Michelangelo makes these tombs into abstruse symphonies of death. On each, a figure symbolizing the dead man sits in a central niche. Lorenzo wears a grotesquely ornamented classical helmet and puts a hand pensively to his face, while Giuliano wields a commander's baton and strains an unnaturally long neck. A monstrous face glowers on his breastplate. Beneath each of these frozen ghosts, pairs of majestic nudes recline on top of scroll-decorated curving sarcophagi in postures of immense pathos.

These nudes that lounge melancholically on the Medici sarcophagi are arguably the most poetic and extravagant in all Renaissance art. Because the nudes recline, because they include women as well as men, these figures by Michelangelo invite direct comparison with the contemporary nudes of Correggio and Titian. It is as if Michelangelo takes the sensual nymphs and satyrs from the paintings of his time and recasts them as metaphysical colossi. His nudes in the New Sacristy are massively physical but they belong in a realm of contemplation, a

philosophical sphere where flesh becomes mind. Each pair of figures consists of one male and one female nude. Below the brooding Lorenzo lie incarnations of *Crepuscolo* (*Evening*) and *Aurora* (*Dawn*). *Crepuscolo* is a bearded man whose face inclines downward in rumination as if at the end of a rustic drinking party as the sun goes down. *Aurora* stirs, awakes, raises herself up, her head wrapped in a turban, her body fresh and vigorous where the evening seems old and worn out.

On the opposing tomb of Giuliano the gender roles are reversed. *Notte* (*Night*) is a female nude whose head falls forward, propped from further collapse by her raised arm, while she rests a mighty leg on a garland. An owl perches under the pointed arch of her bent knee. A mask, eyeless and empty, lies under her breast. Her stomach is creased and bent as she relaxes in sleep. Opposite her is *Giorno* (*Day*): a hulking male nude whose back is a convolution of muscles as he raises himself up, his legs crossed as he awakens so that his pose with one leg raised mirrors that of *Notte*.

Michelangelo positions his naked figures in spectacular ways. *Aurora* raises one leg as she bends an arm above her ample breasts, her entire body seeming to expand with emotion. *Crepuscolo* leans forward, while *Giorno* hunches backward. They also rest on top of sarcophagi, like the reclining terracotta life-size figures that banquet on top of ancient Etruscan tombs. Is it possible Michelangelo drew inspiration from such works, which survive in Tuscany? Certainly his tomb-figures seem to reach deep into the mists of antiquity, not just to Greece and Rome but the Etruscans and Egyptians too. The imagery of night and day, the setting and rising sun, might even suggest the Egyptian after-life in the western lands, and the heavenly journey of the sun god Ra.

A tragic pall, a heroic melancholy looms over these tombs and their nude figures. Most spectacularly posed of all, *Night*, with her sublime thigh and downward-turned face, leads the

mind into reveries of sleep and the surrender to unconsciousness. These angular nudes bring the Renaissance portrayal of the body to a zenith of mythological poetry and emotional authority.

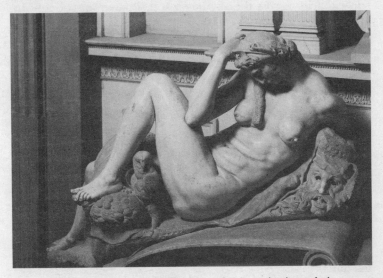

Michelangelo, *Night.* The pose of this majestic nude is bizarre and dreamlike, at once male and female.

Michelangelo's drawing *The Fall of Phaethon,* which he did in black chalk in 1533, while he was in the last stages of his work on the tombs, is a calamity of thwarted craving. The god Jupiter bestrides an eagle in the heavens as he hurls a lethal lightning bolt. A naked young man falls upside down, tumbling out of a chariot hit by Jupiter's bolt, which is dropping out of the sky, shielding his head from the hooves of the flailing horses that cascade with him. These horses have immense flanks and struggling awkward legs, reduced by catastrophe from creatures of grace to hopeless dead weights hideously tangled. This is a sculptor's drawing. The mass of the horses, the devastating pull of gravity

on them and their master is sketched with the authority of some-
body who knows the weight of stone and has seen blocks crash
down quarry faces.

In the ancient Roman poet Ovid's retelling of Greek myths
of transformation in his *Metamorphoses*, the god who drives the
sun's chariot across the sky has a son, Phaethon, brought up
away from him. Phaethon finds out his true identity and han-
kers to imitate his father. He visits his father's palace where the
sun-god sits on an emerald-encrusted throne. The sun offers
one gift, anything, to Phaethon in acknowledgement of his
parentage:

> Barely had it been offered than he answered:
> he wanted his father's chariot for a day
> and the right to drive its winged horses.

It is a mad request. His father begs him to change his mind,
warns him of the terrible danger for a mortal lad, but it is no use:
Phaethon will have his way. As he admires the chariot of gold,
the day begins:

> Keeping vigil in the glowing dawn,
> Aurora has opened wide her purple gates.

As soon as Phaethon takes up the reins, he loses control of the
fire-breathing horses of the sun. He sets the sky alight and sears
the earth, unable to stop the unruly horses or find a safe path,
and to end the destruction Jupiter has to hurl a lightning bolt
that sends Phaethon plummeting to his death.

Below the falling tumult in Michelangelo's drawing of this
myth weep the Heliades, grief-stricken sisters of Phaethon – so
inconsolable that in Ovid's story they became trees, their tears
amber. A man fetches an empty amphora, for rivers were burned
dry by Phaethon's wild ride. Also among the mourners is a swan,

howling with the Heliades. This is Cycnus. Before despair gave him feathers he was a young man bereft of the friend he loved. For he adored Phaethon: 'that was why your death destroyed him'.

Within Michelangelo's mythological drawing this homosexual image is enfolded, the longing of man for man encompassed by a wretched swan. It is highly significant, for Michelangelo drew *The Fall of Phaethon* as a love gift. He gave it to a young Roman nobleman called Tommaso de' Cavalieri, who was the love of his life.

Michelangelo first saw Tommaso in Rome in the winter of 1532. He was thunderstruck. It was love at first sight, which took him by surprise when he felt he was getting old, and made him young again. Love, he thought, must have leaped from Tommaso's matchless eyes to infect his: 'Of course, it must have been your eyes.'

Tommaso de' Cavalieri was a teenager, probably sixteen or seventeen, when he entered Michelangelo's field of vision. Once when he was ill the sculptor asked after his health via a tutor, for Tommaso was still being schooled. Michelangelo could claim the pictures he sent to Tommaso as gifts were to help him learn to draw. But they throb with homoerotic suggestion. A young man turned into a swan mourns his male love in *The Fall of Phaethon*. Michelangelo also gave Cavalieri a drawing of the even more explicit myth of Ganymede, in which Jupiter in the shape of an eagle carries off a beautiful boy. He makes himself still plainer in a series of love poems he sent the youth. For Michelangelo was a gifted poet, specializing in sonnets and short verses in the style of Petrarch. His poems to Cavalieri are stricken explorations of what it feels like to be in love:

This, lord, has hit me, since I laid eyes on you.
A bitter-sweet, yes-and-no mood –

At first Tommaso de' Cavalieri was disturbed by Michelangelo's grand passion for him. The sculptor was in his fifties, black-bearded, craggy, his face corroded not just by time but also by hard physical work. Tommaso did not reciprocate his feelings. Yet when Michelangelo sent him *The Fall of Phaethon* and his other superb drawings the recipient was understandably moved: Michelangelo was the most famous artist in Italy and here he was, giving precious works of his genius as love tokens to Tommaso. A poem written by Michelangelo in summer, 1533, excitedly responds to the young man's satisfaction:

> What a grand, sleazy usury it would be,
> To give you shameful pictures
> And get beautiful living people in exchange.

It would be unreasonable, jokes Michelangelo here, if mere drawings won him real love and beauty in return. The sculptor hopes at this moment for some kind of physical gratification. He can hardly believe his luck that Tommaso is pleased: his drawings of bodies might get him close to that beloved body.

In another of the drawings given by Michelangelo to Cavalieri, a male nude suffers a grisly punishment for a sexual crime. Tityus, having tried to rape the mother of Apollo, lies pinioned to a rock in Hades, where a vulture eats his liver. The liver eternally renews itself and is eternally devoured. Michelangelo does not dwell on the butchery. It is hard even to see what the vulture is doing. Instead, he emphasizes the great feathery wings of the bird as they loom above Tityus, the length of its powerful neck and sharp beak hovering over him, the strain of his muscular body as he raises his head to face his torturer. The solidity of the design makes the scene seem sculpted: Tityus rests on a rock, like a plinth, resembling the nudes on the Medici tombs. The vulture, paradoxically, is both massive and weightless: again a sculptor's perception. Its mass seems to press

down and crush Tityus but its wings can raise it aloft at any second.

According to the Greek philosopher Socrates in his follower Plato's work *Phaedrus*, the lover has wings to bear him upward, towards the realm of the gods. To worship beauty truly and chastely is to rise towards Heaven in the Neo-Platonist thought that Michelangelo learned as a teenager in the Florence of Lorenzo the Magnificent; just as much as his friend Botticelli, Michelangelo was steeped in the Neo-Platonist ideas of Marsilio Ficino. Michelangelo's drawing conveys the agony and ecstasy of love. Tormented in the flesh, Tityus, the earthbound lover, glimpses in his suffering the wings that might have borne him aloft.

Tommaso de' Cavalieri's face is so ravishing it is a link to Heaven itself. Michelangelo is not merely recycling Plato's ideas of love as a transforming force. He is making them his own. In his poems he expresses the most rapturous and transported feelings of the lover. Not only is love a force of desire; not only can it make the lover jealous, or possessive, or exultant. It can seem to transfigure the beloved and ennoble the lover, too. Michelangelo in his poems and drawings for Tommaso de' Cavalieri discovers that high emotion in a love for another man. In an age that punished acts of sodomy with death his love dares not only to speak its name but also to assert its divinity. When Plato wrote of love he always meant homosexual love, culturally lauded as it was in ancient Greece. Michelangelo's drawings given to Cavalieri see this as a love that leads upward to the heavens. Jupiter transforms himself into many shapes to pursue his loves. To carry off Ganymede he becomes an eagle. As the eagle rises aloft in Michelangelo's drawing the naked Ganymede sprawls between its wings, his legs held by its talons, his body shielded by its beak. It is at once savagely erotic fantasy and metaphysical rhapsody.

Michelangelo never did get to carry off Cavalieri. The young

man accepted his love but returned it only as friendship. In his biography of Michelangelo, written with his approval, Ascanio Condivi claims in 1553 that Michelangelo, while having loved beauty in a way that provoked gossip, has also loved beauty as chastely as Socrates loved Alcibiades when they lay together all night: all that night Socrates never touched the comely young aristocrat. Yet Michelangelo's expressions of passion to Cavalieri are not chaste in some calm, philosophical way. His infatuation is extreme; it is demanding – yet it is gentle as it rises from lust to love.

The writing, and reading, of poetry was a finer way to love in Renaissance Europe. In a portrait by the gentle painter Andrea del Sarto of a young woman, she points to lines in a copy of the Aldine Press edition of Petrarch's sonnets. She has the tender look of somebody in love. Petrarch's love poems were cherished in the Renaissance not only as works of literature but as implements of sensibility too. Michelangelo used poetry as a means to both express and deny his desires. In verse, he can declare outright his feelings for a young man, while also transmuting them into a love that is heavenly and chaste.

In one work that he made in 1529–30 Michelangelo portrays carnal lust unequivocally. At that moment Michelangelo was Commander of Fortifications for the Republic of Florence. After the Sack of Rome the Medici had been overthrown and a radical Republic declared; now, as it waited to be attacked by the huge forces massed on the Medici side, Florence was preparing its defences and its loyal citizen Michelangelo visited Alfonso d'Este, Duke of Ferrara, an expert on fortifications, to learn from him about modern theories of defence. While he was there he promised finally to paint a work he had promised the duke years earlier.

In Florence, as the cannon roared and the city was besieged, Michelangelo painted a female nude for Alfonso. This was Leda, seduced by Jupiter – who has changed himself into a swan. Leda

reclines on red pillows with her powerful thigh raised and her face lowered. She shares the pose of *Night* on the tomb of Giuliano de' Medici, except that instead of an owl sitting under her knee she has a swan inserting (that is the only word) itself between her legs. As it pushes its feathery body against Leda, the swan extends its long neck to kiss her. Lips touch beak.

Michelangelo's painting is a smutty joke. Clearly he knew plenty about sex, whatever he claimed about the innocent nature of his inclinations. The lubriciousness in this painting is multi-layered. While the swan's pressure between Leda's legs is an image of heterosexual copulation, the lips of Leda are doing more than kiss that swan. Its beak is not a mouth. It is long and hard. Leda is about to perform fellatio on the god Jupiter in his swan disguise. The fantasy does not stop there. Michelangelo did not simply make a painted version of his statue of *Night*. He prepared for *Leda* by drawing her face from the life – and in the drawing that survives, Leda's closely observed face is that of a young man.

The painting of Leda is long lost, but even in a surviving copy Leda has the male face of Michelangelo's preparatory drawing. It is probably the face of his pupil Antonio Mini. In his painting of the myth of Leda, Michelangelo depicts a male youth, his own student, about to perform an act of fellatio. It's an insight into his own hidden love life, the physical actuality behind the drawings of Ganymede and Phaethon and the poems on platonic themes that he poured out. When he painted this ambivalent erotic work that portrays both hetero-sexual and homosexual lust in the same image, Michelangelo probably thought he was about to die. The Siege of Florence was a tragedy. The city was doomed and Michelangelo, as Commander of Fortifications, escaped being assassinated when it fell to pro-Medici troops in 1530 only by an urgent order from Pope Clement VII not to lay a finger on him. Before that order came through he had to hide in a chimney.

As the city counted its tens of thousands of dead, an agent from Ferrara came to collect the painting. Michelangelo, suddenly offended that the Ferrarese gentleman seemed to look down snobbishly on the 'merchants' of Florence who had just sacrificed their lives for freedom, refused to hand it over. Instead he gave *Leda* to Antonio Mini, who left Italy for France and took this souvenir of life with Michelangelo with him. It soon vanished. In the nineteenth century the best extant copy of it was hung in the director's office at the National Gallery in London because it was considered too filthy to be seen by the uninitiated.

It was convenient for Michelangelo if this confessional painting vanished. In the years after he painted it he expressed his love for Tommaso de' Cavalieri both openly and in a way that insisted on the intellectual and pure nature of Greek love. It is conspicuous that Michelangelo's public self-portrayal as a chaste lover of another man started soon after the death of his father. Michelangelo's father, whom he always treated with grave respect, passed away in 1531 at just short of ninety years of age. It is surely more than a coincidence that Michelangelo's first openly displayed love for another man started when he met Tommaso de' Cavalieri the year after his father's death.

Coming out in sixteenth-century Italy was dangerous, and Michelangelo's declaration of devotion, however spiritual, was brave in a culture that executed people for sodomy. Perhaps the risk mattered less to him than the emotional impact on his aged father. Yet behind all that, away from the public language of amorous poetry, lay the snug atmosphere of the artist's workshop, where this most idolized of all masters was in reality quite familiar with male mouths sucking on beaks.

Michelangelo's unfinished *Prisoners* stand near his statue of *David* in the Accademia Gallery in Florence. The contrast between his youthful hymn to heroism and these tortured, incomplete, struggling forms that he carved as he turned fifty is

a persuasive image of how Michelangelo became ever more daring and introspective as an artist and a man. In these works the very uncertainty and hesitance of Michelangelo's carving communicates the mystery and pain of life. His *Prisoners* strain to emerge from massive blocks of stone, their immense muscular torsos tense with the sheer labour of becoming real. Formless, roughly chiselled weights of marble crush them down as they heave upward and outward. They are trying to become themselves – but are drowning in shapeless matter. The earth is reclaiming them even as they stretch and twist in a desperate bid for freedom. When Michelangelo fell in love with Tommaso he glimpsed a chink of light in the prison of earthly existence. Like his suffering *Prisoners*, he strained every sinew to reach it as the cavern closed.

Chapter Nine

DÜRER AND THE WITCHES

He stood outside his house at midnight. He did not want to go in. The candles would be lit still at Pirckheimer's place, a book of drawings on the table. Why not go back? But, as he turned to cross the square, something froze his heart. It was a hex, surely. He stopped and shivered. He seemed to see something move in the darkness under the jutting frame of the market hall. Could it be a pig snuffling for scraps? A dog? But then a glint of long yellow hair caught his eye, and white flesh, and horns, and cloven hooves.

Love hurts. In Albrecht Dürer's black-and-white printed image *Melencolia I*, engraved and published in 1514, a female figure broods among scattered objects of science and craft. Her dress is realistic, expensive, as if she were a woman, but her feathered wings reveal that she is a spirit. In her right hand this genius of Melancholy holds a pair of dividers, while at her feet a plane, a saw, nails and tongs are among the discarded tools of the builder and maker. Melancholy is the lot of the artist and the architect, the fate of the gifted, this image implies. Dürer portrays the obscurity of a great mind crippled by doubts: as time runs out, its sands measured by an hourglass, efforts fail. A pair of scales, a geometric many-sided stone and an alchemist's burning-vessel all allude to the failure of science as well as art. A ladder leads upward, towards higher truth, but the melancholiac

is earthbound, her wings useless. *Melencolia I* looks deep into the anxious imagination of the artist. Dürer portrayed himself again and again in paintings that drink in his own appearance and personality. In his most famous self-portrait he gazes directly at the viewer. His hair is long and curled, he looks like Jesus Christ. His steady piercing eyes are unnerving in their refusal to blink. *Melencolia I* is another kind of self-portrait: an inner document. It personifies the psyche. Dürer gives the bleak thoughts that afflict him a face and a name.

This portrait of the artist's state of mind is a universal image of sadness, despair and self-doubt. In sixteenth-century Europe, where it was circulated widely, *Melencolia I* inspired portraits of the lovelorn. The way Dürer's melancholiac rests her shadowed face on her hand is a gesture of woe with a long medieval history. Dürer gives it a new urgency that is, among other things, a recipe for love. In a portrait by the northern-Italian artist Moretto da Brescia that dates from about 1540–45, a young man poses as a soulful, sensitive type with his head resting on his hand in the manner of Melancholy. An inscription in Greek on his cap badge follows the mood of Dürer's print: 'Alas, I desire too much.' This portrait is immediately recognizable as the Renaissance stereotype of the despairing lover, listlessly sighing and writing sad verses.

Michelangelo Buonarroti was such a lover, longing hopelessly for what he could never have. Dürer's print *Melencolia I* gives a name to Michelangelo's sorrow. In Renaissance Europe love did not only mean frolicking satyrs and merry nymphs. It meant frustration and dejection, loneliness and loss. The intensity with which these tribulations of love are expressed in Renaissance culture marks a new self-awareness in the human soul. Antique and medieval men and women all knew the pain of love. But the way Renaissance artists portrayed the sovereignty of desire opened up a new emotional landscape. The sexually charged art that reached such a pitch of beauty and seduction after 1500 was not

merely gratifying. It was much more complicated than that. Artists were exploring untamed sensual territory that was fraught with emotional terrors. They were entering, without the maps provided by modern psychology, a realm of dreams, nightmares and fantasies: the brave new world of the modern mind. Albrecht Dürer's *Melencolia I* is still a unique image of the exotic inner territory of our own minds. The reason he was able to create it is that he himself was afflicted by a black melancholy that took the form of acute sexual ambivalence. Torn between sensuality and Christianity, the hedonism of Italy and the wintry north, between marriage and men, Dürer was tormented by demons of desire.

He was born in the southern German city of Nuremberg in 1471, a city of tall half-timbered houses, red church spires, towers and battlements. His father was a goldsmith and the gifted young Albrecht would have been expected to follow him in the family craft. Instead, he showed such a talent for drawing that by the age of thirteen he created his earliest surviving self-portrait. With long hair under a louchely slung-back soft hat, he already looks in this authoritative work as if he is emulating the fashions of Italy.

Dürer was to be the first great German artist to study properly in Italy and bring home the art of the Italian Renaissance. It was not only a cultural but also a sexual adventure for him to travel to Venice in the 1490s and early 1500s and sample its sophisticated ways. We've seen how he portrayed the attractive women of the Adriatic city-state when he was painting an altarpiece for its Fondaco dei Tedeschi. He was also interested in the men he saw on the Rialto. You'd love the soldiers, he wrote teasingly to his friend Willibald Pirckheimer back in Nuremberg. He visited the workshops of Italian artists, getting to know Giovanni Bellini. It is apparent from his works that he learned in detail about the art of Leonardo da Vinci, Michelangelo and Raphael. He discovered that in Italy homosexual acts were a routine part

of studio life. A letter from Canon Lorenz Beheim, a friend of Dürer and Pirckheimer, offers an impression of how Dürer recreated Italy at home in Nuremberg. In the letter, dated 19 March 1507, Beheim jokes that 'our Albrecht' is more concerned with his physical appearance than his work. He is awaiting a drawing from Dürer, but he fears the artist is distracted:

> What keeps him busy is his pointed beard (*barba bechina*) which no doubt needs waving and curling every day. But I know that his boy loathes his beard (*Ma il gerzone suo abhorret, scio, la barba sua*); so he'd better shave.

Beheim puts his insinuations into Italian. Perhaps this was a way of keeping them private, but it unmistakably associates Dürer's sexual relationship with his *garzone*, his boy, with the ways of Italy. The journey south was an education of the senses. Like generations of northern Europeans to come, Dürer found sensual release in the Mediterranean sun. The Italian nude was an expression of erotic freedom. That freedom was a reality among the courtesans, mercenaries and painters he met. But what would happen if he brought the mythology and physical grace of the Renaissance north?

It would be a collision of worlds.

In a portrait of a woman of the Hofer family painted in Swabia in southern Germany in about 1470, a fly crawls over the white linen of a headdress. The fly is pictured by the anonymous artist with hypnotic realism, but its black body on the clean cloth is an irksome presence. Flies feast on rotting flesh. Delectable as the woman is, long and willowy as her fingers are, she is, like every mortal, destined to die. Her flesh is food for flies and worms. Because it is corrupt it must not be ostentatiously displayed. Only the woman's face and hands can be seen: her body is concealed

by a sober dress, her head by the neatly folded cap with flowing wings of cloth on which the deathly fly squats.

A new realism was born in northern European art in the fifteenth century. Flemish painters, led by Jan van Eyck, who was working by 1422 and died in 1441, pioneered the use of oil paints to mimic life with astonishing precision. They were ahead of Italian artists as masters of portraiture, at least until Leonardo da Vinci painted Ginevra de' Benci. Their sense of space was just as impressive as the Italians, without the theorizing of the perspective-addled Florentines. So why is the Renaissance usually thought of as a cultural revolution that started in Italy? It is not just because artists like Michelangelo and writers like Vasari were so effective in dramatizing Italian achievements. There was a genuine difference. The north was folded in medieval mental habits like bodies wrapped in draperies. What set Italy apart was the rediscovery of classical civilization. The sensual myths of the gods and their loves licensed a new cult of the human body. The nude statues of antiquity allowed Italian artists to wallow in physical beauty.

Meanwhile in the north bodies were swaddled. Van Eyck's great painting the *Arnolfini Portrait* shows a couple at home in Bruges in 1434 – the artist wrote the date on the wall at the back of the room, proclaiming 'Jan van Eyck was here 1434'. Yet even as this merchant and his wife hold hands beside their magnificent bed, they are smothered in heavy clothes that allow only faces and hands to peek out. He has on an immense hat; she has her head covered in cloth as she holds up her green skirts to parade not her body but its opulent coverings.

The insistence on decent covering in late-medieval art reflects a heritage of Christian contempt for the flesh. Hair in particular tended to be hidden because it was strongly associated with sin. In the folklore of the Middle Ages the woods were inhabited by 'Wild Men', hairy savages who lived by bestial instinct and served as hirsute embodiments of wickedness. Mary

Magdalene, the holy prostitute, was always shown with long flowing hair. In Christian society such lush locks must be controlled with hats, veils, hoods and wimples. This did not mean portraits could not be sensual. In an appealing portrait by Petrus Christus that dates from about 1470 a young woman with enigmatic almond eyes poses in a tall black-velvet hat, like a fez, with a black scarf tying it under her pale throat. Her shoulders are bare. The sartorial rules are being playfully stretched in a sensual game, in a masterpiece painted a few years before Leonardo's *Ginevra*.

Nudity, however, is reserved in northern art of the 1400s for Adam and Eve, or apocalyptic scenes of the Last Judgement. In an engraving of Christ's descent into limbo by Martin Schongauer of Colmar in Alsace, the Redeemer sets free an army of lost souls from their demonic captivity. They are naked.

Schongauer's most influential work, which dates from the 1470s and became famous all over Europe (the teenaged Michelangelo based a painting on it as an exercise), is his engraving *The Temptation of St Anthony*. In this nightmare image a saint floats in mid-air, his face impassive as he silently prays and resists the tormenters who cling to his robes and pull his hair. Anthony is being plagued by flying devils. These mutant beings exhibit naked bodies that are fantastic hybrids of the human and the bestial. One devil is hairy like a Wild Man, with a snout. Another has female breasts, an emaciated torso and goatish legs. A demon clinging on below has breasts, a scaly face between its legs, a lascivious tongue. The carnal temptations that trouble the saint are expressed as bodies at once lustful and freakish. Sexuality is not a liberation. It is a madness.

No painting is more fantastic in its visions of sexual joy and suffering than the triptych by Hieronymus Bosch that has come to be known as *The Garden of Earthly Delights*. Its creator lived in 's-Hertogenbosch in the Netherlands. Bosch is recorded there from 1474 and died in 1516. Three-panelled, hinged paintings

known as triptychs are usually painted as altarpieces, but this cannot be an altarpiece: it swarms with profanities. Adam and Eve stand naked in Eden in the left-hand panel. With her long golden tresses falling in ringlets behind her, the first woman is disported by God, who holds her by the wrist as he presents her to Adam. Her pale body is curving and narrow-waisted. All the men and women in this painting are slender. Around Adam and Eve in Paradise are animals both common and rare: a giraffe and an elephant, a monitor lizard, an owl, a hare, a unicorn, a swan, a two-legged dog. Nature produces monsters through sheer energy and generosity. The fountain of Paradise is grotesque: a pink flesh-coloured stamen, an interior organ grown outward. Spraying water from assorted orifices, its sensitive antennae, tongues and fronds marry the vegetable and the animal. In the central panel of *The Garden of Earthly Delights*, nature is overwhelmed by a human orgy. Sex conquers the world. Giant strawberries provide food for merry-makers: the strawberry is the north-European equivalent of the grape. Others crawl into giant eggs. Couples make love in grottoes and gigantic bubbles. They are fed by birds or feed one another. Buildings rise that are moist and prickly organic entities, marbled livers, enfleshed thistles. Rocks are tongues. In the fleshy buildings naked people clamber, while below them nude riders parade.

In Hell it all turns sour. A pig-nun kisses an unwilling man. A tree-man gropes a sleeping woman. A man turns around to see the hollow white shell of his torso become a house raised on tree-like arms, with giant bagpipes on a tray on his head. What a fate. A bird-creature eats people and shits them out through a globule. A man has music written on his arse. It is noisy in Hell. The damned hang from harps.

Bosch opens a window onto a world of mental chaos. As at carnival time when priests were mocked and Lent was scorned, this painting thinks the unthinkable. Three mesmerizing visions

are held forth. In Paradise, the innocent Adam and Eve are tutored by God. In Hell, the damned contort in their sufferings. These are the moral polarities of Christendom accepted and experienced by Europeans throughout the Middle Ages. The big panel at the centre of the triptych proposes a third way, a state that seems neither Edenic nor damned – a blissful amoral realm where naked savages, who include black as well as white people, enjoy the cornucopia of nature and the miracle of one another – a garden of earthly delights.

Even the date of this painting is wildly uncertain. Perhaps it was created in the 1490s, maybe in the 1500s. Bosch is a riddle. The earthly delight in this painting is very far from the civilized sensuality of a Giorgione. Bosch put all his most brutish longings and deepest fears into superabundant, festering fantasies. He longs for orgies among the strawberries but he fears the embrace of a pig-woman. In Hell the senses are stimulated in ways beyond description and beyond desire. The pale-faced man with a hollow body is experiencing the inventive cruelties that await the damned. Sex explodes in this northern masterpiece. Libertarian urges are shadowed by the vilest imaginings. Earthly delight risks gibbering madness.

In a society of walled towns, merchants counting money, artisans drinking beer at guild meetings, peasants sowing, noblewomen reading Books of Hours, and everyone who can afford fine garments wrapped up in furs and hats, the dream visions of Schongauer and Bosch characterize sex not as a sybaritic pleasure but a barbaric and dangerous force. Their melancholic brooding on the flesh and its temptations suggests good reasons why men and women ought to dress modestly and decently, for temptation truly is an abyss.

In Albrecht Dürer's 1504 engraving *Adam and Eve*, a parrot sits on a branch in Eden, as it might in the forests of South America. The snake that holds an apple in its mouth to be clutched by Eve

resembles a python. This garden is an untamed forest: towering trees packed close together surround the first man and woman with fearsome shade and inscrutability. In the distance a goat perches precariously on a mountain cliff, while in the foreground a cat chases a mouse – intimations of the cataclysm the apple is about to unleash. Dürer's fierce and exotic Eden was shaped by the wilderness of America that was described to Europeans in the early 1500s by the traveller Amerigo Vespucci. Dürer was a true Renaissance man fascinated by the new and the unknown. He drew a rhinoceros and even recorded in a journal his admiration for the treasures of the Aztecs seized by Spanish conquistadors:

Also I have seen the things, that men have brought the King from the new golden land: an entirely golden sun, a whole fathom broad, likewise a completely silver moon, equally large, as well as various strange things from among their weapons, armour, and missiles [. . .] And I have never in my life seen anything, that so filled my heart with joy as these things. For I have seen among them artistic wonders and have marvelled at the subtle genius of the men in far off lands.

Dürer had an appetite for foreign cultures. Yet the remote and alien world he celebrates at the heart of his engraving of *Adam and Eve* is that of ancient Greece and Rome. He depicts Adam and Eve as classical nudes, their physical proportions exactly calculated. Adam has the grace and power of Apollo. Eve is a harmoniously curved Venus. Both of them look like designs to be cast in bronze. Created in the year that Michelangelo's *David* was unveiled, this is a manifesto for the classical nude. Knowing his northern audience, Dürer hides the Edenic genitals with leaves. But his solid and anatomical nudes defiantly assert the primacy of the naked human body in art. In the moment

before the fall Adam and Eve are innocent in their nudity, like statues.

Dürer calculates the proportions of the perfect bodies of Adam and Eve so systematically that they seem almost inhuman. In his hands, the beautiful nudes of Italy are strangely transformed: they assume a savage pride. Nymphs become demonic and gods can be confused with monsters. In his engraving *Hercules at the Crossroads*, created in about 1498, a satyr with horns and goat legs cuddles a naked nymph; she raises an arm in self-defence and he clings to his weapon, an ass's jaw, as Hercules and a clothed female companion raise cruel wooden staffs to beat them. Cupid runs away in horror. The satyr and his love might be primitives, about to die at the hands of more 'civilized' aggressors. Yet the force of the print lies in its ambivalence towards sexuality. The satyr and nymph inhabit a paradisiacal hideaway, separated by a clump of trees from the town and castle in the distance. If they personify desire, the mighty warrior and his companion, menacing them with lethal clubs, embody the revulsion at sin that is also part of Dürer's Christian heritage.

Violence traumatizes Dürer's northern Arcadia. In his 1494 drawing *The Death of Orpheus*, two women beat the poet with massive tree branches; Orpheus kneels on the ground, his beautiful body helpless against their anger. In an eerie version of the myth of Europa and the Bull, he depicts a nude woman dragged across a German lake overlooked by a castle. She is being abducted not by a bull but by a sea-monster: the bearded creature has an antler on his head, a scaly body and a turtle shell for a shield.

All these images portray the human body as elegant and in proportion: divine. Yet this devotion to the classical body is troubled. Even as Dürer loves beauty he fears it. In his woodcut *Apocalypse*, he gives the Whore of Babylon the looks of a Venetian courtesan.

Dürer married Agnes Frey of Nuremberg in 1494. It was an arranged marriage, brokered by their burgher families. They were never to have children and never to be happy. He expressed dislike of her in his letters and other writings and travelled apart from her for long periods, to tour Germany and visit Italy. Their biggest tensions, however, were in Nuremberg itself. Dürer's closest companion in Nuremberg was his friend the wealthy and learned Willibald Pirckheimer. Agnes thought they spent too much time together, and Pirckheimer scathingly accused her of making Albrecht miserable. A particular light is cast on this male friendship by a note written on one of Dürer's portrait drawings of Pirckheimer: 'with the stiff cock in the arse of the man.'

Dürer teases Pirckheimer about his liking for men in letters. Two prints by Dürer depict men and women in separate worlds of physical enjoyment: his *Men's Bathhouse* and *Women's Bathhouse* perhaps suggest that both sexes are happiest naked among their own kind.

In Dürer's 1513 print *Knight, Death, and Devil* we discover why he could never simply enjoy the senses, why his attachment to the nude is tainted by violence. In a bleak, rocky landscape, far from the shelter of a distant city glimpsed on a hill, a knight in armour rides on, ignoring his two terrible companions – the skeletal rotting figure of Death, turning to speak to the knight as snakes eat its remaining flesh, and a devil with the hideous snout of one of the demons in Schongauer's *Temptation of St Anthony*. The knight is the Christian soul, steadfast and armoured against a world that is a nightmare of horror and enticement. The fate of the body, in which we take such joy, is signalled by a skull lying on the ground above Dürer's signature: the forgotten remains of some handsome lad or pretty lass.

'Dürer is in a bad way,' wrote Pirckheimer in 1519. That same year a visiting young artist found the Nuremberg master lost in 'the disruptive teachings of Luther'. By the following year Dürer's conversion was complete and he vowed that

If God gives me a chance to see Dr Martin Luther, I will carefully draw his portrait and engrave it to preserve the memory of the Christian man who has released me from dreadful anxieties.

Like so many people in northern Europe who turned to the teachings of Luther, Dürer had been nursing 'anxieties' about his faith. Luther offered a way out of these melancholy thoughts.

In 1517 in Wittenberg in Saxony, in north-eastern Germany, the Augustinian monk and university lecturer Martin Luther protested in public against Pope Leo X's sale of Indulgences to pay for the new basilica of St Peter's. His *95 Theses* were nailed, it is said, to the church door. They started a campaign that rapidly escalated into a denunciation of what medieval Christianity had become. Indulgences were wrong but no worse than good works and charity done to earn heavenly merit, no worse than relics and the worship of sacred statues. All these ritualistic accretions got in the way of the truth: we are born in mortal sin and all our actions deepen our sinfulness. The fact that God saves anyone at all is a proof of divine love, not the efficacy of works or prayers. Only grace from God can redeem us worthless sinners.

When Dürer offered himself as Luther's artist, he was applying for a job already taken. The revolutionary theologian was a close friend of and collaborator with Lucas Cranach the Elder, court artist to Friedrich the Wise, Elector of Saxony. Cranach was one of the wealthiest, most powerful citizens of Wittenberg. Like Dürer, his towering rival down in the south-west, he worked with the printing press as happily as the paintbrush. The first press in Wittenberg, a small place apart from its castle and university, was set up in 1502, but it was Luther who set the local printing trade alight. His *95 Theses* and a string of works defending and elaborating them started pouring off the Wittenberg presses, to be rapidly reprinted across Germany. Soon Luther was so dissatisfied with the speed and

quality of local craftsmen that he invited a leading Leipzig printer, Melchior Lotter, to open a shop in the town. Lucas Cranach, a convinced Lutheran and born entrepreneur who also opened a pharmacy in Wittenberg, became a partner in the business and used the team of apprentices and artists in his busy workshop to create highly original woodcut images and decorations for Luther's works, especially his German translation of the Bible.

Yet Cranach's friendship with Luther went further than a business collaboration. He used images brilliantly to publicize Luther, not just through woodcuts in books but also a series of portraits, painted and engraved, that were calculated to put personal pictures of the Reformer in homes everywhere. Cranach mass-produced paintings as well as prints: his workshop churned out so many versions of his paintings that his true talent has until recently been obscured. But as propaganda the proliferation of Luthers was a work of genius.

In 1520 Cranach portrayed Luther as a tonsured monk. Like all monks this thin-cheeked ascetic had taken vows of celibacy, but as Luther's attack on the props and tics of Christian tradition took hold, his followers turned on the 1,000-year-old Christian belief that sexual purity was essential to true holiness. What did celibacy mean except a pretentious separation of the clergy and monastic orders from ordinary mortals? Everyone was equal in sin and equally dependent on divine grace. In 1525 Martin Luther himself got married. As an ex-monk he married an ex-nun, Katharina von Bora. At the wedding, Lucas Cranach was Luther's best man. He even stood in for Katharina von Bora's family to give her away. Where he went beyond the usual duties of a best man was in painting portraits of them both.

In his marital portraits of Martin Luther and Katharina von Bora, Cranach illuminates the private life of a revolutionary couple. Dr Martin Luther looks a man of now chubby-faced domesticity, his wife a powerful, keen-eyed character: there is a

definite sexual dynamic between them and it is Katharina who seems to spark with authority. Cranach leaves no doubt this is a marriage of love rather than propriety. In these paintings he offers an ideal of marital virtue in a world that has abandoned the ideal of celibacy.

In a few years a movement that started in a university town in Saxony transformed northern Europe. Art, religion and sex were related to one another very differently in Protestant towns, cities and countries from the old ways that continued in Catholic Europe. In Catholic lands, art was a sacred instrument of faith, beauty a way to revere the Madonna and saints. Meanwhile celibacy was the ideal for all clergy but was widely flouted by the likes of Fra Filippo Lippi. Everything was sacred, so much so that in Protestant eyes nothing was sacred at all. Now, as Luther's message competed with still more radical Reformers, sacred art was at best muted and at worst destroyed in Protestant communities: Albrecht Dürer, who had painted some exquisite Madonnas, in 1523 reviled the *Beautiful Madonna of Ratisbon* as a 'spectre that has risen up against the Bible and has not been exorcised because it makes people money'.

Beauty could no longer be part of religious worship. The love of appearances was lustful. Sexuality was at once irredeemably sinful and integral to the human condition. Marriage was the most honest way to regulate it, for clergy and lay people alike. This new Protestant view of sexuality influenced the art of the Renaissance immediately. For Lucas Cranach is not remembered primarily for his Lutheran propaganda. He is famed as an astonishing painter of the nude. His images of women are some of the most outrageous ever painted. They are angular and preposterous and coldly erotic. Lucas Cranach painted the sexuality of a sinful world.

In Cranach's painting *Cupid Complaining to Venus* – done in about 1525 while German peasants were rebelling against their overlords in the belief that Luther's ideas licensed their protest,

and Cranach himself was helping Luther to marry Katharina von Bora – sin is both mocked and incited. Cupid, stalking a honeycomb in the German countryside, has been stung by bees: as it says in the inscription on the painting, 'life's pleasure is mixed with pain'. Yet the painting is not a call on the beholder to avoid such painful pleasures, but instead a goad to pursue them. It is a vision of Venus for us sinners, a nude for the fallen. To add to its murky hinterland, this picture was owned during the Second World War by Adolf Hitler.

Venus poses, tall and thin like a twenty-first-century model, in nothing but a hat and an expensive necklace. She looks out of the picture with cool flirtation. Cupid complains that indulgence hurts, a warning to us, but Venus stands there looking irresistibly disdainful. Far more than any Venetian or Florentine artist, Cranach makes nudity wicked. And he delights in that wickedness. He pictures the seduction of sin itself. His 1529 painting *Venus Standing in a Landscape* repeats the tease without the admonition: this time Venus, chanced on in the woods across the river from a town, displays her long gold hair under her red-rimmed, rakishly cocked hat, while her throat is enclosed in a band of bejewelled gold. In front of her slender long-legged body she holds a silk veil that hides nothing. She is sex incarnate.

Cranach needled the court of Friedrich the Wise with images of hard-hearted loveliness. His painting of Judith with the severed head of Holofernes that dates from about 1530 portrays the Biblical heroine who slew an enemy of the Israelites as a fashionable beauty jubilant in her destruction of a man: there's a sadomasochist tint to this picture that feasts fetishistically on her white gloves, heavy gold jewellery, tightly laced bodice and bulging bosom as she holds a sword and vaunts the gory grey head of her victim with the red flesh inside its truncated neck horribly exposed.

Sex is not simple. Dürer and Cranach explore secret territo-

ries of desire. For Cranach it seems that beauty is always vitiated by sin. The fascination of his art is that he exults in sinfulness – he makes Venus and Judith look alluringly bad. But it would be a mistake to think fantasies of sinful women played the same role in sixteenth-century Germany that sexual fantasy might in modern life. The culture of Renaissance Europe did not distinguish in the same way that our scientific age does between fantasy and reality.

Lucas Cranach was a very powerful man in Wittenberg. In 1537 he became Burgermeister. His duties included trying criminals, and in that year he sentenced two supposed witches and their accomplices to burn at the stake for the crime of '*Teufelbuhlschaft*' – having sex with the devil.

The salaciousness of Cranach's supermodel Venuses and the magnetism of his Judith take on a different meaning when we know this. They were not harmless erotica. In his images of women Cranach illustrates the stark threat of female desire, which drives women to give themselves to the devil himself. The imagination really was working overtime in sixteenth-century Europe – with spectacular artistic results and harrowing social consequences.

Cranach's belief in witches was shared by Albrecht Dürer. Nothing reveals Dürer's sexual melancholy more vividly than his depictions of the imaginary crime of witchcraft. In his anguished pictures of demoniac women, the mythological art of the Renaissance intertwines with German folklore. Dürer's *Witch Riding Backwards on a Goat*, engraved in about 1500, shows a witch on her way to meet the devil. She is naked; her aged body is heroic and muscular as well as gnarled by time. Four winged cupids help her on her way.

The Four Witches, engraved in 1497, is even more daring in its mingling of classical and popular culture. The nude witches dance in a round like the Graces in paintings by Botticelli and Raphael. Their bodies are coarse and earthy with stiff nipples

and bulging buttocks on view as the devil, in the form of a horned monster, approaches at a doorway that connects their chamber directly with the fires of Hell.

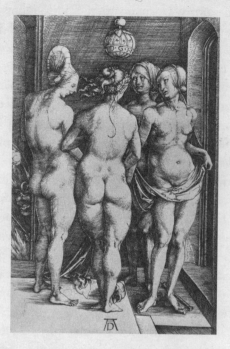

Albrecht Dürer, *The Four Witches*. In Germany
the classical nude aroused sexual superstitions,
as in this vision of statuesque witches.

Dürer's witches had an insidious effect on his pupil Hans Baldung Grien, who was born in about 1484 and worked in his native Strasbourg after his Nuremberg training. Witches mushroom in this artist's intense visions: they ride, frisk, laugh and feast. Hans Baldung Grien's pictures of the witches' Sabbath are no-holds-barred erotic fantasies in which the plush beauty of classical nudes meets the base, diabolical behaviour described in

the demonological treatises of the time. Three nude witches writhe in mutual pleasure: one woman masturbates as she places her foot on the bent back of her friend. Another woman, long-haired and voluptuous, lets a hellish creature lick her vagina. These fantasies of witchcraft portray beautiful young women in league with the devil. Hans Baldung Grien evidently enjoys picturing the witches' sexual pleasure. But he does think they should burn at the stake for it.

This is the cauldron of yearning and dread that Albrecht Dürer stirs to find his image of melancholy. Tormented by his own divided sexuality, he lived in a world of demons. His witches dance hypnotized by their own flesh, as fires burn. In sixteenth-century northern Europe the classical beauty unleashed by the Renaissance clashed in weirdly fruitful ways with dreams and nightmares that bubbled in the fancies of townspeople who lay in bed at night trembling at what went on just outside their walled communities. Beyond the gate, witches had sex with the devil, wild people embraced in the woods and savages skipped among the giant strawberries.

Chapter Ten

HEARTLESS HANS

Anne of Cleves posed for her portrait in a white cap, wait-ing patiently while the artist, sent by King Henry, drew her. They spoke German, for to her surprise the painter who served the English king was a man of Augsburg. He would not say much about Henry. He was not very talkative at all. He stared and he drew; and she felt her skin prickle, as if some conjuration were stealing her soul.

She is like an insect caught in amber. She glitters under glass, a tiny woman trapped inside a rose. The rose is carved from ivory. It is the emblem of the Tudor dynasty and it holds a princess imprisoned forever. Her face is pale and triangular, bright against a circle of blue, flattered with gold, lace, crimson. This painting on a disc of vellum is less than five centimetres in diameter and is a work of sorcery. Anne of Cleves truly appears to have been compressed onto the vellum, so that a woman can be held in the palm of a cruel king's fat hand.

This miraculous image was painted in 1539 by Hans Holbein, court artist to Henry VIII of England. Holbein's paintings are love-charms. They can make a queen live forever and lure beauties into the king's chamber. These pictures create memories and obliterate them. Yet the artist who wove spells of love and beauty at the English court was himself a man without love. And he knew it. Hans Holbein was in this alien

city of London, living among strangers, because he had no
heart.

The portrait of his family that he painted in Basel in about
1528–29 is a devastating document. It is a painting without
illusions, flattery or sentiment. His wife and children seem
remote and bleak to him – people for whom he feels a twinge of
sorrow, but no joy. With her infant daughter on her lap and her
son kneeling beside her, Elspeth Binzenstock looks down in
wretchedness. She appears to have been crying. The narrowness
of her eyes may be the result of an illness, but that does not
account for the despondency of Holbein's children. All three of
his subjects seem downcast: the boy, Philipp, looks up with trep-
idation and a seriousness beyond his years, and even the baby
girl, Katharina, has woeful eyes.

A sullen wife and glum children: Holbein does not seem
enamoured of domestic life.

Born into a family of artists in Augsburg in Bavaria in
1497–98, Holbein was probably trained at first by his father
before moving to Basel on the River Rhine to learn from the
local artist Hans Herbst. Part of Renaissance Basel is well pre-
served. Its wood-framed houses, churches and cobbled alleys
indicate a prosperous place that was a centre of the book trade
and home to the famous publisher Johann Froben, known as
Frobenius. Holbein painted a shop sign for Frobenius, which sur-
vives. In 1519, the year he became a master painter of Basel, he
married Elspeth Binzenstock. This cynical portrait of her a
decade later suggests it was not a happy relationship.

He makes her look not just tired or ill but lacking all vitality
too. Her complexion rough, her nose lumpen, she is the antithe-
sis of the beauty that so obsessed Renaissance artists. Holbein
refuses to be gentle or loving towards his wife. He sees her bru-
tally. It is an unkind painting. Holbein is confessing to a lack of
love.

Hans Holbein, *The Artist's Wife and Children.*
Stories of Holbein's unhappy marriage surely
started with this painting.

At about the same time Holbein portrayed his family, the
Augsburg artist Hans Burgkmair and his wife Anna Allerlai sat
for an equally harsh image. In Lucas Furtenagel's 1529 portrait
of this married couple in their fifties, Anna holds a mirror as
they blazon their aged faces. An inscription warns the beholder:

> This is how we two looked. But then in the mirror there is
> nothing but a skull.

Burgkmair in a black cap looks like a tasteful vampire. His wife
looks like Holbein's wife. There is surely a connection between
the two paintings. Burgkmair may have been one of Holbein's

teachers. He certainly knew the Holbein family as a fellow Augsburg artist. I suspect this *memento mori* was directly inspired by Holbein's intimate yet distant painting of Elspeth Binzenstock. This tough painting was to go on unsettling observers. In 'The Lives of the Illustrious Netherlandish and German Painters', published at the start of the seventeenth century as part of his manual for artists, *Het Schilder-boeck* (*The Book of Painters*), Karel van Mander tells the lives of northern artists in a way that imitates Vasari, adding anecdote and drama wherever he can. In his Life of Hans Holbein, 'outstanding painter', van Mander claims that the gifted artist went to England because

> his wife had such a complaining and miserable nature that he could never look forward to any tranquillity with her.

Van Mander is not simply repeating gossip. He is interpreting, or his informers are interpreting, Holbein's painting of his wife. Holbein told his own story, the truth of his marriage as it looked through his eyes. It's a shame Elspeth cannot retort with a truth of her own. Like a spouse condemned in a *roman à clef* or embittered memoir, she is trapped inside Holbein's punitive image of her.

Holbein left Basel for England a few years after painting this, and worked there until he died. He never brought his wife to live with him in London. Instead he fathered two illegitimate children there. His painting of Elspeth is a document of a failed marriage.

It is also a work of melancholy – the condition that is typical of artists, according to Albrecht Dürer's engraving *Melencolia I*. In the age of the Reformation, when arguments about religion were dividing Europeans from one another, there were many reasons to be melancholy. In 1529 Protestant mobs would

ransack the 'idolatrous' art treasures of Basel. Holbein's own religious beliefs are a mystery. His evasiveness about his faith is another symptom of the withdrawal of feeling that let him portray his family in such a disabused way.

When Holbein portrayed his family he was afflicted by a melancholy just as corrosive as the despair that assailed Dürer, expressed in the depressing realism of his most ruthless painting of all. At the start of the 1520s Holbein made a painting of a male corpse, naked except for a loincloth, lying flat in a compressed stone box: *The Body of the Dead Christ in the Tomb*. The eyes stare sightlessly up at the lid of the coffin. The face is cloudy, blue-black, on the verge of decomposition. His feet are turning grey as the extremities begin to putrefy: with a chill we notice that his fingers have started to go green. Clearly this is a real corpse, observed closely by Holbein to record the visible facts of death. The emaciated body is taut with rigor mortis. Its mouth hangs open. The stomach is collapsing inward, making the bones of the ribcage and pelvis jaggedly apparent as if about to tear through the skin. There is no promise of resurrection or eternal life in this painting. It is a moment of glacial truth. Death mirrored. This painting could destroy someone's faith, said Dostoevsky.

It is that same hopeless perception of the unpalatable that makes Holbein's portrait of his wife such an unnerving work of art. Melancholy slashes at illusion. What is love anyway? In Holbein's series of prints *The Dance of Death* lords and peasants, bishops and burghers are all interrupted in their dreams and delusions of fulfilment by the bare bones of death, a skeleton at the door. In this world that is bound for the grave, what is the worth of love?

Thomas More believed in loving your family. The English Chancellor was a man who worked at affection. In his book *Utopia*, an essay on the ideal commonwealth, he describes his domestic life:

I'm out most of the day, meeting other people – the rest of the time I spend with my family [. . .] I must chat with my wife, talk to my children, and speak to my servants. I see this as my daily duty, because it is essential, otherwise I might become a stranger in my own home. Anyway we really should try and get on with those we live with.

More's insistence on communicating properly with his wife and children, making time specifically for family relationships, might stand as good advice for busy people today. In early sixteenth-century Europe it was highly enlightened – and More genuinely had a lot of pressures on his time. He was a lawyer, a politician, an author. He also found time for a friendship with the scholar Erasmus, the greatest mind of the northern Renaissance. Erasmus translated the Bible and revealed discrepancies between the original text and the version promoted as sacred by the medieval Church. In his *Adages*, a sixteenth-century bestseller, he draws modern morals from classical Greek and Roman sayings. In the preface to his parodic celebration of superficiality *Praise of Folly*, he addresses his friend More. 'I have always enjoyed my memories of you when we have been parted from each other as much as your company,' Erasmus tells him, and his large reading public. He goes on to explain that its title is a joke on More's name, for the Greek word for 'folly' is *moria*. He knows More will appreciate this because he knows his warm sense of humour.

Erasmus was living in the 1520s in Basel, where he worked closely with his publisher Frobenius, and sat to Hans Holbein for his portrait. Holbein hit it off with Erasmus. His portraits of the humanist have a calm, friendly, oxygenated quality, as if he were portraying wisdom itself. Holbein's sympathy for Erasmus is grounded in a genuine interest in his ideas. A copy of *Praise of Folly* that survives is full of notes and doodles by Hans and his brother, Ambrosius.

It was Erasmus who first sent Holbein to England. There

Holbein took an exploratory trip to London, where he lived as a guest at the new riverside home of Thomas More. London's great houses were mostly sited along the Thames, connected by boat travel, from the royal palace at Greenwich to the new and impressive residence of Cardinal Wolsey at Hampton Court. In 1525 or maybe at the start of 1526 Thomas More and his family moved into a fine new house near the river at Chelsea. More was Chancellor of the Duchy of Lancaster, and soon enough to be Lord Chancellor. As the Mores settled into their house Holbein arrived with a letter from Erasmus declaring that 'the man who bears these letters is the one who painted me'.

In Thomas More's house Holbein started to sketch away. It was typical of Thomas More's belief in family that he did not only want the German artist to portray him in his robes of office as a man of position (though Holbein did that too). More commissioned Holbein to create an ambitious portrait of the entire More family: More and his wife, Alice, his elderly father, Sir John More, his children and their spouses. This capacious family painting expresses an ideal that boldly contradicts the social reality of family life in Britain and northern Europe in the sixteenth century. You could almost say it is Utopian. People in northern Europe had, for millennia, lived in nuclear units of wife, husband and children. More writes in *Utopia* of a communist society where individuals are part of something bigger than themselves. In the family portrait he commissioned from Holbein that ideal of community is expressed as familial abundance. More is surrounded by his extended family, all part of his life at Chelsea, all caring about one another.

Holbein began by making precise and vividly coloured drawings of them all. Anne Cresacre, ward to More, stands side on and turns her head towards the artist a little, while fixing her eyes coolly on an object somewhere to his side. He captures her diamond-shaped cap, smoothed hair, the pattern of a sleeve in rapid grey lines. She could be standing in front of us. So could

Cecily Heron, More's youngest daughter, turning her head away from the artist as if she has just noticed something. More himself, in wide black cap and fur collar, holds a steady gaze, his face slightly unshaven, resolute, quietly tough.

After making these individual drawings Holbein designed a group portrait, with More surrounded by his family in a room in Chelsea where a clock marks time. In his comments written on the compositional drawing More asks that his wife be portrayed seated rather than kneeling. The final painting is gone, destroyed in the eighteenth century, but from what survives it is clear that Holbein's first ambitious work in England idealized family life as a conversation among loving companions.

It was soon after he returned to Basel from his creative encounter with the More family that Holbein portrayed his own wife and children. By contrast with More's extended kin, the Holbein family is nuclear and claustrophobic. It is as if Holbein unmasked the reality that More resisted. The More family portrait is a utopian ideal, the Holbein family portrait a cynical riposte. Holbein does not find the rich, jocular life of More's family reflected in his own home.

The Protestant mood in Basel made religious commissions hard to come by. In England he had garnered a lot of interest in his portraits. Holbein left his wife in Basel and returned to London.

The clock that noted the time in Thomas More's house was telling off his days. On 6 July 1535 he was executed on Tower Hill by decapitation. The witty friend of Erasmus, the Thomas More who had his fool, Henry Patenson – not to mention his pet monkey – included in Holbein's portrait, could not laugh off his scruples about the king's divorce.

Henry VIII's passion for a French-educated, Protestant-sympathizing, dark-eyed beauty called Anne Boleyn turned state and Church inside out. Henry was already married, to Catherine of Aragon, daughter of Ferdinand and Isabella of Spain. But Catherine had been briefly married to his older

brother, whose early death put Henry unexpectedly on the throne. When she failed to give him a male heir but only a daughter, the king convinced himself that his marriage must be unholy. It was against the prohibitions of Leviticus to marry your brother's wife. When he fell for witty, sophisticated Anne, who was au fait with all the French mannerisms of courtly love but who strategically refused to sleep with him until he could offer her something more than a gift or two, Henry VIII started searching for a way to get rid of Catherine. Cardinal Thomas Wolsey's efforts to persuade the pope to annul the marriage fell on stony ground – and the mighty Wolsey fell from favour.

In later sixteenth-century portraits based on a lost contemporary original Anne covers her brown hair in a pearl-fringed black headdress, and wears a necklace with a golden 'B'. Her face is long, with ruby lips, and she flaunts her slender throat and shoulders bedecked in gold and pearls. Henry wanted her and he was not interested in the answer 'No'. The king, who had once published a book denouncing Luther, now started to find Protestant criticisms of the pope absorbing. His scholars discovered ancient proofs that England had always been an 'empire', sovereign unto itself in all matters. Anne Boleyn, in her heart a Protestant, encouraged Henry in this direction. She was supported by Thomas Cranmer, Edward Foxe, Thomas Cromwell and other elite Protestant sympathizers. Cromwell manipulated the English Church into submitting voluntarily to Henry's authority, driving Thomas More, for whom the pope was supreme and the Church sacrosanct, to resign as Lord Chancellor. By December 1532 Anne Boleyn was pregnant and Henry promised himself a male heir. In the new year, Henry and Anne were secretly married. Soon the break with Rome was sealed in a series of statutes in Parliament. The Act of Supremacy in 1534 declared Henry VIII head of both state and Church. It was a colossal act of Renaissance individualism – a nation and its religion remade to suit one man's desires.

Hans Holbein, who had prospered in London painting the portraits of German merchants, became Henry VIII's court artist in 1536 at a moment of blood and terror. His job was to smooth over a painful crisis with beautiful pictures. He had to obliterate the memory of one wife with the image of another.

The wife whose memory he was employed to expunge was not the callously divorced Catherine of Aragon. It was the beheaded Anne Boleyn. Her marriage to the king, so hard won by them both, brought her sorrow and death. When the child with whom she was pregnant turned out to be another girl, the impulsive Henry VIII brooded once more on the rightness of his actions and God's view of his private life. Anne Boleyn's courtly ways made her a soft target. She was accused of demonically seducing the king 'by means of sortilege and charms'. She was also accused of incest with her brother and adultery with several courtiers. Five men, including her brother and a musician, were executed a few days before Anne herself was beheaded at dawn in the grounds of the Tower of London on 19 May 1536.

One of Holbein's first tasks as Henry VIII's court artist was to portray the king's new bride, Jane Seymour. It was an attempt to remake reality. Anne Boleyn was dazzling and notorious and hard to forget. Holbein's portrait must authoritatively replace her image with that of the quieter, more obedient Jane. Henry was betrothed to Jane Seymour the day after Anne Boleyn's execution and they married ten days later. Holbein's job was to put her into history as the sole queen, the true wife, consigning the first two to oblivion.

He drew Jane Seymour from the life with acute clarity. She stands with her hands clasped in an almost nervous gesture, far from the flirtatious movements and darting glances that were said to be Anne Boleyn's trademark. Holbein shows the tapering elegance of her body under her dress and opulent royal jewels. Yet he does not flatter. He records, meticulously, her rough-skinned, lumpen chin and slightly bent nose and placid eyes. If

this drawing is meant to efface the charisma of executed Anne, it does so not with lies but with truth. Holbein does not claim the new queen is more beautiful than Anne Boleyn. He claims she is more real. Fleshed out and thinking and breathing, here is a person, rather than that mercurial fantasy woman who perhaps was just the devil's illusion.

Holbein's portrait is a replica of Jane Seymour: a model of her in living colour. In the finished painting she stands against a silvery-blue wall in a dress of red velvet with pewter-toned sleeves of the finest lace, a gold-threaded shawl over her arms, a necklace on her bare throat. A diamond-shaped hat encloses her puckered features. Holbein uses clothes to bridge the gap between reality and ideal beauty. The power of his painting lies in its absolute truth: here is the queen, as in a mirror, ungainly chin and all. But her magnificent garments transfigure her without the need for clumsy deceit. Accurate drawing is embellished by sensual colours. The cumulative effect is beautiful. It was taken a stage further when Holbein painted a mural of the Tudor dynasty in the king's great palace of Whitehall. In a portrait by a lesser artist, Henry and his family are seen on a high garden terrace overlooking the chimneys and courtyards of this new royal residence that Henry built as his power-centre in London. The palace burned to the ground in 1698, destroying Holbein's mural – which probably occupied a wall in or just outside the Privy Chamber – but it is preserved in a copy by the Flemish artist Remigius van Leemput as well as a surviving part of Holbein's original cartoon drawing.

Jane Seymour looks as temperate in this family group as she does in her isolated portrait, posing with the same modest gesture, holding her hands together in front of her. On an ornamented gold cup that Holbein designed for Henry to give her as a gift, an inscription reminded Jane of her duty: 'Bound to obey and serve.' In return for her obedience she is enshrined in Henry's myth of the Tudors. His dead mother and father

stand behind them: all four figures were painted at life size, large enough to spook anyone admitted to the royal presence. The living and the dead are made equally real by Holbein's miraculous precision. By the time it was finished Jane Seymour too was dead and the only living face in the mural was that of Henry VIII himself. Henry mourned Jane Seymour sincerely because she died after a childbirth that finally gave the king his male heir.

The monster who dominates Holbein's surviving full-size drawing for the left-hand side of the *Whitehall Mural* has a thick neck sprouting straight out of broad shoulders, narrow eyes, a bulging codpiece. Henry VIII is so much man in this captivating drawing, its surface a network of filigree decorations, that his father Henry VII seems a pale spectre behind him. It is a monument to Oedipal triumph as the king in his mighty girth shoves the founder of the Tudor dynasty into the background. Henry's dagger and codpiece attest to the raging appetite that had already driven him to marry three times and made him look for a new queen soon after Jane Seymour's death.

This time Henry and his minister Thomas Cromwell looked beyond the aristocratic families of England, to a European dynastic match. Just so long as the princess was beautiful. Henry's marriages to Anne Boleyn and Jane Seymour had both begun in face-to-face rendezvous: he was alive to sexual attraction. How could the spark of flirtation be recreated when the woman in question lived across the sea? The secret weapon of long-distance courtship was Hans Holbein. The magical truth of his brush, his pictures at once humble and gorgeous, meant that Henry could fall in love at first sight – without seeing his lady. It was a failsafe method, or so it seemed.

On 10 March 1538 Holbein arrived in Brussels to visit the court of Maria of Hungary. There he was to portray Christina of Denmark, the sixteen-year-old widow of the Duke of Milan.

Holbein was granted three hours in which to draw her on the afternoon of 12 March. A full-length oil painting that he worked up from his drawings makes Christina look captivating. Clad as she is in black silk mourning robes and a black velvet cap, her pale face and bright-red lips light up the painting. Holbein uses her widow's clothes to recreate the fascination of early Flemish portraits that frame white faces with tight wimples. Her face is long and oval, her cheeks chubbily youthful. Most of all what Holbein communicates is a droll and self-aware personality: her half-smile is as knowing as the *Mona Lisa*'s. This is probably not a coincidence. Holbein visited the French court in the 1520s and may have seen Leonardo da Vinci's portrait. He gives Christina of Denmark something of its enigma.

Henry VIII was smitten, even though the picture he saw that March must have been far sketchier than the finished oil painting. He fell in love. Musicians were ordered to play for him, to harmonize with the amorous mood Holbein's painting aroused. Yet the king was to be frustrated. The marriage negotiations failed: Christina of Denmark never became one of Henry VIII's ill-starred wives. She is the one who got away.

Thomas Cromwell was anyway keen to lock Henry into a dynastic alliance with the Lutheran rulers of Saxony in northern Germany, so as to buttress the Reformation. For this reason he pushed a match with Anne of Cleves, daughter of the Duke of Cleves. Portraits of her sent to London by the Germans were veiled and uninformative, and the Saxon court artist Lucas Cranach made himself mysteriously unavailable. So in summer 1539 she sat to Holbein in the city of Düren.

The image that Holbein took back to England was handsome in the same way as his portrait of Jane Seymour had been. It does not give the face of Anne of Cleves any kind of extravagant allure – she is not anything like as fetching as his picture of Christina of Denmark. What Holbein stresses is the evenness of

her features seen straight on. He portrays Anne looking directly at the beholder, her face a symmetrical oval. Yet there is a sleepiness in her eyes, a flat disengagement. The legerdemain of the image lies in colour and ornament. He dresses Anne of Cleves in red velvet trimmed with gold, and documents every detail of her jewels and headdress. This cocktail of luxury and colour – on a green background that ignites her red velvet in the full-scale painting, and on blue in a tiny roundel set in an ivory rose that Holbein made for Henry to handle – is potently energizing. It creates a mystique of beauty.

Henry was delighted. He fell in love all over again. But it could not last.

As soon as he married Anne of Cleves in January 1540 the king confessed himself unable to consummate the marriage, because he was so repelled by 'this Flanders mare'. Holbein's portrait had misled him. The impression he took from it was nothing like the real woman. Anne was so far from his idea of beauty that he said he would never 'know her carnally'.

Holbein was not in the sights of the faction at court waiting to pounce on this disaster. They were after Cromwell and his Protestant scheming. That summer Cromwell was beheaded. Hans Holbein survived. Yet his painting of Anne of Cleves is a work of deception, a conjuring trick. It uses colour, the fire of the senses, to hypnotize the beholder. Seduced by gold and red velvet, the eye ignores the empty expression on her face.

Henry VIII loved to fall in love but for Holbein romance was just another lie, a deception to distract us from the imminence of our deaths. In his painting known as *The Ambassadors* two French visitors to the Tudor court, Jean de Dinteville and Georges de Selve, are represented with an extravaganza of objects that signify the pursuits and occupations of keen Renaissance minds. A celestial globe and a globe of the earth, mathematical instruments and books add up to an imagery of the mind's reach that

is as cogent as the array of tools and artefacts in Dürer's *Melencolia I*. The melancholy of Holbein's painting is absolute and extreme. Across the lower part of the painting, against a sumptuously coloured marble pavement, hovers a black-and-white smear that when you look from the correct angle resolves itself into the image of a skull. Death slices through everything. All is vanity.

Prominent among the objects the men value is a lute. It is painted with astounding foreshortened precision like a real thing, there in front of us. Of all instruments, the lute was the symbol of the lover. It was the instrument the amorous Giorgione was said to have played – the clichéd instrument of every young man or woman in love. Henry VIII loved music. 'Give me pastime and good company,' he sang. But for Holbein the lute, whose music is the food of love, was food for worms.

He died and was buried in Aldgate in London in 1543. He was about forty-five. In Basel his wife, Elspeth Binzenstock, lived six more years.

Chapter Eleven

VENUS AND CUPID

The bed was hung with a silken canopy embroidered with hundreds of tiny satyrs. The king and his lover lay below this heavenly fabric looking at a new painting installed in the royal chamber – wondering who the people in it were, what it all meant. As they spoke, their eyes were fixed on the slender fingers manipulating a breast; until they spoke no more, but kissed.

In about 1545 King Francis I of France received a gift from the Duke of Tuscany. It was a painting with a sheen on it like polished glass and an impudence that made all who saw it gasp. It was moved straight away into the private apartments of Fontainebleau. After a day's hunting for stag and boar in the woods around the ornately frescoed and stuccoed palace, the king could contemplate undisturbed the picture's glittering aggregation of stimuli: eggshell skin, daring gestures, lascivious lips.

A beautiful woman curls her legs on a violet silk sheet, beside a pink pillow, in front of a blue curtain. As she raises her arm in a graceful fleshy loop, a curly-haired youth kisses her and caresses a nipple between the fingers of his right hand. She looks into his eyes with evident pleasure. Sex is a cool game in this painting, a calm hedonism. No need to rush, for Father Time himself, bearded and bald, watches red-faced but helpless as the lovers enjoy their eternal mutual beauty. The boy is as handsome

as the woman, androgynous even, his skin smooth, his buttocks arched.

She is Venus, goddess of love, and he is Cupid, her son. Their incestuous relationship may be a reference to the legend of Cupid and Psyche, as told by Lucius Apuleius in the second century AD. In this story the love affair of Psyche and the god of love suffers many setbacks – one of which is the jealousy of Cupid's possessive mother, Venus. Apuleius describes Venus kissing her son with lingering sensuality, like a lover.

Since Venus and Cupid are deities of desire, they can hardly be expected to behave themselves. But most representations of their relationship are cuddly and innocent. Venus hugs a baby

Bronzino, *An Allegory with Venus and Cupid*. This picture revealed its daring only when prudish veilings were removed during a twentieth-century restoration.

Cupid, or is surrounded by winged *amores*. This picture is unusual in savouring an amoral encounter between the deities of love. It actively seeks to make sex as dirty as possible, and to exalt the perverse.

Its creator's life was as enigmatic and uncommon as his masterpiece might suggest. *An Allegory with Venus and Cupid* is the greatest work of Agnolo Bronzino, a painter of cold, sexy brilliance who was born in Florence in 1503 and died there in 1572. Bronzino is a nickname: his father was a butcher with no surname, which is no lineage worth boasting about. So Bronzino it was, 'little bronze', maybe describing the colour of his hair. He appears, at the age of about fifteen, in his teacher Jacopo Pontormo's painting *Joseph with Jacob in Egypt*, sitting in brown robes and a black cap on some steps while all around him nudes cavort, statues twist themselves in extreme postures, pale bright colours waft and architecture spirals in fantasy.

Bronzino's relationship with Pontormo is the first conundrum of his life. Artists in Renaissance Florence all served apprenticeships to become masters. It was a medieval craft tradition, regulated by their guild. Pupils traditionally sought to outdo their masters and Michelangelo loathed his teacher Ghirlandaio so much he denied he had even been apprenticed to him. But Bronzino loved his teacher. His friendship with Pontormo was one of the dominant influences in his life, decades after their teaching relationship ended. They were more like father and son, but this son was more attentive than most. Pontormo was an eccentric genius. In his old age he lived in a house with no stairs, so the only way of getting to his bedroom was by a rope ladder that he raised behind him. He was highly reclusive, a judgement not only reported sadly by his admirer Giorgio Vasari but confirmed by Pontormo's own diary too. The diary also reveals how much Bronzino cared for the old man, spending as much time with him as possible and luring him out of his solitude to eat suppers together.

Pontormo's art discloses an appetite for the male body. His drawings of contorted, prancing male nudes rival those of his hero Michelangelo. One drawing by him in red chalk portrays a hermaphrodite, a figure whose body is at once male and female: seen from behind, this sinuous youth displays feminine hips and bulging buttocks to the artist. Pontormo's androgynous idol has curly hair. In fact this sensual being looks remarkably like the soft-skinned Cupid who makes love to Venus in Bronzino's erotic painting.

In the 1520s Pontormo, at the peak of his powers, painted a *Deposition* in the church of Santa Felicità in Florence that is a fluttering veil of colours, eggshell blues, flamingo pinks, rosy reds, gold-dust yellows. Pale, flimsy people, swooning women and straining youths twist in and out of the billowing sails of a fragile brightness. It is a painting of a sigh. Everyone is lost in a rhapsody of colourful pain. In the roundels above the painting in its little chapel, Pontormo's pupil Bronzino – who was in his early twenties now – worked with his master to paint portraits of the four evangelists. To any honest eyes these sinewy, serpentine images of Matthew, Mark, Luke and John look lushly homoerotic. Saint Matthew lunges forward with bare shoulders, a face of passion and beauty; Luke poses in dreamy sensitivity.

Why be timid? The relationship between Pontormo and Bronzino looks like that between Leonardo da Vinci and Francesco Melzi: an ardent and loving bond.

Pontormo was not the only intense presence in Bronzino's life. Walk out of Santa Felicità, where they painted their shapely evangelists, and the touristic heart of Florence narrows just over the road to a congested artery as crowds cross the Ponte Vecchio, the city's ancient bridge, lined with jewellers' shops that hang over the olive-green River Arno. This famous bridge is a relic of Florence five centuries ago when it was hot with forges, loud with hammers and smelled of sawn wood and smoke. This was a city of artisans, thick with workshops. In his

autobiography, Bronzino's contemporary Benvenuto Cellini, who trained as a goldsmith, describes tensions, insults and fights between the rival gangs of craftsmen along the narrow streets. Painters may have thought of themselves as loftier than other artisans but their workshops nuzzled against those of metal-workers, woodworkers, paper-makers.

In the late 1520s Bronzino met a worker in metal, an arm-ourer named Cristofano Allori. They became inseparable. Allori had a wife and children, but Bronzino moved in with them and became part of the household. When Allori died in 1541 Bronzino took over the burden of financially supporting the entire family and trained his friend's son, Alessandro Allori, as a painter. The bond between Bronzino and young Alessandro was as loyal and loving as that between Bronzino and Pontormo: eventually Allori would be buried in his master's tomb. Old Jacopo Pontormo was also a regular visitor to the Bronzino-Allori household, and took a grandfatherly interest in the budding artist.

Was the armourer Bronzino's lover? It was evidently a very close relationship. One clue to Bronzino's feelings may be the way he paints armour. In his portraits of men he depicts armour in a peculiar way, as a second skin that moulds the wearer's body, a confining sculptural carapace. The nobleman Stefano Colonna in Bronzino's 1546 portrait of him is sealed inside a slender suit of black armour that gives him a torso and arms of blackly glint-ing steel. In a 1543 portrait of Cosimo I de' Medici he encloses the ruler of Florence in silvery, glinting metal that again totally constrains his torso and arms into the shape made by the armourer. These portraits pay homage to Cristofano Allori's craft. They also make a fetish of armour. Perhaps locking these men in the metal of Allori's skill kept alive the memory of the dead armourer.

Bronzino's portraits of men pulse with desire. His *Portrait of a Young Man as St Sebastian*, painted in about 1533, audaciously

acknowledges the carnal appeal of one of Renaissance art's favourite religious themes. The ancient Roman soldier Sebastian, shot at close range with arrows for his Christian faith, offered artists an image that throbbed with erotic potential, under the mask of piety. The phallic arrows piercing Sebastian's body were rendered with gory ambivalence by the Pollaiuolo brothers, Andrea Mantegna and in drawings by Leonardo. But Bronzino did something more outrageous. Far from denying the sexual implications of the image, he called attention to them. This is not St Sebastian but a curly-haired youth pretending to be him. No blood is spilled by the arrow that appears to stick in his side. As he shows the stiff wooden shaft entering his bare body, he grins and chats with someone in the room. A delicate pink cloth is wrapped around his shoulders, stressing the pale beauty of his penetrated torso.

Bronzino, a talented poet, wrote comic, bawdy verses as well as love sonnets. His paintings share the wit of his writings. He introduces sexuality into paintings where it might not seem to have any place at all. In his *Portrait of Andrea Doria as Neptune*, he pictures a famous Genoese admiral in the nude: the heroic Doria is a literally godlike figure – the sea god Neptune – whose torso is golden and muscular as, with a powerful arm, he lowers a cloth to give a shadowy glimpse of his penis. In his right arm he wields a substitute penis, the thick pole of his trident, and as if these hints of virility were not enough he also stands in front of the massive circular shaft of a wooden mast. The name 'A. DORIA' is carved into the mast above the forks of his trident, as if to say this sea dog is a walking phallus.

Yet for all the overt and even jokey praise of male beauty in his portraits, Bronzino's brush responds to women too. His painting of Venus having her nipple fondled does not suggest a man who never looked at a woman. His portrait of Lucrezia Panciatichi, wife of a Florentine patrician, done in about 1541, smoulders with restrained sensuality. 'Splendid as she is, one

doubts if she was good,' says an admirer of this painting in Henry James's novel *The Wings of the Dove*. Lucrezia certainly protests her virtue, for she has a Book of Hours open on her lap as if she has been interrupted in a spiritual moment. Her face is long and grave, her eyes pregnant with thought, yet her long, slender throat, her ivory flesh and pearly lips and fine soaring cheeks, the jewels that radiate in circles from her alabaster neck, her fiery-red silk dress, and the way her body, tapered to a tightly corseted waist, seems to tense in her chair communicate an uneasy, restless sexuality. Bronzino sees past the holy book. Lucrezia looks to him like someone burning with inner fire, secret pleasures. He conveyed a similar sense of contained passion in his painting *Lady in a Red Dress with a Fair-Haired Little Boy*, also from the 1540s. A woman poses with her small son beside her, wearing a bright-red dress of intricately patterned velvet and ruffled silk, looking serenely and slightly melancholically out of brown eyes in an oval face at once waxen and pink with blood and life. She seems saddened by impulses her social role does not permit.

It is the very impassiveness of Bronzino's technique that implies, in almost anyone he portrays, a hidden furnace of passion. Bronzino is so stylized that he draws attention to what he cannot show: the fury and wild nights his portrait sitters in their frozen majesty seem to have in mind. Even his portrait of Eleanora of Toledo, painted in 1545, hints at a tempestuousness behind the stilled pose of the wife of the Duke of Tuscany. Compared with the placid-eyed wives of Henry VIII in Holbein's court portraits, a much more dynamic, impulsive character is suggested by Bronzino. By subjecting sitters to his gelid spell he paradoxically reveals their warmth. Their appearance of self-discipline suggests a turbulence that requires it.

The *Allegory of Venus and Mars* is, like all his paintings, at once ice-cool and ablaze with feeling. His marble-smooth yet milk-soft portrayal of the flesh of Venus is richly ambiguous. At first sight

Venus and her lover seem hardened by lust, as choicely unyielding as his men in armour. Look again and this fetishistic chill is an illusion: the tenderly aroused flesh of Venus is full of animal warmth. The painting contains more secrets.

Vasari wrote in 1568 that Bronzino's picture of Venus and Cupid shows all aspects of love: as well as Venus being kissed by Cupid it includes

> Pleasure on one side accompanied by Play and other Loves, with Fraud and Jealousy and other passions of love on the opposite side.

Vasari had probably never seen the painting – it was in France – but his description may echo Bronzino's own opinion of it, for they knew each other. According to Vasari this painting is an allegory of the complex reality of love. Around the astounding portrayal of lovemaking at the painting's heart revolve figures of love's pleasures and its pain.

A green-faced monster clutches its hair and screams with bitterness. It is, surely, Jealousy, the gnawing agony of the anxious lover. Contrasting with this glimpse of inner hell, a boy brings flowers with a big grin on his face – the happiness and joy of love, its fecundity. Yet behind the boy is a girl with the body of a serpent: the deceptive lover, the lying seducer. A mask of flesh with no face inside it might be a false face of love, or a body without a soul. And Time is there, always waiting to do his ruinous work.

The allegorical meanings of this picture are endlessly elusive and teasing. The more you try to unravel them, the more you come back to the confident and sinful celebration of desire that makes this painting live.

Cosimo I de' Medici, Grand Duke of Tuscany, showed a fine understanding of the French court when he sent this painting to

King Francis I as a gift. The court of France was highly permissive in the sixteenth century. Italian art was greatly admired there – Leonardo da Vinci had died as court painter to Francis – and it was adored above all as a feast for the senses. The nudes and mythologies of the Italian Renaissance were interpreted in French royal circles as cultivated erotica.

Bronzino's painting plays up to that perception of the Italian Renaissance. It was a sexual diversion sent from Florence to Fontainebleau to liven up royal nights.

This appetite for eroticism in Renaissance France originates in medieval rituals of courtly love. Courtly love with its conventions of knights and nobles dedicating themselves to their ladies was popular all over Europe, yet France was its true home. French courtly love can be glimpsed in the painting for May in the sumptuous Book of Hours that the Limbourg brothers painted for the Duc de Berry in about 1415. Women of the court ride side-saddle, dressed in green, with leaves in their hair and green and gold trappings on their horses. Men too wear leafy crowns along with cloth of blue and red and gold, as trumpeters announce their spring procession. In the distance, through a veil of trees under a deep-blue sky that glitters with astrological symbols, the spires and castellation of a fantastic château reach heavenward. The château of the Duc de Berry, seen from many flattering vantage points throughout *Les Très Riches Heures*, is a perfect stage setting for courtly love, that formal and civilizing dance of ladies and their lovers. The culture of courtly love glows in the Limbourgs' scene as the gentlemen pay their loyal regards to their companions. The same ideal of decorous felicity is encapsulated in the great series of tapestries known as the *Cycle of the Unicorn*, woven in about 1500. In these tapestries, six in all, a circular garden floats in a pink space speckled with flowers and beasts. The garden is in bloom, and in its refined sanctuary an elegant noblewoman conducts a series of stately encounters with allegorical beasts. In one tapestry the unicorn

rests its hooves on her lap as she shows it a mirror; in another the lion and the unicorn listen to her playing on a small table-top organ. The martial appearance of the lion and the unicorn's phallic narwhal tusk make it clear the lady is taming masculinity. Bronzino's painting of Venus and Cupid must have looked to its French recipients like a more explicit version of courtly love's old song. Lecherous kisses replace the leads on which medieval ladies were depicted keeping their men. Yet the theme of love conquering the world is the same – and so is the imagery of women in charge.

Soon after Bronzino's *Venus and Cupid* arrived in France an unknown artist of the court at Fontainebleau painted *The Toilet of Venus*. The goddess of love sits in an expensively furnished boudoir looking at herself in the mirror while she attends to her hairstyle. A winged cupid brings her a bottle of perfume. Venus is nude (if that needs saying by this point) and her pose, with one arm raised, resembles that of Bronzino's Venus. The goddess is imperial, again like Bronzino's Venus: clearly his painting held a fascination for Fontainebleau. It licensed paintings like this in which women are pictured as both sexualized and free from male influence. Women of the court were invited to identify with Venus herself, ruling with beauty. A handful of formidable women in Renaissance France tried to do just that.

In 1547 Francis I died. The new king of France, Henri II, was a twenty-seven-year-old man with a forty-eight-year-old mistress. This woman, Diane de Poitiers, became a power in the land. This sent mythological symbols into wonderful disarray, for the name of Diana, virgin goddess of the hunt, became equated with sexual charisma. In the 1550s a Fontainebleau artist painted a nude Diana patrolling the woods with her bow and her hound; as she looks our way she is less a chaste maiden than a dominant Venus-like persona who bares her breast in tantalizing profile. This painting may be an allegorical portrait of Diane de Poitiers. It is certainly not a hymn to the virginity of the divine huntress.

Bronzino's nipple-tweaking masterpiece had many echoes in French Renaissance art and apparently in French court life. In about 1570 the court painter François Clouet portrayed a lady of high rank in her bath. She wears a regal-looking hairstyle and displays her breasts without self-consciousness: she has a bowl of fruit to enjoy in the bath and a child hoping to take some of it, while a servant breastfeeds a baby beside her. Beyond we see a room in what is clearly a very fine palace, where a servant fetches hot water while paintings hang next to a grand fireplace. The bathing lady's face is ideally beautiful yet the details of the scene imply a real place and a real person. She seems to be a royal mistress, but who? Like the Venuses and Dianas of Fontainebleau, she triumphs in her court of the bath.

In 1590 Gabrielle d'Estrées met King Henri IV of France and became his mistress. In 1592 he married her off, but when she gave birth to a son in 1594 the monarch – impressed by her fertility and as mindful as other rulers of the need for male heirs – arranged for her marriage to be annulled; in 1599, when she was pregnant again by him, he put the coronation ring on her finger and planned to marry her just after Easter. She died on Holy Saturday, before the wedding could take place. But before that, in her courtly campaign for the royal hand, she posed for her portrait in the bath together with her sister the Duchess of Villars. *Gabrielle d'Estrées and One of Her Sisters* is a proudly erotic painting. Both of them reveal their pale and sumptuous nudity, tall hairstyles, firm breasts. The Duchess of Villars holds her sister's nipple between two fingers. It is an allusion to her strengths as a mother, but this picture is no worthy allegory. It is a divertissement for the eyes.

In the Florence where Bronzino painted his *Allegory with Venus and Cupid* there was nothing as straightforward as simple lust. If this painting seems to be decadent that is because Bronzino was the greatest artist of a period of political atrophy. His brittle,

double-edged beauty insinuates the amorality of the Medici court in an age when the Republic of Florence was turned into an absolutist dukedom.

In 1530 the last attempt by Florence to run itself as a free republic ended in thousands of deaths as the city fell to an army sent by the emperor Charles V to return the Medici family to power. Bronzino's early art, like that of his father-figure Pontormo, manifested a sympathy for the defeated Republican cause but to make his way as an artist he became the brilliant portraitist of the Medici. Somehow his thorny, odd pictures suggest his mixed feelings. The erotic abandon of his painting of Venus and Cupid is not purely gratifying. With its images of masks and fraud and jealousy, this painting diagnoses a corruption in human affairs.

Bronzino was the most gifted of a constellation of artists whom Cosimo I de' Medici employed to mythologize his new dukedom. These artists ravished the senses to honour the Florentine court. The Boboli Gardens, created by a team of architects and sculptors for the Medici family, is a yielding horticultural striptease of sensual panoramas, culminating in a grotto that leads into languorous realms of fantasy. The entrance to the Pitti Palace in Florence leads towards the gardens through a massive rusticated facade, like a man-made cliff, into a deep courtyard of even weightier, craggier rustic blocks and bulbous, grotesque columns, at the far end of which rises a mountainous enclosure, opening into a dark grotto where a fountain plays into a pool. Beyond the sunken court the Boboli Gardens ascend a tall hill. A central staircase climbs terrace after terrace, while woodlands recede on either side and paths enclosed by tall hedges and groves lead to fountains, cascades and stucco caverns. River gods, monsters and satyrs lurk in this labyrinthine hillside park. Statues of gods in English eighteenth-century gardens are noble and contemplative but rarely create the sense that Venus might be just around the next hedge – they

are there to give the landscape classical hauteur. The Boboli Gardens are more secluded and uncanny. The statues are not just statues; mythological beings actually seem to inhabit the nooks and dells. It is a truly intoxicating place, a living landscape of pastoral fancy that incites dalliances in shady arbours.

Most enchanting of all is the garden's Great Grotto, where stalactites fringe a cavernous mouth within which stucco shepherds play music on moulded rocks in a painted landscape. A satyr looks down from a cliff near the bright oculus that lets in sunlight. He puts the side of his finger to his nose and grins.

The architect and sculptor Bartolomeo Ammannati, who designed some of the most dramatic effects in this dreamlike garden, also created a flamboyant *Fountain of Neptune* for the duke right on the central piazza of Florence. Like Bronzino's portrait of *Andrea Doria as Neptune* it makes the sea god a massive figure of male potency while around the basin of the fountain play bronze satyrs, creatures of sexual licence. If gardens can be sensual, fountains are spurting sprays of abandon. The sculptor Giambologna competed for the commission for the Neptune fountain but lost out to Ammannati; he created a masterpiece of a fountain in Bologna from his rejected plans. This fountain on the city's cathedral square does not occupy a vast space. It is compressed into a small area and, above a marble basin, rises with the intensity of a spire. A massy and brooding bronze Neptune stands on high with his trident piercing Heaven, while putti and female sea monsters bask below him. The sea monsters, enticing women above the waist and fish below, shoot water in cool arcs from their breasts.

Under the Loggia on the main square of Florence is Giambologna's *Rape of the Sabines*, a swarming column of three bodies, with a young male nude grabbing a woman who claws her way up into the air to escape while her feeble husband is driven to the bottom of the flowing waterfall of marble flesh.

This daunting depiction of sexual violence got its name after it was carved. Giambologna was interested not in the story but in the modelling of the figures, the energy and movement of their interlocking forms. He shaped them spontaneously in wet earth. His fired terracotta model still survives to show how he moulded his nude fantasy.

By the later sixteenth century the eroticism of Italian Renaissance art was in demand not just in France but also at courts and in cities right across Europe. From fountains and gardens to nude paintings of nymphs, the paraphernalia of sensuality spread to the remotest towns and coldest castles. The house of Sir Paul Pindar was built in Bishopsgate in the City of London in 1599–1600. Its ornate timber front survives, a three-floor mass of carved wood that includes monsters with bulbous breasts. These home-grown English versions of the sexualized mythological beings to be found on Italian fountains would have been visible from the street below: a glimpse of the erotic Renaissance for anybody walking past.

Pindar was a merchant who traded in Venice. He was not the only Elizabethan enjoying myth at home. A painted panel of Luna and Mercury from Stodmarsh Court, Kent, reveals the popularity of Renaissance decoration in fine Tudor houses. British miniature paintings, which Holbein helped to popularize, had by the late sixteenth century a sophisticated grasp of the imagery of love. In a miniature painted in 1588, perhaps by Isaac Oliver, a pale young man poses with unkempt hair in an open shirt, touching the pendant he wears around his neck: behind him gold flames fill the oval frame. This is a passionate love token that refers captivatingly to a Neo-Platonic idea of love as a flame-like spiritual substance, able to rise to a higher sphere.

In Shakespeare's play *The Taming of the Shrew*, when a lord's servants set out to fool the drunkard Christopher Sly into thinking he is wealthy, they bait him with paintings of erotic myth:

We'll show thee Io as she was a maid,
And how she was beguiled and surprised,
As lively painted as the deed was done.

In *The Winter's Tale*, Shakespeare mentions Giulio Romano by name. Could this be a ribald joke? It may be no coincidence that his friend the dramatist Ben Jonson, in his 1607 comedy *Volpone*, has a character named Lady Would-Be mention Giulio's literary partner in the notorious erotic publication *I Modi*:

But for a desperate wit, there's Aretine!
Only, his pictures are a little obscene –

No doubting which pictures she means. *The Positions*, the prints of sexual positions designed by Giulio Romano that were accompanied by Aretino's verses, were evidently well known in literary London in the age of Shakespeare. Jonson returns to the joke to portray an archetypal French or Florentine Renaissance man as a hot-blooded lover schooled by erotic art:

[. . .] some young Frenchman, or hot Tuscan blood
That had read Aretine, conned all his prints,
Knew every quirk within lust's labyrinth,
And were professed critic in lechery;

This familiarity with not just the Italian Renaissance but its most daring images too was now widespread. In Prague in the late sixteenth and first decade of the seventeenth centuries, the Habsburg emperor Rudolf II created a phantasmagorical court in the castle that loomed over the city, stuffing its chambers with his collections of curiosities and art. Everything from red coral (believed to have aphrodisiac powers) to scientific instruments had its place in Rudolf's microcosmic theatre. He owned Correggio's paintings of *Jupiter and Io* and *Jupiter and Ganymede*,

which took their places alongside the erotica of his court artist Bartholomeus Spranger. In Spranger's painting *Vulcan and Maia* he gives Maia the most visible pubic hair in a female nude since Giorgione's *Tempest*. His nudes pose in drastic ways to embrace lovers who are behind them – it allows him to show both a kiss and a frontal display of Venus's divine body in his painting of *Venus and Adonis*, done in about 1597. Another Flemish artist in Rudolf II's Prague, Dirck de Quade van Ravesteyn, portrayed a courtesan lying back on a luxurious pillow, her slender thigh delicately raised, wearing a solid gold item of lingerie that consists of a jewelled chain strung across one shoulder and joining on to a gold band just under her breasts. Adriaen de Vries, who came from the Hague and was Rudolf's court sculptor, also specialized in heightened sensuality. In his bronze relief *Bacchus Finding Ariadne on Naxos*, a robustly sexual nude Ariadne is unveiled by the curious Bacchus who has found her sleeping in a tent, while a satyr holds up a torch to illuminate her fleshy hips and large-nippled breasts.

Bronzino's *Allegory with Venus and Cupid* is the blue-and-silver jewel at the heart of this mannered seduction that engaged the courts of Renaissance Europe. Jealousy and fraud and bitter old Father Time look on, but still love enraptures the eye and mind.

Chapter Twelve

METAMORPHOSES

The palace was kept dark, as he insisted. He himself wore black. Philip fingered his rosary beads and looked at a new map of some outlying area of his dominions. Was it Mexico or Flanders? For a moment he was confused. He was pleased with the cartographer's clear lines and bold colours; this would be added to the growing collection of maps at which he liked to gaze every day. But now he walked on, down the lonely corridor, past a window left un-shuttered and letting in a scathing blast of Castilian sunlight. At last the king came to a room where his choicest paintings glowed, fire-bursts of colour in the perpetual half-light. He knew the artist was a man very different from himself. Such festivals of flesh, such women! He almost shuddered at the pleasures these paintings implied. But he recognized the artist's emotions. A sultry sadness inhabited these profane visions. He contemplated Venus wrapping her arms around Adonis, making of herself a fenced park, and sighed for his own days as a bridegroom.

In his mature years Titian painted a cycle of erotic mythological paintings for the severe Philip II of Spain, which are the most enthralling of all depictions of the loves of the pagan gods. Titian called these paintings his '*poesie*'. They are truly visual poems that peer into the world of myth – and the heart of love. The six masterpieces, created in Venice and sent across Europe

to the Spanish king, declare a new moment in European history. They embody the triumph of Italian Renaissance sensuality right across Europe, in the sombre palaces of Madrid and even in the half-timbered houses of London, where a temporary stop-off for one of Titian's dreams was to inspire the greatest love poet in the English language.

Titian's *poesie* are formidable paintings. In the greatest of them all – *Diana and Actaeon* – the goddess reels back in alarm, raising a white cloth to shield herself; but it is just a rag, not enough to conceal her shining thigh and soft breast and buttocks that spread out on the red velvet drapery upon which she rests. Her raised arm, fleshily curving, hides part of her face, as she glares across the reflective pool at the intruder. He puts out a hand as if to stop himself falling, as if to push back the picture before his eyes. He never intended this. Actaeon has chanced upon the virgin goddess and her nymphs while out hunting in the woods. His arrows hang in their quiver on his back, suspended from a leather strap over his bare shoulder. As he thrusts out his hand, palm forward, fingers extended, a pink velvet hanging suspended from a rope that has been slung across the woodland grove seems to yield before him, like a kissing tongue. The architecture behind it is unexpected: not a classical ruin but a decayed Gothic vault coloured with bright mosaic provides the sheltered sanctuary where Diana and her followers wash and relax around a fountain. On an ancient gatepost, a stag's skull announces the rule of the huntress. Olive and gold leaves softly roof the sanctuary. Through the gilded arch, fast-moving puffs of silvery cloud smoke the blue sky. In the foreground Actaeon's hunting dog faces Diana's lap dog. A stone mask gazes blindly from the fountain. A mirror and a bottle rest on its carved abundance, while white foam spurts from a monstrous stone head into the blue-green, translucent waters. Around this fountain or wellhead, overlooked by the accidental voyeur Actaeon, nymphs are exposed in their nakedness. One young

woman reclines against its classical frieze, her face in red shadow, as she looks across at the startled Diana. Another, sitting on the circular structure, hunches her nude form in discomfort to see him there. One hides behind the stone gatepost. Two more, drying themselves after bathing, have not yet noticed Actaeon. Diana's black servant has spotted him. Moving fast, she reaches towards the goddess in an instinctively protecting gesture. With all these postures and reactions, the view that Actaeon sees is all the more breathtaking: one nude from behind, another reclining, another seated, one bending, and Diana herself in outstretched majesty.

Titian does not so much illustrate the Greco-Roman myths as dramatize them with piercing emotional insight. He pictures not only the gestures but also the psychology of his actors. The shock of Actaeon, the fear and rage of Diana are described by him as if he himself has experienced such a moment. Actaeon has seen what he should not. The beauty of Diana is too great for mortal eyes. She radiates divinity. By the time he painted this, in the late 1550s, Titian was no longer aiming for the solidity of his earlier works such as *Bacchus and Ariadne* or the *Venus of Urbino*. His brushwork was more wilful, partial, suggestive. A mottled cloud of colour, a glowing mist of pigment discloses the luminous forms of people and landscapes.

Titian painted his mythological cycle for the man who was to send an Armada against the English and the army of the Duke of Alba against the rebellious Dutch. Philip II was an embattled imperialist Catholic king. When he was ruling Spain as regent, before his accession to the throne, he married the conservative English queen Mary I, the Catholic daughter of Henry VIII, in an attempt to extend Habsburg dynastic power and religious conservatism. He built the Escorial, a palace retreat from Madrid with the atmosphere of a monastery. Yet the paintings Titian sent him are monuments to the senses. The scenes from mythology they depict – the other five are *Diana and Callisto*,

Danaë, *Venus and Adonis*, *Perseus and Andromeda* and *The Rape of Europa* – are stories that run riot with eroticism. The pictures he made of them are poems of love.

Titian never went to Spain. He met Prince Philip, as he then was, in Milan in 1548 and at his father Charles V's court in Augsburg in 1550–51. A portrait of the prince by Titian shows him in black-and-gold armour and grey hose: the style mixes manly readiness for war with courtly grace, but the face that emerges from the glinting metal collar is small and red-eyed. Philip's nervous temperament cannot be hidden by Titian's brush. In 1555 Charles V would retire, and Philip would rule the Spanish, Dutch and American part of his father's vast dominions for almost half a century. Titian painted his sumptuous mythological works in Venice, packed them and sent them across Europe. The sky in *The Rape of Europa* is a blazing display of red cloud in the deep blue that might transfigure an evening view of the Grand Canal. Titian's mythologies infused the imagination of a continent with the sensuality of Venice.

On 23 June 1592 the theatres of London were closed by order of the authorities. The dispute was swiftly followed by plague; and for reasons of health playhouses were kept shut, besides a couple of brief respites, until June 1594. William Shakespeare was at a loose end. The young dramatist and actor from Stratford had only recently begun to make his mark in London with plays, including his comedy of gender roles *The Taming of the Shrew*, the bloody historical epic *Henry VI* and a classical farce, *The Two Gentlemen of Verona*. Now all of a sudden this 'upstart crow', as he had recently been cursed by a dying rival, had no stage to fill. So instead he turned his hand to other kinds of literature, and dedicated his actor's wit to courting the elite. In 1593 he published a poem called 'Venus and Adonis', dedicated to Henry Wriothesley, nineteen-year-old Earl of Southampton. It is a teasingly erotic, lustrously phrased version

of Ovid's tale in the *Metamorphoses* of how the goddess of love was herself smitten by love for a beautiful young man called Adonis.

Ovid's poem *Metamorphoses*, written in Latin just a few years after the birth of Christ, is an incomparable source of pagan erotic mythology that transfixed both Titian and Shakespeare. Its author, Publius Ovidius Naso, had a nose for trouble – indeed the last word of his name means 'Nose' – and there were plenty of pitfalls in his age for it to sniff out. He was born in 43 BC; Julius Caesar had been assassinated the year before on the Ides of March, 44 BC. Caesar's killers acted in the name of the old Roman Republic but instead their deed brought years of internecine war that ended with the rise to power of Rome's first emperor, Caesar's great nephew Octavian, who took the name Augustus. More than 1,500 years later, Shakespeare would dramatize these bloody days in his tragedies *Julius Caesar* and *Antony and Cleopatra*. Young Ovid lived through them.

When, in Ovid's teenage years, the emperor Augustus established his dominion, the stage was set for a clash between poetry and power. Ovid had a rare poetic gift – but not for the kind of patriotic epic that might please Augustus. His contemporary Virgil took up that task. 'I sing of arms and a man' begins Virgil's *Aeneid*. By contrast Ovid proclaimed himself the poet of intimacy: 'Venus has appointed me her engineer of love.'

By love he means sex. His poems portray the pleasures of flirtation at the theatre and forum, the delights of seeing your mistress, the sorrows of an affair gone wrong. In his *Amores* he writes honestly about impotence and quarrels, and in *Ars Amatoria* (*The Art of Love*) he offers guidance to any Roman who does not know how to seduce.

This stuff was not exactly music to the ears of Augustus. The first Roman emperor put moral reform at the heart of his rhetoric and laws. He set out to strengthen family life and make elite couples have more children: poems that celebrated illicit fun

subverted these policies even when Ovid put in some obligatory praise of Rome's wise ruler. Ovid also seems to have done or witnessed something that offended Augustus more tangibly, for in AD 8 the emperor exiled him to the wild shores of the Black Sea. Ovid would die there in AD 17 or 18.

Before his fall, Ovid composed the *Metamorphoses*, in which the Greek myths inherited by the Romans become adult fairy tales. It was here that Renaissance artists were to find the stories of Jupiter transforming himself to make love to women – into a bull to steal away Europa, into a simulacrum of the goddess Diana to seduce Diana's follower Callisto, to take two of the tales Titian visualizes. The *Metamorphoses* had a special fascination for Renaissance Europeans because it provided a truly erotic imaginary world, free from Christian scruple. In the fourteenth century, Boccaccio and Chaucer penned their scabrous, saucy, hilarious stories. Why then did the Renaissance need Ovid? Why not just illustrate Boccaccio? Ovid offered an approach that was not mocking and bawdy but instead stylish and grand. He takes sex seriously. Titian and Shakespeare respond to that adult boldness in Ovid, and add another fathom of profundity all their own. Oddly enough, given that Titian died in Venice when Shakespeare was twelve in Stratford, the interpretation of Ovid's story of Venus and Adonis that Shakespeare sat down to write in the early 1590s was practically the double of Titian's painting of the same tale.

In the *Metamorphoses*, Venus is accidentally scratched by one of her son Cupid's arrows, and with the drug of love in her blood she falls for the handsome young hunter Adonis. It is a season of pastoral delight for them both. Venus gives up her usual indoor life of cosmetics and beauty treatments and goes hunting with Adonis: as Arthur Golding translates it in 1565 in a version Shakespeare probably read alongside the Latin original, 'Pursuing game of hurtless sort [. . .]'

But she avoids dangerous prey like the fierce wild boar, and

warns Adonis to shy away from such behemoths too. Lying with her head in his lap, she tells the story of how a lad called Hippomenes was changed into a lion and urges Adonis to steer clear of all such lethal animals. But when she is away he goes hunting big beasts and is killed.

In Shakespeare's poem this cautionary tale is transformed – metamorphosed, even – into a realistic drama of unrequited love. Shakespeare changes it radically, to cast ill-matched lovers in a pastoral tragedy. Venus adores Adonis. But he is not interested in her: amazingly, this beautiful young man disdains the goddess of love herself. As she says in disbelief, she was good enough for Mars the mighty war god ... And so Venus woos Adonis with words, works herself up to heights of amorous rhetoric to try and win him over:

> 'Thou canst not see one wrinkle in my brow,
> Mine eyes are grey, and bright, and quick in turning.
> My beauty as the spring doth yearly grow,
> My flesh is soft, and plump, my marrow burning.
> My smooth moist hand, were it with thy hand felt,
> Would in thy palm dissolve, or seem to melt.'

Adonis is a cold, churlish youth who barely says anything at all in reply. As Venus talks and talks, weaving love garlands of language, he blushes in stupid silence. The reader feels the dead weight of his mute passivity like a stone on which her fountain of words crashes. Finally Adonis has had enough and the youth, so much less graceful than his looks, blurts out

> 'Fie, no more of love:
> The sun doth burn my face, I must remove.'

Venus calls him a 'lifeless picture', and alleges that there must be something wrong with his libido:

'Thou art no man, though of a man's complexion,
For men will kiss even by their own direction.'

But Venus cannot stop loving Adonis. She weeps, shakes her
head, shakes his hand, looks at him, stares at the ground: then
she tries to make him hers by flinging her arms around him and
refusing to let go. This is an image that does not have any source
in Ovid. It is a riveting, so-recognizable picture of desperate love:

Sometime her arms enfold him like a band:
She would, he will not in her arms be bound.
And when from thence he struggles to be gone,
She locks her lily fingers one in one.

'Fondling', she saith, 'Since I have hemmed thee here
Within the circuit of this ivory pale,
I'll be a park, and thou shalt be my deer:
Feed where thou wilt, on mountain, or in dale;
Graze on my lips, and if those lips be dry,
Stray lower, where the pleasant fountains lie.'

Venus holds Adonis in her tight embrace, the 'ivory pale' of her
beautiful arms, and compares herself to an enclosed park where
he can wander like a deer – all the way to her 'pleasant
fountains'.

Shakespeare has created, improvising on Ovid, a portrait of
some very human love-trouble, as the beautiful goddess finds her
passion unrequited. And yet, his image of the goddess making
of her arms an 'ivory band' with which to hold Adonis tight is
not entirely unprecedented. True, it has no origin in Ovid. But
it does uncannily resemble Titian's painting of this mythic
couple.

Like Shakespeare, the Venetian painter diverges from Ovid's
text in the painting of *Venus and Adonis* that he created in

1553–54 for Prince Philip of Spain. Like Shakespeare, he changes the story in a way that increases the turmoil, contrasting the passion of Venus with the crass impulse of Adonis to be gone. To express that moment of a woman frantic not to lose her beloved, he too portrays Venus with her pale arms embracing Adonis. The sun is high in the sky, a ball of yellow fire sending out searing rays of light. Under a shady tree, Cupid sleeps. His bow and arrow rest in the branches. Adonis longs to hunt, to spend the day in manly sport, and already has his spear in his hand, his hounds on a leash, as he moves across the painting, inclining his body as he steps into action, keeping his entire frame headed that way, towards the hunt, as he turns to look back to Venus, who is impairing his liberty. For she hugs and hugs, holding him with soft arms as she looks him in the eye, her face shadowed by her fear, for something tells her that he is in danger. Her dress lies open beneath her, along with an empty flagon, as she sits with her back facing the painting's beholder, reaching out in her embrace, her last-ditch arm-hold. As for her body, Shakespeare's words seem just right: 'My flesh is soft, and plump [. . .]'

Adonis is more of a man's man than he is in Shakespeare, muscular and strong rather than boyishly beautiful, and – a crucial difference – they have made love: the discarded garments of Venus make that plain. What the two Renaissance giants have in common is the image of the embrace, a human touch, a dramatic stroke of genius, that has no source in Ovid. And there it might be left. Great minds think alike.

Especially when they copy each other.

It was the autumn of 1554 and London was tense. The body parts of rebels hung on the city gates. Mary I was not – she would be the first to admit – given to nuptial joys. She said she 'had never felt that which was called love'. Yet she was infatuated with her relation, Philip, and had been enthusiastic to fall in with

her cousin Charles V's plot for her to marry his son. She needed an heir. Philip does not seem to have appreciated England, for he never showed nostalgia for it later. But here he was, the wedded consort of the English queen, while those with the sixth sense woke in the night, their nostrils full of smoke from burnings soon to come.

The newlyweds (their marriage took place on 25 July 1554) made an effort to be lovers, for in November Mary announced her pregnancy. But even when he took delivery of his package from Venice there was a grumpiness in Philip that he could not conceal. He noticed a line visibly dividing the canvas, and thought it must have been badly packed. In fact it had had a long journey, first to Spain, where Titian assumed the king was, then on to England. Still. Here it was, a warm Italian vision to get the consort through the English night: *Venus and Adonis*.

Titian's painting of *Venus and Adonis* remained in England for several years before it was returned to Madrid. It was one of Titian's best-loved works in his time: about thirty early copies survive, including versions from Titian's workshop that are today in the National Gallery of Art, Washington DC, the Metropolitan Museum in New York and the National Gallery in London. Was there a copy made of the painting when it was in England? There were certainly engravings of the painting, including one by Giulio Sanuto, published in 1559, that faithfully includes all the salient details of Titian's scene, including the fierce sun. That detail is also echoed by Shakespeare: the midday sun 'With burning eye did hotly overlook them [. . .]'

Both the blazing sun and the hooping embrace from Titian's painting recurring in Shakespeare is too much to dismiss as coincidence. Surely it is clear that Titian's painting did leave a trace of itself behind in London and that Shakespeare knew this image. In his poem, Adonis pulls away, just as he does in the painting:

The time is spent, her object will away,
And from her twining arms doth urge releasing.

This encounter between an Italian painter and an English poet, across a continent, and across the forty years that separate the painting and poem, triumphantly displays the cosmopolitan nature of the Renaissance. By the late sixteenth century the myths of the pagan gods, and their voluptuous depiction in art, were known all over Europe. Even before writing 'Venus and Adonis' Shakespeare has the servants who tease the drunkard Christopher Sly in his early play *The Taming of the Shrew*, making him think he is a great lord, offer him a picture of these same lovers:

'Dost thou love pictures? We will fetch thee straight
Adonis, painted by a running brook [. . .]'

By Shakespeare's time the English Renaissance was fully plugged into the European mainstream. One of London's most daring Renaissance men was Christopher Marlowe: spy, Machiavellian and Shakespeare's fellow dramatist. Marlowe was murdered in 1593, the year in which Shakespeare published 'Venus and Adonis'. In Marlowe's unfinished poem 'Hero and Leander' the image of Adonis is invoked:

Where Venus in her naked glory strove
To please the careless and disdainful eyes
Of proud Adonis that before her lies.

In Ovid there is no hint of Adonis rejecting Venus. But that is a reasonable interpretation of what is going on in Titian's painting as the hunter struggles to be away and looks down coolly at his impassioned love. Marlowe too seems fixated on Titian's image of a thwarted Venus unable to keep her man for all her naked glory.

The apparent influence of Titian's art in Elizabethan Britain demonstrates how far the Venetian's paintings of mythology penetrated European culture. The paintings that Titian created for Philip II have transformed the very myths they depict. The image of Venus clinging hopelessly to Adonis as he pulls away has become the truth of this tale. This is because Titian's paintings of the loves of the gods possess an authority that is impossible to ignore or reject. These paintings are sensual yet full of gravity. They have the weight of religious art and the grandeur of historical frescoes. In Titian's imagination the sexual outrages of the pagan gods are true events that have shaped the world. These loves matter.

In his painting *The Rape of Europa*, which he seems to have worked on for as long as three years before sending it to Philip of Spain in 1562, Titian treats with compassion a tale that had been imagined by earlier artists as a ridiculous bit of sauce. The ancient story in Ovid's *Metamorphoses* tells how Jupiter transformed himself into a bull to carry off an Eastern princess named Europa. While she played with her maidens on the coast of Tyre, the god in his taurine disguise appeared on the beach and let her stroke him. When she climbed on his back, he walked into the sea and by the time Europa started to panic they were far from shore. The bull swam to Crete, in a journey that connected Asia and Europe. A white-glazed terracotta relief made in Florence, probably by Giovanni Francesco Rustici in about 1495, plays it for laughs. It depicts Jupiter swimming across the sea with Europa on his back: as he swims he turns his animal head towards her and licks her nipple. She closes her eyes in pleasure.

In Titian's painting she feels the gravity of the situation. She arches back on the bull, showing an ample breast as her clothes fall into disarray, raising an arm to wave a pink velvet flag at the people watching helplessly from the shore. It is very sexual: Titian feasts his eyes on Europa's generous body, and her hand

holding the bull's horn is a glimpse of her sexual destiny, the hard horn cupped by her flesh. And the sexuality is menacing: the sky blazes, the waters of the sea are inky black, the bull is taking her from day to night. Cupids gather in the sky and sea, as if witnessing this momentous event. *The Rape of Europa* is terrible and awe-inspiring, a truly mythic episode that expresses at once the history of the world – for it is the discovery of Europe – and the power and violence of desire.

Another of the paintings that Titian sent to Spain presents Danaë, who was seduced by Jupiter in the shape of a shower of gold. As gold coins shower from Heaven a servant holds out her skirt to catch them. Danaë herself is calm and contemplative on her bed: she knows this is not just about money. For the rain of gold pours from a turbulent sky of black silver-edged clouds, from inside which shines a heavenly fire. The sexuality of Jupiter is an awe-inspiring mystery: at once coarse and majestic, hard and ethereal. Compare the realism with which Correggio had painted Jupiter as a cloud embracing Io for Philip II's father, Charles V, his paws enfolding her. That made a myth cinematically real: by contrast Titian's painting is abstract and elusively poetic. The gold that illuminates Danaë is a smoky revelation.

It is also instructive to compare Titian's *Danaë* for Philip II with the earlier version he painted for Alessandro Farnese. His nude for Farnese was the climax of his golden glowing beauties, more resplendent even than the *Venus of Urbino*. But the body of Philip II's Danaë is very different. She is not golden – and she is not perfect. Her pale skin is more varied in tone, mottled and marked, the skin of a real person rather than a dream. This is a development in Titian's art. In his mythological paintings for the king of Spain, flesh is less luminous, more earthly. This accompanies a new way of painting. The later style of Titian is expressive and intuitive. His brushstrokes become ever-looser, free from all pedantry, as he builds up allusive ruffles and flakes of colour. This is not a decline but a new birth. A late Renaissance.

The realism of the flesh in Titian's mythological paintings for Philip II makes them even more redolent than his earlier works of the sex life of Venice. Even though these paintings emanate significance, even though they dramatize ancient stories with Shakespearean insight, they are also records of a sensual sub-culture. Who are the women who pose in his profuse and lifelike painting *Diana and Callisto*? They exhibit themselves from different angles, in contrasting degrees of light and shadow, standing, sitting, crouching. While the goddess Diana is enthroned in nude glory, one attendant half-kneels, half crouches below her, partly in shadow, looking up, another sits in the foreground with her back to us, her buttocks pressed and spread upon the ground. One woman stands in profile, giving a side view of her breasts, belly and buttocks, as she lifts a velvet drapery to expose the pregnant stomach of Callisto.

Painted with the edgy irregularities of Titian's later freedom – hinting at dimpled, sinewy limbs and uneven flesh – these nudes are too convincingly posed for it to be an entirely imaginary gathering. Real women adopted these postures. Who? Where? It does not look like a moment from myth so much as a brothel scene or preparations for an orgy. Titian's gathering of nudes is a forerunner of Picasso's brothel painting *Les Demoiselles d'Avignon*. It has a quality of real, unadorned life. Is this the kind of party Titian might have enjoyed at his friend Aretino's house? Or at his studio? *Diana and Callisto* was painted at the same time as *Diana and Actaeon* and shares its powerful realism. The scene Actaeon chances upon looks like a gathering of Venice's top courtesans: all varieties of beauty are on offer. A shame he has to die for looking.

Most unexpected of all is Titian's *Perseus and Andromeda*. In this painting a hero whirls in the sky, wielding his scimitar, ready to slay a sea monster and rescue the princess chained to a cliff. But as she hangs there, nude, the chains are curiously unconvincing: they seem designed to show off her figure more than to restrain

her. Again the sense is unavoidable that we are glimpsing the secret life of the Serene Republic. Here Titian is extremely faithful to Ovid, who throws in a reference to amorous bondage when Perseus protests at Andromeda's plight:

'O,' he said, 'these chains are not worthy of you,
unlike the ones passionate lovers put on together.'

It is not just that Titian's later paintings of sensual subjects are hazily expressive and gratuitously painterly. As he aged, his preoccupation with sexuality became more fraught and introspective. He unpeeled new layers of psychological depth, as he explored not only the pleasures but also the terrors of desire.

This is not completely new in his art. In 1511, when he was perhaps twenty-one, Titian painted a fresco in Padua, near Venice, called *The Miracle of the Jealous Husband*. It shows a man in contemporary dress stabbing his wife, who sprawls on the ground pleading for her life. Analogies with Shakespeare loom again: the British dramatist set the world's most famous tragedy about a jealous husband in Venice. It is based on a tale from Italy: the story of Othello appears in a 1565 collection of *novelle* by Giraldi Cinthio. Venetians told the traveller Thomas Coryat that they allowed courtesans and prostitutes to trade freely because this release for male energies helped protect the virtue of wives. Perhaps Venice truly was a city of acute jealousy and possessiveness. It was the converse of the city's sexualized culture: a terror of being cuckolded. Titian's portrayal of a husband murdering his wife is appallingly convincing.

When he returns to this image of a man assaulting a woman, dagger in hand, in his late painting *Tarquin and Lucretia*, the result is a shocking and visceral masterpiece. Titian painted this scene from ancient Roman history in about 1568–71, that is, when he was about eighty. The tyrant Tarquin is raping Lucretia at knifepoint: he grabs her arm as she resists and, while she tries to push

him back with her free hand, draws back his dagger. His face is a mask of rage. Her face is heartbreakingly desperate: in the story in Livy's *History of Rome*, the virtuous Lucretia committed suicide after Tarquin raped her. But Titian's painting is ambivalent. It shows the beholder a beautiful nude in a sumptuous bedroom: Lucretia is naked; she is pushed back by Tarquin's fury against a white pillow on white bed sheets. A silken green curtain surrounds her bed. She has on pearls, signifying her honour. Tarquin himself is clad in luxurious green and pink velvet. It is as seductive as anything Titian ever created. Yet it depicts a rape.

To enjoy the textures and colours of the painting is to be lulled into sensual pleasure; and yet to look at Lucretia's face is to be gripped by dread and compassion. It is a painting of pleasure and pain, beauty and savagery.

Titian's disturbing rape scene is one of his very last paintings of the sexual realm. In 1576 he died during a devastating outbreak of plague. More than sixty years after his youthful peer Giorgione, and at the great age of about eighty-six, Titian too appears to have been taken by the disease that tormented Venice. One of the paintings left in his studio was an unfinished picture of *The Death of Actaeon*. In an autumnal, mossy woodland, created with broad impressionistic slabs of brown and yellow, a man is changing into a stag as the goddess Diana fires her merciless bow. His head is antlered. His dogs are about to tear him apart.

Once again and finally, in this painting, Titian drinks deep of Ovid. This is the ultimate scene of the story of Diana and Actaeon from the *Metamorphoses*. Diana has changed the accidental voyeur into a beast, to be hunted by his own pack. Yet once again there are shades, too, of Shakespeare.

The English poet always remembered his Ovid, but the high tone of his poem 'Venus and Adonis' is unusual in his work. When the theatres reopened in 1594 he went back to writing popular plays in which folklore and profanity rub against history

and the classics. In his comedy *A Midsummer Night's Dream* he reinvents Ovid for the people. A group of hapless lovers in a wood are enchanted by fairies – quintessential creatures of English folk belief. Yet at the heart of the play is an Ovidian metamorphosis that echoes Actaeon's, with comic instead of tragic results. Bottom, a humble man, is given a donkey's head through mischievous magic and – by another spell – the fairy-queen Titania is made to love him. It is the madness of midsummer, the craziness of love. Titian, in his unfinished painting of Actaeon, seems to identify with a man caught by surprise by magic hidden in the woods. Perhaps he would have recognized Bottom's wonder when the spell is lifted:

'I have had a most rare vision. I have had a dream, past the wit of man to say what dream it was.'

For Titian, Shakespeare and their master Ovid, life is that dream.

Chapter Thirteen

THE SISTINE BROTHEL

Pietro Aretino sat in his house by the Grand Canal, the cries of hawkers and splash of gondoliers' poles and chatter of the market in his ears – and perhaps one of the mountain chickens from his friend Titian in his stomach. He was writing one of his famous letters to the great powers of Europe: those letters that kings and emperors felt obliged to respect and defer to; and that later, when printed for his eager audience, revealed Aretino's dialogue with the eminent. This letter, however, was not a condolence or a criticism addressed to some leader or dynast. Its recipient was, wrote Aretino lavishly, still greater than his royal correspondents, such as Francis I or Henry VIII, for

[. . .] the world has many kings, and just one Michelangelo.

It was 1537, and news had reached Aretino that Michelangelo was working on a spectacular new project. In the last year of his life Pope Clement VII had been talking to the renowned artist about a new work for the Sistine Chapel, where Michelangelo's ceiling already proved his genius. Clement's successor, Paul III, of the Farnese family, confirmed the commission and by 1536 Michelangelo had completed his design and was starting to paint *The Last Judgement* on the altar wall of the Sistine.

It was a traditional decoration for a European church. In

getting its own depiction of the Last Judgement the pope's chapel in the Vatican joined hundreds of cathedrals and parish churches throughout Christendom, from Orvieto Cathedral with its mighty *Judgement* by Luca Signorelli to a painting of *Doom* on a wooden rood-screen that has survived in St Peter's Church in Wenhaston, Suffolk. In all these interpretations of the Last Judgement the risen dead are naked, as they stand before God and Christ to be sorted into the saved and the damned.

Aretino was excited, awed, that Michelangelo, in his early sixties, was embarking on such a grand subject on a tremendous scale, filling the entire altar wall of this lofty chapel with his new fresco. Michelangelo could have easily rested on his laurels, he wrote in his enthusiastic missive,

> But I hear that, with the end of the universe which you are painting at present, you intend to improve on the beginning of the world which you previously painted, so that conquering your paintings with your paintings, you will be triumphant over yourself.

Now, at home in his Venice, high perhaps on fame and gifts from princes, Aretino made a mistake. He took it upon himself to offer Michelangelo advice on what to paint in his Last Judgement. As he scratched his quill on paper he wove his own imaginary picture in words of the end of days, presenting it – in a moment of arrogant folly – as a template to inspire Michelangelo, whose attitude to art he had utterly misunderstood. Michelangelo had his own ideas, his own 'divine concepts', and did not work to the dictates of literary men. As he got older, his works, from the Medici tombs to his drawings for Cavalieri, became ever more enigmatically personal. Yet here was Aretino, offering advice as if Michelangelo was some ... *artisan.*

I see fear on the faces of the living; I see the signs that the sun, the moon and the stars are about to go out. I see, as if they were giving up the ghost, fire, air, earth and water: I see to one side Nature standing there, shrunken and barren in her decrepitude. I see Time, withered and trembling; who is near to his end; seated on a parched tree trunk: and while I hear the trumpets of the angels moving all hearts, I see Life and Death, in terrifying confusion [. . .]

Nature standing, shrunken and barren? Time seated on a tree trunk? Life and Death fighting it out? By the time Michelangelo had squeezed all Aretino's allegorical figures – there are many more, such as Fame crushed beneath the wheels of her own chariot – into his composition the altar wall of the Sistine Chapel would have resembled a dry-as-dust emblem book. Fortunately there was no danger of Michelangelo taking Aretino seriously. Even if he had been in the business of painting the ideas of others (which he was not), the suggestion came too late. His reply to Aretino was polite enough. He praised Aretino's description of the Last Judgement by saying it sounded like an eyewitness account: if only it had reached him earlier . . .

I was most grieved, that having already completed a great part of the composition I cannot put your vision into effect, which is such, that if the day of judgement had already been, and you had seen it in person, your words could not describe it better.

Michelangelo's true feelings became obvious the following year, when Aretino – apparently not one to read between the lines – saying that he had placed the artist's reply in a gold chalice, begged a gift of a cartoon from the master's hand. Michelangelo never sent him the requested drawing.

While he worked to finish his great fresco, the most lethal

literary assassin in Italy sharpened his wit and plotted a devastating revenge.

Michelangelo's *Last Judgement* is a painted physical experiment. In a glass jar, a reaction takes place. Bubbles of gas fizz up through a blue liquid while residual salts sink down. In this huge painting the blessed rise and the damned are dragged downward. Soaring up the end wall of the chapel, right into the arched heights where it abuts the vaults of the ceiling he had decorated decades earlier, this fresco pictures salvation as the power to rise, to fly. It is an image that recalls Michelangelo's drawing of Ganymede borne upward by an eagle. He has completely abandoned the traditional scene of the Last Judgement, where the risen dead stand in a crowd to be judged. Instead, as graves open at the left of an earth reduced to its barest elements, those whose souls have any chance of salvation start to float upward, towards the blue heights of Heaven where Christ rules majestically with an arm raised in judgement. Up there, saints stand on clouds, beholding with wonder their creator. But not everyone makes it. The earthbound and base cannot take off. They are shoved straight into the boat of the demonic ferryman Charon who, grimacing hideously, drives them with his oar out onto the other shore, where devils hustle them towards the blazing cavern of Hell. The snake-enfolded Minos, judge of Hell in *Inferno*, the first book of Dante's *Divine Comedy*, which Michelangelo knew by heart, waits to allot each of the damned a fitting punishment.

As the rest of humanity attempt to rise, not everyone is deserving. Devils fly up and attempt to pull down the ascending nudes, grabbing the legs of those who do not possess true grace, dragging them back down. One man covers half his face in horror as he is arrested by the claws and clutches of demons who act as a dead weight on his climb, dooming him. Half good, half bad, his good eye grieves as he covers his wicked one.

Michelangelo's vision is a reimagining of this central Christian

image. It is not a cold Judgement we see but the experience of the souls themselves, clothed in their resurrected flesh. His sculptor's sense of gravity, of weight, attains its most sublime insight. The experience of blessing or damnation is conceived here as an ability to move upward, or a sinking down, pulled by demonic arms. As in his love poems, Michelangelo echoes Plato. The eloquent Socrates in Plato's *Phaedrus* explains that souls are meant to soar: 'A finished soul, meaning a soul that is winged, flies aloft [...]'

The celestial ascent of that part of humanity that is saved is again pure *Divine Comedy*, in which the pilgrim Dante must ascend Mount Purgatory and from there fly towards the heavenly spheres. But Michelangelo in this painting gives philosophical ideas a subjective personal quality. The personal, expressive courage of *The Last Judgement* is obvious to anyone who starts to count how many male nudes wheel and spin up there in the painted blue.

All depictions of the Last Judgement involve nudity. At the last trumpet, the graves will open and the dead will be resurrected in the flesh. Like the dry bones the prophet Ezekiel saw enfleshed by the Lord, the skeletons in graves will have skin and muscle and faces again. Michelangelo shows this process taking place. But his nudes who rise towards Heaven or are thrust out of Charon's boat, not to mention the saints themselves on the clouds, display a muscular, glorious nudity all their own. Michelangelo fills the sky with male bodies revolving, rolling, diving and gliding in free space. Where his *Prisoners* are trapped in the rocks of the earth, the nudes in *The Last Judgement* have the liberty of the sky. They are free. As they turn in space they reveal mighty backs, immense buttocks, and undisguised penises. At least that was Michelangelo's intention. Many anatomical details were concealed after his death by unlikely tongues of drapery that appear from nowhere conveniently to cover up flesh. Modern restorers, astonishingly, chose to leave a lot of these censorious coverings in place. The Catholic

Church has fretted about this work for more than 450 years, and still does. Michelangelo's *Last Judgement* is the painting that took the Renaissance a nude too far.

The trouble started, reports Michelangelo's friend and biographer Giorgio Vasari, as soon as the pope came to see the painting. Pope Paul was impressed, of course, but his master of ceremonies, Biagio da Cesena, piously commented that it was wrong to paint so many nudes in the Sistine Chapel. Michelangelo replied by giving the demonic judge Minos, whose body is half-man, half-serpent, the face of Biagio. But he could not silence the murmurs of the prudes.

Pietro Aretino was an unlikely censor – but he was looking for personal revenge. Still stung by Michelangelo's lack of interest in his advice nearly ten years previously, the pornographer dipped his pen in holy poison. In 1546 he fired off a letter to Michelangelo in which he attacked his former hero for filling the pope's chapel with nudes. The following year he sent a letter along the same lines to Alessandro Corvino in Rome, secretary to the pope's kinsman Duke Ottavio Farnese. He has seen a print of *The Last Judgement* and it reminds him of the noble grace of Raphael – yet even the compliment is barbed:

> [...] as for its being Christian, I look at his licentious brushwork and shrug my shoulders amiably.

Aretino, who was once hounded out of Rome for his sonnets appended to Giulio Romano's pictures of sexual positions, now adopted the voice of an easily offended Christian. He knew how to take revenge. How, he asks, can Michelangelo have done this painting

> where the reverend priests and the vicar of Christ, with Catholic ceremonies, sacred rituals and prayers, come to confess, contemplate and adore His body, His blood and His flesh?

This great Michelangelo

> not only ignores decorum in the martyrs and the virgins; but
> shows genitals and virile members in such relief that even in
> the brothels they'd make one close one's eyes in shame – they
> are more suited to the walls of a voluptuous *bagno* [. . .]

Aretino's hypocrisy is a marvel. He himself imagined, in his
Dialogues, that Nanna lived in a convent with obscene frescoes. He
wrote of nuns enjoying pornography and orgies. Michelangelo by
contrast was a serious Christian setting forth the Last Judgement
in a moving and inspiring way. But Aretino traded in gossip. In
denouncing Michelangelo's male nudes he dredged up every
rumour about Michelangelo's sexuality. The man who wrote
supposedly 'platonic' love poems to male youths was filling the
Sistine Chapel itself with his fantasies, implied Aretino:
Michelangelo must remove his embarrassing homoerotic
excesses, replacing

> the virility of the blessed with the rays of the sun, and the
> manhood of the damned with flames of fire.

The Last Judgement was the first great painting to fall foul of a reli-
gious revival that was to transform the Catholic Church and the
culture of Italy. Aretino cunningly aimed his noxious words at
influential leaders of the Church, who, in response to the
Lutheran threat, were starting to rethink the very place of art in
religious reverence. For centuries churches had been lavished
with beautiful paintings whose piety was taken for granted. The
luxury and magic that art added to church interiors enhanced
the excitement of religious worship. But now the sensuality of
Renaissance art was starting to trouble a new breed of Roman
Catholic – as Christians loyal to the pope would in the future be
called.

The protest launched by Martin Luther at Wittenberg had transformed much of Europe. Luther's own Protestantism (using another modern term) was outstripped by the Protestantisms of Zwingli and Calvin. All were dismissed by the papacy as 'heretics'. Yet by the 1530s it was clear that the heretics were not going away and the Roman Church needed to criticize itself – and change – if it was to survive.

The Reformation had already made art a religious issue. Radical Protestants scorned the decoration of churches as vain and godless idolatry. No one got to Heaven by worshipping pretty paintings and statues of the Madonna. Shrines such as that of Our Lady of Walsingham in England were destroyed. Statues of the Virgin were smashed. Yet in Rome, in 1541, Michelangelo was parading a wallful of nudes in his staggering version of *The Last Judgement*. Were Catholics being naive in giving their enemies such lewd ammunition?

On 13 December 1545 a General Council of the Western Church held its first meeting at Trent in the Tyrol. The Council of Trent was to rethink the basics of the Roman faith and lay the foundations of an internal reform, known as the Catholic Reformation or 'Counter-Reformation'. At the heart of this Counter-Reformation was a reaffirmation of the traditional Catholic belief that people have the power to save themselves through prayer and good works. The Council totally rejected Luther's claim that humans are too sinful ever to be forgiven except by God's random grace. Instead it declared that proper religious observation, under the leadership of the Catholic clergy, and virtue in the community can redeem us sinners and fit us for Heaven. The grace of God can and must be earned. In 1547 the seven sacraments of the Church – seven steps to the salvation of the individual, beginning with baptism – were affirmed by the Council.

The final session of the Council of Trent took place in 1561–63, and by the time it closed the Catholic Church was

moving towards an official theory of art. Nudity was no longer welcome in churches. Art commissioned for holy purposes must be truly holy, in ways that satisfied the Jesuits, inquisitors and pious art experts who now challenged the free thinkers of the Italian Renaissance.

It wasn't just that nudity in art was frowned upon. As Catholicism purged and renewed itself, ascetic, saintly behaviour was extolled and old ideas about the filthiness of the flesh were expressed again. Cardinal Baronius shared St Paul's views on the sinful flesh: he called the human body 'an untameable wild beast'. Unveiled before the Council of Trent, Michelangelo's *Last Judgement* was not so much a victim of these ideas as a goad that incited them.

As the Council of Trent was starting its deliberations and the culture of sensuality that still flourished in Rome was at its zenith Michelangelo met Titian at the Belvedere Palace in 1546. Titian was finishing the first of his three versions of the myth of Danaë. This first *Danaë* is a scintillating, ecstatic painting. As she reclines on a bed of white sheets and bolsters, Danaë looks up, her face shadowed, at a cloud of gold that is mystical and sublime: like a shimmer of light in the mosaics of St Mark's in Venice, it hints at the divine presence.

In this image the Venetian painter – like Michelangelo – bestrode flesh and spirit. It was also a homage to Michelangelo himself – or an act of rivalry. Danaë is posed with her thigh raised like Michelangelo's *Night*, but the lustful eye of Titian makes her much more of a living woman. Michelangelo said kind things to Titian about his painting, reports Vasari, who was there, 'as one does in the painter's presence'. But as they walked away he criticized it to Vasari, telling him that Titian would be a great artist if he knew how to design his pictures properly. Perhaps he was stung by Titian's transformation of one of his own ideas.

This moment was full of significance. Even as the Catholic

Church faced the task of purging itself, Titian was finishing a very erotic nude painting in the pope's palace in Rome. The man he was painting it for was none other than Cardinal Alessandro Farnese, the grandson of the reigning Pope Paul III. It has even been claimed that *Danaë* was modelled on the Cardinal's mistress, a courtesan called Angela.

Michelangelo's *Last Judgement* and Titian's *Danaë* stand together as Roman triumphs on the eve of the Counter-Reformation. The sensuality and freedom of these works is the true spirit of the Renaissance that was about to come under attack. In 1564 Michelangelo died and his body was taken to Florence to be buried. In Rome, his pupil Daniele da Volterra was instructed to paint shrouds over the offending parts of his nudes on the Sistine's altar wall. The veilings exhibit a prurient obsession with Michelangelo's sexuality as they cover up 'licentious' buttocks.

The Counter-Reformation was to revolutionize Italian art. For one thing it gave careers to faith-based artists whose misty lacrymosities would never have got them within miles of a commission in Italy's recent golden age. They churned out paintings totally lacking in dynamism and vitality, such as Federico Zuccaro's *Angels Worshipping the Trinity* in the church of the Gesù in Rome: angels kneel below the symbol of the Trinity, glowing in empyreal light, sans drama, sans humanity. In Federico Barocci's *Madonna of the People*, painted in 1574 for the Lay Brotherhood of Santa Maria della Misericordia in Arezzo, a soft-focus Madonna and a sweet-faced, hippy Christ float in a gold Heaven above a crowd of gentle, innocent-eyed men, women and children. It is lacking in anything the least bit impious or interesting. Barocci's style was perfect for the new Catholic age, and hugely influential. Had piety sucked the life from Italian art?

Chapter Fourteen

PAOLO AND THE INQUISITION

He put on his best doublet and hose. His beard was freshly trimmed but he positioned a mirror in a gilt frame so as to get a good view of his chin and carefully pulled out a few wild hairs. It was as if he were meeting his mistress, he thought to himself, so keen he was to look his best. And that set him thinking about the woman at the banquet, her inviting eyes. Perhaps tonight … For now, he put on his darkest, most respectful-looking cloak and headed out into the streets. He was glad he looked like a proud gentleman of Venice; he was ready to meet the Inquisition.

Even in Venice the new age of devotion had its adepts. The art of the Venetian painter Jacopo Robusti – known as Tintoretto – burns with true faith. Tintoretto, who was born in 1519 and died in 1594, strove for an intense, visionary religious aesthetic. He employed dramatic, rushing perspectives, leading the eye into immensities of imagined space, and a golden, inner light to reject any attempt to show the world as it looks and instead unveil a spiritual dimension beyond everyday perception. The fascination of his works comes from his use of Renaissance techniques to achieve an anti-Renaissance art. Perspective, atmospheric light and anatomy, all developed in the Renaissance to make the world look real, become for Tintoretto the means to explode conventional perception. In his painting *The Removal of the Body of St Mark*

from the Funeral Pyre, Venice (substituting for Alexandria) becomes a ghostly city where a flaming orange sky is riven by lightning: in the storm light, the body of St Mark is carried aloft while a dizzying foreshortened space holds a city of panicking people fleeing the wrath that boils up in the sky.

In the 1560s as the religious ideology of the Counter-Reformation took shape Tintoretto decorated the Albergo of the Scuola Grande di San Rocco in Venice with stupendous sacred paintings in vertiginous perspectives and hallucinatory light. St Rocco, to whom the Scuola was dedicated, was believed to offer protection from plague. Tintoretto's great venture, in the expressive hues of Titian's late paintings, was an act of faith. For him, wanton portrayals of classical myth were ridiculous. In his painting *Leda and the Swan* a ravishing Leda reclines on a bed, with crimson silk curtains and a violet sheet, holding her swan by its wing. In fact she has to hold it tight: this swan behaves like a wild animal, not a god. Leda is merely a woman going to bed with a swan. To make it clear that Tintoretto is accusing her of a sex crime, a servant offers Leda another choice of animal: a duck in a cage. A cat is also hanging around. Leda in this painting is not embracing Jupiter but engaging in perverted bestial frolics. It is a parody of erotic art by a painter who would rather glorify God than the flesh.

Tintoretto nevertheless gave the owner of his Leda a well-painted nude to look at. In his stupendous painting *Susanna and the Elders* he laces beauty with a twist of doubt. Susanna thinks she is alone in a garden, dipping her foot in a pool as she gazes at herself in a mirror. Her clothes lie beside her. The untied dress and pearls are spread on the ground, while she dries herself with a white cloth. A comb and perfume bottle rest on the dark grass. They are in the shadow of a concealing wall of plants and flowers, while she is caught in a shaft of light that touches her bare skin with silver radiance. She is supernaturally graceful, but she does not know she is being spied on. Two old men peep around

the leafy fence: one in the distance and one up front rolling his head past the barrier. It is a surreal scene of grotesque voyeurism. The beholder of the painting, savouring the beauty of Susanna, resembles these bearded fools. Even as he creates one of the most gorgeous of all Venetian nudes Tintoretto interrupts the pleasure with disquiet. Is it sinful to be looking?

The sensuality of Venice did not go down without a fight. Even as Tintoretto painted his visions of salvation, his contemporary Paolo Veronese took on the Inquisition itself to speak up for artistic hedonism. In 1573 this rollicking painter got in trouble with the Church for painting a *Last Supper* that looked scandalously secular and sleazily alcoholic.

In Veronese's painting *The Feast in the House of Levi* a fantastic banquet takes place under the three arches of a dining loggia against a sky spectral with palaces and spires. It is a truly splendid occasion. A hearty, well-dressed company sit at a long table that is covered in a white cloth and laden with game and fruit and wine, which they enjoy from stylish forks off pewter plates. Servants replenish their glasses from carafes of crystal-clear Murano glass, basket-covered bulbous bottles and a golden bucket: there seems to be a sophisticated choice of wines on offer, to judge by this array of serving vessels. Other servants offer dishes bearing new courses to delight the taste buds – the feast is not some gluttonous guzzle but an urbane round of gourmandizing as the guests make conversation and barely acknowledge the well-trained waiters. As the diners continue their cultivated talk, a stylish bearded man in green offers his greeting – this is Veronese himself, in a self-portrait that puts him at the heart of the fun.

Veronese was not born to such refinements. He started his life humbly in Verona in 1528. Yet by the time he completed this sprawling banquet scene – a canvas no less than thirteen metres wide – in April 1573, the churches and palaces of Venice and its surrounding villas were stuffed with his spacious, poised, airily

confident paintings. Today this vast work fills an entire wall of the Accademia Gallery in Venice. The green-clad artist lightly leads our eyes, with his outstretched hand, towards its title inscribed on the painted architecture of the open hall: 'FECIT D. COVI MAGNUM LEVI – LUCA CAP. V.' It is a reference to the Gospel of St Luke: 'Levi held a great banquet for the Lord.' At the centre of the banquet Christ himself is seated. This is the token religious element in a painting that is a hymn to pleasure.

The inscription and title this painting carry today were not part of its original conception. Veronese's corruption of his brief to show the Last Supper was disgraceful enough for the local Roman Catholic Inquisitor, Aurelio Schellino, to summon the artist to explain himself. Instead of demonstrating remorse, however, Veronese was calmly defiant.

This summons to appear before the Inquisition in Venice was a crisis in a dazzling career. In 1556 the Republic of Venice commissioned seven up-and-coming artists to paint three roundels apiece in the heavy gilt-framed ceiling of the Sala d'Oro in the Library of St Mark, across the piazzetta from the Doge's Palace. To this day, Veronese triumphs over his competitors in this golden room. In his circular allegory of *Music*, a chamber orchestra of women perch on a marble ledge overhead playing a lute and bass viola and singing, in a painted architecture dominated by an overhanging statue of a satyr, while a nude graces the scene for good measure. It is a visual entertainment that creates an illusory dream world above the spectator. Looking up at this small yet woozy painting it is not hard to believe the old tale that Titian judged the artists and gave a gold chain of victory to Veronese. Their friendship is confirmed in Veronese's vast painting *The Wedding Feast at Cana* – another banquet scene of overwhelming virtuosity. Here a band of musicians sit right in front of Christ, playing to amuse the assembled cast of high-living Venetians. The musicians are portraits of eminent artists.

Veronese himself plays the viola da braccio, Jacopo Bassano the viola and Titian – thin, bearded and robed in red – the bass viola. It is at once a proud and playfully modest image of painting as a profession: the job of these artists, like the job of musicians at a banquet, is to entertain and delight, to provide the background, the setting, for life. It is life itself, not art, that Veronese gives centre stage.

Veronese, *The Wedding Feast at Cana*. This sprawling scene of social life is a homage to the pleasures of Venice.

Even in one of his very first works in Venice, the sacristy ceiling of the church of San Sebastiano, his ability to open up a space with illusory perspectives is exhilarating. The ceiling of this small room is quite low; yet Veronese's paintings of the four evangelists in a heavenly atmosphere of luminous cloud pierce the overhead barrier and seem to be windows on a loftier world – so near, so far. At the start of the 1560s Veronese decorated the Villa Maser, one of a new wave of luxury rustic retreats along

the Brenta Canal near Venice. It belonged to the Barbaro broth-
ers, tasteful experts in architecture and the classical heritage. At
the Villa Maser he and the architect Palladio play like musicians
in harmony. Veronese's illusionistic paintings – of a young
woman and her nurse looking down from a balcony, and the
Gods of Olympus seated in the heights of a ceiling apparently
opening into a cloudy dome – add a fictional dimension to
Palladio's building. This is a place where it's hard to tell the real
doorways from the painted ones.

Like Veronese, Andrea Palladio – who was born in 1508 and
died in 1580 – came from an unprivileged social background: his
father was a miller in Padua. He worked his way to architectural
mastery by way of stonemasonry, like a medieval craftsman. His
wife was a carpenter's daughter. Yet his vision of architecture
was utterly aristocratic. Like a grand patriarch among plebeian
fawners, the white dome of his Venetian church the Redentore
lords it over the humble houses that flank it on the Giudecca
Island; there, from the approaching boat from St Mark's, it seems
to float on the water so close has it been built to the limit of its
thin strip of land. Unencumbered by rivals, appearing suspended
between sea and sky, the Redentore is the purest triumph of the
obsession with geometry that haunted Renaissance architects.
This church is as neat as a toy building made of symmetrical
blocks: it is a pure-white assemblage of smooth columns and
pilasters, triangular pediments and exquisitely placed statues.
Palladio's training as a stonemason is apparent in the exact cut-
ting of each component. The dome's mounting from below is
perfectly circular; the dome itself a perfect hemisphere.

In his villas Palladio uses this same geometrical perfection to
create a sense of grandeur and freedom. His architecture
expresses the liberty of the Venetian governing class – his patrons.

Veronese pays homage to Palladio in the balustrades, galleries,
loggias and piazzas that are the scenery of his theatrical paint-
ings. In *The Wedding Feast at Cana* he decorates the sky with a vista

of classical columns in different orders – massive red Doric in the foreground, white Corinthian further back – that comes straight out of Palladio's architecture. Palladio's vision of a totally classical Venice went unrealized: his design for a stone Rialto Bridge in a rigorously ancient Roman style was greatly altered by the city architect Antonio da Ponte to create the arching arcade crowds flock over today. Yet in Veronese's paintings Venice becomes a Palladian Utopia of loggias and light, where people live for pleasure.

Why so many 'buffoons, drunkards, dwarfs, Germans and similar vulgarities'? The Inquisitor's question cut through Veronese's art like a vandal's knife. All that joy, play, civilized splendour and love for the colours of Venetian life that makes his paintings such satisfying dishes – and all the Inquisition could see at his interrogation in 1573 was an obsession with lowlife. Clearly, the Inquisitor had not just been looking at one painting. Veronese's questioning followed a succession of painterly spectacles that seem to drown piety in social abundance. In his paintings of martyrdoms in the Venetian church of San Sebastiano, the colourful costumes, dynamic poses and idiosyncratic faces of the crowds distract from the martyrs' sufferings. In his masterpiece *The Wedding Feast at Cana*, the presence of Christ at a marriage feast becomes an excuse for a riotously detailed depiction of sixteenth-century Venice at its most unrestrained. *The Wedding Feast at Cana* portrays a contemporary dinner (albeit it in oriental fancy dress) where sexual tensions are comically explicit. Along an entire row of the white-clothed table laden with low-edged, antique-style silver dishes of fruit, a drama of lust is being played by three couples. As the man closest to us accepts a glass of wine whose shallow fragile basin is mounted on an exquisitely slender stalk, dextrously proffered by an African boy, his beautiful wife or mistress in a white and grey dress is ogled by the man next to her whose

face is red with lust and alcohol. Meanwhile he is watched with dark-eyed rage by his wife or companion in orange, with pearls in her bronze hair, who is in turn looked at with interest by a man much younger than her husband as he listens to a North African diner whispering in his ear. In the meantime an elderly man in an absurd phallic yet soft hat turns towards that conversation, perhaps himself admiring the youth, while his young and pretty wife picks her teeth in boredom. The fork she uses symbolizes the tool their relationship lacks.

This is a Biblical scene painted for the monks' refectory at Palladio's church of San Giorgio Maggiore, across the water from the Doge's Palace. In addition to the sex comedy at Christ's table, this painting is replete with entertainers, servants and incident (after all, Veronese had a canvas almost seven metres tall and nearly ten metres wide to fill). On a rooftop in the distance, young people, including a woman in a low-cut dress, enjoy the lute music of love. The wife of the wine connoisseur stared at lustfully by the red-faced man is also contemplated with lascivious interest by a jester in cap and bells. A dwarf holds a blue-green bird ready to release it for a joke; a cat drinks from a marble wine flagon; teams of waiters dance around with food and drink; someone's lapdog wanders about on the table.

In comparison with *The Wedding Feast at Cana*, painted in 1562–63, the *Last Supper* that got Veronese into trouble a decade later is a milder affront. For one thing, this is mostly a male-only affair, reflecting to that extent the Biblical story of the Last Supper. Even so, a female dwarf makes an appearance. So does a male dwarf, whose pilfered plate of treats a servant demands back, while pikemen eat and drink their supper handed down from the table, and a red-robed host sits grandly near Christ. Such details, recalling the splendid *Wedding Feast at Cana*, are at odds with the sobriety of Christ telling his disciples that one of them is about to betray him. Certainly they were more than enough to anger the Inquisition. The man in red they saw as the

inn's unholy-looking landlord. The soldiers they saw as German mercenaries – and therefore Protestants. Maybe the Inquisition saw the entire emphasis on drunkenness as German and Lutheran. At this laddish supper, vast quantities of booze are being served.

Veronese defended himself fearlessly. The Inquisition did not scare him: Venice had always guarded its liberty from the Church as much as from rival powers. The painter spoke out for artistic freedom:

> We painters take the same licence the poets and jesters take [. . .] If in a picture there is some space to spare I enrich it with figures [. . .]

Painters are like poets – and also like jesters. You should allow them the prerogative of the genius and the fool.

The Inquisition ordered him to revise the painting at his own expense. All he did was change its title. It became a picture of Levi giving a banquet for the Lord, with the inscription that is on it today. In quoting Luke's Gospel he is still arguing with the Inquisition. Pleasure can be holy, he insists.

Veronese was on good behaviour in religious commissions after his encounter with the Inquisition. His late works for churches are models of what was now seen as appropriate – no dwarves or drunks. But he was free to indulge the senses in paintings to decorate houses. His painting *Mars Undressing Venus* dates from about 1580, eight years before he died. It is a magnificent autumnal hymn to sexuality as the armoured and red-faced Mars sits next to Venus under a tree, against a flaming sky. She looks maternally at Cupid playing while Mars artfully undoes her robes to reveal her breasts, exchanging a look with the beholder that is tender and almost tearful as he unveils the beauty of love.

*

Did the Counter-Reformation destroy the sensual art of the nude and put an end to the amorous capers of the pagan gods? The answer is no. Instead it separated religious art, which was regulated with a new stringency, from the art of the palace, where the pursuit of pleasure carried on regardless. The scandals of Michelangelo's *Last Judgement* and Veronese's *Last Supper* were controversies about what should and should not be painted in churches. Even in these sacred settings the tumults had ambiguous results. *The Last Judgement* still soars in all its foreboding in the Sistine Chapel, albeit made decent by draperies. Veronese's renamed painting of *The Feast in the House of Levi* decorated Santi Giovanni e Paolo in Venice until the maritime republic was conquered by Napoleon. The makers of the new Catholicism were not merely prudes and Inquisitors. As the cultured art lovers and talented artists of Italy turned their minds to God, the art of the Counter-Reformation developed a dynamism of its own. The glorious spatial energy of Michelangelo and Veronese anticipated what was soon to come. Swirling frescoes of aureate clouds and angelic hosts would transfigure the domes and vaults of churches in an art of holy magnificence that owed plenty to those masters of grand theatre.

The fact that it was Pietro Aretino, the most notorious pornographer in Europe, who cynically accused Michelangelo of making the Sistine Chapel look like a brothel is a clue to the fragility of the censorious side of the Counter-Reformation. He was mimicking the pettiest kind of prudery. He didn't mean it and he certainly did not speak from the heart of the Counter-Reformation movement. In reality the idea of religious art that emerged from the Council of Trent was positive, not negative. The Catholic Church did not want less art. It wanted more: powerful, moving images and grand sweeping spaces that communicated with large crowds of people. The Council of Trent in its last session in December 1563 said that art must be used to

educate and involve the poor unlettered masses in religion. It decreed that

> through the stories of the mysteries of our Redemption shown in paintings or other images, the people should be instructed and confirmed in habitually remembering, and continually turning in their minds the articles of the faith.

Art must teach the people. Paintings must make everyone – not just learned intellectuals but every man, woman and child of every education and none – think about 'the articles of the faith'. This is a bold manifesto for a popular, visceral art. It calls for art to grab hold of the imagination and refuse to let go. Shock, spectacle and emotional manipulation are the order of the day. Even the naked body has a place in this art – so long as it is in pain. Bloody, battered, tortured bodies of the saints haunt the recesses of later sixteenth- and seventeenth-century Italian and Spanish churches, portrayed in paintings and rendered as lifelike full-coloured statues, sometimes seen in glass coffins, or spattered with imitation blood.

As early as 1565, with the ink still wet on the decrees of the Council of Trent, the Emilian artist Lelio Orsi demonstrated the power of horror to capture the imagination of the people with his painting *The Martyrdom of St Catherine*. A near-naked woman lies on top of a fiendish-looking machine with gears and levers designed to inflict agony and death. The nude, the intensely imagined human body, endures – as a helpless suffering thing. This sadism – or rather masochism (for the beholder should identify with the saint) – brings a new kind of carnal imagination into Italian art.

In 1599 the body of St Cecilia was found in Rome. At least the corpse was pronounced to be this early Christian martyr. It was also pronounced to be miraculously preserved. Stefano Maderno's sculpture of her in the church of St Cecilia in Rome

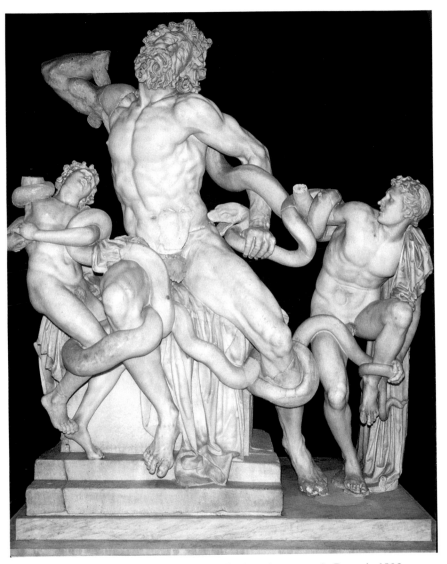

Laocoön, first century AD. The discovery of this ancient statue in Rome in 1506 was a seismic moment for the Renaissance. In his *Dialogues*, Pietro Aretino compares the Laocoön's expression to the face of a priest at a convent orgy.

Hans Holbein the Younger, *Christina of Denmark*, 1538. Henry VIII of England fell in love with this painting, but Christina preferred not to join his list of divorced or beheaded wives.

Bronzino, *Lucrezia Panciatichi*, about 1541. Sultry passion bursts out of the frozen pose of this fascinating portrait. 'Splendid as she is, one doubts if she was good', as the novelist Henry James put it.

Titian, *Venus and Adonis*, 1553–54. This painting of love's anguish reached its owner, Philip II of Spain, when he was in London with his new bride, Queen Mary I.

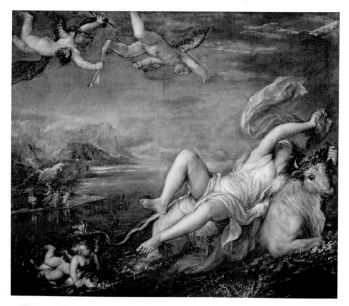

Titian, *The Rape of Europa*, 1559–62. The origins of Europe itself are imagined to have begun in a dangerous sexual encounter in this blazing vision of ancient myth.

Michelangelo, *The Last Judgement*, 1536–41. The colossal gyrating nudes in Michelangelo's greatest painting flew straight into a gathering storm of prudery.

Titian, *Danaë*, 1544–45. The grandest of nudes receives Jupiter in the form of a shower of gold in a painting that simultaneously jokes about prostitution and visualizes the divine.

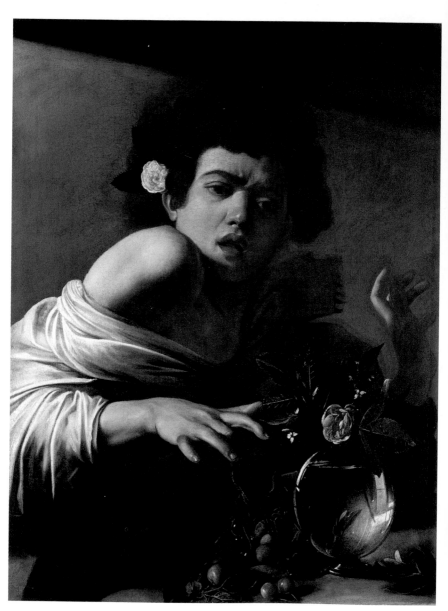

Caravaggio, *Boy Bitten by a Lizard*, about 1595–1600. The boy's sins go beyond stealing fruit in this painting whose half-length format and floral imagery recall the courtesan portraits of early sixteenth-century Venice.

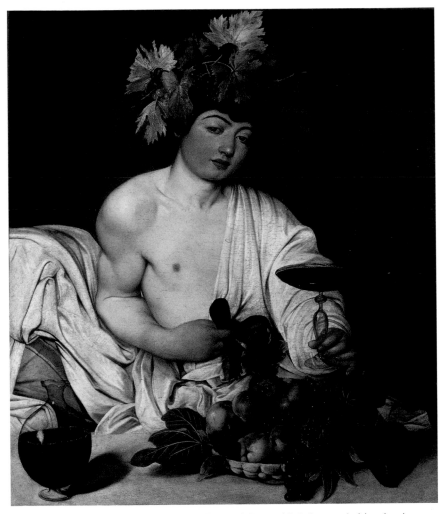

Caravaggio, *Bacchus*, 1596–97. The wine-god fingers his belt to undo his robes in a dangerous offer of ecstasy.

Gianlorenzo Bernini, *The Ecstasy of St Teresa*, 1644–47. The carnal quality of the ascetic saint's bliss has always astonished observers of this statue that uses sex to sell God.

was carved in 1600 to record the marvel. A young woman is lying dead in her tomb. The pure-white marble statue, glistening uncannily because Maderno chose such a bright clean piece of stone, is set back inside a recess as if a tomb has just been opened. She is wrapped in her burial clothes, yet her knees press against the white shroud and her bare neck twists as her head turns away. It is an unsettling encounter with beauty that is stone dead.

If perversity blossoms darkly in the passionate new religious art, the pleasures of courts continue on their merry course. The revitalized Catholic Church wanted to compel the imaginations of the people. No one could stop the wealthy and powerful enjoying nudity. Rich clients still wanted paintings of courtesans in their apartments even as they were paying for images of martyrs in church. In Genoa the artist Luca Cambiaso provided both. Genoa in the Middle Ages had been the rival of Venice for dominance of Mediterranean trade. The two cities, Venice on its Adriatic lagoon and Genoa pitched between steep mountains and the Mediterranean, fought wars with commercial domination as the prize. Venice won, but in the sixteenth century Genoese maritime skill was once more making waves. The Genoese admiral Andrea Doria played a crucial part in holding back the menace of the Ottoman navy and shaping a new aristocratic Genoese Republic. Palaces dominated the steep streets and narrow squares of Genoa as proudly as they lined the Grand Canal of Venice. In the mid- to later sixteenth century Luca Cambiaso frescoed villas and palaces for the Genoese elite and painted emotive religious works such as his *Martyrdom of St George* in San Giorgio, Genoa. But he also specialized in sensual nudes that are his best-known works outside his own city. In fact lusty paintings by Cambiaso can be found in galleries all over the world. His *Venus and Adonis*, painted in the later 1560s, shows a very crisply and brightly painted nude, her flesh almost silky. Another of his paintings, *Venus and Amor*, has a similar cool

sexiness – his Venus in both paintings is pictured as a contemporary model whose beauty is shown off by expensive jewellery. The same erotic luxury glints in a painting now attributed to his pupil Giovanni Battista Paggi that may have been painted as late as 1580.

Religious awe and sensual delight live side by side in the art of Annibale Carracci of Bologna. This gifted artist was born in 1560. Together with his brother Agostino and cousin Lodovico he set up an academy in the 1580s where they consciously pioneered a style of painting that reinvigorated the classical tradition. The brothers from Bologna painted moving altarpieces. Annibale Carracci's *Virgin with St John and St Catherine*, which dates from 1593, is a tremendously ambitious picture: the people in it are arranged in a towering pyramid, set in a grey stony alcove. Bright-red and gold robes are beautifully set off by a smoky atmosphere. The young Jesus stands on a pedestal, nude and revealing his penis, while Mary holds the child St John close to him. Echoes of Leonardo, Michelangelo and Raphael give authority to a painting that invites the faithful to share its mood of loving calm.

Christian art made Annibale Carracci famous in this religious age. Yet when he took his talent to Rome in the 1590s it was because Cardinal Odoardo Farnese invited him to paint pagan frescoes in the Farnese Palace. Carracci's ceiling paintings in this palace near the Tiber are among the most spectacular of all depictions of myth. In a soaring vault flowing with his warm tender colours, Bacchus and Ariadne ride a triumphal chariot surrounded by satyrs and amores, while nudes perched like Michelangelo's Ignudi look down from the heights and Ganymede is carried off by Jupiter. The Farnese Palace is just across the river from Agostino Chigi's villa, which itself became a property of the Farnese family. There in the early 1500s Raphael had painted the *Banquet of the Gods* while (it was said) his mistress looked on. As a new century dawned in 1600 the

Church proudly vaunted a new age of faith. Yet in Carracci's painted heights, to please a Cardinal, the pagans gods live on, and love.

In the late 1590s, when he had started work on the ceiling, Annibale Carracci decorated a harpsichord or some other keyboard instrument for Cardinal Odoardo's tutor Fulvio Orsini. These pictures from the Farnese Palace breathe an atmosphere of pleasure and wit. They portray the fat satyr Silenus, follower of the wine god Bacchus, and his followers enjoying themselves among vines that are fronds of fruity colour seen against dazzling gold space. Silenus and his helpers, two athletic youths who raise him up between them to grab a bunch of grapes, are all naked. Their pink flesh is set off by the sun-like gold. At another vine, a cupid climbs up to get the grapes – or is he a cupid? Like Donatello's bizarre sculpture *Amor-Atys*, created nearly 150 years earlier, this cupid has a tail. It protrudes just above his buttocks and is stiffened and pointed. Another cupid has a face of merry wickedness.

Another of Carracci's decorations of this same musical instrument portrays an old satyr, perhaps Silenus but probably Marsyas, watching a handsome youth as he plays the pipes. It surely recalls – and is meant to recall – an ancient Roman statue of goat-legged Pan making sexual advances to the pipe-playing youth Daphnis who belonged to the Farnese family. In other words, in the palace of Cardinal Odoardo Farnese, at the heart of Counter-Reformation Rome in the 1590s, these paintings make homoerotic jokes and conjure up a comic atmosphere of knowing debauchery. That does not mean gay orgies were taking place in the Cardinal's household. It does mean his artist and his tutor felt free to jest about such things.

It's an eye-opener into the reality of life in Italy during the Counter-Reformation. Sometimes the story of this religious revival is told as if its saintly leaders such as Charles Borromeo, Archbishop of Milan, and Ignatius Loyola, founder of the Jesuit

Order, succeeded in remaking every soul in the Catholic world. Perhaps if you spend long enough in the Gesù, the grandiose, oppressive church in Rome consecrated in 1584 for the new Jesuit order, it can seem that official faith and everyday reality completely merged in this period. Life is never that simple. Sexuality does not die because asceticism grips a culture. In the great historical novel *The Betrothed* (*I Promessi Sposi*) written by Alessandro Manzoni in the Romantic age, St Charles Borromeo features as a heroic character in a tale of young love thwarted by society. But so do professional thugs ('*bravoes*'), nuns forced into convents by cynical fathers and local bigwigs who eye up beautiful villagers. Manzoni tries to imagine the complexity and ironies of a real historical world, where the relationship between ideals and realities is never simple or predictable – especially when it comes to the private and difficult stuff of love and sex.

In the court of love, no one is mastered by doctrine. Catholic Italy had long known and accepted this. Raphael's love life was never an obstacle to his fame as a religious artist. How much did this now change? In the late sixteenth century the Counter-Reformation papacy sought to confine the prostitutes of Rome to their own 'ghetto', the Ortaccio. They were also ghettoizing the city's large and longstanding Jewish population. But there was no decline in prostitution in Rome. Courtesans could still become famous. This was after all the heart of Catholic Christendom, a magnet for single men, with a ratio of sixty men to every forty women. The city of the popes had always been full of pent-up men ready to pay for sex – and it still was.

In the Counter-Reformation new celibate orders were born, including the Jesuits, bringing still more earnest men to add to the testosterone surplus of Rome. Meanwhile, even the most saintly of religious experiences could be questioned. In 1619–23 the Abbess of a Tuscan convent was on trial. She had experienced visions and seemed a hero of rhapsodic faith. Yet the trial found against this supposedly holy 'Sister Benedetta Carlini of

Vellano [. . .] Who pretended to be a mystic, but who was discovered to be a woman of ill-repute.'

Veronese told the Inquisition that artists take the licence of the poet and the joker. He was gracefully defiant, an unlikely hero whose cultivated persona gave him the panache to face down his would-be censors. In the decades that followed, secular art still flourished in palaces and sensuality still gratified aristocrats, including those who wore cardinal's hats. Venus and Bacchus did not step aside for Christ.

Chapter Fifteen

CARAVAGGIO: FORBIDDEN FRUIT

He was a war-weary soldier in a defeated cause. Rome was a refuge and a holiday. Here he could put the roar of cannon and clatter of hooves behind him and linger over melancholy fragments of broken statuary. His name was Richard Symonds. He was a scholarly man, shy and retiring. When civil war broke out in Britain in 1642 he tried to stay out of it, but in the end everyone had to take sides. He had served as a cavalryman in the army of the king, and now here he was in Rome – the king having unfortunately lost his head. It was eerie to think of that, walking in these Italian palaces among so many paintings of the beheading of Holofernes, the beheading of John the Baptist.

Then he saw the boy.

In his travel diary of his visit to Rome, the sometime-soldier Symonds wrote that he had been shown a painting of Cupid by Michelangelo Merisi da Caravaggio. His guide told him a story about it. The model, it seems, was the artist's boyfriend, who 'laid with him'.

A strange fragment of information, refracted by history: a story told about an artist's love life, translated from Italian into seventeenth-century English, written down as a curiosity by a man on the run from war and politics. And yet it is one of those sudden shafts of light that brilliantly illuminate the past.

*

Sunlight is held in a vase in Caravaggio's painting *Boy Bitten by a Lizard*. It congeals like something trapped. If light can ever be said to rot, it rots. The oval bulb of the vase is filled nearly to its top with water, and in the water hang green flower stems. At first sight the effect of light in the water, seen through glass, is simply radiant. But look closer and it is radiantly weird. The water is discoloured: it is warm and slightly stagnant. A thick, bubbly, stilled-liquid world arrests and poisons all light that enters it. This water is like the dusty atmosphere of a room on a hot afternoon. In it the reflection of a window reveals either a lowered blind or a yellow sky. The vase stands on a table-top. Around it, fruit lies scattered. Pink cherries shine on the side that catches the light. Purple cherries skulk in shadow. The hand that reaches for them has filthy fingernails. Brown, even bloody ridges of collected dirt darken each nail where it slides under the skin. At the fingertip ends of the nails, more dirt festers. This unwashed hand, this impure hand, stretches its fingers to snatch a sweet succulent cherry – and freezes in pain. A tiny lizard that lay hidden in the fruit is biting a mucky finger.

The boy who hoped for pleasure and got pain furrows his brow between black trimmed eyebrows. His lips part in a silent utterance of fury: the air feels electric with unheard profanities. He is starting back, his unbitten hand raised in a gesture of alarm that resembles those of the disciples in Leonardo da Vinci's painting *The Last Supper*. His entire body hunches and twists as he jerks his head backward, with a ferocity that is much more ungainly than any pose created by Leonardo. The boy's nose is greasy, his hair a mass of curls. His lips are as purple as the cherries on the table. They are full, blood-filled lips that look made for kissing. The top lip is shaped like Cupid's bow. His bare shoulder rubs close to his face as the sun brightens a curving silvery pool of skin on his upper arm. The boy has undressed. The misdeed that got him into trouble is not just an appetite for cherries. Having discarded his proper clothes, he wears just a white

sheet that falls around his elbows. This is tied by a reddish belt of cloth with a bow that flutters in the shadows. In his wild hair he has a flower, pink and delicate in contrast to his expression of nose-wrinkling disgust.

It is impossible to look at this painting without being shocked and excited. That naked shuddering shoulder demands a gut response. For some hypothetical onlooker who might study the painting with nothing but cool judgement, it is an allegory of sin: a picture of a miscreant whose crime brings punishment. But has that onlooker ever been born? How many people can look at this painting in such a sterile way? Its pool of deep colour is queasily seductive. It tempts the witness into accepting the glamour of an exposed shoulder – so that to look at the bitten boy is in some sense to be bitten. The painting itself offers pleasure, and produces pain: the pain of self-consciousness.

That is the meaning of the poisonous water in the vase. This painting is a reflection in infected liquid. It lures you in, and submerges you in its world of harsh dangerous eroticism.

That is, it submerges you in Caravaggio's world.

In the 1590s the young Michelangelo Merisi, whom everyone called after his home town, Caravaggio (in Lombardy, northern Italy), was trying to make it in Rome. At the time he painted *Boy Bitten by a Lizard* he was pursuing an extreme, desperate strategy. He was selling paintings through a dealer. Selling pictures! Art was rarely bought on the open market in the sixteenth century. Artists worked to commission; they had patrons and protectors. They certainly did not aspire to sell paintings through a dealer in a shop. But Caravaggio was in dire need.

Michelangelo Merisi was born in 1571. He trained as a painter in the Lombard capital Milan, but it was a provincial and second-rate education. It gave him just one special skill. The Milanese were good at painting flowers, fruit and vegetables.

Caravaggio turned up in Rome in the winter of 1592–93 when he was in his early twenties. The city of holy patronage was packed with swaggerers who acted like great painters, sculptors and architects. He got a job with one of the best known at the time, the pretentiously titled Cavaliere d'Arpino, who set him to paint flowers and fruit in his workshop. How could young Caravaggio turn such a humble-seeming gift as still-life painting into the stuff of artistic glory?

The newcomer from the provinces had another problem: his character. He was violent, unsettled, unpredictable. He carried a sword and often a dagger, too – an inventory of his possessions in 1605 lists two swords and two daggers. Caravaggio's volatility cost him. He is said to have walked out of one lodging because he was sick of the monotonous food. His employment with the Cavaliere d'Arpino also came to an end soon enough. This was when Caravaggio started to sell paintings through a dealer called Maestro Valentino in a shop near the church of San Luigi dei Francesi. The church is still a landmark of the part of Rome known today as the Centro Storico, the old medieval town that grew up among the ruins of the ancient imperial city. In Caravaggio's day it was a densely populated human honeycomb. Ancient Roman buildings and statues still survived, incorporated into the life around them. The huge circular hub of the Pantheon, a temple to all the gods, stood on a piazza with a famous inn, overlooking an open space watered by a fountain. In the narrow streets all around, tall houses joined in continual facades interrupted by the classical rectangular blocks of aristocratic palaces. Maestro Valentino's painting shop was located between the Pantheon and the nearby Piazza Navona, a long open space that had once been an ancient Roman stadium. Now it ventilated the city like a lung. On a May night in 1598 a constable on patrol arrested Caravaggio near Piazza Navona for being armed with a sword and a pair of compasses. He was the kind of man who plagued these streets and squares at dead of

night, looking dangerous. The paintings he was making look dangerous, too.

When Caravaggio put his *Boy Bitten by a Lizard* on sale it had a buzz, like selling an actual person. The lad in the painting appears to be a prostitute. Like the courtesans in Venetian paintings of the early 1500s, he sports a flower. In paintings of female prostitutes, flowers recall the ancient Roman Floralia – the festival of Flora at which prostitutes put on lewd shows. Caravaggio knew that imagery of flowers very well. In a portrait of the courtesan Fillide Melandroni, which because it was destroyed in Berlin in the Second World War is less well known than his other works, he had her hold the standardized symbol of her profession: she poses with a bunch of flowers. Caravaggio's *Boy Bitten by a Lizard* also signals his availability with flowers.

Caravaggio stalked the streets around Piazza Navona more like a criminal than a painter. He was part of the lowlife of the great city. The seventeenth-century writer Giulio Mancini claimed that his painting *The Death of the Virgin* was rejected by the church it was intended for because Caravaggio portrayed a dead prostitute as the Virgin. She lies on a bed, her grey feet naked, her hard life over; and, tellingly, among the grief-stricken disciples there is a woman friend sitting realistically by her bedside. This could easily be what Mancini says it is – the true record of a prostitute's deathbed. It may be a personal act of mourning. In 1605 Caravaggio got into an argument over a woman called Lena, described in the court records as 'Caravaggio's woman'. Yet in his earliest paintings, such as *Boy Bitten by a Lizard*, it is young men who fascinate him.

The youth in his painting *Boy with a Basket of Fruit* might be on his way to a street market. But what is he selling? The fantastic display of succulent grapes, apples, plums, peaches and pomegranate seeds enfolded in his arms is tempting to any eye. Caravaggio jokes, or seriously seduces us into accepting, that the youth's bared muscular shoulders are just as desirable. This lad

is tasty, the painting says. The boy is perhaps an actual market worker. As he holds the heavy basket stuffed with flavour and colour, the painter admires his strong body. The boy knows what is going on. His face is dreamy and abandoned: he confronts the onlooker with a melting readiness.

Caravaggio is taking a risk, braving an accusation. He was 'fearless' – as wrote the seventeenth-century artist and artistic biographer Giovanni Baglione, who knew him. Is it possible to really believe that, in the Counter-Reformation Rome of the 1590s, an artist painted homoerotic masterpieces as a scurrilous taunt?

The key to Caravaggio's meaning, in his paintings of male beauty, lies in his relationship with the masters of the Renaissance – and their bold eroticism. He learned the rudiments of art in Milan, where Leonardo da Vinci once lived and worked. The raised hand of his voluptuary youth bitten by a lizard is reminiscent of the eloquent gestures in Leonardo's *Last Supper*. In fact, the shape made with his left hand by Caravaggio's model is virtually the mirror image of the raised right hand of James the Greater in this wall painting in Santa Maria delle Grazie in Milan. It's a tell-tale detail that reveals a serious knowledge of Leonardo's masterpiece. When the teenaged Caravaggio wasn't getting into trouble, he must have spent quite a lot of time staring at Milan's greatest work of art. Even his mesmerizing depictions of fruit and of glass vessels containing water echo *The Last Supper*, its table-top laid with a meticulously rendered meal that includes bread, orange slices, peaches, glasses and carafes.

There were many paintings by Leonardo's followers in Milan. Many of these Leonardesque paintings of St John the Baptist and Narcissus were blatantly homoerotic. If Caravaggio went around Milan thinking about Leonardo, he could easily pick up the quality of eroticized male beauty and soft sensual reverie that perfumes works like Salaì's version of *John the Baptist*,

still in the city today. For that matter *The Last Supper* itself
includes the androgynous figure of John, a sensual beauty at the
table of Christ. All of this young Caravaggio could take as
permission.

Yet his early paintings exhibit a still stronger affinity.
Caravaggio's first biographers in the seventeenth century com-
pared him with the Venetian master Giorgione. Like Giorgione
and other Venetian painters, they said, he painted directly on
the canvas in colours, with his model before his eyes. He did
not design his pictures on paper – not a single drawing by him
has survived. Giovanni Pietro Bellori claims in his 1672 book,
The Lives of Modern Painters, Sculptors and Architects, that
Caravaggio visited Venice, which is after all not that far from
Milan:

> [. . .] and after certain clashes he fled from Milan, and came
> to Venice, where he very much appreciated the colouring of
> Giorgione, which he decided to imitate.

This is a fascinating story because Caravaggio's paintings of
good-looking young men are like shaken and stirred, reversed
and reinvented versions of the paintings of 'beauties' that
Giorgione and his contemporaries painted in early sixteenth-
century Venice. For a start they share the same format, the
'half-length' – a painting that depicts the top half of someone.
Giorgione, Palma Vecchio and Titian found this size of painting
just right for their enticing portraits of courtesans. This format,
of course, resembled the view a prostitute might offer to passing
men from her window: one such painting by Palma Vecchio
actually includes the window. And, just like those women in
Venetian paintings, Caravaggio's boys bare their shoulders. The
draperies that fall to uncover the arms and chests of his youths
are just like the white shift of Palma Vecchio's Flora that falls to
reveal her nipple.

The similarities between Caravaggio's male beauties and the female beauties of the Venetian artists are exact. There is no doubting the eroticism of those Venetian paintings and precious little room for doubt that they portray courtesans. Caravaggio makes the genre more treacherous and uneasy by picturing males in this traditionally feminine genre. He goes further still: in one of his first paintings, done in the first half of the 1590s, he himself is the model showing a muscular shoulder as he looks back at the beholder. He has vine leaves in his hair and a bunch of grapes in his hand. He is the wine god Bacchus, lord of ecstasies, but he is sick. His skin is almost green, his face wizened. His life of gratification is ruining him. The black grapes and yellow apricots on the grey stone lintel in front of him are an invitation to become as sick as he looks.

Caravaggio's come-on worked. His paintings found buyers in the gallery near San Luigi dei Francesi. They particularly impressed Cardinal Francesco Maria Bourbon del Monte, the cultured spokesman for Medici interests at the papal court. Del Monte had two palaces in the Centro Storico, the Palazzo Madama – today home to the Italian Senate – which was conveniently close to the gallery where he saw Caravaggio's paintings, and the Palazzo Firenze. Soon Caravaggio was living in one of them, probably Palazzo Madama, as part of the cardinal's fifty-strong retinue. Bellori says he joined the cardinal's company of 'gentlemen', suggesting a very male community. He was protected. When he was arrested for carrying a sword around in 1598 Caravaggio boasted of his status:

I was arrested yesterday at about two in the night between Piazza Madama and Piazza Navona, because I was carrying my sword as usual; I am the painter of the Cardinal del Monte, and get a salary for myself and my servant, and lodge in his house.

Was Cardinal del Monte, in modern terminology, gay, and was that why he fell head over heels for Caravaggio's painted boys? He was characterized by one seventeenth-century writer as a lover of men. Art historians who wish to see in Caravaggio a respectable religious artist have dismissed this as calumny. Yet Cardinal del Monte was far from narrow-minded. He loved both art and science – he even had his own alchemical laboratory. He was to be a courageous champion of Galileo. This doesn't say anything about his sexual identity. It does, however, portray him as a freethinking, open-minded intellectual. Del Monte was advanced in Rome by Ferdinando de' Medici, ruler of Florence. He got his cardinal's hat at Ferdinando's request when Ferdinando renounced his own cardinalate in 1588 to become Grand Duke of Tuscany. Within a year of leaving the Church the new master of Florence and its region was married, and he went on to father eight children.

To judge from how easily he returned to the world, Ferdinando de' Medici was one Counter-Reformation churchman for whom being cardinal was the civilized day job it had always been for younger sons of top Italian dynasties. Cardinal del Monte was very much his man. He loved earthly beauty – and that shows in the paintings Caravaggio did for him.

Out of one of them a young man watches us softly, his eyebrows ebony curves, a gauzy white scarf tied in his curly hair, his eyes gentle, his red lips parted in song. His slight hands hover on the strings of a lute. He gracefully holds its bulbous wooden body and long neck in front of the pale chest that is exposed by the white robe he wears. Light falls on him as he sings and plays, illuminating too the vibrant arrangement of flowers in a vase on a table where books of music and a second instrument lie among scattered fruits. It is a painting of love. There is no symbol of love so universal and, let's face it, clichéd in the Renaissance as the lute: it is the instrument that Giorgione played, the essential accessory of every lovelorn youth. This

young man plays his lute for del Monte, who was apparently passionate about music.

In another painting for del Monte, four musicians sit in heady disarray. One shows his naked back, another looks at the beholder from a face flushed with colour and with an expression teetering on ecstasy. A third, behind them, also turns to look into the eyes of the painting's owner. The fourth, naked behind a velvet drape as he reaches down to pluck a grape, turns out not to be a musician at all: he is Cupid, his black wings hiding in the shadows. The god of Love himself has joined this all-male music party in a cardinal's palace. It would be perverse to deny the blatant hedonism of these paintings.

Yet in the end, the sexuality of a late Renaissance Cardinal is not very interesting. The sexuality of Caravaggio is. Far from painting his sensuous early works to titillate others, Caravaggio painted them to please himself. Paintings such as *Sick Bacchus*, *Boy with a Basket of Fruit* and *Boy Bitten by a Lizard* are sensational documents of artistic freedom. Caravaggio was a poor and unknown man in 1590s Rome. As such nobody seemed to care what he painted or if he painted anything at all. He could explore his own wild impulses – and he did.

Bacchus offers the wine. Purple, it lies in a shallow glass bowl. Perfectly circular ripples radiate across its dark surface. The stem of the glass has an impossibly slender upper part, bisected by a disc-like bulge, flowing – as the glassmaker stretched it in the hot workshop – out of a long tapering bulb. Through this crystal-clear bulb you can see, smoked and moistened by refraction, folds of the white linen draped over his left arm, as he holds the root of the glass delicately between thumb and fingers. His hand is creamy, except where flushes of blood redden finger nails and the skin under which they press. Below the raised wine glass, fruits are massed in a cornucopian display. Leaves sprawl over the edges of the bowl, their crispness gone, their flopping forms

on the verge of shrivelling yet still, for now, kept alive and emer-
ald by their bright structuring veins. A pomegranate lies there,
split open, revealing a red fleshy interior of bloody seeds.
Opened so far, it won't last long. Black grapes spill over the edge,
green grapes glitter one side of a thick, massive pear and on the
other dully nestle by an apple that a worm has penetrated. With
his right hand he fingers a black ribbon that is knotted in a bow,
which looks as if it might be part of the presentation of fruit
until you notice how its black band continues under his white
sleeve and realize that it is a belt.

His fingers are poised to undo it. Half his torso is already
exposed, the chubby flesh of his hand and creased skin of his
bent elbow rising to a muscular upper arm and prominent shoul-
der blade. All this is seen with the same limpidity as the slowly
vibrating wine. A brown nipple nestles in the softness of his
chest, near the secret hollow of his armpit. His face is pink, rud-
died by the vintage: it is round with a wide, plump cheek turned
to us. His lips are large and strongly coloured, the upper lip once
again shaped like a bow, with the slightest of gaps between it and
the ample cushion of the lower lip. His eyebrows are long, man-
icured and deepest black, as is his hair under its crown of
autumnal leaves. The sable pupils of his eyes look straight out of
the painting, with an offer and a challenge.

The shock of Caravaggio's *Bacchus*, painted in about 1596–97
when he was living in Cardinal del Monte's palace, lies in its still-
ness. Apart from that trembling wine there is no movement, but
the painting offers no repose. Bacchus contemplates the beholder
familiarly yet coldly. He is offering but not giving. To complete
the drama the spectator must act. It is not to a fictional charac-
ter in a story that Bacchus makes his silent, immobile gesture of
holding up the wine glass. It is towards us, and he is painted with
such living, bony, imperfect reality, on such a human scale, that
it is impossible not to respond to this picture as a living fact. The
stillness allows the skin and cool regard of Bacchus to sink into

the mind's eye, the physical presence of him to become real. It allows the black eyebrows to make their quizzical suggestion. Bacchus is neither theatrically languid, nor teasingly suggestive. On the contrary he is tough and cold and his invitation as tangible as a sword drawn in the night.

Artists had been painting and sculpting Bacchus since the early days of the Renaissance. In Michelangelo's statue of him the wine-god is drunk, his eyes scarily out of focus. In Titian's paintings of Bacchic stories for the Duke of Ferrara the god's followers tear beasts apart with their bare hands and roll in drunken bliss. These artists try to find visual analogies for the ecstasies and irrationalities Bacchus brings. By contrast, Caravaggio makes Bacchus look self-possessed as he offers the wine. He is in control: it is the person he is looking at who is in danger. This is a new way for a work of art to relate to the world it is in and it is why the sex life of Caravaggio's paintings matters so much. If the sensual promise or threat of this painting is ignored or denied, its power to hold and shake is diminished. Bacchus is about to undo his gown. It is an explicit gesture. What do you feel about it?

It is not the detailed verisimilitude of Caravaggio's paintings that makes them real. That only makes them realistic. The explosive quality of his art has to do with its unprecedentedly severe demands on the people who look at it. These pictures call out to us, absorb us, seem more real than other art because they draw our minds into an engagement that is like the one we make with living people: they thrill and terrorize as real events thrill and terrorize. Sexuality is fundamental to how Caravaggio achieves this electrifying involvement.

Caravaggio's supporters among the cardinals and aristocrats of Rome cared about one thing: his genius. The sins that came with it were forgivable.

Cardinal del Monte's attitude to his discovery is preserved forever in a work that he sent to Ferdinando de' Medici as a gift.

Either on his own initiative or at del Monte's suggestion, Caravaggio in about 1597–98 created an object that the cardinal presented to the Grand Duke of Tuscany in a subtle homage to the art of Florence. It is a circular convex shield, on which the face of a monster floats in serpentine gory horror. Caravaggio has painted the severed head of the mythological Medusa on the shield. Simply to see this gorgon with snakes for hair was a death sentence, for the sight of it instantly turned the observer to stone. The Greek hero Perseus tackled Medusa by looking only at its reflection in his shield; he killed it and took the head in a bag to use as a magical weapon to petrify his enemies. What does Caravaggio show us? The bodiless head of the monster seems to gaze at its own reflection, with a shock that is forever frozen on this shield. Its horror is Caravaggio's own: for he was the painting's model. He sat in front of a mirror, contorting his face into a scream, portraying his own gaping mouth and self-revolted eyes. The turbulent painter contemplated himself and saw a monster.

It is the stuff of nightmares. Yet it is also the stuff of art. At the time Cardinal del Monte made his gift to the Medici ruler of Florence, the Medici collection was famous for possessing a painting of Medusa's gory head by none other than Leonardo da Vinci. This painting, long since lost if it ever was a real Leonardo, is described by Giorgio Vasari in *The Lives of the Artists*. In the seventeenth century it was replaced by a version falsely credited to Leonardo that was still catalogued as his authentic work at the start of the twentieth century. Vasari tells another story. As a youth in Florence, he says, Leonardo da Vinci made a monster out of bits of snakes, bats, insects and other bizarre creatures then painted its portrait on a round shield. Caravaggio's painted shield manifestly alludes to this legendary creation by Leonardo. Caravaggio too has decorated a buckler – and, where the Florentine master modelled his painting on a monster he sewed together, Caravaggio has painted snakes from

the life, writhing on his own head. As a gift for the Grand Duke of Tuscany this macabre shield pays tribute to the most famous of all Tuscan artists. Yet it is also an act of competition with the 'celestial' Leonardo, as Vasari calls him. Caravaggio is claiming to be a new Leonardo. He too can fashion marvels. He too is prodigious.

This painting reveals that in his own eyes and those of his supporters Caravaggio was a reincarnation of the greatest artists of the High Renaissance. In a Rome overcome with mediocrity here was genius reborn – with a vengeance. This is not simply a case of his learned patron imposing a comparison on Caravaggio – a '*paragone*', as such standoffs were known. As we have seen, Caravaggio was very familiar with the work of Leonardo da Vinci. In one of his very first paintings, *Boy Bitten by a Lizard*, he alludes to *The Last Supper*. So it is perfectly possible that he himself came up with the idea of rivalling both Leonardo's monster shield and his painting of Medusa's head in a single, devastating image. If so that means he must have read Vasari's *Lives of the Artists*. By the 1590s this entertaining, heroic account of the great Renaissance artists was famous all over Europe. Its second and definitive edition came out in 1568 and brimmed with gossip. It projected a new idea of the artist as more than a craftsman, as a creative original.

Caravaggio's *Medusa* is grisly proof of his genius – and that is what it is intended to be. For Caravaggio himself, and for Cardinal del Monte, the biographies of artists written by Giorgio Vasari provided a template for how an artist should work and live. Caravaggio claims in this painting to be a divine creator like Leonardo. That means he also claims – and clearly in the eyes of del Monte deserved – the licence and freedom of great artists. For Vasari makes it clear that Leonardo loved men and boys, that he doted on the long curly hair of his young assistant Salaì. If we need to know how Caravaggio could get away with his daring sexual images in Counter-Reformation Rome, here is the answer.

He convinced his supporters and fans that he deserved the same freedom as Leonardo with his Salaì.

While he was living in the Cardinal's palace Caravaggio painted pictures not just for him but for an influential circle of eminent art lovers. By the summer of 1601 he was no longer del Monte's man but had his own house in a narrow alley close to the piazzas where he liked to strut about with his sword. One of Caravaggio's first biographers in the seventeenth century was Giovanni Baglione, a painter of distinctly second-rate abilities whose *Life* of his rival is an act of vendetta. In the early 1600s he and Caravaggio competed for commissions in Rome, and Baglione's bitterness at losing out shows in his account of Caravaggio's success. This upstart duped the city's elite, says Baglione. His works were 'praised to the skies by evil people [*maligni*]'. The Marchese Vincente Giustiniani was one of his fans: 'Caravaggio got hundreds of scudi from this gentleman.' Another was Cardinal Scipione Borghese. This enthusiastic collector gave a demonstration of his belief in the artist's right to experiment and defy strict religious rules when he bought a painting by Caravaggio that was rejected for its original sacred purpose.

The *Madonna dei Palafrenieri* is a painting drenched in darkness. Caravaggio developed rapidly as an artist, his 'quarrelsome and fearless nature', as Baglione called it, enabling and even forcing him to embrace extremes. When he got his first commission for a Roman church, to paint scenes from the life of St Matthew in San Luigi dei Francesi, right at the heart of his own territory, Caravaggio astonished everyone with an inky, shadowed style out of which dramatically illuminated bodies and faces glimmer. Baglione rages in his biography at the crowds and 'commotion' these paintings generated in the church. Caravaggio's radical use of blackness and deep shadow is yet another extraordinary response to the art of Leonardo da Vinci. In Milan when he was

a teenager he could look as much as he liked not only at *The Last Supper* but also Leonardo's second version of *The Virgin of the Rocks*. This altarpiece includes some of Leonardo's most experimental uses of 'chiaroscuro', the suggestive manipulation of shadow. It makes profound use of darkness, even depicting the Virgin's body within her robes as a black void. Caravaggio must have thought long and hard about this masterpiece, because soon after establishing himself in Rome he abandoned his initial floral style and instead unveiled a startling transformation of Leonardo's shadow-play.

Caravaggio's paintings, with their extreme contrasts of brightness and blackness, are like seeing the moon in the night sky. Perhaps this analogy is telling. Cardinal del Monte was an enthusiast for astronomy – did Caravaggio ever peep through a telescope?

His great work *The Calling of St Matthew*, one of the pictures that drew crowds to San Luigi dei Francesi in 1602, portrays a group of gallants and *bravoes*, like the streetwise types he himself moved among, huddled over money at a table as if counting the profits from a mugging. The room they are in is high and dim. A grimy window offers little light. Yet as Christ points at the man he wants, a shaft of bronze enters above him and illuminates faces in the dark.

The same reality that makes Caravaggio's sensual paintings so naked makes his paintings of Christian saints and stories among the most moving in Western art. Caravaggio was the perfect painter to fulfil the Council of Trent's demand for crystal-clear art in churches to teach the people and make them contemplate the Catholic message. In Protestant regions of northern Europe the Bible was by now widely read in vernacular translations: the King James Bible, which gave earlier English versions a new literary splendour, dates from 1611. In Italy by contrast vernacular Bibles were banned from lay households by the Church. This Counter-Reformation act of censorship meant that paintings in

churches were at the heart of how laypeople absorbed religious stories. Caravaggio's hyper-lucid way of making his art seem not a fiction but a real event is a gift to the Church's popular story-telling.

In Santa Maria del Popolo in Rome his painting of St Peter being crucified upside down is a mysterious encounter with suffering. As three workers struggle to raise the cross to which they have already nailed the elderly disciple, he looks at the iron spike driven through his left hand. His eyes contain anger, resignation, astonishment, melancholy, pity. The light from above that falls on his near-naked body and singles out this scene from the enfolding darkness is particularly bright on his face. Caravaggio makes us study it and then makes us see what St Peter sees, for we like him are forced to see the reality of that nail, the metallic fact of what is being done here. Yet our sympathies also go to the poor men employed to do the hard work of martyrdom. One is hunched under the wooden cross, using his body as a lever, while another pulls hard on a rope to raise it. Neither of their faces can be seen. Only the third executioner reveals his face, as he ponders the expression and nailed hand of St Peter. There is compassion in his eyes, a wrinkle of self-doubt on his illuminated forehead – his head is lit, his mind. He is examining his conscience.

The executioners of Christ and the martyrs are conventionally depicted as out-and-out villains. In Titian's painting *The Crowning with Thorns*, which was in Santa Maria delle Grazie in Milan when Caravaggio lived in the northern city, Christ's torturers are muscular ciphers: all empathy is directed at the suffering Christ. Caravaggio takes a dramatic leap by making them ordinary men whose labour and even thoughts worry the onlooker. These are people like you, he reminds the humble churchgoers of Rome, and people like me. Even the cruel are human. The most evil acts may be done by decent people to pay the rent.

In Caravaggio the religious needs of the Counter-Reformation stimulate not crude gore-fest martyrdoms or sentimental portraits of saints but an art that illuminates the human condition. In his *The Entombment of Christ* the eyes of Nicodemus look out of the painting as he holds up the grey legs of his Lord's lifeless body. Those eyes are urgent, interrogatory. By 1602 Caravaggio held the gaze of Rome as a religious painter. Did he now set aside his youthful dalliance with the erotic? Did sex vanish from his works, driven out by sacred themes? Nothing could be further from the truth. It was when he was in the midst of his religious master-pieces that Caravaggio was to create his most sexually explicit pictures of all.

The searchlight of Caravaggio's imagination could not be filtered by decency. Even as he became the most authoritative religious artist in Rome his paintings pushed at the limits of Church approval. Again and again his images were judged inappropriate. Even in his first church commission at San Luigi dei Francesi he hit the invisible screen that divided exhilarat-ingly vital religious art from insulting coarseness. His painting of *St Matthew and the Angel* showed a balding saint with bare legs who is almost touching the angel revealing God's truth. It was rejected by his religious patrons. The new version that Caravaggio painted has a decently robed Matthew, with no knees showing, communing with an angel who hovers at a safe physical distance from him. Caravaggio's painting *The Death of the Virgin* was also rejected for its heartbreakingly blunt factual portrayal of the dead. The Church wanted holy art to look real, but not this real.

Caravaggio painted the *Madonna dei Palafrenieri* in 1605–06 for a confraternity, a type of lay religious brotherhood that became increasingly important in Counter-Reformation Italy as a means of organizing lay devotion. The painting was commissioned for the Palafrenieris' chapel in St Peter's itself, the most prestigious

basilica in the entire Catholic world. It was rapidly removed from there and sold to Scipione Borghese.

It portrays a standing Mary holding the child Christ as together they stamp on the head of a snake. They are crushing Original Sin. Mary's mother, St Anne, looks on darkly, as she does in drawings and paintings by Leonardo da Vinci. But the scandal of the painting is Christ's nudity. As he stamps out sin, Christ shows his infant penis. The light beaming into darkness falls on his tall figure and, equally strangely, on Mary's bulging breasts. Again it is too real to be quite holy. The best of Caravaggio's seventeenth-century biographers, Giovanni Pietro Bellori, commented that it was

> removed from one of the minor altars of the Vatican Basilica because of its vile depiction of the Virgin with the nude [*ignudo*] boy Christ [. . .]

Bellori wrote that the painting could be seen at the Villa Borghese in Rome. It is still there today, four centuries on. This luxurious villa with its superb art collection vouches for the aesthetic sensibility of the man who built it. Cardinal Scipione Borghese was the nephew of Camillo Borghese, who was elected Pope Paul V in 1605. His magnificent house on Rome's Pincio Hill was ultimately modelled on the villa of Agostino Chigi down by the Tiber. The Borghese family had one rule for public art, another for private art. In 1603, before he became pope, Camillo Borghese reactivated a law insisting that every work of art for a church must get an official permit. While he strengthened religious censorship, his art-loving nephew bought Caravaggio's 'offensive' altarpiece for his personal collection. A villa is not a church, and elite eyes do not need the same protection as those of the common people.

Caravaggio's religious paintings experiment with the nudity the Church wanted to eradicate from sacred spaces. His *Rest on*

the Flight to Egypt pictures Mary asleep, her child blissfully resting in her arms, in a lush, almost Titian-like landscape. As she slumbers, her husband Joseph has a sweet encounter with a naked angel. The angel is playing music for him, while he holds the score open. This angel is a boy with only a few swathes of drapery orbiting his golden body as he turns his back to the onlooker. It is incongruous and impossible to ignore, this column of bare flesh dividing the picture. In another early religious painting, Caravaggio shows St Francis swooning in the arms of a near-nude male angel who looks down at him lovingly. But his most sexually charged holy painting of all happens to be a brash personal revelation.

Caravaggio's *St John the Baptist*, painted in about 1602, presents a naked youth embracing a ram. He sits in the wilderness – at least that's the official location suggested by a rapidly painted clump of leaves in the foreground. Yet he rests his bare bottom on comfortable fur among red and white sheets that belong more to a bedroom in Rome than a desert in the Holy Land. As he rests an arm among the bed linen, he stretches out his nude body in a dramatic, languorous posture, which Caravaggio's raked lighting dramatizes. Bright-gold light dwells on the long bent leg nearest the beholder and lands on the raised thigh behind it. Brighter, sun-blinding light hits his thin back as he stretches his right arm around the ram with its hard coiled horns. The subtlety of Caravaggio's light is nowhere more ravishing, as a cool shadow falls on the youth's stomach and on his penis.

Caravaggio boasted about his artistic heritage just as blatantly in this painting as in his painting of Medusa. His portrayal of St John has a predecessor in Leonardo da Vinci's sensual *St John the Baptist*. Caravaggio could easily have seen versions by Leonardo's imitators in Milan; if he did, he would know the theme's homoerotic potential. Yet it is not only Leonardo whose homosexual reputation he remembers here.

The pose his model adopts is derived from one of Michelangelo's Ignudi on the ceiling of the Sistine Chapel. Four decades after Michelangelo's altar-wall Sistine nudes started to give the Church the shivers, Caravaggio ostentatiously revisits Michelangelo's heroic male bodies. He does so in a way that is unequivocally erotic.

The taunt of this painting is obvious in St John's face. He looks over his shoulder, out of the painting, with a cocky, mischievous, conspiratorial grin that shatters the genteel illusions of art. His face is as real as an artichoke. It wrenches us out of the art gallery and deposits us in Caravaggio's bedroom, with his boy who laid with him. As clearly as any artist in history, Caravaggio here depicts his own nocturnal companion.

Caravaggio, *Love Victorious*. This painting shocks and discomforts the museumgoer, even more than Donatello's *David*.

Love casts everyone down and demands absolute obeisance. This is the message of Caravaggio's painting known as *Amor Victorious*, or *Love Victorious*, or just plain *Cupid*. Painted in about 1601–02, it is a uniquely unnerving work of art. As a reproduction in a book, it may seem to be just another painting. But keep looking at the reproduction in this book. Cupid's penis is framed between silvery thighs, their bare flesh made real by light. The same intense illumination, opening up the dark, that enables Caravaggio to make the suffering of St Peter such a demanding fact makes this youth's body a dangerous truth. His genitals are not the actual centre of the painting yet Caravaggio skews all eyes towards them. As well as the triangle of Cupid's thighs, they are set off by the silvery drapes on which he is sitting.

His toenails are grubby. All Caravaggio's people, from the *Boy Bitten by a Lizard* onwards, have dirty fingernails, toenails, and where they can be seen, the soles of their feet are dusty and grimy. This puts them in the streets, on the piazza. They are tough, poor, working-class Romans, including prostitutes both male and female. This character is no angel – and no Cupid either. He is not a god. His wings look stuck-on. In a rare detail of Caravaggio's daily routine, the painter Orazio Gentileschi told a court in these years that he had recently lent Caravaggio a pair of wings. Always his angels look like boys wearing wings, and you can even see how they are balanced on ladders to look as if they are flying. This winged youth does not fly. His power is not in his wings or even in the arrows he clutches. It is in his flushed grin, his eyes boldly confronting the onlooker, his insouciant display. As in Caravaggio's portrayal of unmistakably the same model as St John, his knowing, barbarous grin is what makes his nudity so terrifyingly sexual.

To look at the original painting in an art gallery is awe-inspiring and uncomfortable. Caravaggio and his boy collaborate to disconcert anyone who comes into its magnetic field. *Love Victorious* proves the truth of what it depicts. The array of objects of

art and virtue at Cupid's feet, scattered like the emblems of achievement in Dürer's print *Melencolia I* (surely yet another early sixteenth-century work that Caravaggio knew well), match these words of submission to love in the last of Virgil's *Eclogues*:

Love conquers all: and we too must bow down to Love.
[*Omnia vincit Amor: et nos cedamus Amori.*]

The painting makes anyone who encounters it recognize the untameable nature of the erotic.

It was in front of Caravaggio's *Victorious Love* that an Italian told the English diarist Richard Symonds, in 1650, that here the artist portrayed his studio boy Cecco, who 'laid with him'. There is no reason to doubt that story when we see the same grinning, adolescent face in Caravaggio's paintings of Cupid and St John the Baptist. There is another piece of evidence that makes the nature of Caravaggio's relationship with this model explicit – and this does not come from decades later.

When Caravaggio's frustrated rival Giovanni Baglione saw *Love Victorious* he painted his own very pointed reply. In Baglione's *Divine Love Overcoming the World, the Flesh and Devil*, done in about 1602, an armoured angel steps between a naked Cupid and a swarthy nude devil who has plainly been acting improperly towards the young love god. The angel who stops this satanic sodomy wears armour even on its legs to avoid any impropriety.

Baglione showed the painting in an exhibition held every August in the courtyard of a Roman church, and apparently sold it to Cardinal Benedetto Giustiniani – brother of Marchese Vincenzo Giustiniani, who owned Caravaggio's *Love Victorious*. Caravaggio and his friends understood what he was getting at, and started blackguarding Baglione in return. Obscene verses satirizing him and his paintings began to appear. Anonymous insults were a recognized cultural ritual in Rome, where they were often credited to the ancient statue nicknamed *Pasquino*. But

Baglione had no doubt who was behind these particular *pas-quinades*. He sued Caravaggio and his associates for libel: at the trial in September 1603 the painter Orazio Gentileschi made it clear this was all somehow about Caravaggio's portrayal of the invincible god of love. He told the court how Baglione exhibited 'a Divine love to rival an Earthly Love by Michelangelo da Caravaggio'.

This obviously means Caravaggio's black-winged amorous tyrant. Even though it was not considered as good as Caravaggio's painting, said Orazio, the mediocre Baglione received a gold chain for his pious riposte from Cardinal Giustiniani. He seemed to be suggesting that Baglione's moral posturing paid off. But he added that he, Orazio, criticized Baglione's painting to his face:

> This picture was very faulty, as I told him, for he had made a full-grown man in armour, when it should have been a naked child; so later he made another, which was completely naked.

Baglione's second version of his painting gives the angel of Divine Love a bare leg, making it look a little less ridiculous. But in case this might weaken his meaning, he adds a savage satirical detail. The devil whose sodomy has been stopped by the messenger of Divine Love now turns in frustration and terror to show his face. It must have been recognizable to contemporaries (it is plainly recognizable today from his self-portraits) as the face of Caravaggio himself.

The stand-off of the *pasquinades* and the libel trial, as Gentileschi revealed in his statement, revolved around Baglione's visual denunciation of Caravaggio. What he says in his painting, especially its second version, is crude and explicit: the boy Caravaggio painted as Cupid is his sexual partner. This painter belongs in the fires of Hell. He is a lascivious demon.

Cecco made another appearance in Caravaggio's art. In about 1603 he was the boy Isaac, portrayed here in *The Sacrifice of Isaac* not as a tough street kid but as a vulnerable child. His father, Abraham, holds him down on a rock and wields a knife ready to cut his throat. The knife glints; the hand pushing down on Isaac's neck is strong and irresistible. The young face pressed against the stone looks out of the painting and is vividly recognizable as the same boy Caravaggio pictured as Cupid. Now he screams: his mouth open, a hole of fear. His frightened eyes are slits of panic. What must it have been like to live intimately with Caravaggio?

Chapter Sixteen

LOVE AND HATE IN
BAROQUE ROME

The sword felt heavy in her hand. 'Hold it against his throat,' commanded the painter. 'Press it against the skin. And grab his hair. Pull!' And so she took a fistful of hair and pulled, while he lay there with the blade of the sword against his neck. The scene in the golden candlelight at last resembled the artist's dream.

In May 1606 the challenge that Caravaggio had for years been offering on the streets around Piazza Navona finally found a taker. Ranuccio Tomassoni died after a game of tennis that descended into a brawl. Swords were drawn and Caravaggio stabbed his opponent decisively. Soon Tomassoni lay dying while Caravaggio himself was bleeding. Once his wounds were bound he fled the city where his genius had shone so briefly and vividly. He was never to return to Rome. Over the next few years he would live a desperate Mediterranean odyssey that took him from Naples to Malta, where he was accepted into the order of crusading knights that ruled this rugged island. He seemed to have made a fine new start but soon got involved in a violent argument with another knight. He was thrown into prison in the harbour of Malta's heavily fortified capital Valetta – and some-how escaped. Having sailed the short distance to Sicily, he painted masterpieces in Syracuse, Messina and Palermo yet kept moving as if he had a hellhound on his trail. The Knights of

Malta were furious with him, adding to his troubles. He returned to Naples and was mysteriously attacked. Caravaggio died in the summer of 1610, while trying to sail along the coast to Rome. He seems to have collapsed after staggering along a sweltering shore to catch up with a boat that was carrying his luggage. It was a wretched end.

On Malta in 1608 he painted one last *Cupid* that is a strange lament for the hedonism he left behind when he was exiled from Rome. The grapes are gone, the grin is gone. This Cupid looks broken or sickly. He is an unconscious, deformed child. His hips appear feminine and out of proportion to his male chest. His black wings glimmer in the dark. A bronze light reveals ungainly contours and loose skin. Love is diseased.

Artemisia Gentileschi spoke courageously in the courtroom. Tassi was supposed to be teaching her to paint, in her father's house in Via della Croce in Rome, when he raped her. She fought back. She hurt him. Yet 'in spite of her strong resistance and the wounds she inflicted' this man who claimed to be a friend of her father succeeded in his attack. Artemisia Gentileschi was still a teenager, her assailant a man in his thirties. He bought her co-operation by claiming he would marry her. Soon she realized it was a lie and told her father. In his petition to the pope for justice, Orazio Gentileschi complained of the offence and injury to himself, including the loss of several of Orazio's paintings that Tassi tricked his daughter into handing over. But he did not shy from the nature of the crime. His daughter 'has been deflowered by force and known in the flesh many a time by Agostino Tassi, painter [. . .]'

For the teenaged Artemisia Gentileschi the resulting trial was a public humiliation and a physical ordeal. She was tortured with thumbscrews to verify her testimony. Tassi was there watching. She yelled at him: 'This is the ring you gave me! These are your promises!'

In her paintings she was to find a still more articulate and enduring way to tell the truth about men and women in the Europe of her time.

Artemisia Gentileschi was born in 1593. She went to court hoping for justice against her attacker in 1612, her nineteenth year. Her father was a noted painter and friend of Caravaggio – not so long ago Orazio had been in court alongside Caravaggio himself when they were both accused of libel. Now Caravaggio was gone, but his shadows and illuminations lingered. A whole gang of artists, much later to be nicknamed the Caravaggisti, were inspired to paint like Caravaggio. Some of them, like Orazio Gentileschi, had known him well. Others were simply stunned by the power of his images. Yet the rape of Artemisia Gentileschi reveals that it was not just the painterly radicalism of their hero that transfixed these artists. The short, sensual, violent life of Caravaggio inspired some of them to live dangerously, on the edge of a criminal underworld. Only a belief that artists are inherently disreputable characters could have convinced Orazio Gentileschi that Agostino Tassi was a suitable man to have access to his daughter. Tassi admitted in the courtroom in 1612 that he had previously been sentenced to a period as a galley slave. Other witnesses painted a horrific picture of him as a wife killer. He had been married in Lucca to a woman called Maria, it was claimed, and when she ran off he'd had her assassinated. Tassi's own sister had told a court the year before that her brother was 'a rogue and a wretch'. After the trial he was to be accused of further crimes, including beating up a prostitute called Pretty-Feet. Yet Orazio Gentileschi gave him the run of his house – but then Orazio himself was a tough character who had conspired with Caravaggio to insult an enemy.

The risk-filled life of the Caravaggisti is reflected in paintings by north-European artists who visited Rome in the early 1600s and were entranced by Caravaggio's art and milieu. Hendrick ter Brugghen was born in Utrecht in the Netherlands in about

1591 and reached Rome in the early 1600s when Caravaggio was still at work in the city. He lived in Rome for a decade. Years later, back in Holland, he was still painting lowlife images that recall his wild youth. *A Man Playing a Lute*, painted in 1624, portrays a toper, not a beauty. His red nose suggests he's a regular drinker, singing a raucous love song. Gerrit van Honthorst, born in Utrecht in 1592, also went to live in Rome and returned to Holland full of Caravaggesque ideas. His 1623 painting *The Merry Fiddler* is another representation of a boozer, this time holding up a glass to the onlooker. Yet these drunks are creative types: artists even, like the rowdy crew of Caravaggio's followers in Rome.

Sexual liberty was also part of Caravaggio's legacy. In about 1623 van Honthorst painted St Sebastian with his flesh penetrated by arrows. With its dramatic lighting that silvers the saint's nearly naked body amid a pool of blackness, this painting is manifestly a tribute to Caravaggio. It is also manifestly homoerotic. Honthorst shows Sebastian's body up close and personal, a pale and lifelike yet stilled form filling the picture's foreground. It is an intimate style of physical portraiture that Caravaggio pioneered in a picture of the ascetic Jerome. It makes the sexual undertones of this image very obvious. In fact this eroticized near-nude saint follows on from the Italian painter Guido Reni's *St Sebastian*, painted originally in 1616 or 1617 and also paying homage to the power of Caravaggio. Born in 1575 and probably trained partly by the Carracci brothers in Bologna, Reni is said to have known Caravaggio in Rome. In his *St Sebastian* he uses a Caravaggesque intensity of white flesh surrounded by darkness to heighten the vulnerability of a young man pierced by wooden shafts. Is this a homosexual painting? Oscar Wilde thought so when, as a young would-be writer on holiday, he came across Reni's picture in a palace in Genoa. One of Wilde's earliest written intimations of his own homosexuality can be easily recognized in his praise for this

lovely brown boy, with crisp, clustering hair and red lips, bound by his evil enemies to a tree [. . .]

This very same painting gave the Japanese writer Yukio Mishima his first orgasm when he saw a reproduction of it at the age of twelve.

The artistic subculture of Rome in the wake of Caravaggio was profligate and seedy but that was not the only reason Tassi thought he could rape Artemisia Gentileschi and get away with it. He thought she was fair game because she had stepped outside the narrow limits imposed on women by early modern society. Instead of preparing for marriage she wanted to be a professional artist. Her ambition made her a freak, an anomaly. In the courtroom Tassi had no trouble throwing doubt on her honour. The reason he thought his promise to marry her was meaningless, he and his friends claimed, was that he knew she had slept with at least one other man before him.

After the trial, her name mired in defamation, Artemisia Gentileschi decided to get out of Rome and work somewhere at a safe distance from the furore. She headed for Florence, where she painted a work that bleeds with pain and anger.

The enemy of God's people Holofernes lies on a bed whose white sheets are rumpled and ruffled in folds of linen beneath his bearded head. He lies with his head directly facing the beholder, upside down, looking out: his legs stretch away under a velvet covering that reveals a muscular arm and thigh in the yellow light pouring into an expanse of darkness. A mighty arm holds Holofernes's head down on the mattress, tipping it over the side, as with her other hand Judith saws at his throat with a gleaming sword. Her half-shadowed face looks impassive and determined as she hacks at this monstrous head. Her servant holds down his body, pushing her arms against his chest. Holofernes is strong, but two well-built women working together are stronger. He raises a fist to bat off his assailants but it is no use. They have

pinned him in just the right way to render him helpless. He is alive and conscious as Judith cuts into his neck and dark red arterial blood spurts in the air and runs in rivers down the white bed sheet.

This painting scared the Medici family who commissioned it so much that it was hidden away in a shadowy corner. Yet Artemisia Gentileschi believed in it and painted the scene more than once. In art at least she got revenge on her rapist. Her painting of Holofernes writhing as two righteous women cut off his head is a glowing, gory wish-fulfilment, a dreamlike fantasy of retribution.

Artemisia Gentileschi is a woman artist who answers back the men in this book. Her achievement is astonishing. In a world that made it almost impossible for women to become artists she not only triumphed in her profession but also succeeded in visually turning the world upside down. Her visceral painting of a man being killed by brave and virtuous women is literally an inversion of the social order that prevailed throughout seventeenth-century Europe. In the great chain of being men stood above women. In *Judith and Holofernes* women stand above an immobilized man. The figures of Judith and her servant are higher than Holofernes: they look down on him. They are armed where he is not. Lying on his bed, interrupted when he was at ease and vulnerable, Holofernes is being violated. It is Judith who wields the phallic instrument, the straight sword.

Is the blood that spatters the painting meant to make us think of the blood of deflowerment? Orazio Gentileschi told the pope that his daughter had been raped and her virginity stolen. Tassi claimed in court he knew she was already sexually active. In painting this ambitious history with its shocking personal echoes did Artemisia intend to assert that she was indeed a virgin who bled when Tassi attacked her? The bed sheets down which blood flows in red rivulets are gathered in a way that might be called vaginal.

Caravaggio too painted a sensationally real *Judith Beheading Holofernes*. Her face, as she saws through the neck of her victim, is thoughtful and patiently focused. She has a job to do and it is not easy: it takes concentration and effort to kill a man. Caravaggio's Holofernes is wide awake as his blood spurts out. The mystery is why he does not fight back. Either he has awoken when crucial nerves are already severed, or he is paralysed by some supernatural force. Artemisia Gentileschi offers a far more practical explanation for his helplessness. In Caravaggio's painting Judith's servant is a withered old woman. Gentileschi makes her a fit and strong accomplice who helps to hold down the evil Holofernes while Judith does her deadly work.

Caravaggio showed Artemisia Gentileschi how to give a nightmare the colours of reality. Yet she imagines this reality in a more heroic way. His feelings are with Holofernes, paralysed by occult forces as a woman kills him. Gentileschi sides with the women and offers a recipe for females seeking justice: work together, sisters.

Far from getting her thrown in prison or burned as a witch, Artemisia Gentileschi's epic art won her fame in the courts of Europe. In 1638 Charles I, the artistically knowledgeable king of England, invited her to his court where her father Orazio had been working since 1626. In Britain she painted a self-portrait in which she dynamically leans forward in space, a gold chain presented by a grateful patron hanging over her breasts as she concentrates on the canvas she is painting. Her hair is unkempt as she pays attention to her work, not her looks. A brush in one hand, an easel in the other, she personifies Painting itself, as if the mythological world of the Renaissance and Baroque imaginations has come to life as a woman of flesh and blood.

'Baroque'. The word is no longer avoidable. By the 1620s this new style was flourishing. It was the art of a triumphant Catholic Church whose internal reforms, initiated by the Council of Trent in the 1560s, had rolled back the heresies of Luther and

his kind and made the Church once more an unquestioned power in southern Europe, a force to be reckoned with throughout the continent. Under Pope Urban VIII, who ruled from 1623 to 1644, and his immediate successors the extreme terrors and holy corpses of earlier Counter-Reformation Church art gave way to an exuberant, massively confident celebration of papal authority in sculptural and architectural commissions that were to define the look of Rome down to our own time. The same love of abundance and ecstatic glorification of the name of Jesus filled churches in cities such as Naples and Palermo with cascades of stucco and angels of gold. Baroque art swirls and rises, it spins in the void. It is deliberately theatrical and aims to create an ever-moving opera of exhilarating effects in all media, inventing spaces that awe and delight with their energy.

If it gave the Church a new glory, this art also allowed monarchs to imagine themselves as divinities floating in glowing clouds of power and creativity. Another group empowered by this change in European art were, surprisingly, women.

Artemisia Gentileschi's dramatic visual attack on men in her painting of the killing of Holofernes did not come out of nowhere. Why, in the early seventeenth century, was it suddenly possible for a woman to paint such a forceful personal mythology of oppression and retribution? Why had it not been possible before? Artemisia's career was in fact enabled by a subtle change in the ways women were represented in art. The handful of women who became artists in the sixteenth century were trapped by the Renaissance cult of beauty into promoting themselves as beauties with a brush. One example was Lavinia Fontana, who painted a portrait of herself at the spinet – an inscription declares that this was done before a mirror. Her easel is in the background. The daughter of a Bolognese painter, she had a successful professional career and was inducted into the Academy of St Luke in Rome. Yet in her image she is playing a ladylike musical instrument and showing herself off.

By contrast in Artemisia Gentileschi's self-portrait she is a painter and nothing else. She strains and stretches with ambition, intent on being a great artist, indifferent to her own appearance. What has changed?

Nudes and erotic encounters were as popular in seventeenth-century Europe as they had been previously. When the future Charles I visited Spain undercover he fell in love with Titian's sensual paintings in the Spanish royal collection and even tried to get one as a gift. One of the paintings his queen, Henrietta Maria, later commissioned from Artemisia's father, Orazio Gentileschi, at the English court was a big canvas of Potiphar's wife trying to seduce Joseph. In this Biblical story a powerful Egyptian woman makes advances to the young Joseph. In Gentileschi's picture painted for a queen she half-sits, half-lies on a richly ornamented bed which has gold feet and frame under its plump pillows and mattresses and purple and white linen. Semi-dressed, revealing bare legs and pale upper body, she reaches lustily towards Joseph. But he is saying no.

This is a sensual painting – with a difference. There's skin on display, but Potiphar's wife is asking rather than giving. Her psychology is much more in the foreground than that of, say, Titian's *Venus of Urbino*. The same is true of another painting Orazio did for Queen Henrietta Maria, which portrays the queen herself and her ladies-in-waiting acting out the story of the discovery of baby Moses in the bulrushes. These are paintings about women.

The impact of the Reformation and Counter-Reformation made Bible stories fashionable, even in erotic art. Painters still painted love but often the tales of David and Bathsheba, Susanna and the Elders and Samson and Delilah replaced the naughty adventures of Jupiter. On one level this is transparently a religious excuse for sexy pictures. Yet in the hands of a thoughtful artist these strange Old Testament tales of a king

demanding to sleep with a beautiful woman he just happens to see, old men spying lasciviously on a young woman and a strong man brought down by love offered disturbing images of the power and danger of desire.

For Orazio and Artemisia Gentileschi the story of Susanna and the Elders is not a scenario for a delicious painterly romp. It is a creepy image of voyeurism. In a painting that may be by them both – or just one of them – Susanna is claustrophobically imprisoned by the marble wall of her bath between the two old men and the front of the painting. The two voyeurs spy directly over the wall, making no effort to conceal their interest, looking straight down over the parapet at Susanna who, nearly nude, raises her arms to stave off their stares. But we are staring too: she is caught between their eyes and ours. The light on her is bright, remorseless.

In mythological art, too, painters became more aware of the power relations of looking. To paint a nude at all in Catholic Spain was to risk a tough time from the Inquisition. Here nudes really were outlawed. Yet between about 1647 and 1651 the court painter Diego Velázquez did paint a superb Venus for a noble art collector and libertine, Gaspar de Haro, whose father was Spain's first minister at the time. Gaspar de Haro was known both for his beautiful wife and his mistresses and affairs. He probably kept his magnificent nude hidden away in private. Yet it is a work with a strange double effect that makes us think about the mind of Venus as well as her dazzling body.

Velázquez was born in Seville in 1599. His early paintings of street life and servants in his southern city have the same edge as Caravaggio's. Everyone is real and immediate. Even when he went to Madrid to paint for the king Velázquez held true to his factual eye. His paintings of ancient mythology fuse uneasily the fables of the gods with the tough life of poor people and work- ers. In *The Feast of Bacchus* the wine god, with vines in his hair, sits

among a gang of drinkers – drunken, poverty-stricken derelicts. By the time Velázquez painted his Venus he had been to Italy and also had plenty of time to study the works of Titian in the Spanish royal collection. He was now able to paint in an extraordinary way that combines the reality of Caravaggio and the sophisticated painterly textures of Venetian art. That is the wondrous synthesis we see in his *The Toilet of Venus* (*The Rokeby Venus*). She lies with her back to us, her body a warm misty shimmer of subtle tones that define shape and substance through sheer gradations of tone. The sensual roundness of a calf, the nervous valley of her spine, the fragility of her shoulder are all created with colour alone. Velázquez gives Venus a bed of shudder-inducing beauty: she lies on a sheet of grey silk, which glows sombrely against the hazy edges of her pinkness. A rose velvet curtain hangs above her, perhaps like the curtain the owner would pull back to reveal his private painting. Cupid holds pink ribbons over a wooden mirror frame, while a blue strap appears to hold his wings in place. Yet amid this unabashed voluptuousness, the beholder is forced to be introspective. Venus gazes in her mirror and we see her face in the glass. It is blurred and distant. She seems lost in melancholy thought. While we contemplate the beauty of her back she looks into her obscure, reflected eyes, disengaged from the world, uncertain, alone.

St Teresa is no longer alone. Years of meditation and ascetic devotion have brought her through the soul's night into an encounter with Heaven's bliss. A handsome winged angel – for all the world like one of Caravaggio's boys brought to life as impossibly agile stone – holds a spear, like Cupid's dart, aimed straight at Teresa. As she floats on the cloud of her visionary experience in a cascade of robes that mass in myriad soft folds that seem to gather and rearrange themselves in front of your eyes, so energetically and exquisitely has the marble been carved, the saint lets her arm fall loose as she is overcome. Her face falls

back in her hood, eyes closed, lips parted. Up close her eyelids are parted just a fraction to reveal dark interiors, her teeth show under her lips, her cheeks are loose and ecstatic.

She is having an orgasm.

This is not exactly an original observation. Many visitors, down the centuries, to the church of Santa Maria della Vittoria in Rome have gawped at the strange cocktail of spiritual revelation and sensual delight that makes Gianlorenzo Bernini's sculpture of St Teresa so gripping. In the early nineteenth century the French art critic and novelist Stendhal said it suggested profane and not divine love. In fact this is already implicit in the way Bernini's first biographer in the seventeenth century praised what was already his most famous work: '[the angel] pierces her heart with the arrow of divine love while she is caught up in a most sweet ecstasy.'

It was St Teresa herself who described her visions in her writings as if they were erotic experiences. She achieved such 'sweet ecstasy' through a personal quest for the divine that made her one of the great heroes of the Counter-Reformation. The reasons why Bernini is the purest and greatest Italian Baroque artist are glaring in his decision not to clean up the image of St Teresa for popular consumption but to directly, unmistakably equate her rapturous experience with sexual ecstasy. This is not art for popes, or for prurient male collectors. It is art for women. Bernini wants to thrill and excite women with this work, and he does that by putting the female orgasm into sacred art.

Women also have orgasms in Renaissance paintings. Titian's *Bacchanal of the Andrians* and Correggio's *Jupiter and Antiope* both represent women in euphoric poses. Other sixteenth-century paintings portray men seeking to give women pleasure. In a painting by Garofalo of lovers in the countryside, for instance, a man caresses his lady's nipple while she lies back enjoying it. This painting is nowadays described as an 'allegory of love' but it looks more like a lover's guide.

Bernini's *Ecstasy of St Teresa* is different because the woman is not nude. In early sixteenth-century paintings the women experiencing pleasure simultaneously delight their male onlookers by displaying themselves naked. This, however, is a sculpture of a saint swathed in modest robes. Only a hand, a foot and her overcome face peep out of her draperies. The depiction of her ecstasy is not a titillation for male viewers of erotic art; it is a portrayal of the sweet bliss of paradise addressed to women in prayer. Bernini suggests in no uncertain terms that women who imitate St Teresa can share this bone-shaking bliss.

Gianlorenzo Bernini was born in Naples in 1598. His father was a sculptor and Gianlorenzo started to carve marble when he was very young. It was obvious to everyone he had a gift comparable with that of Michelangelo. Where Michelangelo impossibly unearths breathing bodies from cold stone, Bernini makes marble seem to tremble with life. He excels at precious details that never bothered Michelangelo, at rendering hair and cloth and feathers in marble. His delicate caressing of stone matches the Venetian way with paint. In his early masterpiece *Apollo and Daphne*, flutters of foliage and tiny leaves are created from pure white marble as Daphne transforms into a laurel tree.

It's typical of Bernini that in this great depiction of classical myth he portrays a moment of metamorphosis. As an artist he is fascinated by change and flux. The world in motion is his theme. Like Leonardo da Vinci in his notebooks, Bernini venerated the fluid element of water above all others. He even designed a theatrical spectacle called *The Tiber Flood*. His best-loved works, even for visitors to Rome who may not know he created them, are his exuberant fountains. Earlier Italian fountains are juxtapositions of statuary and spurting water. Bernini found a way to synchronize stone and spray so that his carved creatures seem to flow and rise in harmony with the waters that cascade over them. His masterpiece the Four Rivers Fountain on

Rome's Piazza Navona is an infectious fantasia of illusory rustic rocks, grottoes, monsters, muscles, a reused Egyptian obelisk and constantly running water.

Keep it flowing; keep the show on the road. This is the principle of Baroque art, an ever-splendid theatre of dynamic life that overawes and seduces with sheer vitality. Matteo Barberini, who, as a cardinal and member of a rich family, loved art, composed poetry and daringly had his portrait painted by Caravaggio, was elected Pope Urban VIII in 1623. He is supposed to have called the twenty-five-year-old Bernini to him and said:

> It is your immense good fortune, Cavaliere, to see Matteo Barberini pope; but we are even more fortunate that the Cavaliere Bernini lives in the time of Our pontificate.

Urban VIII saw himself as a new Julius II and Bernini as a new Michelangelo. Restraint was for pious provincials: the Church triumphant deserved boundless glory. Urban, who was to reign more than twenty years, together with his successors Innocent X and Alexander VII added to the wonders of antiquity and the Renaissance to make Rome a city of staggering pomp. Bernini was the genius of the age. He built a soaring golden Throne of St Peter in St Peter's Basilica, the black-and-gilt canopy called the Baldacchino ascending towards Michelangelo's dome on spiralling serpentine columns, and the embracing colonnades of St Peter's Piazza, as well as the fountains that turn Rome's squares into eternal works of art.

Bernini was a devout Catholic, an active lay-churchman who read spiritual texts such as *The Imitation of Christ* by Thomas à Kempis. He was also excitable. In the 1630s his passionate nature exploded in a dangerous, violent affair. Bernini conceived an intense love for Costanza Piccolomini – the wife of the sculptor Matteo Bonarelli, who was one of his assistants. In his

obsession with her he spied on her house and saw his own brother, Luigi, leaving while Costanza stood at the door, half-dressed. He followed Luigi and attacked him. His mother, Angelica, watched in helpless horror as Gianlorenzo chased his brother with a sword through her house and then through the nearby ancient church of Santa Maria Maggiore.

Meanwhile Bernini gave his servant a razor and told him to go and slash Costanza's face.

Bernini's mother anticipated trouble by petitioning the pope's family, lamenting her son's 'impetuous' nature and his swordplay in Santa Maria Maggiore 'without any respect'. She asked Cardinal Francesco Barberini to tame her son but also to show mercy. Urban VIII took it all in his stride. He made Bernini pay a fine and told him to find a wife.

Costanza was injured by Bernini's ferocious attachment. She was also given immortality in one of the greatest portraits of all time – and the very greatest to have been carved from stone. Bernini's ability to make marble look like skin, hair, lips becomes nothing short of miraculous in the bust of his love that he carved in about 1636–38. Costanza is caught in a moment of casual, private conversation, her hair loose and wildly brushed back, a loose shift unfastened over her breasts. It is not a pose, and definitely not a delectation for the lustful, but a real moment in life. Bernini was a painter and brilliant draughtsman as well as a sculptor and architect. The spontaneity of Costanza Piccolomini-Bonarelli shows that he must have sketched her from life, not in a formal pose, but while they were chatting. Her casual disarray combined with his infusion of love hints he made the drawing after they had sex.

It is the intimacy of this portrait that is revolutionary. The surprise of that intimacy is partly that it is carved from marble. The marble bust seems an inherently formal, public art, suited to authoritarian images of popes and princes. Bernini takes those associations and turns them upside down. His soft and exquisite

stonework creates a woman in a relaxed moment, her characterful face lovingly seen and recreated by her lover. The fluidity of her cheeks and lips is so animate it seems as if, like Pygmalion's statue, she is about to speak. This is about love, not lust. It is Costanza's head, not her body, that we see. Bernini does not prettify her face: he is not trying to capture her erotically but emotionally. As she seems about to speak, it is her eyes, her pulse, her inner thoughts and person that Bernini loves. His expression of love recalls the love poet who had begun the Renaissance and was still being read and imitated in the seventeenth century: Petrarch. In one of his poems about a portrait of his beloved Laura that he commissioned from the painter Simone Martini, Petrarch laments that the painting cannot speak:

> but when I come to talk with her,
> she seems to listen so kindly:
> I wish she could answer my words!

Gianlorenzo Bernini, *Bust of Costanza*. The energy and intimacy of this sculpture make stone appear ready to speak.

In the art of love Bernini has outdone Petrarch because he has created an image of Costanza that forever engages in conversation with whoever sees it. Energized, thinking, feeling, this woman was made to be loved.

It is stunning to come across this sculpture, suddenly, among marble heroes, to be in the bedroom with Costanza. Quite simply, this is one of the most important works of art in Western history. That is not just because of its technical excellence or bombshell disclosure of Bernini's love life. It is not just because it makes a seventeenth-century woman our contemporary and the contemporary of all human generations to come.

Bernini shows that art does not have to be elevated. It can record, and honour, both the most simple and the most complex human experiences. It can set another person before us.

The Renaissance, which deserves to be seen not simply as an art movement but as a cultural transformation that gripped the whole of Europe, reached a climax in the decades around 1600. The most important and enduring invention of the Renaissance world was an augmenting of what it means to be human. From the introspective love poems of Petrarch to Shakespeare's soliloquies, the self, the individual, was explored in ever-greater depth. The sensuality of Renaissance art is at the vanguard of this exploration. Leonardo's portraits and Titian's paintings explore the richness of the human face and body, the mystery of you and me. By the time we get to Bernini's *Costanza* we are close to the culmination of this voyage of discovery. In the bedroom, we meet the naked soul.

Chapter Seventeen

REMBRANDT IN BED

In about 1654 a woman looked into her lover's eyes. She was wearing a white fur wrap over soft pale breasts but her black, wide pupils dominated her beauty. Her character showed through and was more captivating than the gold glint of her jewellery or the red velvet that enthroned her. Did Rembrandt paint her in the bedroom? Perhaps that is an anachronism, for his house in Amsterdam had a bed in its main living room – and yet the simplest and most accurate way to describe the majestic mood of his intimate portrait of Hendrickje Stoffels is to call it a bedroom moment. To look at it is to meet Rembrandt's lover not simply face to face but in a frank atmosphere of complete self-revelation and passionate openness. To see this painting is to step inside a secret world of love.

How did Rembrandt, in that shadowy house in Amsterdam, see love so clearly? To understand his amorous gaze we have to understand how the sensual art of the south travelled north to inspire an introspective vision of desire. As love crossed the Alps it retreated from the pastoral meadow to the privacy of the home, and strengthened as it snuggled under warm bedcovers. Northern painters knew this and joked about the contrast between eroticism on the shores of the Mediterranean and the windswept Atlantic. More than one northern artist illustrated a Latin saying coined by the ancient Roman dramatist Terence: 'Without Bacchus and Ceres, Venus freezes', meaning that

sexual passion needs food and booze. It needs a warm bed, too, if you are from Antwerp or Amsterdam and the rain is lashing down outside. In his 1614 painting *Venus Frigida (Freezing Venus)* the Antwerp artist, courtier and diplomat Peter Paul Rubens portrays the nude love goddess shivering in a windswept field, her bare flesh rippling with goose bumps as the cold bites her.

Can nudity even exist in the north? Is it entirely and inevitably a Mediterranean art? The nude had originated on the shores of that land-hugged, sun-kissed southern sea. Primitive statuettes made in the prehistoric Aegean evolved into the proud nude realism of classical Greece. In his painting *Venus Frigida* the erudite Rubens modelled his chilly goddess on a Greek statue known as the *Crouching Venus*. In the seventeenth century this statue itself, or rather an ancient Roman copy, found its way north to rainy London and was eventually bought there by the Dutch migrant painter Peter Lely. In his own picture *Nymphs Beside a Fountain* Lely shows how triumphantly the nude can live in the north. His gathering of naked beauties in some unknown corner of an aristocratic English estate (we imagine) shows that his models had no reserve in taking their clothes off – whatever the weather.

The rise of intimacy, I have claimed, is the culmination of the Renaissance art of love. The natural home of this intimacy was to be the north, where winter firesides and curtained beds had always seemed to bring people close together for comfort and solace. Italian artists were eager lovers, in a sensual culture which climaxes in Bernini's bust of Costanza. Northern artists in the seventeenth century would portray their own domestic lives in ways that are loving and cosy. The point of Rubens's painting *Freezing Venus* is that a sensitive-looking satyr brings the wine and food that will warm the cockles of love's heart. It is this northern style of love, at once domestic and ebullient, that gives rise to the tenderly erotic art of Rembrandt.

*

A story is told of the painter Pieter Bruegel the Elder. This six-teenth-century Flemish artist had a quirky way of enjoying himself, says his biographer Karel van Mander in his 1604 work *Het Schilder-boeck* (*The Book of Painters*). For fun, he and a friend used to dress up as peasants and go out into the country. Disguised as rustic folk, they went to villages outside Antwerp on days when weddings were being held. As the peasants cele-brated, Bruegel in his countrified clothes would join in the fun and games, feasting and dancing.

The tale casts a warmly comic light on Bruegel's painting *The Peasant Wedding*, which dates from about 1568. Van Mander invites us to imagine Bruegel as an interloper at this wedding feast held in a half-timbered village hall or barn where tables have been set up under the high roof and a white tablecloth set out. Youths bring in a pallet laden with pancakes, while a child sits on the floor in an oversized red cap eating bread. A man is pouring beer into clay vessels. As the pancakes are handed out a band of musicians play bagpipes, one of them turning to watch the food's arrival. At the table, top families of the village, including the kin of the bride and groom, sit in their best clothes along with the landowner, dressed in black and with a sword at his side, speaking with a monk. The bride sits radiantly at the heart of the banquet under a suspended paper crown, with a red coronet on her long brown hair. Her big round face is full of expectation as she awaits the completion of the wedding ritual of the time, when the groom will make his appearance. She is flanked by elder women of her family while two seats from her in a high-backed wooden chair sits the lawyer who has drawn up the wedding contract. The poor of the village congregate at the entrance of the hall while these better-off rural folk are seated. Presumably everyone will get a drink, if not a pancake.

In the country as in a palace, marriage was a solemn social rite. Many people were involved in making a marriage in the Europe of more than 400 years ago, from the lawyer, priest and

landlord portrayed here to monarchs who brokered weddings for dynastic purposes. In this wedding, just as much as in some arranged royal marriage, considerations of property and family are paramount – the people at the table are all there for a reason, and the local ruler respects their power in the village enough to sit with them, however grumpily. Men are discussing land usage, pasture, that horse you want to sell. Bruegel captures all that made marriage a porous, public institution – a tethering post of the social and economic fabric rather than a passionate private experience. Yet the face of the bride in his painting is isolated and emotional. She closes her eyes as if to ignore the tumultuous occasion. For her this is indeed a solitary moment: she is lost in thought and feeling, and what she feels may even be what the poets call love.

At the *Peasant Dance*, also painted by Bruegel, in about 1568, the fun continues. In the village square, couples dance robustly to the music of the bagpipes, leaping and running, hand in hand. As the young lovers gambol in their clogs, amused villagers sit drinking from huge jugs at an outdoor table. Even a musician is drunk, chatting to an inebriated ne'er-do-well when he ought to be blowing into his bagpipes. While an elegant and dapper peasant, a cock of the walk, leads his tired-looking lady in proud dance in the foreground, over by the inn a man in red snogs a chubby-faced lass. Once again, as in his painting of the feast, Bruegel reveals individual experiences within the communal action. Neither the girl being kissed among the drinkers nor the woman worn out by her cocky partner's jig are stereotyped rustics; they are individual faces in the crowd. Everyone in this scene has a story – a comedy or a tragedy or a bit of gossip. Bruegel's peasant world is full of life. It is the Renaissance of cakes and ale.

The art of northern Europe, as Bruegel embodies it in pancake fat and beer, has a tremendous appetite for everyday life. Where Italy soars on wings of myth, Netherlandish painters are at their very best snuffling the ground for earthly treasures.

Bruegel, whose date of birth is uncertain but who was dead by 1569 soon after painting his *Peasant Wedding*, is an artist who left a living legacy. He married Mayken, the daughter of his fellow painters Peter Coeck and Mayken Verhulst, in Brussels in 1563. Their sons Pieter and Jan also became painters. The Bruegel family business flourished after Bruegel the Elder's death. While Pieter the Younger often copied his father's works, Jan hit on a highly original idea that makes him a northern rival of the young Caravaggio: he painted flowers. Jan Brueghel (who added an h to his name) helped northern art to maintain and deepen its focus on the humble and the domestic. For what is more domestic than flowers in a vase?

In about 1611 to 1613 Jan Brueghel posed with his family for a portrait. It was painted by his fellow Antwerp citizen Peter Paul Rubens. In it, Brueghel and his wife in ruff collars stand close together showing off their children. This is an affectionate painting of an affectionate family. She smiles gently as she puts an arm around her son: both the boy and her small daughter reach out to touch their father's hand. It is a circle of love. This picture shows why the Brueghel artistic dynasty was so hale: it was nourished by feeling. In about 1623 Jacob Jordaeans, another of this accomplished group of artists in Antwerp, portrayed himself with his family in a garden. The garden is flourishing, the family relaxed and happy. A young girl grins out of the picture as her mother warmly embraces her. A marriageable young woman poses in a straw hat. The artist himself has a lute, to serenade his wife. Jordaeans displays his material wealth but makes his emotional wealth look as if it is greater.

These are quietly revolutionary paintings. They inaugurate a new kind of portraiture that introduces the beholder to loving couples and their families. The enigmatic, remote world of private life four centuries ago opens out with spectacular generosity.

In his *Wedding Portrait of Isaac Abrahamsz Massa and Beatrix van der Laen*, the Haarlem painter Frans Hals in about 1622 gives a

newlywed couple an easy spontaneity. Sitting close together in a woodland bower with a palatial garden behind them, Beatrix rests her right arm casually on her husband's shoulder. As she shows off her wedding ring in this cheekily informal pose, she raises her eyebrows and grins at the onlooker. Meanwhile Isaac looks out of the painting with immense dreamy satisfaction in his newlywed state. This is not some austere document of a brokered marriage. It is a portrait of a happy, loving, humorous couple. Had love broken out in seventeenth-century Europe? Or were artists getting better at portraying the feelings that always exist in happy families?

The source of all this marital bliss, in art at least, was Rubens. Born in 1577, he made the family portrait of his friend Jan Brueghel soon after coming home to Antwerp from a long stay in Italy. Going there to hone his knowledge and skills among the masterpieces of the Renaissance, Rubens was so plainly exceptional that the Gonzaga family in Mantua made this young untried man their court artist. In return he persuaded them to buy Caravaggio's *Death of the Virgin* after its brutal realism got it rejected as an altarpiece. In the art of Rubens the reality of Caravaggio, his contemporary, mixes with the sumptuous colours of Titian and Veronese, the physical grandeur of Michelangelo and the dynamism of Leonardo da Vinci's painting *The Battle of Anghiari*. Out of an exhaustive understanding of the art of Italy and his own impetuous imagination Rubens created swirling paintings whose limitless energy and tempestuous life are definitively Baroque. His mythic and religious extravaganzas were coveted by rulers all over Europe as triumphant dramatizations of power. Rubens worked at the courts of France and England and served Spain as a diplomat and even a spy. But he always came back to Antwerp. Deep down, his cosmic repertoire is grounded in the homely art of the north. He loves earthy delights: the ripeness of a landscape, the fullness of flesh.

In 1609, soon after returning from Italy, Rubens married Isabella Brant in St Michael's abbey church in Antwerp. She was eighteen, he was in his thirties. Isabella was the daughter of a wealthy and powerful local eminence named Jan Brant, so it was a good marriage in practical terms. But paintings and drawings by Rubens give it all the appearance of a marriage made by love. *The Artist and his Wife in a Honeysuckle Bower*, which he painted in 1609 or soon afterwards to celebrate their wedding, portrays them sitting with nonchalant flair and warm intimacy in a garden. While Rubens sits cross-legged in red stockings, Isabella Brant in a rakishly high hat, immense ruff and gold-fronted, purple-skirted dress places her hand on his hand and looks out of the painting with an almost wry smile.

It is a marriage of friends, companions for life. The ideal portrayed here – which, so Rubens tells us with his proud picture, is also a reality he is lucky enough to enjoy – is of spouses joined in love and good cheer. This painting was widely studied and emulated. The other images of Antwerp artists and their families that we have encountered grow out of it – and so does Hals's great painting of a pair of witty newlyweds. Rubens offers a template for a new kind of amorous domestic portrait. In his later images of Isabella Brant her intelligent smile persists like the Cheshire cat's grin. Did she always smile or did he just love to picture her like that? The amiable smile is undimmed even in a painting that Rubens probably finished after Isabella Brant died, during a plague epidemic, on 20 June 1626. A vine circling a column in the background is an emblem of love conquering death. In her hand Isabella has a devotional book, the road to joy after death. Her smile reassures Rubens she has gone to Heaven.

Isabella Brant's early death is a reminder of the costs of feeling at the dawn of the modern world. Most marriages were fated to be brief. Death intervened. The gifted Antwerp artist Anthony van Dyck, after working with Rubens, went to Britain to paint

Charles I and his aristocratic supporters. Death stalks his paintings. In one of his most vivid portraits Thomas Kiligrew, a courtier and writer, rests his head on his hand and gazes in grim resignation and distraction out of the painting. Behind him is a broken column. He pays no attention as a friend shows him a blank sheet of paper, maybe urging him to express his bottled-up grief in words. Kiligrew's wife, Cecilia Crofts, had recently died, two years after they were married. In another Van Dyck painting Venetia, Lady Digby, lies pale and unconscious in bed. She is dead. When she suddenly passed away in her sleep in 1633 her shocked and helpless husband Sir Kenelm Digby called on Van Dyck to portray her corpse as a last record.

Maybe enduring love was too much to hope for, or to risk. Van Dyck himself had a turbulent relationship in Britain with his mistress Margaret Lemon. She posed in armour and a white chemise for him, with Cupid flying above her. In a print by Wenceslas Hollar based on this painting, Van Dyck's lover is given a bunch of flowers like an Italian courtesan as she looks smoulderingly outward. Among the inscriptions under her are the Caravaggesque words 'Love Conquers All'.

The widower Rubens became ever richer and ever better-connected with the crowned heads of Europe. He was full of energy and appetite. In December 1630 he married again. He definitely did not choose his new bride, Helena Fourment, for her status or wealth. He was so lofty among the courtiers of Europe he could have married a noblewoman. To explain why he preferred the daughter of an Antwerp silk merchant he told a friend that his 'young wife', being 'of honest middle-class family', would not object to his manual labour as an artist: she 'will not blush to see me take up my brushes'.

This way of putting it was soon to take on new meaning. It was not just that Helena Fourment did not blush to see him paint. She did not blush when he painted her naked. Rubens

recorded his first marriage as a genial companionate relationship. His paintings of his second wife celebrate Helena Fourment sensually. His young wife is his favourite nude.

It is another pulling back of the bed curtain, another milestone in the history of intimacy. Rubens was getting on. He was in his fifties when he married Helena Fourment. She was sixteen. Rubens had been eyeing up her family for some time. In the 1620s while Isabella Brant was still alive he painted a beautiful portrait of Helena's older sister Susanna that glories in her full bosom and bright eyes. When he married Helena he could no longer contain himself. At least he had a sense of humour about it. In his painting *The Feast of Venus*, an old satyr carries off Helena who turns to look out of the picture with an indulgent smile. Her face, fleshily beautiful and innocent, is also recognizable in his painting *The Three Graces*, where Helena reveals her nude beauty. But his most unforgettable picture of her goes beyond facetious fun or lustful fantasy to portray her undressed. Sex leads to introspection, desire to intimacy. *Helena Fourment in a Fur Wrap* reveals why Rubens admired Caravaggio. It is much more golden and painterly in style than the Italian rebel's works but it shares that sense of raw, living reality. Here stands Helena naked except for the dark fur she wraps around her back and holds in front of her thighs. Her knees are dimpled and ample in flesh; her bare feet tread on a red floor. While her left hand curves delicately over her groin, her right arm caresses her right shoulder and surrounds her nude bulging breasts. As she poses for her husband she does not smile but looks reflective and uncertain, wondering, waiting. Their relationship is on the line. Helena Fourment gives herself to him, body and soul. Rubens repays this risk with the light that suffuses her. It is a glimpse into the secret world of a marriage.

That long youthful stay in Italy taught Rubens the power and beauty of the nude human form. He avidly copied the works of Michelangelo and Titian as well as ancient statues that he saw

in Rome's classical collections. Flesh ripples, rolls and swags in his bountiful paintings. It is as if Rubens sees beauty as something to be tasted, like the cornucopian fruits that his assistants added to his mighty roiling scenes. In crass modern caricature Rubens paints 'big' women. What he really paints is flesh you can feel. He shows dimpled buttocks, fatty backs, because that way the body is not a smooth statuesque creation sealed inside the vitrine of art but a worldly presence. Rubens forsook the perfection of classical statuary because he wanted to suggest sensual, dynamic, real encounters – to make beauty tangible. In his paintings you can't just taste grapes. You can feel curving hips, bouncy breasts.

His passion for Helena Fourment expressed the rampant reality of sex for Rubens. He filled the palaces of Europe with nudes. Today his goddesses decorate all the finest museums. But he was not just providing decorations. The rumps and tummies of his painted women assert his desire to get his hands on them – as he did, when he married Helena Fourment.

In one of Rubens's depictions of the Judgement of Paris, three goddesses show their spectacular nakedness to the young prince of Troy. His choice will have fatal consequences.

In Greek myth Paris chose Aphrodite the goddess of love, who rewarded him by giving him the most beautiful woman on earth. That woman turned out to be Helen, wife of the Spartan king Menelaus, and when Paris carried her off to Troy it provoked the Greeks to attack his city in the murderous Trojan War. Rubens makes this tale of the devastating might of desire a feast of tactile sensuality. The lush forms of the three goddesses, all seen from different angles, are revealed to the onlooker as they are to Paris. It is an apparently consequence-free beauty contest, an indulgence of the eye.

A far more tragic recognition of the power of sex in the history of the world saturates Rembrandt van Rijn's 1654 painting, *Bathsheba with King David's Letter*. Bathsheba, in the Bible, was the

wife of one of the king of Israel's subjects. When David saw her from his palace he wanted her, and asked her to come to him. Rembrandt portrays Bathsheba with his love letter still in her hand as she sits naked on a bed, preparing to meet her royal lover.

Like Rubens, the Dutch painter looks beyond the classical perfections of Renaissance bodies. Bathsheba is beautiful but real. Her belly widens above her hips and creases around her belly button. Flesh bulges under her shoulders and is loose on her arms and legs. Her sexual power is all the greater for not being airbrushed into myth. Her breasts are firm and round, her skin a banner of silver unfurled. Unlike any woman ever painted by Rubens, she is uneasy in this exposure of her beauty. It is in Bathsheba's eyes that we see the momentous choice she has made, the historical weight of a moment of sin. She looks down, dark-eyed, sadly contemplating her fate. Her guilt is on her face. Her feelings are as grave as her body is bright.

The model for Rembrandt's Bathsheba was his own lover, Hendrickje Stoffels, and he painted this extraordinary unveiling of the erotic and the emotional at a time when she was being censured by the Dutch Protestant Church for living with Rembrandt unmarried. If it is steeped in a stark sense of the jeopardy of sex, this is because Hendrickje was experiencing that jeopardy. Rembrandt is opening up the bedroom door wider than any artist ever opened it before.

Rembrandt was born in Leiden in 1606, the son of a well-off miller. By about 1631 he moved to Amsterdam. Both cities were in the Dutch Republic, a new Protestant state that by 1648 fought off Spanish Catholic dominance in a bitter war of independence. The Dutch prospered. The trade routes of Europe had shifted from the Mediterranean to the Atlantic. In the seventeenth century the greatest *entrepôt* of world trade was Amsterdam. The tulip – an Asian flower that is seen to this day

as archetypally Dutch from its cultivation in the seventeenth-century polder fields – is a monument to Amsterdam's global trade.

This flourishing capital centred on a spider's web of canals. Today, in the well-preserved heart of Amsterdam, still waters reflect the tall narrow facades of merchant houses with jutting beams under their eaves to winch up goods to warehouses in attics and upper floors. Behind windows that let in pale sunlight, beds were once placed in day rooms and shielded from the chill air by thick curtains. Rich foods were set on tables covered with Turkish rugs: bright red lobsters, silver-skinned herring, yellow lemons, fat cheeses, brimming glasses, nautilus-shell goblets. In Rembrandt's painting *Belshazzar's Feast*, which he created in about 1636, the wealth of Amsterdam was represented and transcended and implicitly judged. A stupendously clad Babylonian tyrant shudders to see God's writing on the wall, foretelling his doom. 'God has numbered the days of your kingdom and brought it to an end; you have been weighed in the balances and found wanting [...]' Belshazzar's cloak is an impossibly luxurious weft of gold threads, jewels and chains, which up close dissolves into a mighty storm of paint, heavily built-up, grandiosely luminous. Caravaggio gave oil painting new reality; Rembrandt transfigures it. Belshazzar's wealth is so dazzling it seems about to melt in the heat of its own excess. On his table, black grapes mass evilly on a golden platter. A woman spills a gold pitcher of wine as she recoils from the appearance of God's condemning words. She is a courtesan, convulsing in her fine red velvet dress as her alarmed lurch gives the painting's onlooker a view of her bare shoulders and neck. Two more courtesans sit at the table, one petrified by the truth, another seemingly indifferent as she turns her head away, revealing her figure in profile, glamorized by jewellery in the monstrous, gorgeous light.

In 1634 Rembrandt married Saskia van Uylenburgh, the

niece of the art dealer Hendrick van Uylenburgh who happened to be his landlord at the time. She was heiress to a considerable fortune. He recorded their life together with effusiveness. In a brilliantly foreshortened drawing, they pose together at table, Rembrandt magnified as he sketches in the mirror, Saskia refined with her long hair. That same opulence of hair flows over her shoulders when she poses as the springtime goddess Flora, resting her hand on a flower-bedecked shepherd's crook. There's a pathos in these portraits that goes beyond the sensual. Rembrandt seems to capture, in all his portraits, something more essential than the exterior details of physical appearance. His paintings reject banal facts in their pursuit of inner truth. This refusal of conventional portraiture caused him serious career problems. There are well-documented incidents of wealthy portrait sitters and their families feeling enraged at the lack of dumb accuracy in his commissioned paintings. Rembrandt was looking beyond the visible.

In his painting *The Prodigal Son in the Inn* he and Saskia can easily be recognized, although they pose as characters in a parable. Rembrandt is the Prodigal, expensively attired, enjoying a drink with his arm around the waist of a prostitute played by Saskia. Why portray their marriage as sinful when it was perfectly respectable? It is theatre. Like Shakespeare, who died when Rembrandt was ten, this painter is a universal dramatist of the human condition. He loved to dress up in his self-portraits. He loved to get other people to dress up too. When he portrays Saskia as the goddess of Spring, or a courtesan, she is herself – and also the character she masquerades. Rembrandt sees the human condition as a grand Baroque theatre of life. People are always playing parts: the soldier, the king, the lover. Rembrandt shows that, in playing the parts life demands, men and women are simultaneously swept up in the role and somehow separate from it. When he and Saskia smile in their characters of the Prodigal Son and his mistress, they communicate their knowledge

that it is play-acting. But they also communicate a melancholy afterthought: what if the play becomes real?

This curious mood, at once comically indulgent of life's theatre and tragically aware of the brevity of all these incandescent performances on a stage of encroaching shadows, is what makes Rembrandt's famous painting *The Night Watch* so atmospheric. It also gives his domestic portraits their pungency. Saskia as Flora leans on her flowered staff. She seems pale. Is she ill?

Rembrandt was thriving as a portrait painter and Saskia had money. They moved into a grand, spacious house on Jodenbreestraat (as it is now called) in Amsterdam. The house survives and its interior has been lovingly furnished on the basis of an inventory of Rembrandt's possessions. A bed in an alcove, a tiled kitchen, an attic studio with collections of natural wonders and classical busts offer touching peeks into his physical world. His paintings and prints take us further into his home when he lived here. In an etching from about 1646 a couple make love in a four-poster bed with the curtains drawn back. All about them are shafts of shadow, flickers of candlelight.

Saskia's life was short and tough. She gave birth to one child after another, none of whom survived. With each pregnancy her own health deteriorated. In 1641 she finally had a son who would live to be an adult. They named him Titus. She was left mortally sick, and died the following year. Saskia made a will leaving her substantial wealth to Rembrandt and Titus, with a clause that Rembrandt would lose most of his share should he remarry. This clause drove Rembrandt to rebel against the respectable morality of his neighbours in Amsterdam.

The woman leans up in bed, wearing nothing but jewellery, looking out of her curtained nook. She rests on her arm. She seems nervous rather than sensual. This may be a portrait of Geertge Dircx, whom Rembrandt the widower employed as a nurse for little Titus. Soon Rembrandt was sleeping with her.

This painting may be a record of their sex life. Geertge, if it is Geertge, is perhaps posing as a prostitute.

Geertge Dircx probably thought Rembrandt was going to marry her. Instead he had her jailed. He employed another servant, named Hendrickje Stoffels, who stole his bed from Geertge. Rembrandt and Hendrickje were lovers. What could the rejected Geertge do? She tried to sue the artist for breach of promise, claiming he had spoken of marriage. Rembrandt in reply got her locked up in a house of correction. Hendrickje had him to herself, but they could not marry. It would lose him Saskia's money – and the spendthrift Rembrandt needed all the financial breaks he could get.

If Rembrandt's portraits of Saskia are touching, his depictions of Hendrickje Stoffels are revolutionary. She is a powerfully sexual presence in his art. At the same time it is her inmost life, her existential being, we see. She was his lover in the later part of his life when his own self-portraits were becoming ever more unsettling. The artist who in his later self-portraits becomes an emblematic figure of age and experience contemplating the gallery-goer with a force that makes it seem Rembrandt is the onlooker, the visitor, the one under scrutiny, regards Hendrickje with both yearning and empathy.

We have met her as Bathsheba, the Biblical lover of King David. Another painting shows her happy and self-absorbed in her own body as she tiptoes in a little stream, raising her white shift as her legs are caressed by the water. Hendrickje is not acting a part. This is not some scene of Diana bathing, or Susanna bathing – or if it is, the story has vanished into the reality of flesh, water and soul. In these paintings of Hendrickje Stoffels, which date from 1654, the theatre of life is interrupted. She steps off the stage. We see a person, as it were, in the dressing room, before the performance. Hendrickje is undressed, body and soul. Rembrandt wants to broadcast her true nature divested of any social costume, any public pretence.

In these paintings love is the absence of deceit. Rembrandt can truly see Hendrickje. It is as if he sees her through her own eyes, so close is their connection. She gazes down in a moment of inner sorrow as she holds King David's letter and again looks down, this time in innocent happiness, as she paddles in a stream.

Hendrickje was condemned in the year these pictures were painted by the Reformed Church in Amsterdam for living sinfully with Rembrandt. She was excluded from the congregation. The paintings that Rembrandt made of her in this same year 1654 answer prurience and gossip with a simple assertion: here is the true Hendrickje Stoffels, a woman as beautiful in her soul as her body. In a work painted a decade earlier, *The Woman Taken in Adultery*, he shows a tiny figure of an accused woman in a pool of gold light dwarfed by the shadowy architecture of a temple where judges are arrayed like a mighty heavenly court. In his portrayal of Hendrickje as Bathsheba she might be reading the judgement on her by the Church. Her face blazons the depth of her conscience, the injustice of caricaturing her as a sinner without morals.

As Hendrickje steps into the stream she expresses the sinless delight of the moment in her downturned face. The water reflects her legs, as she looks down at it lapping on her skin. She is content in her physical being: yet it is a contentment that is aware of the fragility of pleasure.

In Rembrandt's most irresistible portrait of Hendrickje – the one we met at the start of this chapter – she gazes at the world from calm, truthful eyes. Her frank face is framed by huge gold earrings hung with oval pearls. She wears more gold and jewels in her hair. Rembrandt compares soft white fur and soft pale skin: up close the creamy flesh of Hendrickje's hand, which rests on a gilded post, is the same texture and colour as the fur, a cloud of tender whitenesses. Red sensual shadows surround her. This is a very personal portrait: a lover's portrait of his mistress just before or just after sex.

Her physical presence is luminous. Yet it is the depth of her gaze that shakes and penetrates the beholder.

In his youthful self-portraits Rembrandt often depicts himself in armour. Why? Perhaps he wanted to identify his art with the heroic struggle of the Dutch against Spain. Yet it was also an explicit allusion to an artistic hero. In Vasari's Life of Giorgione he describes how the Venetian artist painted a self-portrait in an armour breastplate that shimmered in the light. Rembrandt's self-portraits in armour use metal in the same way, to reflect and burnish light. Venetian painting is one of the most potent ingredients in the cocktail of rich techniques that is Rembrandt's sumptuous, dazzling painterly style.

In 1506 Giorgione portrayed Laura with voluptuous tenderness. Wrapped in fur, the Venetian courtesan in his sensual picture parts her rich robe to reveal a breast. She is a powerful, enigmatic personality, the ultimate inspiration for Rembrandt's portrait of his lover in about 1654–56. Rembrandt's portrait of Hendrickje Stoffels in fur is clearly indebted to Giorgione.

Hendrickje Stoffels looks steadily out of her painting. She is both different from and similar to her Italian predecessors, the beauties of Venice. Echoes of Italian Renaissance art resound in this masterpiece. Like Raphael, another artist whose works he studied, Rembrandt has guilelessly portrayed his lover. Like Leonardo, he has painted a woman in a mood of sensuality. Most of all his hazy, soft painterly hinting of flesh under fur is a fearless rivalry with Titian's brush.

Hendrickje has something else: her inner being. When all is said and done it is her personality – not her beauty – that is real. She seems to live behind those eyes, and her mind, her feelings, transcend fleshly facts. Her body is beautiful and yet the closer you look, the less is actually revealed. The sensuality of this painting is in the way Hendrickje looks at the beholder. That sensuality is carnal, but soulful, too.

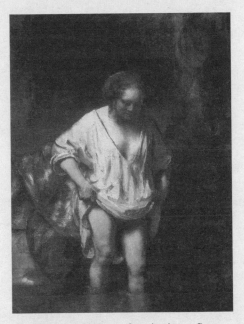

Rembrandt, *Woman Stepping into a Stream.*
Hendrickje Stoffels is gently observed
in a moment of sensual peace.

Conclusion

THE EROTIC REVOLUTION

The Renaissance was an explosion of lust and life. It was like spring. After centuries of cold, Europe warmed up.

Of course, life had always gone on. The birds and the bees always reproduced and so did people. Up until the demographic crisis of the Black Death in the fourteenth century, the population of medieval Europe kept escalating, pushing against the limits of cultivated land. This was a flourishing, vital world. But its culture was at odds with all that bubbling human energy. Medieval Christendom inherited ascetic beliefs and a cult of celibacy from the ancient founders of the Church who had rejected the pleasures of the pagan Roman world. A religious insistence on the sinfulness of desire created a culture at once blind to the realities of life and open to charges of hypocrisy. After the Black Death, satirical voices gleefully pointed out these contradictions of Christendom. Geoffrey Chaucer in his late fourteenth-century comic poem *The Canterbury Tales* mocks a worldly nun who wears an exquisite brooch on which was written *Amor vincit omnia*.

The nun's fashionable dress – 'Ful fetys was hir cloke' – and amorous jewellery show that she played the game of courtly love, an endlessly deferred ritual of courtship and compliment that gave medieval society a language of eroticism to set against the denunciation of lust from the pulpit. But in the Renaissance, the pleasures of courtly love were enhanced a hundredfold by a profusion of explicit, licentious images.

As I hope I have shown in this book, the rediscovery of pagan antiquity in fifteenth-century Italy unleashed a torrent of sensual art. The naked human body was celebrated, not as some rarefied artistic paragon but as the incitement of sex. Nymphs and shepherds, satyrs and satyresses, gods and their loves leaped out of the old Greek and Roman myths to populate paintings. They cavorted freely on trays, chests, bedheads and glazed plates. From frescoes to woodcuts, love and lust are everywhere in the art of the Renaissance.

As we have seen, the artists who created the greatest images of desire in this revolutionary age were not mere hacks churning out erotica on demand. They were explorers, braving the wilds of passion. Raphael and Titian, Giorgione and Michelangelo were great lovers in life as well as art. But it couldn't last.

The nineteenth-century historian Jacob Burckhardt, whose masterwork *The Civilization of the Renaissance in Italy* was published in 1860, saw the Renaissance as the birth of modern, secular Europe. He wrongly believed that the joyous worldliness of Renaissance Italy killed Christianity stone dead. On the contrary, the sixteenth and seventeenth centuries were to see a tempestuous religious rebirth. The very curiosity the Renaissance released, not to mention its exposure of clerical dishonesty, inspired radical new ideas about the basis of Christianity. The 'Reformation' launched north of the Alps by Martin Luther in 1517 and the 'Counter-Reformation' that reshaped Catholicism across southern Europe a few decades later subjected the carnal, pagan energy of Renaissance art to strange metamorphoses.

It is wrong to insist, as some art historians did in the twentieth century in an exaggerated reaction against Burckhardt's secularism, that Renaissance intellectuals and artists smoothly assimilated pagan myth into a Christian belief system. It is palpably ridiculous to claim that a painting like Titian's *Bacchus and Ariadne* contains nothing subversive, no risk to Christian

morality in its visceral sensual parade. Renaissance art is provocatively carnal, flirtatiously pagan. It is a worship of life. Yet that worship could be placed at the service of the Church. Instead of rejecting Renaissance art, the greatest artists of the Counter-Reformation put it to daring use. Titian's *Danaë* lent her sensuality to Bernini's *St Teresa*. Meanwhile some of the ripest and most bizarre eroticisms flourished in the art of the north, where Bosch imagined a heretical love feast and Cranach painted demonic sinful nudes. In Protestant and Catholic Europe alike, sensuality and spirituality enjoyed unexpected dalliances that bore peculiar fruits.

The result of this tangled history, in which the sexual revolution of the Renaissance sailed smack into the changing religion of a conflicted, warlike Europe, was not unlike the 'vicissitudes' of desire that, according to Sigmund Freud, father of psychoanalysis, shape the complex landscape of human sexuality. The rebirth of sensuality in fifteenth-century Italy was unequivocally joyous, a new love of life that is expressed with crystalline happiness in Botticelli's painting *Primavera*. But this happy pleasure in being alive was complicated, not to say pummelled, by religion.

Chastisement only enriched the art of desire. While Caravaggio made his sins look truly dirty, Rubens exulted in married love. The skills these artists brought to the bedroom enabled them to explore not just the simple surfaces of pleasure but its mysteries and emotional depths too. Rembrandt was able to portray moments of intense love with total honesty and clarity.

Modern love and the modern unconscious – the array of desires and terrors and dreams that Freud would analyse in Vienna circa 1900 – was born between 1400 and 1650. The joy of pagan freedom that enraptured Raphael wandered through a forest of guilt and fear to produce the pleasure and pain of the modern individual. We are the bastard children of the Renaissance.

Fair or foul, a marvel or a quintessence of dust, the art of love was fundamental to what Burckhardt called 'the discovery of the world and of man'. There was simply no imagery or vocabulary in the Middle Ages to chart the intricacies of the human interior. In a thirteenth-century book, *The Romance of the Rose*, love is allegorized but it is not revealed as an inner experience. Only with Petrarch did the inner experience of the lover become the theme of poetry, and only when artists gave that experience physical reality did Europe start to map the new world of the self. We are still fumbling our way in this limitless land, in a wild night illuminated occasionally by the insights of great art.

TRUE STORIES

Giovanni Boccaccio's fourteenth-century prose masterpiece *The Decameron* begins with a terrifying and historically acute account of the Black Death in Florence in 1348. As the city's entire social structure seems to be dissolved by the merciless epidemic, a group of wealthy young people meet in the church of Santa Maria Novella. Why, they reason, must they wait in this city of the dead for a horrible fate to overtake them? At least in the country there is clean air. So they flee to a villa in the hills where they pass the next ten days telling stories.

Many of those stories are about sex. Boccaccio is famous for his hilarious lusty tales. A woman prefers a potent pirate to her rich but impotent husband; a friar dupes a pious fool into letting himself be cuckolded; a saintly hermit shows a young woman a very physical way to honour God. But one story in *The Decameron* is not about sex – it is about art. Boccaccio tells how the painter Giotto was caught in a rainstorm in the country with a celebrated Florentine lawyer and they passed the time joking about one another's ugliness.

Art and sex: in the centuries to come these two themes were to provide rich material for storytellers inspired by Boccaccio. The *novella*, a story set in a realistic world, usually without magic but with plenty of money-making, poisoning, plotting and love, took off in the wake of *The Decameron* as one of the great original creations of Renaissance Italy, the ancestor of the modern novel.

In his fiction-about-fictions *The Castle of Crossed Destinies*, the modern writer Italo Calvino recreates this tradition of storytelling. A group of travellers who find themselves struck dumb in

a magic castle try to decode stories told in images, by using a pack of tarot cards. It seems in Calvino's eerie novel that the stories are arbitrary arrangements of limited elements, mixed in apparently infinite patterns yet always with familiar building blocks. A comparable quality of similarity within diversity haunts the tales I have collected in this book, from Fra Filippo's lusts to Bernini's obsessive love. Does this mean artists have similar personalities, or that people like to tell the same tales about them over and over again? In what ways can these stories be 'true'? In this appendix I reveal the sources of each tale, how they were transmitted, and the different ways in which they are True Stories.

I also suggest further reading, and give essential references. Most books cited are widely available and accessible. Where I suggest English translations of classic works these are the editions I think especially good. For instance, there are two excellent translations of *The Decameron*, by G. H. McWilliam (second edition, 1995) and J. G. Nichols (2008), while the standard Italian edition is that of Vittore Branca (1985).

Stories are pebbles washed up, held and shown, thrown back in the river, found again. They exist apart from the books in which they are written. In the Renaissance and Baroque ages, when not everyone could read and public speaking was a cherished art, stories were currency to be treasured, memories to be gathered, an inheritance to be preserved. Yet to tell a story is to change it – which is why, in my own brief retellings of the old tales, I have given these timeworn pebbles a new shake in the rock tumbler.

CHAPTER ONE
Donatello

Stories about the homosexuality of Donatello are preserved in an anonymous collection of hundreds of humorous anecdotes

about local celebrities compiled in Florence in the 1470s and printed there in 1548. In the early twentieth century this collection was republished by the central-European folklorist Albert Wesselski, who named it *Angelo Polizianos Tagebuch* (1928).

In one anecdote the sculptor goes to Cosimo de' Medici to ask for a letter of protection to show the ruler of Ferrara. Donatello's beloved young assistant has run off: he means to pursue the treacherous lad into Ferrarese territory and kill him. Cosimo gives him the letter of protection and tells the Duke of Ferrara who Donatello is. Donatello finds the youth, but when they see each other they both start laughing and make up their quarrel.

Another anecdote in the same collection tells how – because it was well known that Donatello liked beautiful apprentices – he was offered a lad who was exceptionally good-looking. The person introducing this youth added that the boy's brother was even more fine-featured: Donatello replied that such a beauty would not stay with him. A third tale says Donatello used to put unattractive make-up on his apprentices so no one else would want them.

H. W. Janson adduces these stories as evidence for a homo-erotic interpretation of Donatello's *David* in his 1963 book *The Sculpture of Donatello*. This was written long before sexuality became a popular theme for social and cultural history, an academic phenomenon that dates from the 1980s under the influence of the feminist and gay movements. James M. Saslow's *Ganymede in the Renaissance: Homosexuality in Art and Society* (1986) is a founding work in bringing the history of sexuality to Italian Renaissance art, but is sceptical about the significance of anecdotes about Donatello. Yet the clearer the picture of Renaissance Florence that emerges from modern studies, the easier it is to believe not just that Donatello made a dangerously erotic statue but also that it was appreciated and valued as such in the avant-garde circles patronized by the Medici family.

Forbidden Friendships: Homosexuality and Male Culture in Renaissance Florence by Michael Rocke (1996) describes in depth the unique Florentine institution called the Office of the Night (*Ufficiali di Notte*), founded in 1432 and closed in 1502. This agency attempted to scrutinize the sexual offence of 'sodomy' – which in this usage meant mainly homosexual acts but could also throughout the Christian world mean any non-procreative sex, including acts within marriage. The Office of the Night was created because Florence was seen as especially riddled with sodomy. And yet the Medici family stood aside from attempts by the *signoria* to crack down on this vice. As Anthony d'Elia shows in *A Sudden Terror: The Plot to Murder the Pope in Renaissance Rome* (2009), humanists – the Renaissance intellectuals who special-ized in understanding and translating classical Greek and Roman literature, some of the greatest of whom were spon-sored by the Medici family – were widely suspected of sodomy. Humanists knew about 'Greek love' and their reverence for antiquity made them respect it. In the writings of Plato, one of the classical authors most admired by fifteenth-century human-ists, love is a profound philosophical passion that is almost exclusively a matter between men – or rather between older men and male youths. Plato's great dialogues on love are *The Symposium* (translated by Walter Hamilton, 1951) and *Phaedrus* (translated by Robin Waterfield, 2002).

One of the most thoughtful introductions to the Renaissance is *The Waning of the Renaissance* by William J. Bouwsma (2000), which, even though it is concerned with the ending of this epoch, is full of insight into its beginnings. For Bouwsma the Renaissance was a liberation from the cerebral high culture of the Middle Ages, which disdained the body and cleaved to the rationalism of the Greek philosopher Aristotle. In turning to more poetic thinkers such as Plato, humanists unleashed a somatic, experiential attitude to life. The prominent place of nudity in this new carnal conception of humanity is emphasized

by Leo Steinberg in *The Sexuality of Christ in Renaissance Art and in Modern Oblivion* (revised and expanded second edition, 1996). By contrast, the anti-pleasure principle of medieval Christendom is diagnosed by Jacques le Goff in his essay 'The Repudiation of Pleasure' in his book *The Medieval Imagination* (translated by Arthur Goldhammer, 1988).

CHAPTER TWO
Fra Filippo Lippi

The love affair of Fra Filippo Lippi and Lucrezia Buti seems to have already become a funny story by May 1458 when Giovanni, the son of Cosimo de' Medici, mentions in a letter that he and others have been laughing about the friar's '*errore*' or error. This suggests that the illicit sex in a Prato nunnery that resulted in 1458 or 1459 in the birth of the future artist Filippino Lippi was turned into anecdote and comedy even as it happened. It was to become one of the most famous stories about the lives of Renaissance artists, and is told with subtlety and compassion by Giorgio Vasari in 1550 in the first edition of his book *Le Vite de' piu eccellenti archittori, pittori, et scultori italiani, da Cimabue insino a' tempi nostri* – or, as we know it in English, *The Lives of the Artists*.

By this time, the misdeed of Fra Filippo had gathered a snow-ball of supporting stories around it. Fra Filippo was kidnapped from the seashore by Muslim pirates and enslaved, says Vasari – a real enough possible fate in the fifteenth-century Mediterranean yet also a typical adventure in the *novella*, a genre of vernacular tale hugely popular in medieval and Renaissance Italy. Thus Boccaccio in his *Decameron* portrays, in the tale of Madama Beritola and her sons that is the Sixth Story on the book's Second Day, the ease with which people can just vanish off a beach in a Mediterranean world packed with pirates.

When Vasari tells how Fra Filippo was so wicked he had to be

imprisoned by Cosimo de' Medici to keep his mind on his work this too fits into an existing type of story, the 'Cosimo the Elder' anecdote, a narrative tradition first popularized by the fifteenth-century book seller Vespasiano da Bisticci in his gossipy life of the banker-statesman. In other words, Vasari gathers up every bit of folk-memory of the notorious Fra Filippo Lippi that was washing around Florence in the 1540s to weave a captivating fairy tale about an 'amorous' man with a knack for getting into scrapes. Yet this fiction contains fact. Vasari accurately names the nun who had a child with Lippi: '*una figliola di Francesco Buti cittadin fiorentino* [...]' Fra Filippo gave his eye to '*Lucrezia, che cosi era il nome della fanciulla* [...]'

English editions of Vasari include an approachable translation of selected chapters by Julia Conway Bondanella and Peter Bondanella (1991) and, for completists, Gaston du C. de Vere's translation of the entire expanded 1568 edition in two volumes (1912; new edition 1996). An Italian edition of the 1550 version with notes by Luciano Bellosi and Aldo Rossi (1986) gives Vasari's untranslated voice. Patricia Lee Rubin, *Giorgio Vasari: Art and History* (1995) puts Vasari in his biographical and intellectual context. Paul Barolsky's books, including *Why Mona Lisa Smiles and Other Tales from Vasari* (1991) and *Giotto's Father and the Family of Vasari's Lives* (1992), emphasize the fabulist qualities of Vasari. A more balanced view of the place of storytelling in historical literature since ancient Greek times can be found in John Burrow, *A History of Histories* (2007). The fascination with artistic personality that evolved in Renaissance Italy and inspired Vasari is revealed in the classic work *Born under Saturn: The Character and Conduct of Artists* by Margot and Rudolf Wittkower (1963; new edition 2007).

In understanding the world of Filippo and Lucrezia, John Bossy, *Christianity in the West 1400–1700* (1985) stresses the vitality of late-medieval religion, while Richard Trexler's *Public Life in Renaissance Florence* (1980) shows how sacred objects, places and

rituals shaped life in this city. The religious history of Florence, including monasticism, is described in Gene A. Brucker, *Renaissance Florence* (1969), and John M. Najemy, *A History of Florence 1200–1575* (2006). The sexual tensions of convent life in Renaissance Italy are laid bare by Mary Laven in *Virgins of Venice: Enclosed Lives and Broken Vows in the Renaissance Convent* (2002), Jutta Gisela Sperling, *Convents and the Body Politic in Late Renaissance Venice* (1999), and K. J. P. Lowe, *Nuns' Chronicles and Convent Culture in Renaissance and Counter-Reformation Italy* (2003). Olwen Hufton, *The Prospect Before Her: A History of Women in Western Europe, Volume One 1500–1800* (1995), is an epically dismal revelation of the reality of life for women in early modern Europe. Gene Brucker, *Giovanni and Lusanna: Love and Marriage in Renaissance Florence* (1986), goes deep into a case of marital breakdown.

Other glimpses of private life in Renaissance Florence may be found in *The Albertis of Florence: Leon Battista's Della Famiglia* (translated and introduced by Guido A. Guarino, 1971), *Art, Marriage and Family in the Florentine Renaissance Palace* by Jacqueline Marie Musacchio (2008), *Tuscans and Their Families* by David Herlihy and Christiane Klapisch-Zuber (1985) and *The Memoir of Marco Parenti* by Mark Phillips (1987).

The most powerful Florentine family of all, and its friendship towards Fra Filippo Lippi, is portrayed in Dale Kent, *Cosimo de' Medici and the Florentine Renaissance: The Patron's Oeuvre* (2000), and in Jeffrey Ruda, *Fra Filippo Lippi* (1993). Ruda usefully brings together contemporary documents of Lippi's life, although he downplays the significance of the artist's sexual relationship with a nun.

The loves of Dante and Petrarch are preserved in their works that have been frequently translated into English since the Middle Ages. Indeed, two companion volumes, *Dante in English* (2005), edited by Eric Griffiths and Matthew Reynolds, and *Petrarch in English* (2005), edited by Thomas P. Roche, Jnr, anthologize translations since Chaucer's day. An excellent translation

of Dante's *Vita Nuova*, in which he narrates his passion for Beatrice, is by Mark Musa (1992), who has also translated Petrarch, *Selections from the Canzoniere and Other Works* (1985). Allen Mandelbaum's translation of *The Divine Comedy* by Dante is available in an edition illustrated by Botticelli (1995). *Petrarch's Lyric Poems* (1976) by Robert M. Durling offers a parallel text translation that gets the English reader as close as possible to Petrarch's voice.

CHAPTER THREE
Botticelli

The story of how Tommaso Soderini asked Sandro Botticelli why he did not marry is told in an early sixteenth-century manuscript collection of artists' lives by an author known as the Anonymous Florentine. This is, on the whole, a terse document. Edited and republished by Carl Frey in 1892 in Berlin as *Il Codice Magliabechiano*, it mostly lists the works of Florentine artists in brief chapters, almost all of which are unadorned by personal anecdote. It has a collaborative quality in that some paragraphs seem added in as people tell the compiler what they know or remember or were told. The story about Botticelli's conversation with Soderini is one of those insertions – and one of the very few flashes of personality in the entire manuscript. Botticelli died in 1510 and this manuscript was compiled in the 1540s. Given the precision of the anecdote and the *anonimo*'s general lack of interest in enlivening the work with tales, this seems a plausible memory of Botticelli's voice.

Botticelli's dream is an intimate encounter with the more arcane qualities of Renaissance love. The disdain for heterosexual union that this story attributes to an artist whose representations of women are so intoxicating suggests that he shared the dual theory of love held by the Neo-Platonist philosophy. This Neo-Platonist idea of love was promoted in the

circle of Lorenzo de' Medici in Florence in the 1470s and 80s by Marsilio Ficino's book *De amore*, a commentary on Plato's *Symposium* written in 1469 and published in 1484. Ficino claims in the preface that he was inspired to write it by Lorenzo de' Medici himself. The participants in Ficino's dialogue are real Florentines of the day, including Tommaso de' Benci, whose daughter was portrayed by Leonardo da Vinci in the 1470s. It is available in an English translation by Sears Jayne, *Commentary on Plato's 'Symposium' On Love* (1985).

The argument that Botticelli's art is influenced by Ficino's Neo-Platonism as well as his belief in Hermetic magic is associated with the so-called Warburg school of art historians who saw iconology – the study of symbols – as fundamental to understanding Renaissance art. Their interpretations of Botticelli can be found in Aby Warburg, *The Renewal of Pagan Antiquity* (translated by David Britt with an introduction by Kurt W. Forster, 1999), Edgar Wind, *Pagan Mysteries of the Renaissance* (1958), E. H. Gombrich, *Symbolic Images* (1972) and Frances A. Yates, *Giordano Bruno and the Hermetic Tradition* (1964). A powerful general exposition of the Neo-Platonist philosophy as an influence on art is Erwin Panofsky, *Studies in Iconology: Humanistic Themes in the Art of the Renaissance* (1939), while the classic work on Ficino's thought is Paul Oskar Kristeller, *The Philosophy of Marsilio Ficino* (1943). D. P. Walker, *Spiritual and Demonic Magic: from Ficino to Campanella* (1975), reveals the occult side of Ficino. A lucid introduction to the Neo-Platonists, and to Renaissance intellectual life as a whole, is Charles G. Nauert, *Humanism and the Culture of Renaissance Europe* (2006).

The Portrayal of Love: Botticelli's Primavera *and Humanist Culture at the Time of Lorenzo the Magnificent* (1992) is a trenchant repudiation of the Neo-Platonist interpretation of Botticelli that connects him instead with poetry and everyday life. Among Botticelli's many ancient Greek and Roman sources is Lucretius, *On the Nature of The Universe* (translated by R. E. Latham, and revised by John Godwin, 1994). In *The Swerve: How the Renaissance*

Began (2011) Stephen Greenblatt tells how this lost book was rediscovered by a Florentine book hunter at the start of the fifteenth century, and describes its dangerous materialist ideas that contrast with the spiritual Platonist side of Renaissance thought. The great revival of classical pagan mythology that is so beautifully visualized by Botticelli is related in Jean Seznec, *The Survival of the Pagan Gods: The Mythological Tradition and Its Place in Renaissance Humanism and Art* (1953), and Malcolm Bull, *The Mirror of the Gods: Classical Mythology in Renaissance Art* (2005).

CHAPTER FOUR
Leonardo da Vinci

Leonardo da Vinci makes a guest appearance in Matteo Bandello's *Novelle*, one of the most popular prose-fiction works of the Renaissance, which was translated into various European languages following its first Italian printing in Lucca in 1554.

Bandello's eyewitness account of Leonardo da Vinci at work in Milan in the 1490s is a detailed, plausible description with accurate details such as the location of Leonardo's studio. But what about the tale he puts into Leonardo's mouth? Is it possible that the polymath painter really did charm his listeners with the saucy story of Fra Filippo Lippi?

As a matter of fact Leonardo da Vinci was an avid storyteller. It was part of his self-presentation as a court artist and impresario. His notebooks are stuffed with jokes, anecdotes and even a long fantastical story set in Anatolia which Victorian readers took as a true travel diary (giant and all).

Why did he write down these stories and why do lists of his book collection include a joke book, *The Jests of Poggio*? Because Leonardo was a raconteur and wit who worked up material in private to entertain people in public. It is therefore perfectly possible that he told the comic tale of an artist and man of

God who could not control his libido. But if Bandello did remember Leonardo regaling people with the friar's tale, he nevertheless took the story's details from a more up-to-the-minute source, for the *Novelle* appeared four years after Vasari's *Lives*, and Bandello draws enthusiastically on Vasari's 'Life of Fra Filippo Lippi'.

There is no modern English translation of Bandello's *Novelle*, but an Italian edition by Luigi Rosso and Ettore Mazzali (2002) makes the original available. Bandello's eyewitness account of Leonardo da Vinci at work on *The Last Supper* is seen as reliable by, among others, Kenneth Clark, *Leonardo da Vinci* (revised edition with an introduction by Martin Kemp, 1988), and Carmen C. Bambach, Ed., *Leonardo da Vinci: Master Draftsman* (2003).

Leonardo's jokes and stories get a section to themselves in a translated selection from his *Notebooks* by Irma A. Richter, edited by Thereza Wells (2008), and can be read in parallel text, with Victorian translations alongside Leonardo's original words, in Jean Paul Richter's *The Notebooks of Leonardo da Vinci* (originally published 1883; reprinted under its current title 1970).

Of all Renaissance artists, Leonardo da Vinci is the most accessible through his tumultuous writings and drawings. The above editions of his notebooks are full of insights into his life, unmediated by storytellers. Another excellent (though out-of-print) English edition is *The Notebooks of Leonardo da Vinci*, edited by Edward MacCurdy (1938). Martin Kemp, *Leonardo da Vinci: The Marvellous Works of Nature and Man* (revised edition, 2006) is an invaluable guide to the scientific thinking that unifies Leonardo's diverse notes.

Kemp has also edited *Leonardo on Painting* (1989), which includes modern translations, by him and Margaret Walker, of Leonardo's provocative remarks about the power of painting to arouse desire. Leonardo's *Treatise on Painting*, translated and edited by A. P. McMahon in two volumes (1956), gives these passages in the original Tuscan as well as in translation.

Leonardo da Vinci: The Complete Paintings by Pietro C. Marani (2000) includes documents on Leonardo's life in Italian, including the accusations of sodomy made against him to the Office of the Night.

In 1910 Sigmund Freud drew on Leonardo's notes as well as his paintings in his psychoanalytical interpretation *Leonardo da Vinci and a Memory of His Childhood*, available in *The Penguin Freud Library, Volume 14: Art and Literature* (1985). His argument that Leonardo was homosexual dates back to Vasari, but Freud also claims that the polymath was celibate and 'sublimated' his libido into research – when in fact the sodomy accusations and Leonardo's detailed anatomical drawings (see *Leonardo da Vinci: Anatomist* by Martin Clayton and Ron Philo (2012)) suggest a familiarity with the carnal, not a distance from it.

For Freud, sexual libido is a universal drive, and even a genius like Leonardo da Vinci resists it at his peril. By contrast the French *philosophe* Michel Foucault claimed in *The History of Sexuality: An Introduction* (translated by Robert Hurley, 1981) that 'sexuality' is a modern invention. Former ages lacked not only words such as 'homosexual' or 'heterosexual' but also the very concepts: they did not categorize people according to a 'sexual identity' but instead saw particular acts as sins, without labelling the sinner by the sin. This theory has been adopted by many historians of Renaissance Europe, as Guido Ruggiero discusses in his book *Machiavelli in Love: Sex, Self, and Society in the Italian Renaissance* (2007). Yet the idea that no such thing as a 'gay' identity or subculture could exist before modern times simply seems untrue of Italy. The followers of Leonardo da Vinci portray Narcissus and St John as homoerotic archetypes, following their master himself. Similarly, a strong characterization of male-male love as a trait that defines certain individuals is recognizable in Dante's *Divine Comedy* and in the letters of Niccolò Machiavelli – see *Machiavelli and His Friends: Their Personal Correspondence*, translated and edited by James B. Atkinson and David Sices (1996), page 37.

CHAPTER FIVE
Giorgione

Renaissance Venice was a much less literary city than Florence. Although the poet Petrarch left his library to this maritime republic, and although it became by 1500 a great centre of printing, Venetians simply did not share the obsession with putting their ideas, opinions, inventions and memories onto paper that led Florence to become Italy's leading producer of literature. Florentine authors from Dante and Boccaccio to Machiavelli made the dialect of Tuscany a great literary language and typically it was a book published in Florence – Vasari's *Lives* – that in 1550 included a biography of the Venetian painter Zorzo da Castelfranco. The cultural distance between these two very different city-states shows. Vasari, for instance, does not seem to know that Giorgione's given name in Venetian was Zorzo.

Vasari turned Giorgione into a superstar by crafting his life as a desperate romance. Like a figure out of *Romeo and Juliet*, an archetypal lovelorn Renaissance youth, Vasari's Giorgione plays the lute and makes love in those long Venetian nights. Finally a lady he is in love with gives him the plague.

This image of Giorgione had a startling influence on European culture for centuries to come. The lovelorn genius who died young became so famous that many paintings now thought to be by other Venetian artists – especially Titian – were attributed to him. The cult of Giorgione kept on growing until it provoked a backlash. That backlash was severe. Modern art history has caustically pared down Giorgione's proven oeuvre to just a handful of paintings and continues to diminish him.

Even in 1873, the Victorian critic Walter Pater had to acknowledge in the essay on Giorgione in his rhapsodic work *The Renaissance* that 'much has been taken by recent criticism from what has been reported to be his work [. . .]' while he tried from the remaining fragments to weave a portrait of an artist who

aspired to 'the condition of music'. Pater bravely pointed out that

> [...] although the number of Giorgione's extant works has been thus limited by recent criticism, all is not done when the real and traditional elements of what concerns him have been discriminated; for, in what is connected with a great name, much that is not real is often very stimulating.

Pater was right. Culture is a delicate weft: the romantic image of Giorgione in Vasari's Life is itself part of the Renaissance. The myth's influence on later art is unquestionably 'real'. And besides, it is not pure myth.

An actual Giorgione can be encountered directly – in his paintings. In my account of him I describe only a few paintings that have survived the long cull of his reputation. The handful of pictures through which I seek the elusive Giorgione are those that even the most sceptical believe he painted. *Laura* in Vienna's Kunsthistorisches Museum, *The Tempest* and a faded nude fresco in the Accademia in Venice – these form a core of undisputed Giorgione paintings, and I believe they reveal a figure just as romantic, daring and fascinating as the man in Vasari's story.

Sex perfumes these paintings; love lingers in them. In them he is saying mysterious and moving things about sexuality and passion that mirror the story Vasari told.

In addition to Vasari, the tale of Giorgione is told with most of the same details by Carlo Ridolfi in *Le maraviglie dell' arte* (1648). Paintings attributed to Zorzo da Castelfranco are described by the sixteenth-century author Marco Antonio Michiel in his inventories of art in private palaces in Venice and environs: Marco Antonio Michiel, *Notizia d'opere del disegno* (2000). Renata Segre, 'A rare document on Giorgione' in *The Burlington Magazine*, Volume CLIII, Number 1299, June 2011, pages 383–386, publishes a newly discovered inventory of his goods after his death that con-

firms he died on a quarantine island for people exposed to plague. Paul Joannides, *Titian to 1518* (2001), is ruthlessly sceptical about how many paintings can be attributed to Giorgione and so provides a perfect guide to what he *did* paint. See also Peter Humphrey, *Painting in Renaissance Venice* (1995), for a more positive view of 'the artistic revolution created by Giorgione'.

Private Lives in Renaissance Venice by Patricia Fortini Brown (2004) sets aside such issues of connoisseurship to see art and architecture as material expressions of Venetian society, with a chapter on the homes of courtesans. *Rich and Poor in Renaissance Venice* by Brian Pullan (1971) shows how prostitution was treated as a social and religious problem by the Most Serene Republic. *The Honest Courtesan: Veronica Franco, Citizen and Writer in Sixteenth Century Venice* by Margaret F. Rosenthal sees Venetian prostitution through the eyes of the eloquent Franco, whose letters were originally published in Venice in 1580. C. Santore, 'Inventory of a courtesan's possessions', in *Renaissance Quarterly*, 41 (1988), A. Barghaze, *Donne o Cortigiane? La prostituzione a Venezia* (1980), G. Masson, *Courtesans of the Italian Renaissance* (1975), L. Lawner, *Lives of the Courtesans: Portraits of the Renaissance* (1987), S. Chojnacki, *Women and Men in Renaissance Venice* (2000), and S. K. Cohn, Jnr., *Women in the Streets: Essays on Sex and Power in Renaissance Italy* (1996), add to the picture. Guido Ruggiero argues in *The Boundaries of Eros: Sex Crime and Sexuality in Renaissance Venice* (1985) that in Renaissance Venice an alternative culture developed, 'that of the mistress, the prostitute, the libertine [...]'

Thomas Coryat's 1611 travel book *Coryat's Crudities* (facsimile edition, 1978) contains an astounded visitor's view of that alternative sexual culture.

An unauthorized edition of Jacopo Sannazaro's manuscript *Arcadia* was published in Venice in 1502, suggesting an appetite for pastoral poetry in the city of Giorgione's paintings. A modern English edition (translated by Ralph Nash, 1966) reveals how Sannazaro's Renaissance pastoral takes inspiration from the ancient Greek *Idylls* of Theocritus (translated by Anthony Verity,

2002) and the Latin *Eclogues* of Virgil (translated by Guy Lee, 1984).

Plague ended Giorgione's life and haunted his world. William Naphy and Andrew Spicer map this disease's dark shadows in their book *Plague: Black Death and Pestilence in Europe* (2007).

CHAPTER SIX
Raphael

Raphael tells his own love story in his painting of his bare-breasted mistress with her armband proclaiming that she belongs to Raphael of Urbino. The courtly painter's proud revelation of his love life is amplified by the stories Vasari tells about Raphael and sex in his Life, published in 1550. One of Vasari's tales is comic, one tragic. Raphael was so besotted with his lover that she had to be with him while he painted his frescoes in the Chigi villa; all good fun, but the young painter's amours went on until they sapped his strength and caused his early death.

In a poem written in Greek in about 1520, in the immediate aftermath of Raphael's death that year, the poet Janus Lascaris sees his fate as that of a lover of Aphrodite, punished by her jealous husband Hephaestus. This is surely a contemporary allusion, in the circle of Pope Leo X, to the belief that Raphael died of sexual excess and confirmation that Vasari's tales reflect widespread gossip in Raphael's Rome.

The poem by Lascaris was rediscovered by John Shearman and can be found in his invaluable and monumental book *Raphael in Early Modern Sources* (2003).

Raphael by Bette Talvacchia (2007) and *Raphael* by Roger Jones and Nicholas Penny are excellent surveys of his life and work. *Classic Art* by Heinrich Wolfflin (1899; translated by Peter and Linda Murray, fifth edition, 1994) defines the 'High Renaissance' and Raphael's centrality to it.

The Renaissance in Rome by Charles L. Stinger (new edition, 1998) richly sets the scene of high culture and ideas. *The History of Italy* by Francesco Guicciardini (translated and edited by Sidney Alexander, 1969) is one of the great works of the Italian Renaissance, a masterpiece of historical writing that offers acute analyses of the popes, several of whom the author knew personally. Michael Mallett takes a less sensational view of the most controversial Renaissance pope in *The Borgias* (1972). The Medici family's conquest of the papacy is lucidly narrated by J. R. Hale in *Florence and the Medici* (1977). The apparent worldly cynicism of the Renaissance popes is defended as a theology of celebration by John W. O'Malley in *Praise and Blame in Renaissance Rome: Rhetoric, Doctrine and Reform in the Sacred Orators of the Papal Court, c. 1450–1521* (1979).

Raphael's friend Baldassare Castiglione published *The Book of the Courtier* with the Aldine Press in Venice in 1528. It instantly became a European phenomenon and was already read in Italian at the court of Henry VIII, with an English translation by Thomas Hoby coming out in 1561. A convenient modern translation is by George Bull (1976).

Castiglione's references to Raphael in *The Book of Courtier* link him with the story of Alexander the Great and his court painter Apelles – which is one of the entertaining anecdotes about ancient artists in Pliny the Elder's *Natural History,* written in Latin in the first century AD. The tale can be found in a selection from the *Natural History* (translated by John F. Healy, 2004).

Another ancient Roman work that illuminates the art of Raphael is *The Golden Ass* by Apuleius, written in Latin in the second century AD (translated by Robert Graves, 1950), which contains the love story of Cupid and Psyche that Raphael and his assistants frescoed in the Villa Farnesina (formerly Agostino Chigi's villa).

Ingrid D. Rowland has edited and annotated *The Correspondence of Agostino Chigi (1466–1520) in Cod. Chigi R.V.c.* (2001)

Bette Talvacchia recovers the pornographic publication *I Modi* from censorship and oblivion in her fine book *Taking Positions: On the*

Erotic in Renaissance Culture (1999). *I Modi* can be seen in a vast historical context in *Seduced: Art and Sex from Antiquity to Now* by Marina Wallace, Martin Kemp and Joanne Bernstein (2007), which also includes Picasso's hilarious imaginary scenes of Raphael in bed with his lover.

Deborah Hayden's medical history *Pox: Genius, Madness and the Mysteries of Syphilis* (2003) helps to understand why Renaissance people associated sex with death.

CHAPTER SEVEN
Titian

In 1648 Venice finally got its own answer to Vasari's Florentine perspective in his *Lives* when Carlo Ridolfi's book *Le Maraviglie dell'arte ovvero le vite degli illustri pittori veneti e dello stato* (*The Marvels of Art, or the Lives of the Illustrious Painters of Venice and its Territory*) was published. Ridolfi's longest Life is that of Titian. In it he puts a name to at least one of the women whose faces and bodies appear in Titian's paintings. Titian was in love with a woman called Violetta, he says, and portrayed her among the orgiastic revellers in his painting *The Bacchanal of the Andrians*.

On the basis of this assertion, enthusiasts looked for Violetta in Titian's portraits and identified her as the daughter of the painter Palma Vecchio. All fiction, but Ridolfi's imagination latched onto the very real sense that Titian's women are painted from life and raised the question of intimacy. Ridolfi puts it sentimentally and makes up a name. The painting in which he chooses to see the artist's lover – the outrageously hedonistic *Bacchanal of the Andrians* – is a clue to the more carnal realities my chapter explores.

The world of licence that Titian paints has a very exact historical context. He evokes and promotes the confident, stylized pleasures of an aristocratic male elite. This peculiarly Venetian civilization of sexual amusement reflects a Republic ruled by a small

aristocratic class of ancient families that was set in place by the *Serrata*, the restriction in 1297 of the Great Council of Venice to roughly 200 long-established families. Aristocrats expressed their power in bed and Venetians excluded from political influence found escape there. The social history of Venice is charted by Frederic C. Lane in *Venice: A Maritime Republic* (1973) and its economic rise and fall by William H. McNeill in *Venice: The Hinge of Europe 1081–1797* (1974). The lavish pleasures of the wealthy in Renaissance Italy are seen as central to cultural life by Richard A. Goldthwaite in *Wealth and the Demand for Art in Italy, 1300–1600* (1995). The fascination that Venetian social stability exerted is a key theme of J. G. A. Pocock, *The Machiavellian Moment: Florentine Political Thought and the Atlantic Republican Tradition* (1975). The attempted definition of social identities through dress in Venice can be seen in Cesare Vecellio's *Habiti Antichi et Moderni*, translated by Margaret F. Rosenthal and Ann Rosalind Jones as *The Clothing of the Renaissance World* (2008). Vecellio, as it happens, was Titian's cousin.

Carlo Ridolfi's *The Life of Titian* has been translated by Julia Conaway Bondanella and Peter Bondanella (1996). It is sparse on truly intimate detail, as are later biographies – the most recent of which is *Titian: His Life* by Sheila Hale (2012) – for Titian left few written words behind, and none of those are very personal. Peter Humfrey, *Titian* (2007), is an overview of the life and art, but the most revealing surveys are catalogues of paintings including Peter Humfrey, *Titian: The Complete Paintings* (2007), and Filippo Pedrocco, *Titian: The Complete Paintings* (2001). *Titian* edited by David Jaffe (2003) is the well-illustrated book of an exhibition that reunited Titian's Bacchic paintings for the Duke of Ferrara.

I see Titian partly through the eyes of his friend Pietro Aretino, whose writings are copious and unbuttoned and fulsomely erotic. Aretino's letters were printed in several volumes in Venice from 1542 onwards, a daring 'live' publication of his on-going correspondence with kings, courtesans and artists. A

selection has been translated by George Bull, *Aretino: Selected Letters* (1976). Aretino's outrageous portrayal of Nanna, a fictional prostitute, and her eloquent views on sixteenth-century Italian life can be read in English in *Aretino's Dialogues*, translated by Raymond Rosenthal with a preface by Alberto Moravia and an introduction by Margaret F. Rosenthal (2008).

CHAPTER EIGHT
Michelangelo

Michelangelo's love story comes from Michelangelo himself. He tells it in poems and letters and drawings he gave as gifts to the young Roman nobleman Tommaso de' Cavalieri. The written words in which the sculptor expresses his passion for a young aristocrat are more than a record of Michelangelo's love. They *are* in some sense that love. A longing that was not physically requited, and that Michelangelo claims in his verses is a spiritual love for Tommaso's divine beauty, works itself out in words, is experienced as writing. This means that Michelangelo's poems preserve his passion for all time, without any need of a storyteller like Vasari to shape life into narrative. Needless to say, the openly homosexual nature of Michelangelo's love meant that it was not celebrated by Vasari. He just says delicately that Tommaso was one of the artist's 'greatest friends'.

Michelangelo's sex life (or rather his insistence that he did not have one) is discussed by his pupil Ascanio Condivi in his *Life* of Michelangelo published in 1553, with Michelangelo's advice and under his influence. Condivi compares Michelangelo with Socrates in Plato's *Symposium*, who admired male beauty in a completely chaste way. This source so close to Michelangelo therefore connects his idea of love very directly with the Neo-Platonist philosophy. Condivi's biography is translated by George Bull in *Michelangelo: Life, Letters and Poetry* (1987).

Michelangelo's Neo-Platonism pervades his poems. The best edition is James M. Saslow, *The Poetry of Michelangelo: An Annotated Translation* (1991), which places Michelangelo's powerful original verses next to English versions.

E. H. Ramsden, *The Letters of Michelangelo* (1963), translates his correspondence.

Michelangelo's Dream, edited by Stephanie Buck (2010), examines Michelangelo's drawings for Tommaso de' Cavalieri and analyses their love affair. On Michelangelo's fascination with the male body, Kenneth Clark, *The Nude* (1956), is deeply insightful. Clark sees the 'pathos' as well as beauty of Michelangelo's figures. James Hall, *Michelangelo and the Reinvention of the Human Body* (2005), also thinks seriously about the nude. Ludwig Goldscheider's *Michelangelo* (new edition, 1998) is the book every lover of Michelangelo needs for its classic black-and-white photographs of those struggling human forms.

CHAPTER NINE
Albrecht Dürer, Lucas Cranach the Elder, Hans Baldung Grien

Speculation about Albrecht Dürer's ambiguous love life started with the modern publication of his letters to Willibald Pirckheimer, with their caustic words about Dürer's wife, Agnes, and aesthetic appreciation of Venetian soldiers, in the nineteenth century. Tortuous Victorian translations of Dürer's dense Nuremberger repartee appeared in W. M. Conway's *Literary Remains of Albrecht Dürer* (1889) and German transcripts in *Dürers schriftlicher Nachlass*, edited by K. Lange and F. Fulse (1893). The exact meaning of terms such as '*clyster*' – as when Pirckheimer threatens to '*clyster*' Agnes Dürer if Albrecht does not come home soon from Venice – is still debated but the art historian Erwin Panofsky was clearly onto something when he concluded in his classic 1943 biography, *The Life and Art of*

Albrect Dürer, that the artist was 'not unsusceptible to the charm of handsome boys'.

Panofsky's biography is still deeply insightful, while Norbert Wolf, *Albrecht Dürer* (2010) brings recent research to bear on the life and art. *The Essential Dürer* edited by Larry Silver and Jeffrey Chipps Smith (2010) is another distillation of modern research. *Dürer and his Legacy* by Giulia Bartrum et al (2003), *The Complete Engravings, Etchings and Drypoints of Albrecht Dürer* (1972) and *The Complete Woodcuts of Albrect Dürer* (1963) convey his graphic brilliance.

Hieronymus Bosch: Garden of Earthly Delights by Hans Belting (2005) summarizes the little that is known about Bosch. *Gothic and Renaissance Altarpieces* by Caterina Limentani Virdis and Mari Pietrogiovanna (2002) places his profane art in the context of sacred altarpieces. *The Waning of the Middle Ages* by J. Huizinga, translated by F. Hopman, (1976) is a visionary interpretation of northern European art and culture in the fourteenth and fifteenth centuries. Eamonn Duffy, *The Stripping of the Altars: Traditional Religion in England 1400–1580* (1992) reclaims a lost world of sacred art and ritual in northern churches before the Reformation. Andrew Cunningham and Ole Peter Grell in *The Four Horsemen of the Apocalypse: Religion, War, Famine and Death in Reformation Europe* (2000) take Dürer's woodcut of the Four Horsemen as a key to a Europe in crisis.

Diarmaid MacCulloch, *Reformation: Europe's House Divided 1490–1700* (2003) combines theology and social history to see the remaking of Christendom as a clash of ideas about how to live. Steven Ozment, *The Serpent and the Lamb* (2012) contests MacCulloch's view of Luther and advocates a warmer understanding of the reformer by studying his friendship with Lucas Cranach the Elder. *The Book in the Renaissance* by Andrew Pettegree (2011) discusses the business partnership of Luther and Cranach.

Norman Cohn, *Europe's Inner Demons* (1976) investigates the origins of the widespread persecution of "witches" in early modern Europe. *The Hammer of Witches* translated by Christopher S. Mackay (2009) is a key document of witchcraft beliefs and the

impulse to persecute. *Witch Craze* by Lyndal Roper (2004) sets Hans Baldung Grien's depictions of witches in the context of popular witchraft fantasies.

CHAPTER TEN
Hans Holbein

At the start of the seventeenth century Karel van Mander, 'the Dutch Vasari', published 'The Lives of the Illustrious Netherlandish and German Painters' as part of *Het Schilder-boeck* (1603–04), which also includes technical advice on painting and a convenient manual of Ovid's myths for artists. Van Mander sets out to ennoble the profession of art in northern Europe as Vasari did for Italy, by bringing the great artists of the north to life through vivid descriptions of their work and dramatic tales of their lives.

It is van Mander who tells of the miserable marriage of Hans Holbein the Younger. He is not a casual fabulist. Although he gets Holbein's birthplace wrong – he thinks he came from Basel rather than Augsburg, where Holbein was actually born – he is aware of a debate about this and acknowledges the existence of an artist with the same name from Augsburg!

Van Mander accurately says that Holbein got to know the renowned humanist Erasmus in Basel and that Erasmus sent him with a letter of introduction to Thomas More in England. He adds that Holbein was glad to leave Basel because his wife there was grumpy and 'shrewish' and never gave him any peace. Did this story that reached van Mander start as an attempt to understand Holbein's uneasy portrait of his family?

Hans Holbein the Younger: The Basel Years 1515–1532 by Christian Muller and Stephan Kemperdick (2006) incorporates recent research on paintings that include Holbein's portrait of his family. *Hans Holbein: Painter and the Court of Henry VIII* by

Stephanie Buck (2003) is excellent on his years in England. *Holbein in England* by Susan Foister (2006) rounds out the picture. *Henry VIII: Man and Monarch* edited by David Starkey and Susan Doran (2009) sets Holbein in the visual and material context of the Tudor court.

Utopia by Thomas More, translated by Paul Turner (1965) is the literary masterpiece of Holbein's first British portrait client. *Thomas More* by Peter Ackroyd (1999) is the standard biography of this doomed man. *The Reign of Henry VIII: Peronsalities and Politics* (2002) and *Six Wives: The Queens of Henry VIII,* (2003) both by David Starkey, are glittering windows on a shadowed age. *Tudor England* (1990) by John Guy and *New Worlds, Lost Worlds* (2001) by Susan Brigden are powerful surveys of Tudor state, religion and society. *The Penguin Book of Renaissance Verse 1509–1659,* selected by David Norbrook and edited by H. R. Woudhuysen (1993) lets Tudor subjects speak for themselves.

CHAPTER ELEVEN
Agnolo Bronzino

Agnolo Bronzino wrote poetry that abounds in bawdy humour, including homosexual as well as heterosexual images. Meanwhile his teacher Jacopo Pontormo kept a diary that reveals their familial relationship and Bronzino's protection of the eccentric Pontormo. Yet the most gossipy book about the court artists of mid-sixteenth-century Florence is Benvenuto Cellini's extraordinary manuscript *Autobiography*, written down in the late 1550s and published centuries later in 1728.

Cellini, who created the fierce bronze *Perseus* that still holds up Medusa's severed head under the Loggia of the Signoria in Florence, portrays a bitchy world of rival artists, including Baccio Bandinelli, Giorgio Vasari and Luigi Ammanati, fighting for Duke Cosimo I's favour – although he is quite nice about the brilliant Bronzino. Most revealingly, he paints a milieu in which

bisexuality seems to be the norm for artists. Cellini levels accu-
sations of sodomy against Ammanati and Vasari. However, the
biggest joke is his own complicated sexual identity. He tells a tale
of how, at an artist's dinner to which every man was to bring his
mistress (there was a prize for the most beautiful girlfriend) he
took his male apprentice in drag, and 'she' won the prize. Cellini
was accused several times of sodomy.

The sexual ambiguities he half-reveals, half-conceals suggest
the perverse culture that produced Bronzino's painting of *Venus
and Cupid*.

Cellini's manuscript is available in several English editions
including *My Life*, translated by Julia Conaway Bondanella and
Peter Bondanella (2002).

Jacopo Pontormo, *Diario: Codice Magliabechiano VIII 1490 della
Bioblioteca national centrale di Firenze* (1996).

Bronzino's verses are discussed by Deborah Parker in her
book *Bronzino: Renaissance Painter as Poet* (2000), while *Bronzino:
Artist and Poet at the Court of the Medici* edited by Carlo Falciani and
Antonio Natali (2010) brings together recent scholarship.
Bronzino by Maurice Brock, translated by David Poole
Radzinowicz and Christine Scultz-Touge (2002) is a survey of
his life and work.

The sculpture of Mannerist Florence is richly chronicled by
John Pope-Hennessy in *Italian High Renaissance and Baroque Sculture*
(1996). Florentine Painting is this period is narrated by S. J.
Freedberg in *Painting in Italy 1500 - 1600* (1993). *Mannerism* by
John Shearman (1977) is a provocative analysis of this contro-
versial style. Niccolo Machiavelli's play *Mandragola* and his
dialogue *The Art of War* diagnose sixteenth-century Florence as
decadent – see *The Essential Writings of Niccolo Machiavelli*, trans-
lated by Peter Constantine (2007).

The French court is analytically chronicled by R. J. Knecht in
The Rise and Fall of Renaissance France (1996). French art and the
influence of Italy on it are finely set out in *Renaissance Art in France:*

The Rise of Classicism by Henri Zerner, translated by Deke Dusinberre, Scott Wilson and Rachel Zerner (2003). *Gargantua and Pantaguel* by Francois Rabelais, translated by M. A. Screech (2006) is a monument to licence and bawdy in Renaissance France. Art at the court of Rudolf II in Prague is examined by Thomas DaCosta Kaufmann in *The School of Prague* (1988).

CHAPTER TWELVE
Later Titian

Titian's correspondence with King Philip II about the series of mythological scenes he painted for the Spanish king is an island of almost expressive writing in his sparsely verbalized life. In his letters Titian calls these paintings '*poesie*', revealing his ambition to be an Ovid in paint, and hints at his thinking as he stresses the variety of nude poses he will depict. A letter from Philip reveals that he was in London, as the new husband of Queen Mary I, when he took delivery of Titian's *Venus and Adonis*.

Nicholas Penny in *National Gallery Catalogues: The Sixteenth-Century Italian Paintings Vol. II* (2008) rejects the idea that Shakespeare came under the influence of Titian's *Venus and Adonis*.

Shakespeare's affinity for Ovid is stressed by Jonathan Bate in *The Genius of Shakespeare* (1997). His life and world are recovered from slight sources by Stephen Greenblatt in *Will in the World* (2004) and James Shapiro in *1599* (2005). *Venus and Adonis* is available in many editions including

The Oxford Shakespeare: The Complete Sonnets and Poems (2008). E. A. J. Honigmann in the Arden edition of *Othello* (2001) makes fascinating observations on this play's Venetian imagery.

The Europe-wide dissemination of the Renaissance is made clear by J. R. Hale in *The Civilization of Europe in the Renaissance* (2005). The age of Philip II is portrayed by Henry Kamen in *Spain's Road to Empire* (2002) and by J. H. Elliott in *Imperial Spain*

1469 - 1716 (2002). Geoffrey Parker illuminates various aspects of the age in *Empire, War and Faith in Early Modern Europe* (2003).

Mark Hudson evokes the old age of Titian in *Titian: The Last Days* (2010). Erwin Panofsky decodes Titian's own view of "the ages of man" in his classic work *Meaning in the Visual Arts* (1970).

Ovid's *Metamorphoses* has been translated many times since the Renaissance. Arthur Golding's Elizabethan version is still available in paperback (1567; 2002). Modern translations range from a prose version by Mary M. Innes (1955) to verse translations by David Raeburn (2004) and Charles Martin (2005).

CHAPTER THIRTEEN
Michelangelo's Last Judgement

Vasari tells how Michelangelo's *Last Judgement* outraged the prudish, briefly in the first edition of *The Lives* ... in 1550 and more fully in the expanded 1568 edition. The villain of his tale is a papal official who objected to the nudes in the painting in words very similar to those used by Pietro Aretino. He says Michelangelo took revenge by portraying this official as the demon Minos.

In the same year that Vasari published *The Lives* ... the savage reality behind this pleasing anecdote was made public. The fourth volume of Aretino's *Letters*, printed in Venice in 1550, includes his letter denouncing Michelangelo's *Last Judgement* as a painting more suited to a brothel than the pope's chapel. Remarkably, Aretino placed in the public eye not just his criticism of Michelangelo but also his change of heart about his former hero. In 1542 he had published his letter to Michelangelo proposing a plan for *The Last Judgement*: he also published Michelangelo's polite rejection of his proposal. Readers of Aretino's letters in print could therefore see how his pious denunciation of *The Last Judgement*'s nudes served as an act of vendetta.

The Catholic Reformation by M. A. Mullett (1999) tells the story

of the Council of Trent and its aftermath. R. Bireley, *The Refashioning of Catholicism, 1450–1700* (1999) adds to the picture. Torquato Tasso's epic poem *The Liberation of Jerusalem*, translated by Max Wickert (2009) is a passionate sixteenth-century expression of reborn Catholicism.

Michelangelo: The Frescoes of the Sistine Chapel by Marcia B. Hall (2002) and *Michelangelo* by Frank Zollner et al (2008) get the reader physically close to The Last Judgement.

CHAPTER FOURTEEN
Veronese

In another example of Giorgio Vasari's bias towards artists working in Florence, Tuscany and Rome, he does not give Veronese a chapter to himself in *The Lives* . . . – not even in the second edition (1568), in which this master of Venetian painting makes fleeting appearances while minor Mannerists get full biographies illustrated by their portraits.

The story of Veronese and the Inquisition is in fact not a 'story' at all but a sombre event recorded in the official transcript of his hearing before the Holy Tribunal in Venice on 18 July 1573. This contemporary legal transcript carefully recording the Inquisitor's questions and Veronese's answers was rediscovered in the nineteenth century, and first published in the *Gazette des Beaux Arts* in 1867.

Veronese's trial transcript is translated in *A Documentary History of Art, Volume II* by Elizabeth Gilmore Holt (1947).

On the resistance of Venice to Counter-Reformation excesses see William J. Bouwsma, *Venice and the Defense of Republican Liberty: Renaissance Values in the Ages of the Counter-Reformation* (1968) and Edward Muir, *The Culture Wars of the Late Renaissance: sceptics, libertines and opera* (2007).

J. W. O' Malley, *The First Jesuits* (1993) and R. Po-Chia Hsia,

The World of Catholic Renewal, 1540–1770 (1998) explore the
Italian religious revival. R. Wittkower *Early Baroque* (1999) sees
artistic developments in this religious context.

Palladio by James S. Ackerman and Phyllis Dearborn (1974) cel-
ebrates the architect with whom Veronese had so much in
common. Palladio speaks for himself in *The Four Books on Architecture*,
translated by Richard Schofield and Robert Tavernor (2002).

CHAPTER FIFTEEN
Caravaggio

The Life of Caravaggio in Giovanni Pietro Bellori's book *Le vite de'*
pittori, scultori ed architetti moderni (*The Lives of the Modern Painters, Sculptors*
and Architects), published in 1672, starts with an engraving of a man
with coal-black eyes, hair like tangled wires, a goatee beard and
sharp, fierce features. This portrait of Caravaggio, based on a draw-
ing of him that still survives but given a sinister twist by the engraver,
contrasts with other images in the book that make artists such as
Luca Giordano and Nicolas Poussin look gentle and introspective.

Caravaggio's harshly incised face reflects his style with its vio-
lent contrasts of light and dark as well the bloody biography that
in Bellori's telling is of a piece with a savage art. Yet while he sees
Caravaggio as a man whose dedication to the pure painting of
what was before his eyes robbed him of a true sense of beauty,
Bellori is a lot more sympathetic to Caravaggio than Giovanni
Baglione in his 1642 book *Le vite de' pittori, scultori et architetti*.
Baglione casts himself as a Christian artist and author. His book
tells artists' lives 'from the Pontificate of Gregory XIII in 1572
to the times of Pope Urban VIII in 1642'. The author's portrait
shows him with a large cross on his robe.

Baglione's Life is a furious denunciation of Caravaggio,
ascribing his success to the machinations of his associate known
as Prospero of the Grotesques who somehow beguiled the

cognoscenti of Rome into falling for Caravaggio's sub-Giorgionesque daubs. By contrast, Bellori stresses Caravaggio's conflicts with the Church over issues of nudity and decorum, and paints a more psychologically real picture of a man who was often in intense male company as when he joined Cardinal del Monte's household and lived as one of the Cardinal's '*gentil uomini*'.

These early biographies are translated along with Giorgio Mancini's account in *Lives of Caravaggio*, with an introduction by Helen Langdon (2005). Langdon's modern biography *Caravaggio* (1990) and Andrew Graham-Dixon, *Caravaggio* (2010) comb contemporary sources to set Caravaggio in the religious climate of the Counter-Reformation. Sebastian Schutze, *Caravaggio; The Complete Works* (2009) and Catherine Puglisi *Caravaggio* (2000) survey his life and paintings. *The Genius of Rome 1592–1623* by Beverly Louise Brown et al (2001) is an exhibition catalogue that sets Caravaggio alongside such rival artists as Baglione.

Sidereus Nuncius, or the Sidereal Messenger by Galileo Galilei, translated by Albert van Helden (1989) and David Freedberg, *The Eye of the Lynx: Galileo, His Friends and the Beginnings of Modern Natural History* (2003) reveal that religion was not the only intellectual context in Caravaggio's Rome. *Words and Deeds in Renaissance Rome: Trials before the Papal Magistrates* by Thomas V. Cohen and Elizabeth S. Cohen (1993) is a window on the social world of Rome through raw trial records.

CHAPTER SIXTEEN
Artemisia Gentileschi and Gianlorenzo Bernini

A detailed transcript dozens of pages long meticulously records the trial in which Artemisia Gentileschi faced her rapist and endured judicial torture. It is a unique window on the world of Caravaggio's followers in Rome.

In 1682 Queen Christina of Sweden commissioned the

Florentine art chronicler Filippo Baldinucci to write a biography of Gianlorenzo Bernini. A contemporary report on Bernini's relationship with Costanza and its brutal end has been found among the Baldinucci papers in Florence and a letter from Bernini's mother about his bad behaviour survives in the Barberini papers in the Vatican.

A translation of the Artemisia Gentileschi trial transcript is included in Mary D. Garrard, *Artemisia Gentileschi: The Image of the Female Hero in Italian Baroque Art* (1991).

Bernini's love affair is told in *Bernini's Beloved* by Sarah McPhee (2012) and *Bernini and the Birth of Baroque Portrait Sculpture* by Andrea Bacchi et al (2008). The art of Bernini is elegantly described by R. Wittkower in *High Baroque* (1999) and made vivid by Simon Schama in *The Power of Art* (2006). The life and art of Velazquez are analysed by Jonathan Brown in *Velazquez* (1986).

CHAPTER SEVENTEEN
Rembrandt

On 15 December 1660 the illiterate Hendrickje Stoffels signed her X to a document in which she and Rembrandt van Rijn's son Titus undertook to continue with an art business they had already been running since 1658, selling paintings, drawings, etchings and woodcuts, as well as 'curiosities', and employing and housing the artist Rembrandt to assist them in their trade.

This document reveals the intensity and depth of the bond between Rembrandt and Hendrickje. She made it possible for him to go on working after he declared himself bankrupt in 1656 by becoming his commercial proxy. Here is an Amsterdam tale of paint, money and love, documented in black and white.

This document is translated in Elizabther Gilmore Holt, *A Documentary History of Art, Volume II* (1947). Early biographies of Rembrandt, which are remote from his real life, are translated in

Lives of Rembrandt (2008). His relationships with and portrayals of women are assessed in *Rembrandt's Women* edited by Julia Lloyd-Williams (2001). *Rembrandt's Universe* by Gary Schwartz (2006) is a compendious volume in the curious spirit of the Dutch Golden Age. *Rembrandt's Eyes* by Simon Schama (1999) is revelatory and, in passing, the best modern biography of Rubens. *Rubens* by Arnauld Brejon de Lavergnee (2004) is the catalogue of an exhibition full of great works. *The Making of Rubens* by Svetlana Alpers (1996) casts a fresh eye on Flemish Baroque. *Rubens* by Kristin Lohse Belkin (1998) is an affectionate overview. *Taste and the Amtique: The Lure of Classical Sculpture 1500–1900* by Francis Haskell and Nicholas Penny (1982) discusses the fascination of the classical nude. Svetlana Alpers, *The Art of Describing* (1983) perceptively contrasts Dutch art with that of Italy. Simon Schama, *The Embarrassment of Riches: An Interpetation of Dutch Culture in the Golden Age* (1987) brings an entire lost world of images and emotions to life.

THE WORKS OF ART

Ancient Art

Cycladic Islands
Figurine of a Woman
Marble
About 2600–2400 BC
British Museum
London

Roman Empire, after Greek
 original
Pan and Daphnis
Marble
Farnese Collection
Formerly in the collection of
 Agostino Chigi
National Archaeological Museum
Naples

Roman Empire, second century
 AD, after Greek original;
 restored in the sixteenth century
Leda and the Swan
Marble
Formerly in the collection of
 Giovanni Grimani
National Archaeological Museum
Venice

Roman Empire, after a second-
 century BC Greek original
Medici Venus
Marble

Formerly Medici family collection
Uffizi Gallery
Florence

Roman Empire, second century
 AD, after a Hellenistic Greek
 original
Crouching Venus
Marble
Royal Collection
British Museum
London

Rhodes, first century BC
Laocoön
Marble
Vatican Museums
Vatican City
Rome

Filippo Brunelleschi
Born 1377
Died 1446

Dome
1420–36
Florence Cathedral

Foundling Hospital
Begun 1419
Florence

Donatello (Donato di Niccolò di
 Betto Bardi)
Born about 1386
Died 1466

Feast of Herod
Gilded bronze panel
1423–27
Baptistery
Siena

Cantoria
Marble
1431–39
Museum of the Opera del Duomo
Florence

Amor-Atys
Bronze
Early 1440s
Bargello Museum
Florence

David
Bronze
About 1440–60
Bargello Museum
Florence

Masaccio
Born 1401
Died about1428–29

Adam and Eve Expelled from
 Paradise
Fresco
1420s
Brancacci Chapel
Florence

Fra Filippo Lippi
Born about1406
Died 1469

The Annunciation
Painting on wooden panel
Late 1430s to about 1440
Basilica of San Lorenzo
Florence

The Coronation of the Virgin
Tempera painting on wooden panel
About 1439–47
Uffizi Gallery
Florence

Woman with a Man at a Casement
Tempera painting on wooden panel
About 1440–46
Metropolitan Museum of Art
New York

Virgin and Child with the Birth of
 the Virgin
Tempera painting on wooden panel
About 1452 or mid-to-late 1460s
Pitti Palace
Florence

The Palazzo Medici Adoration
Painting on poplar-wood panel
Late 1450s
Gemäldegalerie
Berlin

Madonna with Child and Two
 Angels
Tempera painting on wooden panel
About 1465
Uffizi Gallery
Florence

Sandro Botticelli (Alessandro di
 Mariano Filipepi)
Born 1445
Died 1510

The Adoration of the Magi
Tempera painting on wood
About 1475
Uffizi Gallery
Florence

Primavera
Grease tempera painting on wood
About 1481–82
Uffizi Gallery
Florence

Pallas and the Centaur
Tempera painting on canvas
About 1482
Uffizi Gallery
Florence

The Birth of Venus
Tempera painting on linen
About 1484
Uffizi Gallery
Florence

Venus and Mars
Tempera and oil painting on
 poplar-wood panel
About 1485
National Gallery
London

Pallas
Drawing in pencil, pen and bistre,
 white lead and brown wash on
 partly tinted paper
About 1491
Uffizi Gallery
Florence

Calumny of Apelles
Tempera painting on wooden panel
About 1497
Uffizi Gallery
Florence

Francesco del Cossa
Born about 1435–36
Died about 1477–78

April
Fresco
1469–70
Hall of the Months
Palazzo Schifanoia
Ferrara

Giovanni Bellini
Probably born about 1438
Died 1516

Young Woman at her Toilet
Oil painting on wooden panel
1515
Kunsthistorisches Museum
Vienna

Leonardo da Vinci
Born 1452
Died 1519

Ginevra de' Benci
Oil painting on poplar wood
About 1474
National Gallery of Art
Washington, DC

The Virgin of the Rocks (1)
Oil on wood, transferred to canvas
About 1483–84
Louvre Museum
Paris

Lady with an Ermine
Oil painting on walnut wood
About 1489–90
Czartoryski Museum
Krakow

La Belle Ferronière
Oil painting on walnut-wood panel
1490s
Louvre Museum
Paris

Mona Lisa
Oil painting on poplar wood
Begun 1503
Louvre Museum
Paris

Leda and the Swan
Drawing in pen and brown ink,
 brown wash and black chalk on
 paper
About 1504
The Devonshire Collection
Chatsworth

Head of Leda
Drawing in pen and ink over black
 chalk on paper
About 1505–10
Royal Collection
Windsor Castle

Leda
Copy by a follower of Leonardo's
 lost original
Oil and resin painting on wooden
 panel
Uffizi Gallery
Florence

The Virgin of the Rocks (2)
Oil painting on poplar-wood panel
About 1491 or 2–9 and 1506–08
National Gallery
London

Madonna and Child with St Anne
 and a Lamb
Oil painting on poplar wood
About 1510–13
Louvre Museum
Paris

Portrait of a Nude Woman,
 'Monna Vanna'
Copy by a follower of Leonardo's
 lost original
Painting on cardboard
Early sixteenth century
Musée Condé
Chantilly

The 'Angel Incarnate'
Drawing in charcoal on paper
About 1513–15
Private Collection

St John the Baptist
Oil painting on walnut wood
About 1515
Louvre Museum
Paris

Vittore Carpaccio
Born about 1465
Died 1525–26

Miracle of the Relic of the True
 Cross on the Rialto Bridge
Oil painting on canvas
1494
Accademia Gallery
Venice

Dream of St Ursula
Oil painting on canvas
1495
Accademia Gallery
Venice

Two Ladies on a Terrace
Oil painting on wood
About 1500
Correr Museum
Venice

Giorgione
Born 1470s
Died 1510

Judith
Oil painting on canvas
About 1504
Hermitage Museum
St Petersburg

Portrait of a Young Woman
('Laura')
Oil painting on canvas on a
wooden panel
1506
Kunsthistorisches Museum
Vienna

The Tempest
Oil painting on canvas
About 1505–08
Accademia Gallery
Venice

La Vecchia
Oil painting on canvas
1506–07
Accademia Gallery
Venice

Nude
Fresco (detached from Fondaco dei
Tedeschi)
About 1508
Accademia Gallery
Venice

Self-Portrait
Oil on canvas
About 1510
Herzog Anton Ulrich-Museum
Braunschweig

Sleeping Venus
(finished by Titian)
Oil on canvas
About 1510
Gemäldegalerie
Berlin

Giulio Campagnola
Born about 1482
Died after 1515

Woman Reclining in a Landscape
Engraving on paper
1508–09
Art Institute of Chicago
Chicago

Sebastiano del Piombo
Born about 1485
Died 1547

The Death of Adonis
Oil on canvas
About 1512
Uffizi Gallery
Florence

Palma Vecchio
Born about 1480
Died 1528

A Blonde Woman
Oil painting on wooden panel
About 1520
National Gallery
London

Paris Bordone
Born 1500
Died 1571

Venetian Women at their Toilet
Oil painting on canvas
Mid-1540s
National Gallery of Scotland
Edinburgh

Raphael
Born 1483
Died 1520

The Marriage of the Virgin
Oil painting on wooden panel
1504
Brera Picture Gallery
Milan

The Three Graces
Oil painting on wooden panel
About 1504
Musée Condé
Chantilly

Galatea
Fresco
1511–12
Villa Farnesina
Rome

Donna Velata
Oil painting on canvas
About 1515
Pitti Palace
Florence

Portrait of Baldassare Castiglione
Oil painting on canvas
About 1515
Louvre Museum
Paris

Portrait of Cardinal Bibbiena
Oil painting on canvas
About 1516
Pitti Palace
Florence

Stufetto of Cardinal Bibbiena
Room with marble carvings and
	frescoes
1516
Vatican Palace
Vatican City
Rome

The Fire in the Borgo
Fresco
About 1516–17
Stanza dell' Incendio
Vatican Museums
Vatican City
Rome

The Feast of the Gods
Fresco
1517–18
Villa Farnesina
Rome

Study of the Three Graces
Red chalk over stylus on paper
About 1518
Royal Collection
Windsor Castle
Windsor

Portrait of a nude woman (the
	Fornarina)
Oil painting on wooden panel
About 1518
Palazzo Barberini
Rome

Self-Portrait with a Friend
Oil painting on canvas
About 1518
Louvre Museum
Paris

Portrait of Leo X with Two
 Cardinals
Oil painting on wooden panel
1518
Uffizi Gallery
Florence

Giulio Romano
Probably born 1499
Died 1546

I Modi
Engravings on paper by
 Marcantonio Raimondi after
 Giulio Romano's drawings
First published 1524
Panel of surviving fragments
Department of Prints and
 Drawings
British Museum
London

Lady at her Toilet
Oil painting on canvas
About 1525
Puskin Museum
Moscow

The Lovers
Oil painting on panel, transferred
 to canvas
About 1525
Hermitage Museum
St Petersburg

Sala di Amore e Psiche
Room with frescoes
1527–30
Palazzo del Te
Mantua

Correggio
Birthdate unknown: active by 1494
Died 1534

Satyr, Nymph and Cupid
 (Jupiter and Antiope)
Oil painting on canvas
About 1524–27
Louvre Museum
Paris

Jupiter and Io
Oil painting on canvas
About 1530
Kunsthistorisches Museum
Vienna

The Abduction of Ganymede
Oil painting on canvas
About 1530
Kunsthistorisches Museum
Vienna

Titian
Probably born about 1490
Died 1576

Rustic Idyll
Oil painting on canvas
About 1507–08
Private collection on loan to Fogg
 Art Museum
Cambridge, Massachusetts

Bust Portrait of a Courtesan
(formerly attributed to
Giorgione)
Oil painting on canvas, transferred
from a wooden panel
About 1509
Norton Simon Museum
Pasadena

Judith
Fresco detached from Fondaco dei
Tedeschi
About 1509–10
Ca' d'Oro
Venice

The Miracle of the Jealous
Husband
Fresco
1511
Scuola del Santo
Padua

Concert Champêtre
Oil painting on canvas
About 1511
Louvre Museum
Paris

Portrait of a Woman
(La Schiavona)
Oil painting on canvas
About 1511
National Gallery
London

The Three Ages of Man
Oil painting on canvas
About 1512–14
National Gallery of Scotland
Edinburgh

Noli me Tangere
Oil painting on canvas
About 1513–14
National Gallery
London

Young Woman with a Mirror
Oil painting on canvas
About 1514–15
Louvre Museum
Paris

A Young Woman
(Violante)
Oil painting on wooden panel
About 1514–16
Kunsthistorisches Museum
Vienna

Young Woman in Black
Oil painting on wooden panel
About 1514–16
Kunsthistorisches Museum
Vienna

Sacred and Profane Love
Oil painting on canvas
About 1515–16
Borghese Gallery
Rome

Flora
Oil painting on canvas
About 1516–18
Uffizi Gallery
Florence

The Worship of Venus
Oil painting on canvas
1518–19
Prado Museum
Madrid

Bacchanal of the Andrians
Oil painting on canvas
About 1519–21
Prado Museum
Madrid

Bacchus and Ariadne
Oil painting on canvas
1520–23
National Gallery
London

Venus Anadyomene
Oil painting on canvas
About 1520
National Gallery of Scotland
Edinburgh

St Mary Magdalene
Oil painting on wooden panel
About 1535
Pitti Palace
Florence

La Bella
Oil painting on canvas
1536
Pitti Palace
Florence

Woman in a Fur Coat
Oil painting on canvas
About 1536–38
Kunsthistorisches Museum
Vienna

Venus of Urbino
Oil painting on canvas
1536–38
Uffizi Gallery
Florence

Portrait of Pietro Aretino
Oil painting on canvas
1545
Pitti Palace
Florence

Danaë (1)
Oil painting on canvas
1544–45
Capodimonte Museum
Naples

Portrait of Charles V on Horseback
Oil painting on canvas
1548
Prado Museum
Madrid

Portrait of Prince Philip
Oil painting on canvas
1548–51
Prado Museum
Madrid

Danaë (2)
Oil painting on canvas
About 1551–53
Prado Museum
Madrid

Venus and Adonis
Oil painting on canvas
1553–54
Prado Museum
Madrid

Perseus and Andromeda
Oil painting on canvas
1554–56
Wallace Collection
London

Diana and Callisto
Oil painting on canvas
1556–59
National Galleries of Great Britain
 and of Scotland
London and Edinburgh

Diana and Actaeon
Oil painting on canvas
1556–59
National Galleries of Great Britain
 and of Scotland
London and Edinburgh

The Rape of Europa
Oil painting on canvas
1559–62
Isabella Stewart Gardner Museum
Boston

Tarquin and Lucretia
Oil painting on canvas
About 1568–71
Fitzwilliam Museum
Cambridge

The Death of Actaeon
Oil painting on canvas
About 1559–76
National Gallery
London

Michelangelo
Born 1475
Died 1564

David
Marble
1501–04
Accademia Gallery
Florence

Sistine Ceiling
Fresco
1508–12
Sistine Chapel
Vatican City
Rome

The Dying Slave
Marble
1513–about 1516
Louvre Museum
Paris

Risen Christ
Marble
1519–20
Santa Maria Sopra Minerva
Rome

Victory
Marble
About 1520–34
Palazzo Vecchio
Florence

The Boboli Prisoners
Marble
About 1520–30
Accademia Gallery
Florence

Medici Chapel
White marble, *pietra serena* and other
 building materials
1520–34
New Sacristy
San Lorenzo
Florence

Night, Day, Dawn and Evening
Marble
About 1530–34
New Sacristy
San Lorenzo
Florence

Phaethon
Drawing in black chalk on laid
 paper
1533
Royal Collection
Windsor Castle
Windsor

Ganymede
Drawing in black chalk on laid
 paper
1532
Fogg Art Museum
Cambridge, Massachusetts

Leda and the Swan
Copy by a follower of
 Michelangelo of his lost original
Oil painting on canvas
About 1530
National Gallery
London

The Last Judgement
Fresco
1536–41
Sistine Chapel
Vatican City
Rome

Martin Schongauer
Born 1435
Died 1491

The Temptation of St Anthony
Engraving printed on paper
1470s
British Museum
London

Jan van Eyck
Active 1422
Died 1441

The Arnolfini Portrait
Oil painting on oak
1434
National Gallery
London

Albrecht Dürer
Born 1471
Died 1528

The Four Witches
Engraving printed on paper
1497
British Museum
London

Hercules at the Crossroads
Engraving printed on paper
About 1498
Metropolitan Museum of Art
New York

A Witch Riding Backwards on a
 Goat
Engraving printed on paper
About 1500
British Museum
London

Self-Portrait
Painting on lime-wood panel
1500
Alte Pinakothek
Munich

Adam and Eve
Engraving printed on paper
Engraved 1504
V&A Museum
London

Portrait of a Young Venetian
 Woman
Painting on spruce-wood panel
1505
Kunsthistorisches Museum
Vienna

Portrait of a Venetian Woman
Painting on poplar panel
1506
Gemäldegalerie
Berlin

Adam and Eve
Two paintings on oak panels
1507
Prado Museum
Madrid

Knight, Death and Devil
Engraving printed on paper
1513
British Museum
London

Melencolia I
Engraving printed on paper
1514
British Museum
London

Lucas Cranach the Elder
Born 1472
Died 1553

Cupid Complaining to Venus
Oil painting on wood
About 1525
National Gallery
London

Venus in a Landscape
Oil painting on wood
1529
Louvre Museum
Paris

Martin Luther and his Wife
 Katharina von Bora
Oil painting on wood
1529
Hessisches Landesmuseum
Darmstadt

Judith with the Head of Holofernes
Oil painting on lime wood
About 1530
Kunsthistorisches Museum
Vienna

Hieronymus Bosch
Born by 1474
Died 1516

The Garden of Earthly Delights
Painted triptych on three wooden
 panels
About 1504
Prado Museum
Madrid

Hans Baldung Grien
Born 1484–85
Died 1545

Witches' Sabbath
Woodcut printed in colour on
 paper
1510
British Museum
London

Hans Holbein the Younger
Born 1497–98
Died 1543

The Body of the Dead Christ in
 the Tomb
Painting on wooden panel
1521–22
Kunstmuseum
Basel

Thomas More and his Family
Design for lost group portrait
Pen and brush with black ink over
 chalk on paper
1526–27
Kupferstichkabinett
Kunstmuseum
Basel

The Artist's Wife and Children
Oil painting on paper mounted on
 wood
About 1528
Kunstmuseum
Basel

The Ambassadors
Oil painting on oak
1533
National Gallery
London

Jane Seymour
Drawing in black and coloured
 chalks, pen and black ink and
 metal-point on pink prepared
 paper
About 1536–37
Royal Collection
Windsor Castle

Jane Seymour
Painting on oak panel
About 1536–37
Kunsthistorisches Museum
Vienna

Whitehall Cartoon (surviving part)
Drawing in ink and watercolour on
 paper
About 1536–37
National Portrait Gallery
London

Christina of Denmark, Duchess of
 Milan
Oil painting on oak panel
1538
National Gallery
London

Anne of Cleves
Painting on parchment, glued to
 canvas
About 1539
Louvre Museum
Paris

Miniature of Anne of Cleves
Painting on vellum in carved ivory
 box
About 1539
V&A Museum
London

Jacopo Pontormo
Born 1494
Died 1557

Entombment
Painting on wooden panel
1525–28
Capponi Chapel
Santa Felicità
Florence

Agnolo Bronzino
Born 1503
Died 1572

Roundels of the Evangelists
 (collaboration with Jacopo
 Pontormo)
Four oil paintings on circular
 wooden panels
Second half of 1520s
Capponi Chapel
Santa Felicità
Florence

Portrait of a Young Man as St
 Sebastian
Oil painting on wooden panel
About 1533
Thyssen-Bornemisza Collection
Madrid

Portrait of Lucrezia Panciatichi
Oil painting on wooden panel
About 1541
Uffizi Gallery
Florence

Frescoes in the Chapel of Eleanora
 of Toledo
1540s
Palazzo Vecchio
Florence

Allegory with Venus and Cupid
Oil painting on wooden panel
About 1545
National Gallery
London

Lady in a Red Dress with a Fair-
 Haired Little Boy
Oil painting on wooden panel
About 1540, reworked about
 1545–46
National Gallery of Art
Washington, DC

Portrait of Andrea Doria as
 Neptune
Oil painting on canvas
Early 1530s or after 1545
Brera Picture Gallery
Milan

Martyrdom of St Lawrence
Fresco
1565–69
San Lorenzo
Florence

Bartolomeo Ammannati
Born 1511
Died 1592

Neptune Fountain
Marble
1575
Piazza della Signoria
Florence

Benvenuto Cellini
Born 1500
Died 1571

The Nymph of Fontainebleau
Bronze
1542–43
Louvre Museum
Paris

Perseus
Bronze
1554
Loggia dei Lanzi
Florence

François Clouet
Born about 1522
Died 1572

Woman in Her Bath
(Diane de Poitiers)
Oil painting on wood
About 1571
National Gallery of Art
Washington, DC

School of Fontainebleau
Toilette of Venus
Oil painting on canvas
About 1545–50
Louvre Museum
Paris

Diana the Huntress
Oil painting on canvas
About 1550–60
Louvre Museum
Paris

Gabrielle d'Estrées and One of
 Her Sisters
Oil painting on wooden panel
About 1595
Louvre Museum
Paris

Two Women Bathing
Oil painting on wood
Last quarter of the sixteenth century
Uffizi Gallery
Florence

Pieter Bruegel the Elder
Born about 1525–30
Died 1569

The Peasant Wedding
Oil painting on oak
About 1568
Kunsthistorisches Museum
Vienna

The Peasant Dance
Oil painting on oak
About 1568
Kunsthistorisches Museum
Vienna

Bartholomeus Spranger
Born 1546
Died 1611

Venus and Adonis
Painting on canvas
About 1597
Formerly in the Kunstkammer of
 Rudolf II in Prague
Kunsthistorisches Museum
Vienna

Jacopo Tintoretto
Born 1518
Died 1594

Susanna and the Elders
Oil painting on canvas
About 1555–56
Kunsthistorisches Museum
Vienna

Leda and the Swan
Oil painting on canvas
About 1550–60
Uffizi Gallery
Florence

Paolo Veronese
Born 1528
Died 1588

Music
Oil painting on canvas
1556–57
Marciana Library
Venice

La Bella Nani
Oil painting on canvas
About 1560
Louvre Museum
Paris

Frescoes in Villa Barbaro
About 1560–61
Maser
Veneto

The Wedding Feast at Cana
Oil painting on canvas
1562–63
Louvre Museum
Paris

Feast in the House of Levi
Oil painting on canvas
1573
Accademia Gallery
Venice

Venus and Mars
Oil painting on canvas
About 1580
National Gallery of Scotland
Edinburgh

Luca Cambiaso
Born 1527
Died 1585

Venus and Cupid
Oil painting on canvas
1570
Art Institute of Chicago
Chicago

Giambologna (Giovanni Bologna;
 Jean Boulogne)
Born 1529
Died 1608

Fountain of Neptune
Marble
1567
Piazza del Nettuno
Bologna

The Rape of the Sabines
Marble
1583
Loggia dei Lanzi
Florence

Dirck de Quade van Ravesteyn
Probably born 1560s
Died after 1608

Venus
Painting on oak
About 1608
Formerly in the Kunstkammer of
 Rudolf II in Prague
Kunsthistorisches Museum
Vienna

Annibale Carracci
Born 1560
Died 1609

Farnese Gallery
Frescoes
Begun 1597
Farnese Palace
Rome

Panels for a Musical Instrument
Paintings on wood
1597–1600
National Gallery
London

Stefano Maderno
Born 1576
Died 1636

St Cecilia
Marble
1600
Church of St Cecilia
Rome

Caravaggio (Michelangelo
 Merisida)
Born 1571
Died 1610

Boy Bitten by a Lizard
Oil painting on canvas
1595–1600
National Gallery
London

Boy with a Basket of Fruit
Oil painting on canvas
1593–94
Borghese Gallery
Rome

Penitent Magdalene
Oil painting on canvas
About 1593–94
Doria Pamphilij Gallery
Rome

The Lute Player
Oil painting on canvas
1594–95
Hermitage Museum
St Petersburg

Musicians
Oil painting on canvas
About 1595
Metropolitan Museum of Art
New York

The Rest on the Flight into Egypt
Oil painting on canvas
About 1595
Doria Pamphilij Gallery
Rome

Bacchus
Oil painting on canvas
1596–97
Uffizi Gallery
Florence

Narcissus
Oil painting on canvas
About 1597
Palazzo Barberini
Rome

Medusa
Oil painting on canvas on a
 wooden shield
About 1598
Uffizi Gallery
Florence

Judith Beheading Holofernes
Oil painting on canvas
About 1599
Palazzo Barberini
Rome

St Catherine of Alexandria
Oil painting on canvas
About 1599
Thyssen-Bornemisza Collection
Madrid

The Calling of St Matthew
Oil painting on canvas
1599–1600
San Luigi dei Francesi
Rome

The Martyrdom of St Matthew
Oil painting on canvas
1599–1600
San Luigi dei Francesi
Rome

The Crucifixion of St Peter
Oil painting on canvas
1600–01
Santa Maria del Popolo
Rome

The Death of the Virgin
Oil painting on canvas
About 1601–03
Louvre Museum
Paris

Victorious Cupid
Oil painting on canvas
1601–02
Gemäldegalerie
Berlin

St John the Baptist
Oil painting on canvas
About 1602
Capitoline Museums
Rome

The Sacrifice of Isaac
Oil painting on canvas
1603
Uffizi Gallery
Florence

Portrait of Alof de Wignacourt
Oil painting on canvas
About 1607–08
Louvre Museum
Paris

Sleeping Cupid
Oil painting on canvas
1608
Palatine Gallery, Pitti Palace
Florence

Artemisia Gentileschi
Born 1593
Died 1652–3

Judith and Holofernes
Oil painting on canvas
1612–13
Capodimonte Museum
Naples

Judith and Holofernes
Oil painting on canvas
About 1613–14
Uffizi Gallery
Florence

Self-Portrait as the Allegory of
 Painting
Oil painting on canvas
About 1638–39
Royal Collection
London

Guido Reni
Born 1575
Died 1642

St Sebastian
Oil painting on canvas
About 1616
Palazzo Rosso
Genoa

Diego Velázquez
Born about 1599
Died 1660

The Rokeby Venus
Oil painting on canvas
1647–51
National Gallery
London

Gianlorenzo Bernini
Born 1598
Died 1680

Apollo and Daphne
Marble
1622–25
Borghese Gallery
Rome

Portrait of Costanza Bonarelli
Marble
1636–38
Bargello Museum
Florence

Triton Fountain
Travertine
1642–43
Piazza Barberini
Rome

The Ecstasy of St Teresa
Marble
1644–47
Santa Maria della Vittoria
Rome

Four Rivers Fountain
Marble and travertine
1651
Piazza Navona
Rome

Peter Paul Rubens
Born 1577
Died 1640

The Artist and his Wife in a
 Honeysuckle Bower
Oil painting on canvas
About 1609
Alte Pinakothek
Munich

Portrait of the Brueghel Family
Oil painting on wooden panel
About 1612–13
Courtauld Gallery
London

Venus Frigida
Oil painting on wooden panel
1614
Koninklijke Museum of Fine Arts
Antwerp

Portrait of Isabella Brant
Oil painting on wooden panel
About 1621
Cleveland Museum of Art
Cleveland, Ohio

Portrait of Isabella Brant
Oil painting on wooden panel
About 1626
Uffizi Gallery
Florence

The Judgement of Paris
Oil painting on oak panel
Probably 1632–35
National Gallery
London

The Three Graces
Oil painting on wooden panel
Mid-1630s
Prado Museum
Madrid

The Feast of Venus
Oil painting on canvas
Mid-1630s
Kunsthistorisches Museum
Vienna

The Little Fur (Helena Fourment in
a Fur Wrap)
Oil painting on oak panel
About 1635–40
Kunsthistorisches Museum
Vienna

Frans Hals
Born 1582–83
Died 1666

Wedding Portrait of Isaac
Abrahamsz Massa and Beatrix
van der Laen
Oil painting on canvas
About 1622
Rijksmuseum
Amsterdam

Rembrandt van Rijn
Born 1606
Died 1669

A Seated Female Nude
Etching printed on paper
About 1631
British Museum
London

Diana at her Bath
Etching printed on paper
About 1631
British Museum
London

A Bust of a Young Woman Smiling
Oil painting on wooden panel
1633
Gemäldegalerie
Dresden

Saskia van Uylenburgh in a Red
Hat
Oil painting on wooden panel
About 1633–42
Gemäldegalerie Alte Meister
Staatliche Kunstsammlungen
Kassel

Flora
Oil painting on canvas
1634
Hermitage Museum
St Petersburg

Joseph and Potiphar's Wife
Etching printed on paper
1634
Fitzwilliam Museum
Cambridge

A Young Woman at her Toilet
Drawing in brown ink and brown
 and grey wash on paper
About 1634
Albertina
Vienna

The Prodigal Son in the Tavern
 (Rembrandt and Saskia)
Oil painting on canvas
About 1635
Gemäldegalerie
Berlin

Saskia van Uylenburgh in Arcadian
 Costume
Oil painting on canvas
1635
National Gallery
London

A Woman Sitting up in Bed
Drawing in brown ink on paper
About 1635
Groninger Museum
Groningen

A Sick Woman Lying in Bed
Drawing in brown ink touched with
 white
About 1635–40
Musée des Beaux Arts de la Ville de
 Paris
Paris

A Self-Portrait with Saskia
Etching printed on paper
1636
British Museum
London

Sheet of studies with Saskia and
 Others
Etching printed on paper
1636
British Museum
London

Danaë
Oil painting on canvas
1636
Hermitage Museum
St Petersburg

Belshazzar's Feast
Oil painting on canvas
About 1636–38
National Gallery
London

An Interior with a Woman in Bed
Drawing in brown ink with grey
 wash
1640–41
Frits Lugt Collection
Netherlands Institute
Paris

A Woman in Bed
Oil painting on canvas
About 1645
National Gallery of Scotland
Edinburgh

The French Bed
Etching printed on paper
1646
Rijksmuseum
Amsterdam

Rembrandt's Studio with a Model
 (Hendrickje Stoffels)
Drawing in brown ink and wash,
 with white wash, on paper
About 1654
Ashmolean Museum
Oxford

A Young Woman Sleeping
 (Hendrickje Stoffels)
Drawing in brown wash with some
 white mixed in
About 1654
British Museum
London

A Woman Bathing in a Stream
 (Hendrickje Stoffels)
Oil painting on canvas
1654
National Gallery
London

Bathsheba at Her Bath
Oil painting on canvas
1654
Louvre Museum
Paris

Portrait of Hendrickje Stoffels
Oil painting on canvas
Probably 1654–56
National Gallery
London

A Woman at an Open Door
Oil painting on canvas
About 1656–57
Gemäldegalerie
Berlin

A Nude Woman Lying on a Pillow
Drawing in brown ink with wash,
 touched with white
About 1658
Rijksmuseum
Amsterdam

A Reclining Female Nude
Etching printed on paper
1658
Fitzwilliam Museum
Cambridge

Jupiter and Antiope
Etching printed on paper
1659
British Museum
London

A Seated Female Nude
Drawing in brown ink and wash,
 with white wash, on paper
About 1660
Art Institute of Chicago
Chicago

ILLUSTRATION CREDITS

Colour Plate Section

The Lady with the Ermine (Cecilia Gallerani), 1496 (oil on walnut panel), Vinci, Leonardo da (1452–1519) / © Czartoryski Museum, Cracow, Poland / The Bridgeman Art Library

The Tempest (oil on canvas) (detail of 603), Giorgione, (Giorgio da Castelfranco) (1476/8–1510) / Galleria dell' Accademia, Venice, Italy / Cameraphoto Arte Venezia / The Bridgeman Art Library

Le Concert Champetre (Open–Air Concert), c.1510 (oil on canvas), Titian (Tiziano Vecellio) (c.1488–1576) / Louvre, Paris, France / Giraudon / The Bridgeman Art Library

Flora (oil on canvas), Titian (Tiziano Vecellio) (c.1488–1576) / Galleria degli Uffizi, Florence, Italy / The Bridgeman Art Library

The Andrians, c.1523–4 (oil on canvas), Titian (Tiziano Vecellio) (c.1488–1576) / Prado, Madrid, Spain / Giraudon / The Bridgeman Art Library

Mary Magdalene (oil on canvas), Titian (Tiziano Vecellio) (c.1488–1576) / Palazzo Pitti, Florence, Italy / Giraudon / The Bridgeman Art Library

Jupiter and Io, Correggio, (Antonio Allegri) (c.1489–1534) / Kunsthistorisches Museum, Vienna, Austria / The Bridgeman Art Library

Venus in a landscape, 1529 (oil on panel), Cranach, Lucas, the Elder (1472–1553) / Louvre, Paris, France / Giraudon / The Bridgeman Art Library

Laocoon, Hellenistic original, 1st century (marble), Greek / Vatican Museums and Galleries, Vatican City / Giraudon / The Bridgeman Art Library

Christina of Denmark (1522–90) Duchess of Milan, probably 1538 (oil on panel), Holbein the Younger, Hans (1497/8–1543) / National Gallery, London, UK / The Bridgeman Art Library

Lucrezia Panciatichi, c.1540 (oil on panel), Bronzino, Agnolo (1503–72) / Galleria degli Uffizi, Florence, Italy / Alinari / The Bridgeman Art Library

Venus and Adonis, 1553 (oil on canvas), Titian (Tiziano Vecellio) (c.1488–1576) / Prado, Madrid, Spain / The Bridgeman Art Library

Europa, 1559–62 (oil on canvas), Titian (Tiziano Vecellio) (c.1488–1576) / © Isabella Stewart Gardner Museum, Boston, MA, USA / The Bridgeman Art Library

Last Judgement, from the Sistine Chapel, 1538–41 (fresco), Buonarroti, Michelangelo (1475–1564) / Vatican Museums and Galleries, Vatican City / Alinari / The Bridgeman Art Library

Danae (oil on canvas), Titian (Tiziano Vecellio) (c.1488–1576) / Museo e Gallerie Nazionali di Capodimonte, Naples, Italy / Alinari / The Bridgeman Art Library

Boy Bitten by a Lizard, c.1595–1600 (oil on canvas), Caravaggio, Michelangelo Merisi da (1571–1610) / National Gallery, London, UK / The Bridgeman Art Library

The Young Bacchus, c.1589 (oil on canvas), Caravaggio, Michelangelo Merisi da (1571–1610) / Galleria degli Uffizi, Florence, Italy / Alinari / The Bridgeman Art Library

Ecstasy of St. Teresa (marble) (detail), Bernini, Gian Lorenzo (1598–1680) / Santa Maria della Vittoria, Rome, Italy / Alinari / The Bridgeman Art Library

INDEX

(page numbers given in italics refer to illustrations)

ACKNOWLEDGEMENTS

I would particularly like to thank my editor, Mike Jones, for making such a creative contribution to this book.

I am also very grateful to my agent, Will Francis, for being a great friend to this project.

I would like to thank all at Simon & Schuster who have helped bring this book to press, including Monica Hope, Briony Gowlett and the production team. I thank the *Guardian* for many opportunities to see great art. I am especially grateful to my *Guardian* editors, Kate Abbott, Philip Oltermann and David Teather, for making my work as a *Guardian* critic fun. I was lucky enough to meet Professor Simon Schama while starting this book and he reminded me about van Mander, 'the Dutch Vasari' – I am truly indebted to his random act of intellectual kindness. I also enjoyed discussing the book with Julian Bell, James Hall and Martin Gayford.

My father, Eric Lewis Jones, passed away in late 2012. My fascination with art and history was nurtured by childhood holidays in which he drove us to Florence and Rome. I am forever grateful to him, and to my mother, Margaret, who is a wonderful reader of everything I write.